D1442110

FOX TALBOT
and the Invention
of Photography

FOX TALBOT
and the Invention
of Photography

GAIL BUCKLAND

DAVID R. GODINE, PUBLISHER

BOSTON

First published in 1980 by

David R. Godine, Publisher, Inc.
306 Dartmouth Street
Boston, Massachusetts 02116

Library of Congress Cataloging in Publication Data

Buckland, Gail.
 Fox Talbot and the invention of photography.

 Includes bibliographical references and index.
 1. Talbot, William Henry Fox, 1800–1877. 2. Photography–History.
 3. Photographers–England–Biography.
 I. Title.
 TR140.T3B8 770′.92′4 [B] 79–90358

ISBN 0-87923-307-9

Designed by Philip Grushkin

Manufactured in the United States of America

CONTENTS

To My Parents
Adele and Irving Greene

ACKNOWLEDGEMENTS

Without the help and encouragement of Dr. David Thomas (my first teacher in the history of photography) and John Ward, both of the Science Museum, London, this book would not have been possible. Robert E. Lassam, Curator, Fox Talbot Museum, was exceptionally generous in assisting me with my research. Harold White shared with me on many occasions his considerable familiarity with Talbot. Ian Jeffrey suggested the relevance of Merleau-Ponty's writing in relation to the study of Talbot's images. I should also like to thank the following people who provided information, assistance and/or enthusiasm for this project: Douglas Arnold; Dana Baylor; Donald Barliant; Cecil Beaton; Carolyn Bloore; Yorick Blumenfeld; Denis, Valerie and David Buckland and most especially my husband Barry; Anthony Burnett-Brown; Lord Kenneth Clark; Nicholas Cooper, National Monuments Record, London; Arnold Crane; Jonas Dovydenas; Mary Fanette; Adele and Irving Greene; Hugh Edwards; Carole and Arthur Elias; Max Fairbrother; Arthur Gill, Curator of the Museum, Royal Photographic Society; Weston Naef, Associate Curator, Department of Prints and Photographs, Metropolitan Museum of Art; Eugene Ostroff, Curator of Photography, Smithsonian Institu-

tion; the Science Museum photographers; Joel Snyder; June Stanier; David Travis, Assistant Curator, Department of Photography, Art Institute of Chicago; Louis Vaczek and Kenneth Warr, Secretary, Royal Photographic Society.

I should like to express my sincere appreciation to my publisher and to the designer Philip Grushkin for their sensitivity to the subject and their devotion to the making of beautiful books.

Permission has graciously been granted by the following institutions and individuals to quote from letters and documents in their possession: Anthony Burnett-Brown; Controller of Her Majesty's Stationery Office (to reproduce Patent 8,842); Fox Talbot Museum, Lacock; Metropolitan Museum of Art, New York; Royal Institution, London; Royal Photographic Society, London; Royal Society, London; Science Museum, London; the Master and Fellows of Trinity College, Cambridge; and Harold White.

The research for this book has been partially supported by a grant from the *National Endowment for the Humanities.*

AUTHOR'S NOTE

The majority of pictures in this book are from the approximately 6000 photographs in the Fox Talbot Collection at the Science Museum, London. The Science Museum acquired its vast archive of these earliest prints and negatives between 1937–1947 from William Henry Fox Talbot's granddaughter, Matilda Talbot. Most of the pictures are not dated or signed. Absolute confirmation of the authorship of many of the pictures or the dates they were taken is not always possible. Fortunately, Talbot did date many of his earliest photographs, kept a list of the pictures he made between November 1839 and October 1840, sent letters to his family and friends stating where and what he was photographing at particular times, and left other important documents which are invaluable to the photographic historian. Equally important are the letters and lists sent to Talbot from the Rev. Calvert Jones, Rev. George Bridges and others stating the photographs *they* made on their trips abroad and around their homes, many of which have long been attributed to Talbot due to the fact that the negatives were found at Lacock Abbey or the prints were made at the Reading Establishment. Constance, Talbot's wife, photographed as did his one-time valet, Nicolaas Henneman, yet neither's work is signed. The author, after years of research, has done her best, with the help of her colleagues in England, to identify the photographs in the Fox Talbot Collection. Unless otherwise stated, it is believed that all the photographs in the book are by the inventor.

A second point should also be mentioned. The reader may be confused sometimes by what appears to be inconsistency in technique. For example, a photograph placed in the early part of the book may seem to be more "sophisticated" than one that is reproduced later. The majority of the photographs in the book range over a relatively short period—1839 to 1845—a time, however, of constant experimentation for Talbot with the medium he had fathered. Sometimes while he was trying new chemicals, different cameras, lenses and assorted papers, he would make one photograph that exhibited unusually fine technique and exceptional composition. He might not then be able to equal that standard for some time, and would proceed to make, for example, during the summer of 1841, photographs with a similar primitive "feel" to them, but with their own nuances. One would imagine, but this is hardly the case, that at least it would be easy to distinguish between a photogenic drawing and a calotype. Talbot was using similar paper, cameras, and chemicals (even gallic acid in 1839) in both processes and quite often the resulting pictures are indistinguishable. It is best to delight in the variations in Talbot's images—in color, focus, subject, viewpoint, etc.—and not be overly troubled by inconsistencies in style and technique.

Most of the photographs reproduced in this book are from modern contact prints from original Talbot negatives.

1.

Fox Talbot of Lacock Abbey

Do the first photographs, in some sense, go to "the farthest reach of the future"? Do they, in their primitiveness, imply more about the nature of the medium, than any photographs subsequently made? The early paper prints by William Henry Fox Talbot reveal and withhold impressions and information (like cavemen's paintings) simultaneously in their coarse faded fibers. Do they provide clues to the mystery and magic of photography, clues so vital to an understanding of the medium that without them the entire study of the history of photography is impoverished? The photographs by William Henry Fox Talbot are the foundation of photography. They are images about light, about nature and about man's quest for understanding. They are a search for photography itself. Each picture is a celebration—a celebration that it is possible to capture light rays—hold them and pass their traces down through time.

William Henry Fox Talbot, a fascinating and complex individual, was the creator of hundreds of haunting photographs. The inventor of photography as we know it today, he made photograms and pictures with the aid of the camera obscura and the solar microscope. When he began his investigations he did not know if it was possible to draw with the sun and fix its designs. He communed with nature, asked nature to reveal itself, and saw the final result more as a wonderful natural event than the product of his own talents. Talbot did not know what was possible when he started his research and his images have a searching, a genuine innocence, that is profound and to us nearly a century and a half later, strangely enchanting.

The images, although undeniably rudimentary, were made by a man of marked genius. The invention itself that evolved in diverse and far-reaching ways reflected the breadth and multiple interests of Talbot himself. The story of the invention and the life of the inventor assume exciting proportions when related as the tale of a 19th century English gentleman's philosophical quest for "truth." Great Britain, unmatched leader of the newly industrialized Western world, bred and nurtured Talbot.

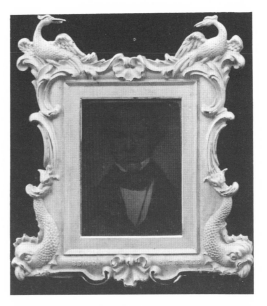

Daguerreotype of Talbot by Richard Beard, c. 1842.

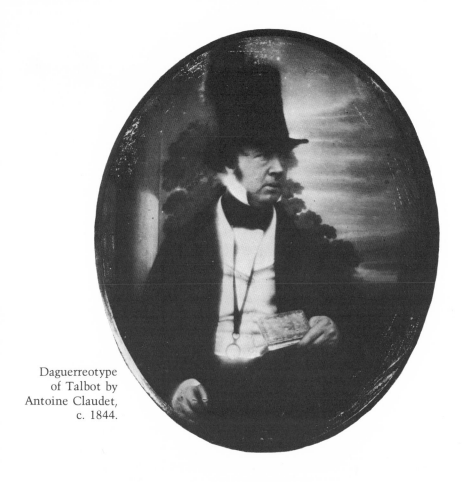

Daguerreotype
of Talbot by
Antoine Claudet,
c. 1844.

Modern photography was conceived by a brilliant man who not only developed it technically, but also used it gloriously to make pictures and wrote philosophically and poetically about its potential. In the history of photography there is no more seminal a figure than William Henry Fox Talbot and no photographs more compelling than the earliest photographs made.

Talbot, born on February 11, 1800, at his maternal grandmother's home, Melbury, in Dorset, was descended from a passionate lady whose petticoats, legend has it, "did somewhat break her fall":

From the parapet wall of this building [the Tower of Lacock Abbey], Olive Sharington, the heiress of Lacock, threw herself into the arms of her lover, a gallant gentleman of Worcestershire, John Talbot, a kinsman of the Earl of Shrewsbury. He was felled to the earth by the blow, and for a time lay lifeless, while the lady only wounded or broke her finger.[3]

Olive's father, Sir Henry Sharington, consented to his daughter's marriage soon after John Talbot regained consciousness, stating "since she made such leapes she should e'en marry him."[4]

Henry Sharington's brother William, a rather shady character in English lore, purchased Lacock Abbey, Talbot's country estate, in 1544. Prior to this time, Lacock Abbey had been a convent, founded in 1232 by Ela, Countess of Salisbury, in loving memory of her husband William Longespee. Longespee was the illegitimate son of Henry II and half-brother of Richard I and King John. Ela (brought up as a ward of King Richard I and the only woman to have served as Sheriff of Wiltshire) and Longespee had four children.[5] Nicholas, the youngest, was Bishop of Salisbury and willed that his heart be buried at Lacock where the heart stone can still be seen among the Abbey's many relics.

Olive, that strong and daring lady, outlived her husband and her son and was succeeded by her grandson, Sharington Talbot, in 1646. *His* son, Sir John, entertained both King John and Queen Anne at Lacock, and John's son, also called Sharington Talbot, brought the direct male line at Lacock to an end, unhappily being killed in a duel in 1685.

John Ivory, grandson of the duelist, lived at Lacock for 60 years and took the Talbot name of his mother's forebears. He incorporated many changes in the architecture of the Abbey, rebuilding much of the house in the Georgian and later Gothic styles.[6] John Ivory Talbot married Mary Mansel of Margam in South Wales. Their second son inherited the considerable property in Wales, thus establishing the Welsh link with the Wiltshire Talbots. Christopher Rice Mansel Talbot of Margam was Henry Talbot's classmate at Harrow and they remained close

Much of his life reflects the ideology and values of his culture. The Victorians had confidence in themselves. They fervently believed they could acquire an intimate knowledge of almost anything with "a little application." They were taught to concentrate and to memorize. They demanded that every sensation yield organized knowledge so that a country walk became a lesson in exact botany. "By contrast," a contemporary writer has lamented, "our schooling is planned amnesia, our work a hiatus between phone calls."[2] To use one's intellect to its utmost extent was a Victorian ideal.

Talbot's intellectual search, whether it was for the derivation of a word, the nature of the image on the piece of paper viewed in the camera obscura, or the comprehension of hieroglyphics, was always the same. He wanted to know its root, its fundamental components, its "ultimate nature" in order to perceive clearly the natural world and man's place within it. Talbot loved life, affirmed it by each creative act. Fascinated with almost every area of human endeavor and field of learning, Talbot studied and contributed to a multitude of disciplines. He saw all his activities integrated, but to the 20th century specialist, his life seems unfathomable and suspect. In fact, however, the study of it results in the impression that it was indeed harmonious, whole and fulfilling.

friends throughout their lives. "Kit" was one of the first people to learn and practice photography on paper.

John Ivory Talbot died in 1772 and, as his son had no children, the estate passed to his daughter, wife of the Rev. William Davenport, and then to their son William Davenport Talbot. The latter, an officer in the Dragoons who had served with Prince Edward's regiment in Canada, died six months after his only child, William Henry Fox Talbot, was born.

It is difficult to ascertain what kind of man was William Davenport Talbot. Portraits suggest he was handsome yet frail. Two important facts are known: he married an intelligent and determined woman, Lady Elisabeth Fox-Strangways, daughter of the 2nd Earl of Ilchester; and when he died he left his estate heavily encumbered with debt. The dominating influence of Lady Elisabeth on Henry and Henry's homelessness for the first 27 years of his life (to pay the debts, Lacock Abbey was leased to a Mr. J. R. Grosett, M. P. for Chippenham, for this period)

had a lasting effect on the future inventor of positive/negative photography. The final entry of his first diary dated April 18, 1813, reads: "I have travelled 6,959 miles and this is the 4,811 day of my life."[7]

Lady Elisabeth demanded and received only the highest intellectual achievement from her son. From his first days at school through his adult life, he sought his mother's counsel and approval. She, however, rarely believed that Henry did himself justice in the eyes of the world and recognized this flaw as a manifestation of his personality, not intelligence. Talbot throughout his life was contemplative and ardent in his studies. He rarely tried and seldom succeeded in self-promotion, facing the world instead with an austere and rigorous visage. He is known through his work and inventions and it is almost impossible to see through them and discern the human being in intimate details, too few of which have been left in the record.

Procrastination did seem a fault in Talbot's character.

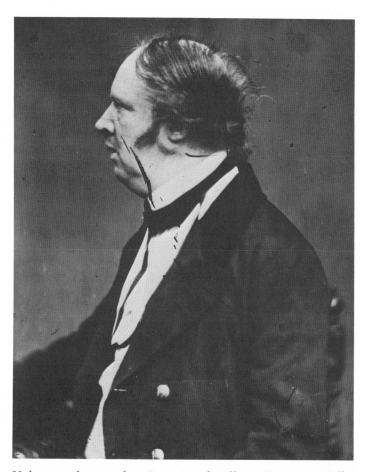 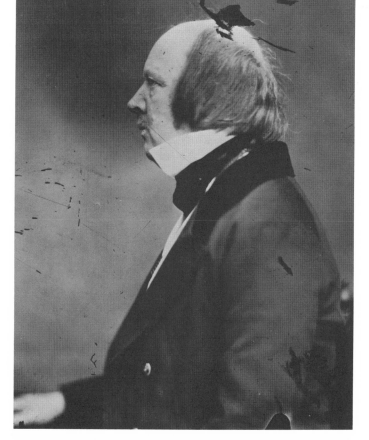

Unknown photographer. Portraits of William Henry Fox Talbot from wet-collodion negatives. Hair up, collar down and hair down, collar up.

It can be interpreted, however, that he did not like to rush into things, especially not into publishing scientific findings. The results of his photographic experiments were safely tucked away for four years before Louis Jacques Mandé Daguerre's announcement of January 7, 1839 motivated him to make them public. This was not an isolated incident. In 1833 he wrote the following letter to his dear friend, the famous astronomer, Sir John F. W. Herschel:

... I saw a very pretty experiment last Friday at the Royal Institution by which it is demonstrated that the Electric spark is never continuous, however close the bodies are between which the sparks pass; but that on the contrary galvanic electricity gives a continuous discharge.

This has brought to my mind a train of experiments which I formerly executed, attended with interesting results, one of which astonished me much when I first beheld it....

I don't know why I have suffered these experiments to slumber in my portfolio for seven years; but I am now thinking of presenting them in the form of a short paper to the Royal Society.[8]

Talbot's ambition was for knowledge, not fame, not friends, not wealth. Knowledge had to be striven for with all the energy and power within him. The other things came naturally, so to speak, in time, and were important but not of utmost importance. An acquaintance from Cambridge said of him:

He is very laborious, not so much I think out of vanity or even ambition as from the mere love of what he is acquiring. He has an innate love of knowledge and rushes towards it as an otter does to a pond.[9]

True, Talbot wanted scholars, scientists and others to recognize his achievements, he wanted stimulating and intelligent friends who could share in his perceptive view of life, and he wanted his applied scientific research to be a source of income. He published his papers, wrote his books and joined societies; he drew to him cultivated and brilliant men; and he patented those discoveries he felt could be used to found important industries. The central concern of Talbot's life, however, was scholarship, not in

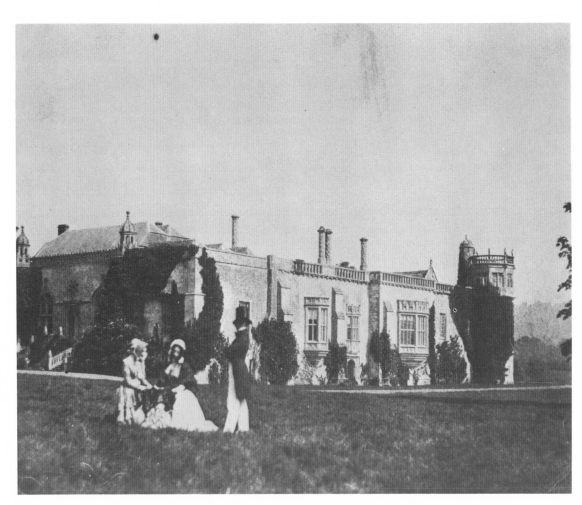

Family group on the grounds of Lacock Abbey. The West Front is on the left, the South Gallery in the center, and Sharington Tower, erected circa 1550, appears in the distance.

any one discipline but in a multitude of subjects; he viewed all knowledge as interrelated. The scientific view of life was connected to the artistic; the derivation of a word explained as much about the world as looking at crystals in a microscope; cultivating plants was as joyous and as challenging as making pictures with the camera obscura; gazing at the stars provoked as many questions as discovering legends of the Middle Ages or translating Assyrian cuneiforms. Never accused of being a dilettante because he made major contributions in many areas, he was still a wanderer, an explorer of ideas, a restless searching soul.

Two letters, one written by Lady Elisabeth in 1841 to Constance, Talbot's wife, and the second written by Talbot to Herschel in April 1840 (while in the midst of great photographic activity—both picture-making and experimenting) reveal much of this aspect of Talbot,

. . . his own library at L[Lacock] Abbey he always complains is cold, tho' it is only so because he keeps such wretched fires and the door generally wide open in all weather and seasons . . . I am now convinced that it is not Laycock [sic] air that disagrees with him, but any *air—and that he requires it to be frequently changed . . . a highly wrought nervous system is the penalty for such extraordinary talents as nature has given him. His brain works so much that the constitution* must *suffer, particularly as it is not counteracted by air & exercise. . . . We dined yesterday at Lord Ilchester, and Henry was so agreeable & talked so well he so seldom does himself justice or shows himself to such advantage. . . .*[10]

And from Talbot to Herschel:

I enclose some photographs, all done with the camera. If they get crushed in the Post Office bags, they may easily be smoothed either by ironing or by being left some hours in a press. The present weather is the finest and most settled, since the birth of Photography—The heat has likewise been excessive for the time of year. Whenever there comes a very bright day, it is as if nature supplied an infinite designing power, of which it is only possible to use an infinitesimal part. It is really wonderful to consider that every portion of the whole Solar flood of light, should be endowed with so many complicated properties, which in a vast majority of instances must remain latent, without meeting any object. . . . This is splendid weather for you on arriving at your new residence. Hawkhurst sounds like a very pleasant rural retirement abounding in hawks and forest glades—I have interrupted this letter several times to listen to a nightingale who is perched on a bush just outside my window . . . I have one of your pretty Cape plants in flower in the greenhouse, long spikes of yellow flowers.[11]

The first letter describes a man of great restlessness for whom changes of environment were a necessity, whereas social interactions, per se, were not. The second letter immediately warms one toward a man for whom living was so full of interest and beauty. In one brief missive,

Lady Elisabeth Feilding dated April 11, 1842.

Talbot discusses the weather, nature's "infinite designing power," the "whole Solar flood of light," listening to a nightingale, and a plant in flower in his greenhouse. Somewhat like the letter, the directions Talbot took in his life have no apparent order but together they form a unique, quite indescribable but fascinating individual.

Talbot's involvements and accomplishments were numerous. Etymology was a passion and his books in this field, to which he made many contributions, reveal more about his personality (intolerant and sarcastic at times), about his wit, his view of history and certain forms of scholarship, than any other source. Introductions to the books and the derivations of the words themselves show Talbot to be an acute and unconventional observer of life. On the title page of his book *Hermes—or Classical and Antiquarian Researches* (1838, 1839) the following quote by Warton appears:

Nor rude nor barren are the winding ways of hoar antiquity—but strewn with flow'rs.

Immediately the reader is enticed to follow a journey back in time that undoubtedly will be filled with pleasures. The chapters in the book have such titles as "Was Homer acquainted with the art of Writing?"; "On the names of the ancient Roman Months"; "On the original meaning of the words *Drama, Comedy, Poetry*"; and "On the original meaning of the word *Rhapsody*."

His approach in deriving words shows that beyond his erudition and joy when playing with ideas, he never overlooked asking the most fundamental questions. This search for clarity, of true understanding based upon the "ultimate nature" of whatever he was studying, appears over and over again in his life. When, for example, in 1833 he thought about the impression on the transparent piece of tracing paper placed in the camera obscura, he asked what the "ultimate nature" of the picture was before him. The following excerpt from *Hermes* shows Talbot's approach in deriving a word—in this instance, *sublimis*:

This word, one of the most important and remarkable of the Latin language, has remained hitherto, as far as I am aware, without explanation, although its origin has been frequently attempted to be investigated both by ancient and modern inquirers.

Great as are the absurdities into which etymologists generally fall, when they encounter a word at all difficult or obscure, they have certainly surpassed themselves on this occasion: if indeed the conjectures which I find on record were ever intended to be seriously proposed. That the reader may judge for himself, I will annex two of them.

Let us open a Latin dictionary and we find this specimen of enlightened philology: SUBLIMIS, quia SUPRA LIMUM; because it is above the mud!! Verily, that is more than can be safely said of the intellect of some persons!

A different, but by no means a happier conjecture, stands next recorded. "Others derive it from sublimen, a threshold." To which (other objections being superfluous) it may be replied that no such word appears to exist.

Such are the absurdities into which grammarians and commentators plunge themselves, rather than acknowledge that the origin of a word, or the meaning of an author, has baffled their endeavours to discover.

Let us proceed more philosophically, even if it should not be successfully, in inquiring first, what is the leading idea contained in the adjective SUBLIMIS?

The leading idea seems to be, anything which we LOOK UP TO, which implies the notion of its being very high.

Now the great stumbling-block in this word has undoubtedly been that it apparently contains the preposition SUB, while the sense requires SUPER. This even our mud-etymologists have felt, since they say "suprà limum," when the word itself says "sub limo."[12]

Language was a key to the truth concerning the past. Talbot wrote:

Etymology is the history of the languages of nations, which is a most important part of their general history. It often explains their manners and customs, and throws light upon their ancient migrations and settlements. It is the lamp by which much that is obscure in the primitive history of the world will one day be cleared up. At present much that passes for early history is mere vague speculation: but in order to build a durable edifice upon a firm foundation, materials must be carefully brought together from all quarters and submitted to the impartial and intelligent judgment of those who are engaged in similar inquiries.[13]

For this same reason, after he had developed his invention, Talbot took great pride in the realization that photography would provide everyone with images of the different worlds of predecessors and thus help eliminate, to a certain extent, "mere vague speculation" about history.

Mathematics was another field to which he devoted much energy. At the age of 22 he published his first paper titled "On the Properties of a certain Curve derived from the Equilateral Hyperbola" in Gergonne's *Annales Mathematiques*. Based on this and other mathematical studies, Talbot was elected to the world's most prestigious scientific body of its day, the Royal Society, in 1831. Members of the Royal Society, such as David Brewster, John Herschel and William Grove, became his closest friends and confidants. Nevertheless, later in his life he wrote to Grove:

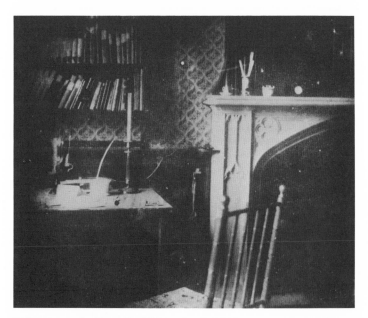

Talbot's study, Lacock Abbey, April 1843.

Intensive study in the mid-1830s resulted in a two-part paper titled "Researches in the Integral Calculus," presented to the Royal Society in 1836 and 1837. He received the Royal Medal in Mathematics and the *Proceedings of the Royal Society* stated that his achievement

must be viewed not merely in the light of difficulty overcome in the progress of abstract science, but likewise as having an important bearing on the advancement of physical inquiry.[15]

And that Talbot's mathematical process

is remarkable for its great simplicity and for the vast number of novel and interesting results which it furnishes, including not merely several of the most remarkable of those which are already known, but likewise many others which are not deducible by other methods.[16]

These mathematical papers consumed much of Talbot's energy during 1834 and 1835, a time when, one would imagine, his interest and concern in perfecting his photogenic drawing process would have been at its greatest.

Although Talbot's notebooks are filled with mathematical annotations, he did not publish anymore in this area until the ten years following 1857, when he submitted six papers to the *Transactions* of the Royal Society of Edinburgh. The concentration and focus required of a mathematician suited Talbot's intellectual needs at times in his life when no form of inquiry other than pure abstraction seemed to satisfy him.

If today the name William Henry Fox Talbot is mentioned in particular corridors of the British Museum or in certain learned societies, recognition will come not as the inventor of photography, but as a brilliant Assyriologist. As a young man Talbot studied Hebrew and collected hieroglyphics but although he never devoted himself exclusively to this study, his accomplishments were of the highest order. For example, he translated independently of but simultaneously with Sir Henry Rawlinson, Dr. Edward Hincks and Dr. Jules Oppert, all reknowned Orientalists, the cuneiform inscriptions brought from Ninevah of *Tiglath Pileser I.*, King of Assyria, 1150 B.C. More than 60 of his translations from the Assyrian were published by the *Transactions of the Society of Biblical Archaeology, Journal of Sacred Literature, Journal of the Royal Asiatic Society*, etc. and in 1858 he was elected Vice-President of the Royal Society of Literature.

Crystallography which required peering through a microscope was another pursuit in Talbot's life. Reflecting on the images he could see using optical devices that

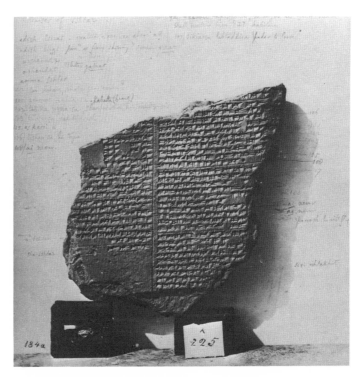

An example of Talbot's use of photography to aid him in his translations of Assyrian texts. Photograph probably taken by Roger Fenton at the British Museum.

could not be seen by the naked eye started with his work in astronomy (he was elected a member of the Royal Astronomical Society at the age of 22 and at the age of 71 presented a paper at the British Association titled "On a new method of estimating the distance of some of the fixed stars"), continued in his microscopic probings and culminated in his use of the camera obscura. Studying life through a lens was comfortable and photography was a natural outgrowth of his knowledge of optics as well as chemistry and physics.

He could be quite poetic when describing the phenomena he saw:

The crystals, which were highly luminous in one position, when their axes were in the proper direction for depolarizing the light, became entirely dark in the opposite position, thus, as they rapidly moved onwards, appearing by turns luminous and obscure, and resembling in miniature the coruscations of a firefly. It was impossible to view this without admiring the infinite perfection of nature, that such almost imperceptible atoms should be found to have a regular structure capable of acting upon light in the same manner as the largest masses, and that the element of light itself should obey in such trivial particulars the same laws which regulate its course throughout the universe.[17]

On May 5 and December 15, 1836, Talbot presented a two-part paper to the Royal Society titled "On the Optical Phenomena of certain Crystals." The paper began as follows:

At present I mean to confine myself to the description of a phenomenon which shows strikingly the beautiful order and regularity with which nature disposes the fabric of some of her minutest visible works.[18]

As with his mathematical papers presented a few months before, his results were applauded and he was awarded another prize—the Bakerian—and gave the Bakerian lecture for the year 1837. The Royal Medal and the Bakerian were major scientific honors and proof that Talbot was highly regarded as a scientist. Such was his reputation that the physicist Sir David Brewster dedicated his *Treatise on the Microscope* to Talbot in 1837.

Part of the reason Talbot did not publish the results of his experiments of 1834 and 1835 in photography until 1839 was that he was achieving major breakthroughs in other areas. These gave him enormous intellectual pleasure as well as the respect of the scientific community. He did not then realize the phenomenal importance of his negative/positive process nor did he feel he had taken his experiments sufficiently far to present them publicly.

Talbot made the world's first photomicrographs in 1835. This photograph of a crystal was made with a solar microscope using polarized light.

Probably spherulites, radiating crystal aggregates, viewed through the polarizing microscope.

Perhaps, too, he was having difficulty proceeding with his experiments. In his own words "There is nothing like having two or three different pursuits *pour se délasser* when anything goes wrong...."[19]

Botany was a subject of keen interest to Talbot as child and as adult, and all his life he planted seeds and watched them grow. Perhaps more of his surviving letters refer to botany than any other field of study. He corresponded with his mother; his wife Constance; his uncle William Fox-Strangways; his children; Sir John Herschel; William Hooker, the first director of the new National Botanic Garden (Kew Garden), and *his* son Joseph Dalton Hooker, who, with George Bentham wrote the standard reference work *Genera Plantarum*; John Lindley, Professor of Botany at London University; the Italian botanists Tenore and Bertolini and many others—all on subjects pertaining to botany. Four such letters, two to Herschel and two to Bertolini, follow:

31 Sackville St.
9th March 1833

... I almost envy you your intended residence in South Africa, [in 1833 Herschel and his family left for the Cape of Good Hope in order that he could complete his survey of the heavens of the southern hemisphere] which possesses I am told serene skies & a wholesome climate. It is moreover a most [?] country

with respect to its vegetable productions, and botany is a science to which I am particularly attached and have paid much attention during my travels through many parts of Europe. I almost think of troubling you with a request that through your means I may be enabled to employ some gardener or labouring man of intelligence in collecting seeds and roots in different parts of the Colony which I may afterwards hope to see flourishing in my greenhouse in Wiltshire....[20]

*Lacock Abbey,
June 11th [1838]*

Any Cape bulbs which you have really to spare, will be very acceptable, but I consider myself not worthy of Satyrium's—I was unable to flower those you sent before....

Do you reside now as formerly at Slough? If so, the railway will prove an amazing convenience to you. I went by it the other day; we reach Maidenhead in 50' (ex. stopstages) I don't want to go faster than that.[21]

(How splendid to read that Talbot, a 38-year-old eminent scientist doesn't "want to go faster than that"!)

And to Bertolini:

*31 Sackville Street, London
June 1839*

. . . I believe that this new art invented by me will be a great help to Botanists—especially the drawings which I am making with the solar microscope. I am limiting myself at present to an enlargement of 100 times the surface, which is sufficient for a great number of objects; I will perhaps come to do something more considerable some day.[22]

August 21, 1839

This view was taken with the Camera Obscura. Then there is a specimen of my drawings made with the Solar Microscope; it is a piece of lace enlarged 400 times on the surface. This will be especially useful for naturalists since one can copy the most difficult things, for instance crystallizations and minute parts of plants, and with a great deal of ease . . . I have practiced this art since the year 1834.[23]

Talbot encouraged his children to be attentive to the intricacies and delicacy of flora and at the same time dis-

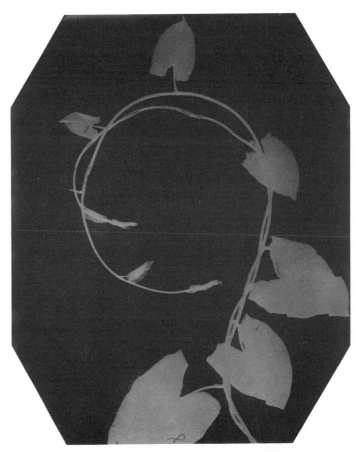

Mimosoidea Suchas, Acacia. A photogenic drawing, c. 1839.

Calystegia sepium. A photogenic drawing, c. 1839.

cussed authoritatively new discoveries with the experts of the Linnean Society, of which he became a Fellow at age 29, an honor reserved for the most distinguished botanists of the day. In this context, his photogenic drawings and calotypes of trees, ferns, leaves and plants take on a new dimension. These were not just random subjects easily available for pictures, but objects to be scrutinized and considered in their own right.

Talbot, for what may be said to be vague reasons, became a Liberal Member of Parliament for Chippenham in 1832. He won his seat on a second attempt, campaigning as before to support the Whigs' Reform Bill. Totally unsuited to political life, his attitude toward Parliamentary debate shifted from mild interest to frightful boredom. Letters between Talbot and his family on the subject are humorous and show something to be wrong when soberminded and mild-mannered Talbot becomes a politician. In a letter to Rear Admiral Charles Feilding, his stepfather, Talbot wrote:

For my part I don't comprehend anything about it, nor who can act with who, and why the remainder cannot. It is all an enigma to me . . . for many months the state of the Government has been like a magazine of combustibles to which the hand of a child might at any time have applied a match.[24]

And later to the Admiral in Nice, wishing he could be there "instead of in this land of eternal politics, elections and poor laws."[25] His mother, who enjoyed discussing politics, had for many years considered it her duty to keep her son well informed on current events and probably encouraged Henry to enter political life initially, but even she wrote in a letter a year after he had left Parliament to devote more time to his researches ". . . it will result in more happiness & fame than ungrateful politics, where after men have strutted their hour, [they] leave but a wreck behind."[26]

Talbot became cynical about man-made laws, political machinery and the chaotic way society functioned. Perhaps his brief involvement with government was the impetus for him to design new types of machinery that would work as efficiently as possible. He devised windmills, electric motors, engines for train travel and in 1840, 1845, 1846 and 1852 took out patents under the general heading "Obtaining Motive Power." Many of his notions were ingenious but few were practical. His final patent concerning a linear electric motor was the most interesting. It embraced the concept of a traveling magnetic field which is now incorporated in modern alternating current generators.

One can speak of circumstance, fate and privilege, but there is no doubt that Talbot had a prodigious intellect as a child and that he developed into a brilliant adult who had a quiet sense of destiny throughout his life. When he

was eight years old he wrote to his step-father, then Captain Charles Feilding, from his first school, Rottingdean, to "Tell Moma and everybody I write to, to keep my letters and not burn them."[27] And so they did, and these letters exist for historians to ponder. The headmaster at Rottingdean stated:

He is certainly one of the most amiable and one of the cleverest Boys I have ever had. I trust he will do me great Credit. . . . I have only to direct his studies and his capacity is so ample and his application to study so steady and uniform that he learns apparently without exertion either from himself or me. . . .[28]

Talbot's education was impeccable. Until the age of eight he was tutored at home and the diary that he kept gives clear descriptions of his activities and interests:

[Monday, 20 October 1806, at Penrice, the home of Lady Mary, Lady Elisabeth's sister, and Thomas Mansel Talbot, where Talbot spent much of his early childhood. Penrice is on the Gower coast, a few miles from Swansea.]

Wrote two tenses of the word avoir, *& six Latin & French words. Did a sum in compound subtraction & another in compound multiplication & proved them. Read 2 chapters of the Roman History. Looked in the map of Ancient Italy for Latium and Hetruria. Counted in French up to 100. Wrote four lines in the Writing Book. Translated part of the French Fable about le garçon & le Papillon.*

[Wednesday, 29 April 1807]

Talked to Mamma about the Parliament being dissolved. Asked her a great many questions about it.

[Thursday, 9 July 1807 at Plymouth Docks]

Got up—not very well. Mr Little came & said I read & sat still too much.

[Sunday, 1 May 1808 at Oxford]

Saw All Souls library. Ran about in it. There was an orrery in it exactly like the real solar system, as the Moon went round the Earth in 28 Days. There was a large terrestrial & a large celestial Globe. Saw two very curious pieces of Papyrus with some Arabic written upon them.

[Wednesday, 4 May 1808, at Windsor]

Went to Dr Herschell's, he was at Bath. Saw his sister Miss [Caroline] Herschell. She shewed us his telescopes. They were exactly in my opinion like Cannons, only bigger.

[Tuesday, 19 July 1808]

Went with Mamma to Windsor. Walked on the Terrace & spoke to the King [George III] & the Princess Augusta & the Princess Sophia.[29]

When Talbot was eight he was sent to boarding school. He was unhappy at first to be away from home. His letters to his family are hardly what one would expect today of a nine- and ten-year-old, and with their balance of re-

porting on his studies and telling stories, they make delightful reading:

Rottingdean December 1809

My Dear Mama,

Pray write to me or else I shall think that some accident has happened to you. It wants 2 weeks and a day only to the holidays. I am doing "Quituor mundi States" in Ovid's Metamorphoses and we are doing "Caesar de bello Gallica." I begin to wish a great deal for the holidays for it has been a very long half year indeed to me.... I wish you would buy me "Peter Wilkins" but don't send it to school. Keep it for me. I have never missed being "very, very good" in the Abbé Monchel's report although every other boy has missed it (sometimes). I have very little to say else because you don't write to me, so I have no questions to answer unfortunately. Frederick Manning has nets to catch Goldfinches in. There are thirteen cages of all sorts in the school at present.

Your affectionate son,
William Henry Fox Talbot[30]

Rottingdean September 2, 1810

My dear Mr. Feilding,

I would have written to you sooner only I wrote such a long letter to Mamma that I had nothing more to say, for I do not like to write the same thing twice: but now I have plenty to say to you. About 5 o'clock Monday morning Burrowes got up & dressed himself, & took his Bible & two story books under his arm, & runaway as fast as he could to Brighton where he tried to sell his books but nobody would buy them so he bought some gingerbread & run on; at Preston he met a turnpike man, who gave him a good breakfast, & told him that he had a coach with four horses coming which could carry him gratis to London, supposing that whoever was his master (for he had told him that he had run away from school) would take four horses for greater expedition. So he staid there till Mr. Hooker [headmaster at Rottingdean] caught him & brought him back. I am very tired it is so dreadfully hot.[31]

Next Talbot went to Harrow and passed effortlessly through the forms, so quickly, indeed, that he had three years to wait before his parents would allow him to enter Trinity College, Cambridge. Between the ages of 15 and 18 he received private tuition in Latin, Greek, Hebrew, mathematics, astronomy, botany, chemistry, Italian, French and the other subjects that constituted a proper education of a 19th century gentleman. He continued to excel in these studies at Cambridge and developed a lively personality, but whether he went to the inn with his classmates or played any sport in summer are the kind of details sadly missing. In 1820 he received the Porson prize for his translation of Macbeth into Greek and graduated the following year Twelfth Wrangler, signifying a first-class honors degree in the Mathematical Tripos.

While at Cambridge Talbot continued to be delighted by letters from home because his mother enlightened him on various topics which were little discussed at the University. She was a clever woman with individual views that he admired, and she was also his mother whom he loved dearly. Their correspondence barely suggests their relationship:

Sackville Street
May 11th 1818

My dearest Henry,

I did receive your most entertaining letter, when I was convalescent & it amused me so much it helped to recover me, for amusement is very wholesome. I was confined to the House for 3 weeks & to my bed for some days of that time, but I am now whats called well tho' with an entire absence of strength....[32]

And those from Henry to his mother:

Cambridge 30th October 1818

I am greatly concerned at not hearing from you: and I really think I shall some fine morning give alma mater the slip, and pay you a visit. Pray write. I was agreeably surprized this morning by a visit from Ld. Winchilsea and George Finch on their way from Burley. It was only nine o'clock, so you will be surprized that I was visible, but I intend to make six, my rising hour for the rest of the term; in which case my levee will not I presume be very numerously attended. I find it quite impossible to get up at seven, it is much easier at six. One's drowsiness attains its maximum about seven....[33]

Cambridge, 1st November 1818

I had a letter from Mr. Feilding today, dated Kelso, franked illegibly. My declamation about the Druids is so far from being over, that I have not yet begun to write it.—I think I become more shortsighted every day. It is really very unpleasant. I have been reading books on the structure of the eye, in order to find out the cause: and have arrived at the learned conclusion, that it is owing to want of due tension in the ligamentum écliare. It occurred to me the other day, that if I was to press my eye gently with my finger, it would render the vision distinct, and upon trial I found that this was actually the case. The distinctness however is not quite as great as can be obtained by the use of a glass....[34]

Cambridge April 29th 1819

I was in hopes we might be able to make a party, to go and read in the summer somewhere near you on the continent: but I could only find Worsley, who was willing to go, if we could find a tutor to our minds. In this respect however our search was wholly unavailing, as the idea appeared so outré and inimical to the study of the Mathematics, that we could get no one to join us. We agreed that it was no use to take a Tutor, unless we could get a good one, and as the good ones were getting engaged very fast, we determined that no time was to be lost, and accordingly engaged Higman of Trinity, taking our chance as to who might add themselves to the party, and as to where the majority should fix the destination. And on the whole, thanks to our stars, the members of our small society

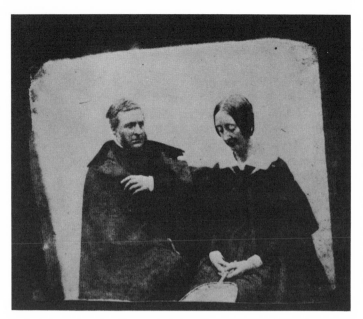

Horatia, Talbot's half-sister, and probably
Mr. Gaisford, her future husband.

*are sufficiently tolerable, to use an elegant phrase. We met at
Higman's rooms, to decide on the* locus in quo *over a bottle of
wine: and several places were started—the Lake—and the Nor-
folk coast—Knowing the* former *pretty well, I was in pain lest
it shd. be carried, while on the other hand, the* latter *seemed
no less disagreeable. Fortunately, those who maintained the
eastern coast, split into two parties; one proposing Cromer, the
other Lowestoft;—Victory was dubious, when somebody pro-
posed the Isle of Wight;—I snatched at the idea, as being Par-
adise in comparison. Worsley did the same, and we carried it
cleverly—I shall therefore have the satisfaction of being as near
you as possible, and will come & spend a month with you,
either at the beginning of the vacation (1st June, or at the end).
Write as soon as you reach your château.... My love to Mr.
Feilding & C. & H.[35]*

<div align="center">

Cambridge 26th Dec. 1819

</div>

*I was very glad to see your handwriting again, I wish I saw
it a little oftener. Why don't you let me know where your res-
idence in Paris is? I don't like directing to that place in Sack-
ville St. because I am afraid they may forget to forward it. I
wish you would send me your opinions on politics and things in
general, for Cambridge is rather dull [at Christmas] as you may
suppose, and your letters would enliven me. My chief solace is
the Quarterly Reviews....[36]*

After sitting his finals at Cambridge, some of Talbot's
tutors are reported to have said "they had never before
examined anyone who exhibited so much genius."[37] After
graduation, he spent long periods traveling in Southern
Italy, France, Corfu, Switzerland and Germany, always
studying, however, something specific in a rigorous and

disciplined manner. Still not in possession of Lacock Ab-
bey, when he was in Britain he stayed at the homes he
lived in as a child—in Cowes, Plymouth, Glamorgan-
shire, Cornwall and Dorset. He spent part of each year at
the London house rented by Lady Elisabeth and Mr. Feild-
ing or at his club, The Athenaeum, of which he became
a member in 1824. This literary and scientific club lim-
ited its membership to 300 selected individuals. The list
of Victorians who belonged, who theoretically might
have sat down with Talbot in the club room, is over-
whelming: W. T. Brande, Charles Wheatstone, Robert
Stephenson, Samuel Wilberforce, the Rev. Thomas Chal-
mers, William Henry Playfair, Charles Landseer, H. C.
Rawlinson, Joseph Dalton Hooker, Colin Campbell, Mi-
chael Faraday, Humphry Davy, John Ruskin, William
Makepeace Thackeray, David Brewster, Thomas Carlyle,
George Pollock, Thomas Henry Huxley, William Powell
Frith, Robert Browning, Anthony Trollope, Benjamin Dis-
raeli, John Everett Millais, Herbert Spencer or George
Frederick Watts. Creators of a new world, interpreters of
a changing time, geniuses and near geniuses, men of tal-
ent and of grace, visionaries and natural philosophers,
politicians and poets—it was from this group Talbot
chose his friends.

Talbot did not marry until he was 32 and information
about affairs or relationships prior to that time have not,
apparently, been preserved. His courtship of the 21-year-

Caroline, left, and Horatia in cloisters, Lacock Abbey.

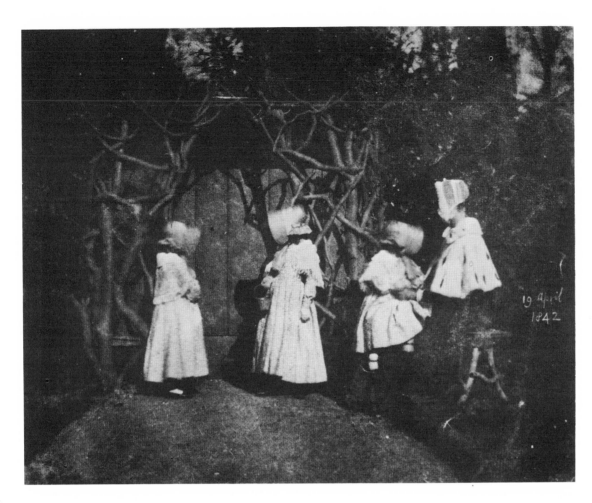

Constance and daughters
dated April 19, 1842.

old Constance Mundy of Markeaton, Derbyshire, who became his wife on December 20, 1832 (ten days after his election to the House of Commons), and who has the distinction of being the world's first woman photographer, was brief. On November 7, 1832, Talbot wrote to Charles Feilding:

. . . I am going to be married. The object of my choice is Constance youngest daughter of Mr Mundy of Markeaton. You none of you know her, which I rather regret, chiefly because if you did you could have no doubt of the prospect of happiness which this union holds out to me, which until you know her must rest upon your opinion of my good judgment. I suppose if I were to tell you what a charming person she is you would not believe half of what I should say. Therefore I prefer to be silent on the subject, for I could not tell you my own opinion of her without using language which might appear to partake of exaggeration. . . . I did not expect Mr Mundy would have given his daughter any fortune, however he says she shall have £6000.[38]

And ten days later his mother replied:

If I knew Constance I would tell her that as you have ever been the best & tenderest of sons you will be to her the best & tenderest of friends and I would congratulate her on having won such a heart as yours. . . . If you really have found a person who will understand the value of your mind, I must love her, because she will certainly not be a common character. . . .

As it is generally considered of some consequence in the eyes of the world the manner in which a lady is received by her husband's family, I must say that you may depend on my expressing myself in the most flattering manner of her in the world and saying all that you could wish when it comes to be known.[39]

Marital relationships in the Victorian era are so hidden by layers of propriety that it is difficult to know how deeply Talbot felt towards the "object" of his choice. In letters he seemed quite tender toward her yet every year he spent about six months away from his family, a situation not uncommon in his society. Constance and Henry had four children: Ela, born 1835; Rosamond, born 1837; Matilda Caroline, who someone thought should be called Photogena, born 1839; and Charles Henry, born 1842.

Letters from Henry to his half-sisters, Caroline, a Lady-in-Waiting to Queen Victoria and the wife of the Earl of Mount Edgcumbe, and Horatia, who married Mr. Thomas Gaisford late in life and died in childbirth, to Constance and to his children reveal the family man. One needs to read only snippets of letters to realize the affection Talbot had for his family and how happy he could be when with them or thinking about them. To Horatia on February 25, 1844: "... Today has been amusement & réjouissance all day in honour of Matilda's [Talbot's youngest daughter] birthday. I gave her a splendid copy of Puss in Boots with a dozen illustrative pictures by a German artist ..."[40] or to Constance on February 12, 1847, the day after *his* birthday: "A thousand thanks for that delightful birthday present *your letter*, which did me all the good in the world, and made everything appear this morning *couleur de rose*."[41]

In the summer of 1827 William Henry Fox Talbot, his mother, Mr. Feilding, Caroline and Horatia regained possession of Lacock Abbey, the ancestral home he had never known. Having for the first time a permanent base for work and development, the fourth decade of Talbot's life proved to be the most consequential. Lacock provided him with an idyllic frame for contemplation and reflection. Set in gently rolling Wiltshire hills along the River Avon, surrounded by farms and a modest village of thatched stone cottages, inns and a few shops, the ancient Abbey served Talbot as a quiet retreat. Its antiquity, too, was a source of inspiration and the object of devout interest, so that Talbot spent the first few years at Lacock investigating the romances and legends relating to his home. Delighted by these and other stories he uncovered, he published in 1830 a slim, handsome book, *Legendary Tales in Verse and Prose.* Some of these are titled: "Conrad; or, a Tale of the Crusades"; "Rubesahl; or, the Mountain Spirit"; "The Bandit Chief" and "Sir Edwin; or, the Zauber-Thal" and a tale prophetically called "The Magic Mirror."

2.

A Little Bit of Magic Realized

The idea came first and remained supreme to everything that followed. Not even the first time Talbot saw that the sun could impress images on silver chloride paper or used one of his negative drawings to make a positive print, or watched a picture appear gradually on an apparently blank sheet of paper—no, none of these experiences that validated the idea could compare with the discovery of the *idea.* The idea of photography was so monumental, universally illuminating countless other ideas and experiences, that no practical solution to any of the problems and no final individual image could, for Talbot, "admit of a comparison." Nevil Story-Maskelyne, a chemist and admirer of Talbot stated:

. . . I have always looked on the Photographic idea as one of the true poet-ideas of this marvelous age—and on you [Talbot] as its herald and enunciator.[1]

A concept, a vision, an epiphany, a sudden coming together of numerous facts, dreams, suspicions and longings into a blazing recognition of something unknown until then, the creative event, is the most mysterious aspect of the mind.

For Talbot, the technology of photography was sublime. It related the physical reality of the world and pictorial illusion of it via the scientific knowledge embodied in optics, physics and chemistry. This blending of profound understanding of nature with the private experience of an individual's esthetic feelings was a discovery, a brilliant, far-reaching discovery.

The "idea" came to Talbot (or Talbot came to it) during his six-month belated honeymoon with Constance in 1833 while attempting to sketch scenes at Lake Como with a camera lucida. His drawings were pitiful. He thought he might do better using a camera obscura as he had done before but realized that being a poor draftsman his attempts would always be hopeless. Suddenly, it seemed, Talbot imagined the outlines in the camera obscura as "fairy pictures, creations of a moment, and destined as rapidly to fade away" but "how charming it would be if it were possible to cause these natural images to imprint themselves durably, and remain fixed upon the paper!"[2]

It is clear from Talbot's subsequent statements that this was the first time the conception struck him forcibly and so memorably. He was never certain, however, that the idea had not occurred to him previously "amid floating philosophic visions." The "nature" of ideas themselves was a metaphysical question that Talbot pondered. He commented in his book *The Pencil of Nature* that immediately after the possibility of fixing the image in the camera obscura occurred to him, he made a note of it in writing "lest the thought should again escape."

While still in Italy in 1833, Talbot made notes about the experiments he wished to perform using inductive

Three pages from Talbot's sketchbook which he took with him on his Continental tour of 1833.

"Villa Melzi" (*right*)

"Bellagio" (*center*)

"Villa Melzi, 5.ᵗʰ Oct.ʳ 1833" (*far right*)

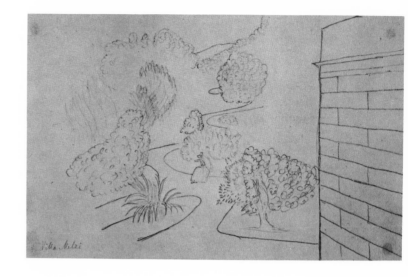

reasoning, a procedure that was then still considered to be the key to "modern science." Inductive reasoning involved designing and carrying out a series of related experiments, observing the various results, and from them drawing a general conclusion. (Deductive reasoning began with a self-evident truth or generalization, which was then applied to various individual conditions or realities. The relative value of these two modes of reasoning was at the heart of the scientific method in its struggle, beginning in the 17th century, against traditional "truths" about natural phenomena, but today the distinction has become trivial because it is recognized that they are not clearly separable.) Talbot, being a "modern" scientist, believed that through inductive reasoning the "true law of nature," as he said, would become apparent. The first step was to ask what was the "ultimate nature" of the picture in the camera obscura. His answer was exquisite in its simplicity:

The picture, divested of the ideas which accompany it, and considered only in its ultimate nature, is but a succession or variety of stronger lights thrown upon one part of the paper, and of deeper shadows on another. Now Light, where it exists, can exert an action, and, in certain circumstances, does exert one sufficient to cause changes in material bodies. Suppose, then, such an action could be exerted on the paper; and suppose the paper could be visibly changed by it. In that case surely some effect must result having a general resemblance to the cause which produced it: so that the variegated scene of light and shade might leave its image or impression behind, stronger or weaker on different parts of the paper according to the strength or weakness of the light which had acted there.[3]

Early in 1834, soon after he returned home, Talbot began his photographic experiments knowing already that certain silver salts turned dark when exposed to light. He first reasoned that if a piece of paper were treated with silver nitrate and an object placed on it, only the areas exposed to sunlight would be affected. The area covered would remain white and, after removing the object, its impression would be left behind. Silver nitrate paper proved not sufficiently sensitive so he experimented with paper coated with silver chloride precipitate. By the spring of 1834 he found that by coating the paper first with a weak solution of common salt and then with a solution of silver nitrate, the sensitivity of the paper to light was greatly improved. Talbot described in *The Pencil of Nature* how he arrived at the proportions of salt and silver nitrate necessary to make plain writing paper receive impressions by the action of light:

In the course of these experiments, which were often rapidly performed, it sometimes happened that the brush did not pass over the whole of the paper, and of course this produced irregularity in the results. On some occasions certain portions of the paper were observed to blacken in the sunshine much more rapidly than the rest. These more sensitive portions were generally situated near the edges or confines of the part that had been washed over with the brush.

After much consideration as to the cause of this appearance, I conjectured that these bordering portions might have absorbed a lesser quantity of salt, and that, for some reason or other, this had made them more sensitive to the light. This idea was easily put to the test of experiment. A sheet of paper was moistened with a much weaker solution of salt than usual, and when dry, it was washed with nitrate of silver. This paper, when exposed to the sunshine, immediately manifested a far greater degree of sensitiveness than I had witnessed before, the whole of its surface turning black uniformly and rapidly: es-

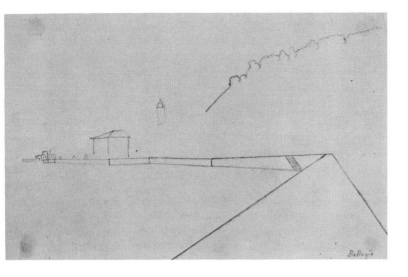

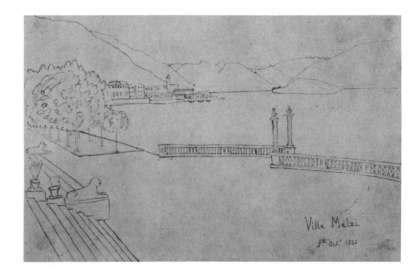

tablishing at once and beyond all question the important fact, that a lesser quantity of salt produced a greater effect. And, as this circumstance was unexpected, it afforded a simple explanation of the cause why previous inquirers had missed this important result, in their experiments on chloride of silver, namely, because they had always operated with wrong proportions of salt and silver, using plenty of salt in order to produce a perfect chloride, whereas what was required (it was now manifest) was, to have a deficiency of salt, in order to produce an imperfect chloride, or (perhaps it should be called) a subchloride *of silver.*[4]

This has been called a basic discovery in science. Previously it had been thought that all silver chloride, no matter how it was made, was alike. Chemists in Talbot's time believed that any excess of either silver or chloride simply remained in solution, and did not help in the formation of the precipitated salt.[5]

By making paper in this manner Talbot was able to obtain "distinct and very pleasing images of such things as leaves, lace and other flat objects of complicated forms and outlines"[6] during 1834. Talbot's experiments to this point were not exceptional. In France the three most famous experimenters were Nicéphore Niépce, Louis Jacques Mandé Daguerre and Hippolyte Bayard, all of whom had the "idea," the determination and the ability, but not the philosophical attitude of Talbot toward the phenomenon. In America Samuel F. B. Morse, inventor of the telegraph, had experimented with silver nitrate as early as 1810 and with different light sensitive materials in 1834.[7] Others were working in this direction as well. In England Thomas Wedgwood, son of the famous potter and an amateur chemist, carried out experiments with his friend Sir Humphry Davy, the famous chemist, at the

beginning of the 1800s. What baffled Wedgwood and Davy was not making paper sensitive enough to receive impressions, but fixing or stabilizing them so that the pictures would not vanish. Talbot wrote in "Some Account of the Art of Photogenic Drawing" that had he read of Wedgwood's and Davy's abortive attempts at fixing the image in the camera obscura, he might not have proceeded with his research.[8] But this was probably only undue modesty, and most assuredly he would have continued. He considered himself "not much of a chemist" but he felt confident enough to pursue his research because first, he had studied the action and properties of light for many years, and second, he intuitively knew that the development and execution of his "idea" necessitated integrated thought, of which he was eminently capable.

By the summer of 1834 Talbot had sufficiently good impressions to send examples to friends and relatives. A letter dated December 12, 1834, from Laura Mundy, his sister-in-law, reads as follows:

Thank you very much for sending me such beautiful shadows, the little drawing I think quite lovely, that and the verses particularly excite my admiration, I had no idea the art could be carried to such perfection—I grieved over the gradual disappearance of those you gave me in the summer & am delighted to have these to supply their place in my book.[9]

Were these just replacements? These photogenic drawings, as he called them, were fundamentally different from the ones previously sent. In September, while on holiday with Constance in Geneva, Talbot made his second great chemical discovery. This he described in the "Brief Historical Sketch of the Invention of the Art" which he wrote as a preface to *The Pencil of Nature.*

The next interval of sufficient leisure which I found for the prosecution of this inquiry, was during a residence at Geneva in the autumn of 1834. The experiments of the previous spring were then repeated and varied in many ways; and having been struck with a remark of Sir H. Davy's which I had casually met with—that the iodide of silver *was more sensitive to light than the* chloride, *I was resolved to make trial of the iodide. Great was my surprise on making the experiment to find just the contrary of the fact alleged, and to see that the iodide was not only less sensitive than the chloride, but that it was not sensitive at all to light; indeed that it was absolutely insensible to the strongest sunshine. . . . However, the fact now discovered, proved of immediate utility; for, the iodide of silver being found to be insensible to light, and the chloride being easily converted into the iodide by immersion in iodide of potassium, it followed that a picture made with the chloride would be* fixed *by dipping it into a bath of the alkaline iodide.*[10]

Thus we learn that it was in the autumn of 1834 that Talbot had discovered a method of stabilizing his photogenic drawings and that the photographs he sent Laura Mundy most certainly were treated with potassium iodide. He would have told her that these "shadows" were fixed, not fleeting. (He did not know at this time that the potassium iodide would cause the photogenic drawings to fade slowly, rather than darken, over time.) The verses

A photogenic drawing with no discernible image. Many of Talbot's earliest experiments exist today in similar states.

that she mentioned in her letter would also represent a new discovery—*cliché-verre:*

Take a sheet of glass and smear it over with a solution of resin in turpentine; when half dry, hold it over the smoke of a candle; the smoke will be absorbed by the resin, and although the glass will be darkened as usual, there will be a sort of glaze over the smoke which will prevent it from rubbing off. Of course, if any opaque varnish should be at hand, it will be simpler to use that. On this blackened surface, when not quite dry, let any design whatever be made with a needle's point, the lines of which will, of course, be transparent. When this is placed over a sheet of prepared paper [photogenic drawing paper], a very perfect copy is obtained; every line which the needle has traced being represented by a dark line upon the paper. In the autumn of 1834, being then at Geneva, I tried several photogenic etchings *in this way, which were executed for me by a friend, as I am not myself skilled in drawing. Among other views was one of the city of Geneva itself, being the view, if I rightly recollect, which we saw from our windows. Another application of the same principle, is to make copies of any writing. This is so very easy, and each copy takes so short a time in making, that I think it may prove very useful to persons who wish to circulate a few copies among their friends of anything which they have written; more especially since, if they can draw, they may intersperse their text with drawings, which shall have almost as good an effect as engravings. The chief expense will be from the quantity of silver used, which is small; but no press being wanted, it cannot fail to be, on the whole, a very economical process.*[11]

It has often been suggested that Talbot *first* fixed his photogenic drawings with salt. This, as has been shown, was not the case. To eliminate any doubt, however, refer to his own statement on the matter written in a letter to the Secretary of the Royal Society and read to the members on February 21, 1839:

After having tried ammonia, and several other agents, with very imperfect success, the first thing which gave me a successful result was the iodide of potassium, *much diluted with water. If a photogenic picture is washed over with this liquid, an* iodide of silver *is formed which is absolutely unalterable by sunshine. . . . The fixation of the pictures in this way, with proper management, is very beautiful and lasting. The specimen of* lace *which I exhibited to the Society, and which was made five years ago was preserved in this manner.*[12]

Talbot was elated by the progress he had made while in Geneva. He was on the threshold of making many new discoveries and the beginning of 1835 would prove to be one of his most creative and rewarding periods. His notebook is filled with experiments he was carrying out to test new chemicals and to try to better understand the properties of those he was already using. An excerpt from it for January 16 shows his approach:

Iodide of silver turns dark when warmed, as it cools its paleness returns. The effect is very striking. The iodide of tin

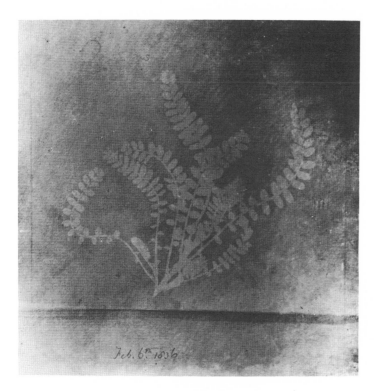

Photogenic drawing made by placing a leaf
frond on sensitized paper and exposing to light,
dated February 6, 1836.

*beautifully white & fixed: but from some [strange!] cause,
some parts of it are apt to blacken.*

[Probably inserted at a later date] This happened in the central part of the paper, and the cause is supposed to be that too much of the solution of silver had been put there. But it is extraordinary that the change from white to black should be per saltum—It shows a curious case of unstable equilibrium.[14]

Although the passage is undated, it appears after the entries for January 1835 and was probably written in February.

It was at this time that Talbot found a way of making his paper much more sensitive to light, *viz.* by repeatedly giving it alternate washes of salt and silver nitrate, and then using it in a moist state. This paper was sufficiently sensitive to be used in the solar microscope. He did not use it in the camera obscura until the summer of 1835.

Up to February 1835 all the photogenic drawings were negative, in other words, had their highlights and shadows reversed. This fact was an integral part of Talbot's process. Until he discovered a stabilizing agent, the impressions he made on his treated paper had to be kept in the dark, in drawers or in scrapbooks, as Laura Mundy was forced to do. And still they turned dark. However, once Talbot could expose his negative images to sunshine for extended periods of time, it was possible to reverse

and lead do not change in a degree at all equal to the former. The protiodide of mercury sublimes readily.

Would potassium burn on the surface of water, if covered with a stratum? of sulphuric ether?

Paper covered with Iodide of Silver shows the above mentioned property very elegantly.

If it is dipped in ammonia, it is whitened & the effect of heat is prevented: but after some time the ammonia evaporates or is expelled by the fire, & then the paper turns yellow with heat as before. This shows that the ammonia was in combination with the iodide.

Paper washed with nitrate of silver speedily blackens before a hot fire, but if it has been subsequently washed with muriate of lime this effect is prevented. . . .[13]

Soon after this Talbot made another significant discovery. He found that the very same substance that made his paper more sensitive to light, also, under other circumstances, destroyed the sensibility. He was referring to salt, sodium chloride. The first mention of this remarkable phenomenon is as follows:

Paper washed with salt and silver (of a certain strength) and darkened in sunshine: the figure of a plant etc. remaining white. If the paper be washed again with the same solution of salt, then dried and put in the sun, the figure remains very

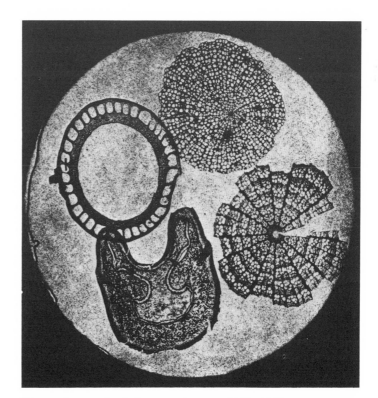

Photomicrograph of plant sections, c. 1839–1841.

them—to make positives. The entry in his notebook for February 28, 1835, reads as follows:

In the Photogenic or Sciagraphic process, if the paper is transparent, the first drawing may serve as an object to produce a second drawing, in which the lights and shadows would be reversed....[15]

The first recorded reference ever to negative/positive photography! From this technical milestone is derived modern photography. Unlike others, Talbot saw the object produced by the initial action of light not as a dark "smudge," as one reviewer referred to the early negatives, or inefficient because it necessitated a second step to obtain a lifelike result, but as a prodigious and fundamental base from which to build. From one "negative," as Sir John Herschel called Talbot's primary picture, any number of "positives," also Herschel's nomenclature, could be produced.

In the midst of this productive activity, Talbot was forced to leave Lacock and accompany his wife to London where they were to await the birth of their first child. They left in early March but Ela, named after the founder of Lacock Abbey, was not born until April 25. It was a difficult delivery and Constance had to convalesce in London until early June when the family of three returned home.

From letters it is known that Talbot was under considerable strain due to his wife's poor health and found it difficult to work. He prepared, however, a paper for the *Philosophical Magazine* titled "On the Nature of Light" published in August, 1835. In it, Talbot discusses some of the experiments he carried out in February 1834 using silver nitrate. He also mentions using iodine vapor, an important chemical in the daguerreotype process, in other experiments. The essay was not of great consequence as Talbot was not revealing anything particularly new, and certainly not all he knew. It is noteworthy in the history of photography in that it is Talbot's first published account of using silver nitrate to study the action of light.

"The brilliant summer of 1835" was how Talbot described the next period of his life. When he left Lacock in March he was fully engaged in his photographic experiments and eagerly observed the results of each new trial. During his months in London he was anxious to return to the Abbey to try his silver chloride paper in the camera obscura (which he had not yet done). He wrote in "Some Account of the Art of Photogenic Drawing" that

... when I had succeeded in fixing the images of the solar microscope by means of a peculiarly sensitive paper, there appeared no longer any doubt that an analogous process would succeed in copying the objects of external nature, although indeed they are much less illuminated.

He then described his first experience with a *photographic* camera as follows:

Not having with me in the country a camera obscura of any considerable size, I constructed one out of a large box, the image being thrown upon one end of it by a good object glass fixed in the opposite end. This apparatus being armed with a sensitive paper, was taken out in a summer afternoon and placed about one hundred yards from a building favourably illuminated by the sun. An hour or two afterwards I opened the box, and I found depicted upon the paper a very distinct representation of the building, with the exception of those parts of it which lay in the shade. A little experience in this branch

The earliest negative in existence, lilac in color, measuring about one inch square, and dated August 1835. The earliest extant print is at the Smithsonian Institution and contains a photographic image of Talbot's handwriting: "June 20th, 1835, written with a pencil of Tin. Lacock Abbey Wilts, abcdefghijklmnopqrstuvwxyz." The purplish print is 3¼ x 4¾ in. Daguerre was not able to fix his plates until 1837. The earliest daguerreotype dates from that year.

Latticed Window
(with the Camera Obscura)
August 1835

When first made, the squares of glass about 200 in number could be counted, with help of a lens.

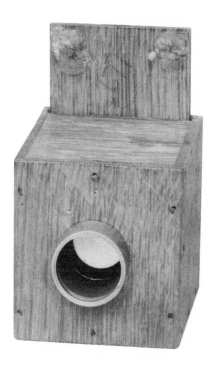

A very small experimental camera, only about 3 inches wide, fitted with a simple microscopic lens, used by Talbot in the period 1835–1839. Sensitized paper was gummed or pinned by its corners inside the removable back of the camera. Constance, Talbot's wife, called this camera and others like it, "mousetraps". Talbot wrote: ". . . I had several small boxes made, in which I fixed lenses of shorter focus, and with these I obtained very perfect, but extremely small pictures, such as without great stretch of imagination might be supposed to be the work of some Lilliputian artist."

of the art showed me that with smaller camerae obscurae the effect would be produced in a smaller time. Accordingly I had several small boxes made, in which I fixed lenses of shorter focus, and with these I obtained very perfect but extremely small pictures: such as without great stretch of imagination might be supposed to be the work of some Lilliputian artist. They required indeed examination with a lens to discover all their minutiae.

In the summer of 1835 I made in this way a great number of representations of my house in the country, which is well suited to the purpose, from its ancient and remarkable architecture. . . .

Only perhaps Niépce, Daguerre and Bayard made photographs with humility equal to Talbot's. One may say that all the first photographs by these inventors were discoveries and therefore in a different category somewhat to later images. Talbot pointed the camera at or laid the leaf on the sheet of paper but he thought his actions small compared to the feats of natural laws that actually created the photograph.

You make the powers of nature work for you, and no wonder that your work is well and quickly done.

No matter whether the subject be large or small, simple or complicated; whether the flower-branch which you wish to copy contains one blossom, or one thousand; you set the instrument in action, the allotted time elapses, and you find the picture finished, in every part, and in every minute particular.

There is something in this rapidity and perfection of execution, which is very wonderful. But after all, what is Nature, but one great field of wonders past our comprehension? Those, indeed, which are of everyday occurrence, do not habitually strike us, on account of their familiarity, but they are not the less on that account essential portions of the same wonderful Whole.[16]

Talbot's "mousetraps" as his wife called his little cameras had no viewfinders or ground glass focusing screen. They were simple wooden boxes in which he pinned or pasted his sensitive paper opposite the lens. He did not set out to make pictures in any *traditional* sense. He was not in control of perspective, composition, content, line of emphasis, nothing except the direction in which he pointed the cameras with their telescope and microscope lenses. His object was to wait until a picture was formed and then to look very, very carefully at the result. The word *picture* itself now had a new meaning.

By this time, Talbot was making photogenic drawings in three distinct ways. The first was the laying of leaves, lace, engravings or other objects on his sensitive paper, exposing them to sunlight, and then fixing the resulting designs with potassium iodide, salt or something new he was trying. The patterns that appeared were predictable: they were the same size and shape as the object. Talbot was in control; he arranged the composition, he chose the subject. Nothing appeared in the picture that was extraneous. Sometimes a slight reference to a third dimension would appear, but very subtly. Their color could be lilac or yellow or burnt orange or some other shade, depending on the chemicals he employed in making the print. Whether he left them as "negatives" or printed them was not of great consequence. Talbot could comprehend these photograms, resolve their meaning. They were not interpreting physical reality in a new manner. They were, indeed, a faithful likeness.

The second manner in which Talbot made photogenic drawings was to use his silver chloride paper with the solar microscope. This method was his original way of producing photographs with an optical instrument. His

objective in these instances were clear. The microscope enlarged the specimen and revealed details and structure unseen by the naked eye. Order in nature was a vital concept in Talbot's life; it was visible, and he wanted to capture the relationships he found. He certainly could not, and neither could most artists, copy microscopically enlarged specimens accurately. Photography could. There was no aim here of wanting to enhance his pictures by imposing a further order or structure on them. His goal with the solar microscope was to show as accurately as possible the structure and order already present in the subject.

His third approach was the one of most consequence. Using photogenic drawing paper in the camera obscura was more than the reproduction of patterns or the recording of detail. The image that resulted had an uncanny relationship to life. Talbot's sensitized paper did not "capture" Lacock Abbey; only some of the light rays passed between it, its surrounding area, and the camera's eye. It was not Lacock Abbey that appeared on the paper but some phantom, miniature-sized, two-dimensional illusion of it. He described his camera pictures as "a little bit of magic realised:—of natural magic." How does a

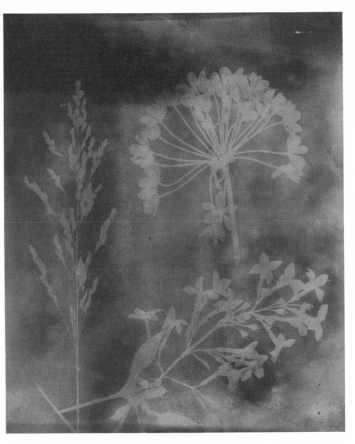

Photogenic drawing, c. 1839, paper watermarked "Whatman Turkey Mill 1838." Talbot wrote in 1840: "I class Photogenic Drawings into the following ten divisions. Sculpture, Architecture, Landscape, Insects, Plants, Facsimiles, Lace, Cotton, Prints, Microscopica. Two or three of these styles might be brought into one drawing & if well combined would make a better specimen of the art."

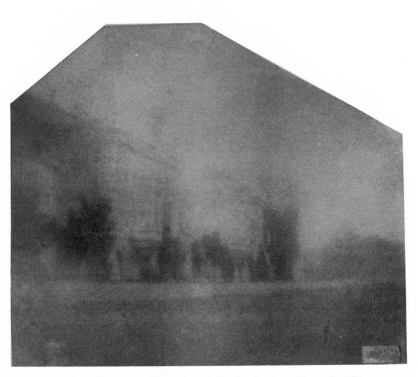

In Talbot's handwriting on back of print: "Lacock Abbey fx 5d H. F. Talbot phot. 1839." The salt fixed print appears pale lilac and is $4^2/5 \times 3^4/5$ in. in the original.

logician like Talbot deal with magic when first beheld? Very circumspectly.

Talbot did not make many photographs for four years after the "brilliant summer of 1835." It has already been mentioned that he stopped these experiments in order to devote more time to other pursuits. It has also been suggested that he stopped because he could not imagine how to devise the next set of experiments to improve his process. A third possibility is that he had achieved his initial aims—and more. Not that the camera pictures were refined, but he recognized them to be portentous and so paused on the threshold of what he knew would be an invention of enormous magnitude.

Few images exist from 1835, the lattice window dated August being the best known. A fair statement about

these pictures would be that they were artifacts for Talbot to contemplate. For four years he considered their meaning and then called them "magic realised" in his first published account. Talbot knew from his earliest trials that the camera picture had, and would always have, a power not totally dissimilar from that of paintings and drawings but unique in its own ways. It was this uniqueness Talbot wanted to consider, for in it he already saw the potential of the medium. He believed that inspiration and insight came in time, with patience, and he did not hurry to find the answers to his questions concerning the significance of his discovery.

What occurred, of course, was Daguerre's announcement on January 7, 1839, that he could use the camera obscura to make faithful and permanent illustrations. This development not only motivated Talbot to reveal his photogenic drawing process, but also to start experimenting again. Details of events relating to Talbot in 1839, the most momentous year in the history of pho-

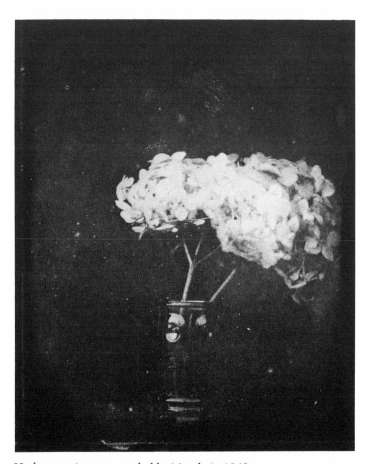

Hydrangea in vase, probably March 1, 1840, from a negative fixed with potassium iodide.

tography, are examined in detail in the following chapter. The photogenic drawings that he made during 1839 and 1840, however, need to be discussed *as pictures* not merely artifacts or scientific experiments.

The pictures that exist of the Abbey, sculpture, books on the shelf, trees, tables set with fine china, farm utensils, all share a sense of becoming—of becoming pictures. The most notable characteristic is their dynamism. There is no sense of stopping time. They appear to be in a state of evolution, of slowly being created by dancing rays of light. The objects in the frame sit uneasily as subjects. Most are commonplace, and in their isolated and abstracted form assume an unnatural importance and a dignity that commands attention. But the uneasiness of looking at the photograph never subsides. The picture is not resolved. The composition is unfamiliar; parts within the photograph seem to want to shift in order that the whole image appear more harmonious. Their imperfections and flaws, however, captivate and entrance and release the viewer from regimented thinking. These primitive, faded pastel prints live and communicate. They talk about what it means to be a photograph. They show themselves to be pieces of plain writing paper, chemically impregnated, watermarked, stained. They do not pretend to be reality, only to deal with it. They depict tables floating in space. They powerfully address the question of time. Shadows with soft edges fall on both sides of a building while the sun moves east to west. They were made with time, in time, and show respect for time. They address the question of viewpoint. A picture of Patroclus, the statue, is taken from one angle, then another. They address the question of the imposition of the frame. Trees are unnaturally confined and push out and up as they reach for the light. The deceit of photography becomes as obvious as its honesty. The picture of books on the shelf tells nothing of the content of the works or in what context the shelf and books exist. It is about parallel lines and edges; some of the books touch and form fine lines, others are separated by a dark, deep abyss. Where books topple over, triangles are formed; when books are piled one on another, stepping stones are created. Books standing upright feel different from those falling over. Book covers have textures and titles, markings and the glorious ability to absorb and reflect light.

Many of Talbot's earliest camera photographs partake of the theatre of the absurd: objects in search of composition, images in search of meaning, pictures in search of a tradition.

The most easily comprehensible of these 1839–1840 images are certainly the photograms. They rest so quietly on the paper. They bear some, but not significant, resemblance to Moholy-Nagy's or Man Ray's attempts at creating the impression of three dimensions on a two-

"Books on two shelves."
Possibly an early calotype
made on October 10, 1840,
exposure 1 minute.

dimensional surface—a space/time continuum. Occasionally a leaf or bud is not pressed flat against the paper and the resulting tones give depth to the illusion. Normally, however, the eye is caught in the joy of exploring curves, lines, patterns, all exquisitely rendered by this process, and is not carried off into infinite space.

There are very few references to photography in Talbot's notebooks or family letters between 1835 and the end of 1838, when he resumed his experiments. One appears in a letter from Constance, vacationing on the Isle of Wight, in September, 1835, to Henry:

... We were fully rewarded by the beauty of the scene—so much prettier everything looked than by daylight, though by daylight too Cowes is a pretty place. The colouring reminded me a good deal of some of your shadows, especially of the moonlight scene at Venice. I wish you could have taken the outline of the castle & fine elms behind just as I saw them but I think you told me you could not produce the desired effect by any light except that of the sun. Shall you take any of your mousetraps with you into Wales? It would be charming for you to bring home some views....[17]

The scene at Venice which Constance referred to was a copy of an engraving. Talbot had not yet taken his camera traveling. His first experience as an itinerant photographer may have been at this time in Wales or the next year at Leamington. The following letter, one of the most pertinent from this period, mentions another photographic excursion:

You are perfectly right in supposing Sir D. B. [David Brewster] to pass his time pleasantly here—He wants nothing be-

yond the pleasure of conversing with Henry: discussing their respective discoveries & various subjects connected with science. I am quite amazed to find that scarcely a momentary pause occurs in their discourse. Henry seems to possess new life & I feel certain that were he to mix more frequently with his own friends we should never see him droop in the way which now so continually annoys us. I am inclined to think that many of his ailments are nervous for he certainly does not look ill. I hear from Sir David that he distinguished himself at the Meeting in a conversation on the Improvement of the Telescope. It is given in the Lit Gazette of last Saturday. When I see the effect produced in Henry by Sir D. B.'s society I feel most acutely how dull must our ordinary way of life be to a mind like his!—and yet he shuts himself up from choice. We cannot fix our day for moving till we know how long Sir David stays—nor can I get Henry one moment to myself to tell him what you say about Mr. Moore [Thomas Moore, the poet]—but I think he would not wish to hinder his enjoying the vacancy in Sackville Street, under the circumstances—& particularly as Henry does not want to remain in Town. He has almost promised to go next week to Leamington & take a picture of Warwick Castle with Sir David but when it was mentioned to me by the latter, I understand that it was to follow our first excursion to Tunbridge....[18]

Sir David Brewster was visiting Lacock during the summer of 1836 as were many other savants. Talbot and Constance were host and hostess to some of the most important intellectuals of the 19th century while they were on their way to or from the British Association for the Advancement of Science (B.A.A.S.) Meeting in Bath. It is obvious from the above letter that Talbot mentioned photogenic drawing at least to Brewster, if not to the oth-

ers. Whether or not he revealed details of the process or actually did go off photographing with him is unknown. But how lovely to think about Talbot wanting to go on a photographic trip with his Scottish friend in the year 1836.

Talbot was blissfully happy in the company of his illustrious friends who visited him at Lacock that summer. He spent hours in discussion. With Sir Charles Wheatstone, the scientific genius who began as a musical instrument maker and later made major discoveries in electricity, he would have discussed optics and light and the stereoscope; with Sir Charles Babbage, a founder of the Astronomical Society and designer of one of the most highly advanced calculating machines of its day, Talbot would have undoubtedly talked about astronomy and mathematics, for in 1836 Babbage held the Lucasian chair of mathematics at Cambridge; with Peter Mark Roget, physician, Secretary of the Royal Society for over 20 years, designer of slide rules and calculating machines and a founder of the Society for the Diffusion of Knowledge, he would have had endless discussions about Roget's hobby of lexicography and possibly his plans to write a thesaurus; with Sir William Rowan, Astronomer Royal for Ireland, linguist, lover of Maria Edgeworth, friend of Wordsworth, Coleridge and Southey, Talbot may have discussed etymology, optics, crystals or mathematics, subjects in which both men were expert; and with his close friend Sir David Brewster, Talbot may have had tête-à-têtes about the properties of light, maybe even family, weather and mutual friends and how Brewster's invention of the kaleidoscope never earned him a penny. In the seventh volume of the *Diary of Thomas Moore*, the poet's entries for August 15, 16 and 17, 1836, are as follows:

Went over to dine with the Feildings. Company, only Sir David Brewster, with whose good sense and simplicity of manner I was much pleased. I spoke of Sir W. Hamilton as one of the first, if not the first, among the men of science of his day . . . 17th. Returned home. Some more of the Savans *expected at Lacock,* viz. *Whewell, Babbage, Dr. Roget & c. . . .*

Talbot always tried to attend the annual meetings of the British Association. He greatly enjoyed being with his peers and he had an ideological preference for the B.A.A.S. over some of the older and more structured London-based societies. This Association was founded in 1831 and its stated aim was "to obtain more general attention for the objects of science." Each year a week-long meeting open to anyone was held in a different part of Great Britain, providing free lectures and an important channel for conveying scientific information to the general public. The B.A.A.S. was founded as a *professional* organization to promote both the interests of scientists among themselves and to satisfy their desire to present their discoveries to the general public. The lectures were specifically directed to a lay audience, dealing, for example, with such topics as economy and geology in the coal fields. In these respects the British Association was diametrically opposed to the Royal Society which kept science abstruse and remote to all but scientists. The B.A.A.S. was a secessionist movement and the impetus to form it was caused by a reactionary and injudicious act on the part of the Royal Society. In 1830 Sir John F. W. Herschel was passed over for the presidency of the Royal Society in favor of an aristocratic layman, the Duke of Sussex. This infuriated the dedicated scientists and convinced them that the Royal Society was not concerned with the broader issues of science but too often served as a club for dilettantes and the elite.

The British Association had certain fundamental ideals that were close to Talbot's own views. One was that if scientists were to be considered professionals in Britain, they must be able to earn a living from their work. The Royal Society was content to have all scientific research conducted by members of the leisure class, who, because their wealth freed them from having to work for their living, could indulge in scientific pursuits without financial reward. The members of the British Association felt

Sphinx at Lacock, photogenic drawing, August 29, 1840.

"Carpenters."

that it was the government's responsibility to subsidize scientific research.[19] The Industrial Revolution had had a profound effect on the whole of British society and one of the many consequences was the creation of a vitally important new group of inventors and scientists who, too often, were financially insolvent. Unfortunately, the government was not interested in the needs of this creative sector of the population.

Talbot became particularly aware of the government's apathy to important scientific discoveries. When in 1839 the French government provided Daguerre and Isidore Niépce, son of Nicéphore Niépce, with an annual pension for their discovery of a photographic process, the British did nothing to reimburse or even honor Talbot for his contributions. It should be pointed out that this was the period in the history of science when pure research, for the first time, led more often than not to marketable inventions for the rapidly expanding technology of the Industrial Revolution, an upheaval that generated national rivalries on a global scale.

Talbot was a landowner whose income came from the tithes paid by his tenants and therefore could pursue his scientific research without government support. He felt, however, that science and technology could not progress during a period of such rapid industrialization unless in-

dividuals from all classes were made to feel they could support themselves through their inventions. If the government would not assist scientists, then the only other way for them to become economically self-sufficient was to patent their inventions.

Almost no one liked patents. They were difficult to obtain (see Charles Dickens "A Poor Man's Tale of a Patent"), expensive, and troublesome to enforce. Although Talbot took out 12 patents in his lifetime, he was critical of the patent laws as they existed in Victorian England and in later life was plagued with the consequences of trying to enforce what he believed to be his patent rights. Thus, his attitude towards patents was ambiguous and is best illustrated in a letter he wrote in 1857 in reply to a comment that Frederick Scott Archer, who died penniless leaving a wife and children, should have patented his wet-collodion process:

Bricklayers with mortarboard.

With respect to Mr Archer, if he had patented his collodion process, early enough, the result would probably have been that he would have acquired a large fortune by it. But on the other hand he would have lost the credit which he now has, or ought to have, of having presented the invention gratuitously to the Public. So there is something to be said on both sides of the question.[20]

This was written after many battles fought and many enemies made due to his strident defense of what he believed to be his legal and moral right to patents.

It is important to underline the criteria by which the Crown granted patents in Victorian England as they were considered quite differently than they are today. This explanation is necessary because too much emphasis on Talbot's patents and confusion as to their significance has proliferated throughout the study of the history of photography. Originally, the function of the patent was less to protect an invention than to protect the capital invested in establishing a new industry. The patentee was expected to "work" the invention and to teach English workers how to do it themselves.[21] Talbot *did not* patent his photogenic drawing process. He gave the details of it freely to the world on February 21, 1839, six months be-

Workman. Talbot owned a camera made by Lerebours of Paris which made circular pictures. The all metal camera was mounted in a wooden box with partitions for chemicals and had a rotating disc with stops immediately in front of the lens. This camera was a daguerreotype camera, adapted by Talbot to make calotypes. He owned three other daguerreotype cameras but all were used for paper negatives and there is no evidence of his having made daguerreotypes although he said he would like to try the process.

fore Daguerre disclosed the details of his. He did, however, patent his calotype process and his photoglyphic engraving process of the 1850s, the foundation of photogravure and halftone reproduction techniques because he felt both could become important new industries if sufficient money was invested in them and if enough people were taught to work the processes. Talbot's setting up of the Reading Establishment in 1843 to print negatives, make books and teach people photography was a direct result of this point of view. In the 1850s and 1860s he planned to set up a factory to make photoglyphic engravings but ill health prevented the realization of this goal. Considerable attention in books is given to Talbot's activities enforcing his patents, but not to the reason why he took them out, which is significant for properly understanding Talbot's attitude toward science and technology. We shall see in later chapters that he was supported and encouraged to put research on a professional basis by some of the most notable men of his day. When Sir David Brewster, famous not only for his scientific contributions in the study of light but also for his active part in the foundation of the British Association for the Advancement of Science, heard of the public announcement of the photogenic drawing process in January, 1839, he wrote his friend the following letter on February 4:

I hope you mean to pursue the subject and endeavour to perfect the process. You ought to keep it perfectly secret till you find you cannot advance further in the matter, and then it would be advisable to secure your right by a Patent. Altho' you do not require to deal with the matter commercially, yet a Patent would give a more fixed character to your priority as an Inventor, and I do not see why a Gentleman with an independent fortune should scruple to accept any benefit that he has derived from his own genius.[22]

Talbot felt, and stated in articles in the popular press, that he did not feel he had perfected an art but only introduced a new one with photogenic drawing. Talbot wanted his invention to be in the public domain so that others could try to improve it. This view did not mean that Talbot himself would not try to find ways to perfect his process. It does, however, suggest that Talbot did not feel in 1839 that he had "founded an industry," one of his requirements for taking out a patent.

The time between August 1836 and December 1838 was eventful for Talbot: there were births and deaths, prestigious publications and gold medals, trips around Great Britain by steamer, rail and coach, social gatherings and intense, solitary periods of research. He thought about his photogenic drawings, but nothing more concrete was done. His notebooks outlining his experiments of 1834 and 1835 were safely tucked away and he was busy with other things. And then suddenly, at the end of

1838, he went back to them, opened to the pages on photogenic drawing and began a new set of experiments. He thought he should write a paper on his researches and present it to a learned scientific body, probably the Royal Society. He could, in December 1838, have heard about a Frenchman named Daguerre trying to sell shares in a new invention utilizing the camera obscura, but he said he had not. On January 7, 1839, the charismatic François Jean Dominique Arago, Director of the Paris Observatory and a leading liberal in the Chamber of Deputies, rose in the Académie des Sciences in Paris and gave the following speech in a strong, commanding and pervasive voice.

. . . From now on there will be no need for this regret [that images which appear in the camera obscura cannot be made permanent], for M. Daguerre has devised special plates on which the optical image leaves a perfect imprint—plates on which the image is reproduced down to the most minute details with unbelievable exactitude and finesse. In fact, it would be no exaggeration to say that the inventor has discovered the means of fixing the images, if only his method preserved the colours; but I must hasten to explain, in order to undeceive the public, that in M. Daguerre's copies—as in a pencil drawing, an engraving, or, to make a more correct comparison, in an aquatint-engraving—there are only white, black and grey tones representing light, shade and half-tones. In other words, in M. Daguerre's camera obscura light itself reproduces the forms and proportions of external objects with almost mathematical precision; but while the photometric proportions of the various white, black and grey tones are exactly preserved: red, yellow, green, etc., are represented by half-tones,

for the method produces drawings and not pictures in colour. . . .

M. Daguerre not only had to discover a substance more sensitive to light than any hitherto known to physicists and chemists; he had also to find a way of stopping its sensitivity at will, and this is precisely what he has achieved: when he has fixed his picture it can be exposed to full sunshine without undergoing any further alteration. . . .

M. Daguerre's invention is the fruit of several years' assiduous work, during which he had as a collaborator his friend the late M. Niépce of Chalon-sur-Saóne. Wondering how he could best be compensated for his trouble and expense, the distinguished painter did not fail to realize that a patent would not help him: once revealed, anyone could use his process. It seems, therefore, indispensable that the Government should compensate M. Daguerre direct, and that France should then nobly give to the whole world this discovery which could contribute so much to the progress of art and science. To further this project I intend to address a request to the Ministry or to the Chambers as soon as M. Daguerre has initiated me into all the details of his method, and has given proof that in addition to giving the brilliant results shown, the method is also economical, easy, and capable of being used by travellers anywhere.[23]

Talbot was staggered. The entire civilized world was stunned by the announcement and Frenchmen went wild. Talbot did not know if Daguerre's method of fixing images in the camera obscura was the same as his, but he knew there could be no more hesitation. He had to prove that he had, independently, also invented a method of capturing and preserving the drawings of the sun—of fixing the image in the camera obscura.

I think the year 1839 may fairly be considered as the real date of the birth of the Photographic Art, that is to say, its first public disclosure to the world.

William Henry Fox Talbot
The Pencil of Nature, *1844*

3.

Eighteen Thirty-Nine

The following is a compilation of quotations extracted from documents—letters, newspaper articles, notebooks, journals, scientific papers, etc.—dating from January 1839 to December 1839. The developments relating to Talbot's invention are described in his and his contemporaries own words. The personal responses to his announcement, the hopes and fears for the future, are also expressed. Talbot's statement of his achievement stimulated the imagination of all people in a manner both similar to and different from Daguerre's. Talbot gave to the world not merely a technology, but he also enunciated an idea. The reactions, therefore, were to both his technique and his theory. The manner in which artists, scientists, entrepreneurs, and others used these and extended them is the story of photography's integration into society.

January 25, 1839
(Talbot, in London, to Herschel)

Having a paper to be read next week before the Royal Society, respecting a new Art of Design which I discovered about five years ago, viz. the possibility of fixing upon paper the image formed by a Camera Obscura; or rather, I should say, causing it to fix itself, I should be most happy to show you specimens of this curious process. If you could not make it convenient to call here, Slough has now become so accessible by the railway that I would take a drive there any day if you would appoint an hour.[1]

January 25, 1839
(The Literary Gazette, *Saturday February 2, 1839;*) N. B. In future, published remarks will be placed chronologically from the date they appear in the press. Letters are placed according to date written.

. . . At the conclusion of the lecture [at the Royal Institution] Mr. Faraday directed attention to drawings in the library, sent there by H. F. Talbot, F.R.S., and by him named 'Photogenic Drawings.' They were of the same character as those of M. Daguerre. The two processes, he observed, of M. Daguerre and of Mr. Talbot, effecting the same objects, may be different, or may be the same. As yet neither is known; and each has been perfected by two scientific experimenters in different countries, without a knowledge of each other's pursuit. The principal object of the exhibition of the photogenic drawings, on this occasion, was meant (as was understood) to establish a date, in order, that should M. Daguerre's discovery be made public previously to the reading, before the Royal Society, of Mr. Talbot's paper detailing his process, no charge of imitation could be brought against Mr. Talbot, in case of identity of process. And that each discovery should be thus proved to be original. No human hand has hitherto traced such lines as these drawings displayed; and what man may hereafter do, now that Dame Nature has become his drawing mistress, it is impossible to predict.

January 27, 1839
(Herschel, in Slough, to Talbot)

I am sorry that it is impracticable for me to come up to town to see your curious process for fixing the image formed by a Camera obscura—the interest of which at this moment is particularly great after what has recently been announced in Paris—but I am tied here by many

engagements to say nothing of a rheumatic affliction which confines me a large portion of each day to my bed and forces me to avoid all exposure to cold which is not indispensable.

On Thursday we have a few friends to dinner with us and perhaps you would join our party, and by putting yourself into a 2 o'clock train there will be abundant time to talk over your process before dinner. . . .

But on rereading your note I see your paper is to be read on Thursday—and you may possibly intend to be present at the meeting

—In that case whatever morning or afternoon t[hat] you like to drop in I shall be very happy to see you. . . .[2]

———

January 28, 1839
(Talbot, in London, to Herschel)

I regret to learn that you are so much indisposed. This is our English climate! After four years of an African sun it must prove a sad contrast indeed. I will come down by the 1 o'clock afternoon train if there is one on Friday next if not prevented by anything, and return to town by one of the evening trains. My paper for the Royal Society will be in the hand of the Secretary this afternoon. . . . P. S. Do you think you could furnish me with the proper curves for a Camera Obscura object glass, of two feet focus, not *achromatic (since the violet rays only are active) but to combine if possible, the greatest diameter of object glass, with a tolerably flat field of view.*

The Camera Obscura pictures which I will show you are Lilliputian ones and require a lens to look at them. When first made they were extremely delicate but are now 3 years & a half old and I intend, as soon as the sun acquires power in the Spring, to make a fresh lot of them, more worthy of being looked at.[3]

———

January 29, 1839
(Talbot, in London, to Herschel)

The Editors of the 2 London principal scientific newspapers, "The Athenaeum" & "The Literary Gazette" have taken up with zeal (much more than I could have expected) the subject of my discovery of Photogenic Drawing. The Editor of the Athenaeum has applied to me this morning for leave to publish in full, the paper which will be read on Thursday at the Royal Society, because, he believes, no time ought to be lost, the Parisian invention having got the start of 3 weeks—I replied to him that a resolution of the Council would be necessary to that effect, & there is no Council before Thursday week, but that I would enquire of the members beforehand if they would consent to this temporary suspension of the rules, without prejudice to the papers afterwards being printed in the Transactions. . . .[4]

———

January 30, 1839
(Draft letter from Herschel, in Slough, to Talbot)

I should not object to printing your paper as a part of the Phil Trans [Philosophical Transactions] on the ground of it having been published in the Athenaeum under all the circumstances of the case however I think that rapidity of communication of invention to the Public is of more importance than points of form and the interest of this particular invention supposing it to accomplish all the conditions required to make it particularly available, is such that it ought to be preserved in some more durable collection than the ephemeral leaves of a Litry & Sci. weekly Journal. However I believe that the practice of the Royal Society hitherto so far as I recollect it has been very strictly of a contrary character & prior publication in any other work has to the best of my knowledge been held a fatal objection. . . . However as before said—I shall not be the one to object—

It has occurred to me that supposing chloride of silver to be the substance employed—the chief difficulty in the case is the preserving the imprint intact by further exposure to light.—Now this may perhaps be accomplished thus.—Let paper be prepared with chloride introduced into its pores by moisting 1st with Nitr. Silver—drying, then moisting again with Mur. [Muriate] Soda, washing & drying in the dark & cold—pressing to give a smooth surface.—Now let the picture be formed. This

> *supposes the reduction to the*
> *metallic state of all that*
> *part which is black.—Before*
> *exposure to light, then, let*

the whole be sponged with or immersed in, a solution of hyposulphite of Soda. This will wash away all the chloride wch had escaped the action of the light & leaves the reduced silver black as before. Thus there is nothing further left for the light to act on & the picture may afterwards be freely exposed like any other drawing.—[5]

———

January 30, 1839
(Herschel, in Slough, to Talbot, in London)

(The previous letter was a draft and *not sent* to Talbot. The actual letter sent did not mention hyposulphite of soda. Herschel must have first communicated the use of this chemical for the fixation of photogenic drawings when Talbot visited Herschel on Friday, February 1. The first paragraph of the letter Herschel sent was almost identical to the draft. The second part of the letter read as follows:)

I have myself been thinking since I got your note about this enigma.—Here is the one fact that forms the ground-

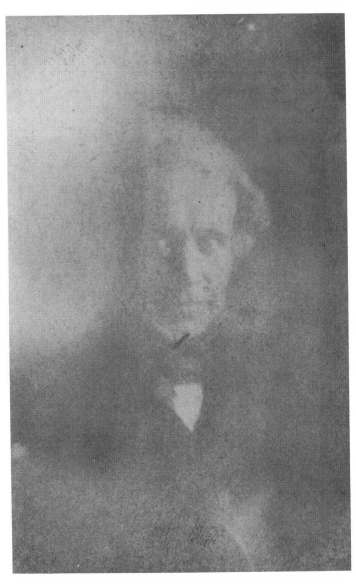

Portrait of Sir John Herschel, c. 1841.

work of my view of the process supposing chloride of silver to be the material used—that the image in a Camera obscura may impress itself on a paper imbued with that substance in its pores and rendered more susceptible than usual by moisture and gentle warmth (and perhaps also by the pressure of hydrogen gas) I have satisfied myself by experiment. Thus we have a picture in which darkness represents light and vice versa. Now this picture will darken every time it is exposed to light till it is become entirely black and thus one picture is destroyed.

But if the whole of the unreduced chloride be washed

out of the paper which may be done instantaneously and to the last atom by a process I have discovered—leaving the reduced silver still on the paper in the form of a firm brown or sepia tint—our picture becomes permanent.[6]

January 30, 1839
(Letter to the editor of The Mechanics' Magazine from Anthony Carlisle, Vol. 30, 1838–1839)

At the evening meeting holden at the Royal Institution on Friday last, several specimens of shaded inpressions were exhibited, produced by the new French Camera. The outlines, as well as the interior forms of the objects, were faintly pictured, and hence the application of this method of impressing accurate design may become disregarded after public curiosity subsides.

Having, about forty years ago, made several experiments with my lamented friend, Mr. Thomas Wedgwood, to obtain and fix the shadows of objects by exposing the figures painted on glass, to fall upon a flat surface of shamoy leather wetted with nitrate of silver, and fixed in a case made for a stuffed bird, we obtained a temporary image or copy of the figure on the surface of the leather, which, however, was soon obscured by the effects of light. It would be serviceable to men of research if failing experiments were more often published, because the repetition of them would be thus prevented. The new method of depicting by a camera, promises to be valuable for obtaining exact representations of fixed and still objects, although at present they seem only to possess the correct elements for a finished drawing.

Few artists of competent skill addict themselves to drawing natural objects, although the value of such designs should be faithfully correct, and the new instrument and new method are well suited to those purposes

January 31, 1839
(The Literary Gazette, Saturday, February 2, 1839)

A highly interesting paper by Henry Fox Talbot, Esq. was read [at the Royal Society]. It detailed the author's discovery upwards of five years ago, of the new process of delineating objects. . . . By repeated experiments, and the most devoted attention, Mr. Talbot, by what he calls sensitive paper (a great improvement upon that which he originally employed), has overcome this great drawback (the picture fading); pictures he has had in his possession for years are now as vivid as they were when first produced. The image obtained is white, but the ground is beautifully coloured, and readily obtainable, either sky-blue, yellow, rose-colour, or black,—green is excluded; these variations of colour Mr. Talbot considers as so many compounds. Objects the most minute are

obtained,—the delicate hairs on the leaves of plants,—the most minute and tiny bivalve calyx,—nay, even a shadow, the emblem of all that is most fleeting in this world, is fettered by the spell of the invention, and remains perfect and permanent long after it has been given back to the sunbeam which produced it; in short, to use Mr. Talbot's own words, the picture is "ended as soon as begun." The extent of the value of this invention cannot at present be anticipated; already the author has applied it with perfect success to the copying of sculpture, engravings, hand-writing; and in every case so complete has been the image, that it has been mistaken for the original. The value of it even now to naturalists and others travelling abroad, many of whom are ignorant of drawing, must be immense. Lord Brougham was present, and paid profound attention to Mr. Talbot's paper.

———

Talbot's first published account of his photogenic drawing process read before the Royal Society, January 31, 1839.

January 31, 1839
(*Letter from J. B. Biot of the Académie des Sciences, Paris to Talbot, in London. Translated from the French*)

I have just received your letter in which you inform me of your intention to address the Academy of Science a formal priority claim in respect of the invention announced by M. Daguerre.

I feel sure that you will do me the justice of believing that I would not wish to hazard a preconceived opinion in such a delicate matter but I must, in the interests of truth, inform you in case you are not aware of it, that M. Daguerre, as his friends know, has been constantly occupied with this research for more than fourteen years and I can attest that he spoke to me about it several years ago. He has kept and shown us a great number of reasonably satisfactory results that he obtained by various processes before arriving at the one he now uses, in which the accuracy and delicacy is admired by all our artists. . . .

Finally, he has communicated everything, under cover of secrecy, to M. Arago who you know, as I do, to be a man of too generous instincts to be guided by any prejudices of nationality.

I address this letter to you in order that you may judge these facts for yourself and I feel I owe it to you on account of the esteem I have for your previous work in optics as well as the consideration you have been kind enough to show me.[7]

———

February 2, 1839
(*Condensed from* L'Artiste *in* The Morning Post)

. . . We live in strange times. Steam has fivefold increased the numbers of workmen; before long railroads will double that fugitive capital called life; gas has taken the sun's place, every effort is being made to find means of travelling through the heavens. This rage for supernatural means has soon passed from the world of facts into the world of ideas, from commerce into the arts. . . .

A proposal is about to be made to the Chambers by M. Arago himself, towards giving to M. Daguerre, not a patent—for he is quite disposed to disclose his process—but a national reward. . . . Surely France will grant to the author of universal engraving, not the recompense he deserves, but that only which he demands.

———

February 2, 1839
(The Literary Gazette)

The great sensation created by the new discovery in the fine arts, which our friends on the other side of the Channel have, with national and personal characteris-

ticness, chosen to call Dagueroscope, *but which our unpretending countryman, Mr.* Talbot *(rather than Talbotoscope), has denominated* Photogenic, *has induced us to bestow further attention upon the subject, which we had the pleasure of first making known to the public. What is done in the* Literary Gazette *today will be important, as settling the claim to originality in regard to all parties concerned in this interesting discovery. The favour of a letter from Mr. Talbot (a gentleman so justly honoured in the scientific circles), puts on record the unquestionable dates of his experiments; and we have seen and examined the exquisite specimens which mark his progress and demonstrate his success. . . . In order to complete the matter, as far as present circumstances admit, we have also, at the risk of repetition, procured the most accurate details of M. Daguerre's process, and the opinion of the French philosophers thereon. As he is recommended to be more secret than Mr. Talbot has been, in order that he may treat with government for his sufficient reward, we cannot, of course, speak more plainly than the somewhat flowery description we have received enables us. . . .*

Different preparations of silver seem to be adopted . . . but whoever attains the object most effectually, it is a generous rivalry, and will, we trust, be continued to the end. Mr. Talbot's method of fixing his drawing, so that the sun can effect or alter them no more, is of the utmost value. His copying of engravings (there is a sweet one of Venice), by first getting them with the lights and shades reversed, but then copying from the reversed impression, as before, is singularly ingenious . . . and an oriel window of many feet square is reduced to a picture of two inches, in which line is preserved with a minuteness inconceivable until seen by the microscope. . . .

———

(Letter to the editor of the Literary Gazette *from Talbot, written January 30, published February 2, 1839)*

Dear Sir,—I have great pleasure in complying with the wish which you have expressed to me, that I would go into some details respecting the invention which I have communicated to the Royal Society; viz. the art of photogenic drawing, or of forming pictures and images of natural objects by means of solar light.

I do this the more readily, on account of the interest with which the scientific public have read the accounts which have recently appeared respecting the discoveries of M. Daguerre, of Paris, in some respects identical with mine—in others, I think, materially different.

Although I am very far indeed from being of the opinion, that "Chance rules supreme in the affairs of men;" yet I cannot help thinking that a very singular chance (or mischance) has happened to myself, viz. that after

having devoted much labour and attention to the perfecting of this invention, and having now brought it, as I think, to a point in which it deserved the notice of the scientific world,—that exactly at the moment that I was engaged in drawing up an account of it, to be presented to the Royal Society, the same invention should be announced in France.

Under these circumstances, by the advice of my scientific friends, I immediately collected together such specimens of my process as I had with me in town, and exhibited them to public view at a meeting of the Royal Institution. My written communication to the Royal Society was, from its length, necessarily deferred to the week following.

These steps I took, not with the intention of rivalising with M. Daguerre in the perfection of his processes (of which I know nothing, but am ready to believe all that Biot and Arago have stated in their praise), but to preclude the possibility of its being said hereafter, that I had borrowed the idea from him, or was indebted to him, or any one, for the means of overcoming the principal difficulties. . . .

Up to a certain point, these inventions [camera obscura and camera lucida] are excellent; beyond that point they do not go. They assist the artist in his work; they do not work for him. They do not dispense with his time; nor with his skill; nor his attention. All they can do is to guide his eye and correct his judgment; but the actual performance of the drawing must be his own.

From all these prior ones, the present invention differs totally in this respect (which may be explained in a single sentence), viz. that, by means of this contrivance, it is not the artist who makes the picture, but the picture which makes ITSELF. All that the artist does is to dispose the apparatus before the object whose image he requires; he then leaves it for a certain time, greater or less, according to circumstances. At the end of the time he returns, takes out his picture, and finds it finished. . . .

The very foundation of the art, therefore, consists in this eminently curious-natural fact, viz. that there exists a substance so sensitive to light as to be capable of receiving even its faint impressions. . . . Moreover, it is not sufficient that the paper should be so sensitive as to receive the impressions of external objects; it is requisite also, that, having received them, it should retain them; and, moreover, that it should be insensible with regard to other objects, to which it may be subsequently exposed. . . .

With this kind of paper, eminently susceptible of being acted on by light, and yet capable of losing that property when required, a great number of curious performances may readily be accomplished. The most remarkable of

these is undoubtedly the copying [of] the portrait of a distant object, as the facade of a building, by fixing its image in the Camera Obscura; but one perhaps more calculated for universal use is the power of depicting exact facsimiles or smaller objects which are in the vicinity of the operator, such as flowers, leaves, engravings &c., which may be accomplished with great facility, and often with a degree of rapidity that is almost marvellous. . . .

A person unacquainted with the process, if told that nothing of all this was executed by the hand, must imagine that one has at one's call the Genius of Aladdin's Lamp. And, indeed, it may almost be said, that this is something of the same kind. It is a little bit of magic realised:—of natural magic. . . .

I hope it will be borne in mind by those who take an interest in this subject, that in what I have hitherto done, I do not profess to have perfected an Art, but to have commenced one; the limits of which it is not possible at present exactly to ascertain.

I only claim to have based this new Art upon a secure foundation: it will be for more skilful hands than mine to rear the superstructure.—I remain, Dear Sir, Yours, &c.

H. FOX TALBOT
44 Queen Anne Street, January 30, 1839

February 2, 1839
(The Athenaeum)

. . . From the abstract of the paper read on that evening [Jan. 31], it appears that the highly curious invention of M. Daguerre, described in the letter of our Paris correspondent, is almost identical with a discovery made five years ago by Mr. Fox Talbot, and which he has been ever since engaged in perfecting. Of the latter and its results, we can speak from observation; and assuredly, when we consider the means employed, and the limited time—the moment of time, which is often sufficient—the effects produced are perfectly magical. The most fleeting of all things—a shadow, is fixed, and made permanent; and the minute truth of many of the objects, the exquisite delicacy of the pencilling, if we may be allowed the phrase, can only be discovered by a magnifying glass. Mr. Talbot proposes for this new art the name of Photogenic Drawing. It enables a person, however ignorant of the art of drawing, to obtain faithful representations of objects, and does not even require his presence; so that these pictures may be executed while the operator is himself engaged about other things. One obvious difference, as it appears to us, between the process of M. Daguerre and that of Mr. Talbot, is, that the former employs metal plates, whereas the latter used prepared pa-

per. There can be no question as to the superior advantages of the latter; for it would be most inconvenient, if not wholly impracticable, for the traveller to carry about with him several hundred metal plates. At the same time we must admit, that, if our Paris correspondent be correctly informed, a greater difference than is apparent must exist: for Mr. Fox Talbot cannot, we believe, by his process, take views by moonlight, which our correspondent reasserts that M. Daguerre has done. . . .

February 2, 1839
(Talbot, in London, to Herschel, in Slough)

I enclose a transparent drawing which I imagine may prove a good subject, if you like to copy it with the carbonate of silver, & then transfer it again, so as to have its original lights & shades. . . .

I hope you will continue the very interesting experiments which you showed me yesterday as I am anxious that something should be effected worthy of the scientific reputation of the country. . . .[8]

February 2, 1839
(Letter from Charles Wheatstone to Talbot)

. . . According to my promise I send you this respecting the action of light on chloride of silver and other substances which I hope may be of use to you in your future photographic experiment. . . .[9] [The first time the term "photographic" is used.]

February 3, 1839
(Letter from Lady Elisabeth Feilding to Talbot)

. . . but I shall ever wish it had been otherwise. This is at least the second time the same sort of thing [being the second to announce a discovery] has happened, how I do wish it might operate in future as a spur to make you do yourself justice. . . .[10]

February 5, 1839
(Talbot, in London, to Lady Elisabeth Feilding)
My Dear Mother,
It appears that in point of fact M. Daguerre's experiments were prior to mine.

I have received a letter from M. Biot in which he says that he himself is able to attest that M. D. has been occupied on the subject for fourteen years. . . .[11]

February 9, 1839
(The Athenaeum)

According to our promise, we this day publish in full, Mr. Fox Talbot's interesting paper 'On Photogenic Draw-

ing.' A somewhat eager examination of the contemporary discoveries of Mr. Fox Talbot and M. Daguerre is going on at Paris. A communication from the former was laid before the Académie des Sciences *on Monday last. . . . The following is an extract from a letter which appeared in the* Augsburgh Gazette, *on the 22nd ult.: "While I was reading the statement of Mr. Arago on the subject of M. Daguerre's interesting discovery, I felt something like the enviers of Columbus, when he made the egg stand on its end. I thought 'You might have made the discovery yourself long ago, if you had happened to think of it.' I immediately went home, patched up, as well as I could, a camera obscura, with a little lens prepared, instead of a plate of metal, a piece of writing paper, and in a quarter of an hour the window of my apartment, with a view opposite, was fixed on the paper, like a most beautiful and delicate drawing in India ink. . . . I am certain that I too possess the art of M. Daguerre. My only object is, that it may be published as soon as possible, that the secret is already discovered in Germany. Satisfied with asserting the honour of my country, I renounce the vanity of publishing my name. . . ." The worthy German seems to be unaware of what really constitutes the discovery of M. Daguerre and Mr. Fox Talbot. The fact that an image or picture might be produced by the action of light on nitrate of silver, was shown more than a quarter of a century since, by Sir H. Davy . . . but the difficulty, it appears, was* to *fix the image or picture; and in this consists the discovery and the secret, which the German writer does not pretend to have penetrated.*

[Note: Some Germans later felt that the use of the camera to copy nature was sacrilegious and blasphemous. Perhaps they would have thought differently had photography not been a French and English invention.]

———

February 8, 1839
(The Morning Post)

When a new discovery is announced, there are usually numbers of persons, hitherto silent, who hasten to lay claim to it. Some deem it fully described in some passage of their voluminous works; or, when they have not that luck, exhibit it under the shape of a conjecture or a prediction. Others find the means of imparting shape, substance, and life to some vague and positive idea which they have expressed, but have attempted neither to prosecute nor demonstrate. Such is the case with M. Daguerre's beautiful discovery. As the news of it is gradually spreading, letters from persons laying claim to the invention are pouring into the French Academy of Sciences, or finding their way into the periodical press from all quarters. Among these rivals of genius we do not, however, mean to include our distinguished country-

man, Mr. Talbot, who has also addressed a memoir to the French Institute. . . .

———

February 8, 1839
(Talbot, in London, to Herschel)

As I understand that you exhibited some photogenic drawings at the Royal Society last night, allow me to ask if it is your intention to publish at present any account of your method of "washing out?"

My motive for asking is, that in that case I could take the opportunity of making known my method of "fixing", either separately, or in a joint communication with yourself to the Royal Society if you should be willing to adopt that suggestion. . . .

P. S. Concerning "washing out" vide *Sir H. Davy in the 1st vol. of journal of R. Institution.*

He could not effect it.—perhaps nothing else will answer than your ingenious recipe?[12]

———

February 10, 1839
(Herschel to Talbot)

I left one or two photographic [author's emphasis] *specimens (very poor ones) with Mr Roberton not as a formal exhibition to the R.S., but merely with a view to keep up attention on the subject by affording matter of conversation to those who might chance to see them in his hands or on the table in the Library in the Evening.*

As Daguerre has obtained his price for his kind of [?] it will soon be published. I am told his performances are so exquisite as to be almost miraculous. So far therefore from having not the smallest objection to your mentioning either publicly or privately my application of the hyposulphite to washing and the superfluous silver, I rather wish it to be known and have myself now mentioned [it] conversationally to more than one inquisitive person though I have no idea of writing on the subject unless something should turn up of a more striking character than anything I have yet hit upon. . . .

That Davy should have missed the "washing out" process is no wonder as he was not acquainted with the Hyposulphites—and although ammonia is a solvent of fresh chloride of silver, it is but a poor one and would, I doubt not, have little effect on paper impregnated with it. The nitrate would be precipitated by it as oxide.

. . . [Further paragraphs discuss the pros and cons of immediate publication of Talbot's paper by the Committee of the Royal Society in their weekly notice, bad weather preventing Herschel from doing photographic experiments, and then, after the salutation, the following:]

I have just met with a very strange and apparently unaccountable singularity which if it arises from no cas-

ual pressure of moisture, hydrogen, or what-not will lead into a whole train of new researches. I find that certain paper is more discoloured when covered with certain glass than when exposed to the full sunshine! The glass [strongly tinged?] with green and ergo must have intercepted some material portion of violet rays, that being the case with all green media, also much of the red. Immediately I began to throw concentrated red rays on a paper freely exposed.—Expecting to find a comparatively light spot where they had fallen.—No effect but experiment hasty and to be repeated. [13]

[The next letter from Herschel to Talbot dated February 12, shows Herschel to have done a number of experiments with colored glass.]

———

February 11, 1839
(Talbot, in London, to Herschel)

... Although Daguerre is said to succeed so admirably with the Camera, it does not follow that he can copy an engraving, a flower, or anything else that requires close contact. I say this, on the supposition that he uses a metal plate covered with a liquid from which light precipitates something previously held in solution. If so, it is evident that the engraving would prevent all effect. This was my idea when I suggested that it might be best not to disclose at present the washing out process, the retransfer, &c. until brought to a state more worthy of publication, inasmuch as the Parisians would hardly be able to discover it immediately if it is no part of Daguerre's process, & I wished to show them that we could do something here which they could not imitate as yet. Do you think me right in this respect? There is not the smallest doubt that the finest engravings can be imitated & I wished that we might have the honour of first exhibiting them. I can work with very thick engravings on a summers day.... [14]

———

February 13, 1839
(Letter from J. B. Biot to Talbot, in London.
Translated from the French)

No one here doubts for a moment the independence of your research on the fixation of images in a camera obscura. ...

Far from regretting that M. Daguerre's announcement forced you to publish your results now, which you might have preferred to conserve with the object of further improvement, we are naturally pleased purely from the scientific point of view since we shall probably have his subject treated from different points of view and by different means.

It is still, Sir, in your power to be the first to allow all scientists to know of your invention, independently of all rivalry, whilst in M. Daguerre's circumstances ... the legal action he has taken with M. Niépce's family, prescribes him from still keeping his secret. For my part, I cannot urge you enough to publish and I take the liberty of expressing to you my regret in not finding your method explicitly given in the copy of your memorandum which was sent to us from the Athenaeum. ...

When it has been verified that his [Daguerre's]—rather than yours—has artistic advantages that a painter as capable as he must have specially strived for, and about which I would not like to hazard an opinion in advance, you will, nevertheless, still have rendered a great service to your scientific colleagues by publishing now your method as an experimental process and I would be the first, but certainly not the last, to acknowledge publicly the thanks owing to you since there is already in your results, especially as regards your sensitive paper, enough to occupy us profitably in the physics of light. ...

You ask me if M. Daguerre copies pictures. He has shown us a large number, all very faithfully reproduced, whether in a camera obscura or otherwise I do not know and I would not ask him in view of the action that ties him. ...

As regards the time he requires to make 10 copies of views or buildings, all of which have a surprising perfection of detail and light distribution, according to what he says and what M. Arago confirms, a few minutes is sufficient, even at this time of year. ...

I assure you that we are solely concerned with the advancement of science and the propagation of discoveries which may hasten its progress. [15]

———

February 18, 1839
(From Talbot's notebook for February 6, 1839
to June 2, 1840)

Comparative experiments

Good writing paper washed on one side with ½ saturated soln. of salt, wipe dry, then covered with nit. silver; & dried at fire one half of the paper immed.ly exposed to a cloudy daylight for some hours, & so blacked. Then washed with different substances as follows: ...

Iodine. preserved the whiteness of the paper but injured the ground—

Hyposulphite of soda
1. left in, not washed out; & quickly dried. Result, nearly white, a pale shade of brown. Answers very well.

2. paper soaked in the liquid 1½ hours—same result—ground not injured.

3. soaked 1½ hour; then washed with weak Mur. Tin. same result.

4. do. washed out immed.ly. Result not so good, the limits of the darkened part of the part (or of the design) become indistinct, & the design becomes covered with dirty specks—

Salt.

Strong. left in. Result uniform pale lilac ½ saturated, left in. Result same. The same two, wash'd out. Fails, except in one or two places that are white; therefore it seems it may be successful.

Prussiate Potash. Strong.

wash'd out & quickly dried. Result iron grey, not altogether an unpleasant effect: but too dark. left in. Fails. soaked 2 hours, & then wash'd out. Result nearly white, a little yellowish. But the ground is injured & sinks to a rich yellow brown—

Muriate Tin, strong.

left in, or washed out, both fail.

Try mixture of salt & iodine: of salt & cyanide potash; of cyanide & prussiate potash.

Try pruss. potash, then wash'd out: then dipp'd again & wash'd out; so on, 3 or 4 times.

Immersion in hyposulphite does not preserve, if any mur. tin is used in the paper.

Try if mixing an opalescent liquid with solution of nitrate silver, would cause it to precipitate in sunshine? Would milk or cream spread on sensitive paper increase the effect?

Common photogenic paper 1 or 2 days old, seems made much more sensitive by washing with very weak iodide of potassium.

Paper washed with Nit. silv. then touched with hyposulphite soda turns deep red brown—but if the nitrate has been washed out with water as far as possible, then no change of colour takes place—nor does the hypo. colour chloride of silver tho' it dissolves it. Upon this principle the following process is founded. (Feb. 27) Wash the photograph [author's emphasis] in 2 waters, to expel all the superfluous nitrate of silver, dry, and then wash with hyposulphite soda, w.ch maybe somewhat diluted. It seems best not to wash this out again, but at once dry it at the fire.

A washed photograph does not discolour in the sun so much: sometimes indeed very little. Try to fix a washed ph.gh with iodine, ferrocyanate pot. or salt: perhaps it wd be more regularly acted upon.

Make picture of Kaleidoscope—[16]

———

February 18, 1839
(Talbot, in London, to Herschel)

I will now inform you of the 2 methods of fixing which I discovered & which I have often employed with success; requesting you not to mention them just at present.

The first, is hydriodate of potash [a solution of potassium iodide]. This requires some nicety of management, because if too strong, it injures the ground; if properly managed it answers beautifully. The piece of lace I showed you at Slough was preserved by this means, & has lasted five years [author's emphasis]—often exposed to the sun.

But my usual plan, is to immerse the design into a strong solution of common salt and not to wash it out. Exposed to sunshine this often acquires a light lilac tint; but if it is an object to secure perfect whiteness this may be obtained by proper management. . . .[17]

———

February 18, 1839
(Letter from J. B. Biot to Talbot.
Translated from the French)

The requests that I have taken the liberty to address to you in the interests of science, asking you to put your discovery of Sensitive Paper in the hands of physicists, now makes it necessary for me to write to you today without delay . . . he [Daguerre] has confided in me a process for the preparation of a paper which he has had since 1826 and which appears to me to produce astonishing effects by the rapid impression that light, even diffused, produced on it in a few moments.

He has authorised me to communicate this to the Academy and I am doing this at today's session. Time prevents me from describing it in detail to you. . . .

I am now going to post this letter but as I would not wish to call into question the confidence you may have had in me, I have warned M. Daguerre that if, on account of your liberal nature, I receive today a letter from you, I will only unseal it in the presence of the Academy so that if, by hazard, it contains some indication of your method, your rights to simultaneous or prior publication remain perfectly intact. I know too well the difficulty one has in finding new discoveries, especially important ones, not to be scrupulously careful to give the merit to those who discover them and who wish to make them known to scientists. . . .[18]

———

February 20, 1839
(Talbot, in London, to Herschel)

I am very much obliged to you for a sight of your photogenic drawings, some of which possess great beauty, and give promise of still more. I have found out how to use the ferrocyanate, viz. by washing the picture with it, & then washing out, 3 times successively—

If there is a meeting of the R. Society tomorrow, I intend to request Mr. Christie [Secretary of the Royal So-

ciety] to read a note, briefly mentioning the nature of my processes; which will then be free to all the world to adopt, or to find out better ones for themselves. The weather both yesterday and today was of the most antiphotogenic description in London.[19]

February 21, 1839
(*Read before the Royal Society,*
February 21, 1839. Published in the Philosophical Magazine,
Vol. 14, no. 88, March 1839)

An Account of the Processes employed in Photogenic Drawing, in a Letter to *Samuel H. Christie, Esq., Sec. R.S.,* from *H. Talbot, Esq., F.R.S.*

Dear Sir,—In compliance with the request of several scientific friends, who have been much interested with the account of the art of Photogenic Drawing, which I had the honour of presenting to the Royal Society on the 31st of last month, I will endeavour to explain, as briefly as I can, but at the same time without omitting any thing essential, the methods which I have hitherto employed for the production of these pictures.

If this explanation, on my part, should have the effect of drawing new inquirers into the field, and if any new discoveries of importance should be the result, as I anticipate, and especially if any means should be discovered by which the sensitiveness of the paper can be materially increased, I shall be the first to rejoice at the success; and in the meanwhile, I shall endeavour, as far as I may be able, to prosecute the inquiry myself.

The subject naturally divides itself into two heads; viz. the preparation of the paper, and the means of fixing the design.

(1.) Preparation of the paper.—In order to make what may be called ordinary photogenic paper, I select, in the first place, paper of a good firm quality and smooth surface. I do not know that any answers better than superfine writing paper. I dip it into a weak solution of common salt, and wipe it dry, by which the salt is uniformly distributed throughout its substance. I then spread a solution of nitrate of silver on one surface only, and dry it at the fire. The solution should not be saturated, but six or eight times diluted with water. When dry, the paper is fit for use.

I have found by experiment, that there is a certain proportion between the quantity of salt and that of the solution of silver, which answers best and gives the maximum effect. If the strength of the salt is augmented beyond this point, the effect diminishes, and, in certain cases, becomes exceedingly small.

This paper, if properly made, is very useful for all or-

dinary photogenic purposes. For example, nothing can be more perfect than the images it gives of leaves and flowers, especially with a summer sun: the light passing through the leaves delineates every ramification of their nerves.

Now, suppose we take a sheet of paper thus prepared, and wash it with a saturated solution of salt, and then dry it. We shall find (especially if the paper has been kept some weeks before the trial is made) that its sensibility is greatly diminished, and, in some cases, seems quite extinct. But if it is again washed with a liberal quantity of the solution of silver, it becomes again sensible to light, and even more so than it was at first. In this way, by alternately washing the paper with salt and silver, and drying it between times, I have succeeded in increasing its sensibility to the degree that is requisite for receiving the images of the camera obscura. . . .

(2) Method of fixing the images.—After having tried ammonia, and several other reagents, with very imperfect success, the first thing which gave me a successful result was the iodide of potassium, much diluted with water. If a photogenic picture is washed over with this liquid, an iodide of silver is formed which is absolutely unalterable by sunshine. This process requires precaution; for if the solution is too strong, it attacks the dark parts of the picture. It is requisite, therefore, to find by trial the proper proportions. The fixation of the pictures in this way, with proper management, is very beautiful and lasting. The specimen of lace which I exhibited to the Society, and which was made five years ago, was preserved in this manner.

But my usual method of fixing is different from this, and somewhat simpler, or at least requiring less nicety. It consists in immersing the picture in a strong solution of common salt, and then wiping off the superfluous moisture, and drying it. It is sufficiently singular that the same substance which is so useful in giving sensibility to the paper, should also be capable, under other circumstances, of destroying it; but such is, nevertheless, the fact.

Now, if the picture which has been thus washed and dried is placed in the sun, the white parts colour themselves of a pale lilac tint, after which they become insensible. Numerous experiments have shown to me that the depth of this lilac tint varies according to the quantity of salt used, relatively to the quantity of silver. But, by properly adjusting these, the images may, if desired, be retained of an absolute whiteness. I find I have omitted to mention that those preserved by iodine are always of a very pale primrose yellow; which has the extraordinary and very remarkable property of turning to a full gaudy yellow whenever it is exposed to the heat

of a fire, and recovering its former colour again when it is cold.

I am, &c.
H. Fox Talbot

———

February 21, 1839
(Letter to the editor of The Times)

Sir,—Reading in a newspaper last week that a German had found out M. Daguerre's secret, I was so impressed with the testimony to the possibility of seizing a shadow, that I thought over all the little I knew of light, colours, and chemistry; the next day, the 15th inst., I took a piece of writing paper, hastily prepared by myself, placed it behind the lens of a camera obscura made on the spur of the moment, and obtained a satisfactory result, for the trees in front of my house were produced, but not the parts agitated by the wind. Since that, I have obtained, progressively improving, several landscapes, which may be called most appositely 'lucigraphs.' I mention this my humble effort as corroborative of the reality or feasibility of M. Daguerre's beautiful discovery; and I can readily conceive that in a very short time the traveller's portmanteau will not be complete without the very portable means of procuring a lucigraph at pleasure.

I remain your obedient servant.
Welney, Wisbeach, Feb. 18.

CLERICUS

———

February 26, 1839
(Letter from W. G. Mundy,
Talbot's father-in-law to Talbot)

I conclude the young lady [Talbot's newborn daughter] must be called Photogena in memory or rather honour of your new discovery! [20]

———

February 28, 1839
(Herschel to Talbot)

You are quite welcome to make such mention as you may think proper to M. Biot of my process for washing out by the hyposulphite of soda....

No. 2. Is the same subject [as No. 1], more successfully photographed* [Note on bottom of page: *Your word photogenic recals [sic] Van Bran's exploded theories of the [?] ogen & photogen—It also lends itself to no inflexions & is an analogy with Litho & Chalcography.]

I had been trying various modes of rendering nitrated paper more sensitive—till I read your most curious account of your processes, which opens quite a new view of the subject and is altogether one of the most singular things I ever saw. You must have hunted down the caprices of these combinations with great perseverence and patience—When I read it I gave up further trials, your

processes being so very simple and complete—I had most hopes of the Gallate of Silver, which is affected by light very differently from its other salts. . . . [21]

———

February 28, 1839
(Letter from Charlotte Traherne, Talbot's cousin, to Talbot. The letter also refers to John Dillwyn Llewelyn making sensitive paper.)

Mr. Calvert Jones is quite wild about it [the photogenic drawing process] and I dare say by this time is making experiments in Swansea for himself. [22]

———

March 1839
(Talbot, in London, to Sir John William Lubbock, treasurer and vice president of the Royal Society, dated only "Thursday evg.")

I am very much obliged to you for the Comptes Rendus which you sent today, as with [and?] for the preceding one. Biot seems to take a great interest in the sensitive paper. . . .

I recommend to you to try the sensibility of paper washed first with nitrate of silver, & then with gallic acid [author's emphasis] the latter to be pure. I have not tried it yet, but it has been mentioned to me both by Herschel & another experimenter, so that I think it must be among the best recipes yet found out. . . .

I want to repeat Biot's experiment with the oyster shells which are lighted up by the moon's rays. . . .

We leave Town next Tuesday for Lacock Abbey. When in the country I hope to find more leisure for experimenting on this subject. [23]

———

March 3, 1839 (or immediately afterwards)
(From Talbot's notebook February 6, 1839
to June 25, 1840)

See in Comptes Rendus 25 Feb./39 M. Biot's account of the great sensibility of oyster shells calcium with sulphur, to diffused daylight. Suppose them reduced to fine powders, this mixed with water, & paper plunged in it, so as to impregnate its pores. We should then have a phosphorescent paper. If nit. silver were mixed with powdered shells wd. the effect on the latter cause the former to blacken? . . . To obtain a sensitive liquid, try nit. silv. mixed with milk, both very dilute; or mixed with opalescent liquid (resin, alcohol, water). If pictures are washed with Iod. potass. & then soaked in water 24 hours, they seem to be perfectly preserved. Try the same with saturated salt instead of iod. potass. Paper prepared with strong salt has a less even ground, than with weak salt. And in full sunshine the white chloride is very apt to form. Did not observe this with diffused light. Is there really a difference? . . . [24]

March 21, 1839
(Talbot, in London, to Herschel)

The enclosed scrap is to illustrate what I call "Every man his own printer & publisher"—to enable poor authors to make facsimiles of their works in their own handwriting. [Probably cliché-verre, discovered by Talbot in Geneva in the autumn of 1834.]

It is a poor specimen, the hyposulphite having failed somehow to do its duty. . . .[25]

March 23, 1839
(The Literary Gazette)

PHOTOGENIC DRAWING

Few discoveries or disclosures have produced so many amateurs in the art and the science of the subject. . . . We have done some service in giving honour to Neipce [sic] where honour is due, by the disclosures which we have made, and publication of his claims, for which we were indebted to Mr. Bauer. . . . Since publicity has been given to the latter of these discoveries [Talbot's], many and important improvements have been made, by Sir J. Herschel and others, among men of science, and by artists, especially engravers; in the hands of two of these, who appear to have simultaneously made the same discovery, it has become an important art. Mr. J. F. Havell, and Mr. Willmore, [sic] have, by covering glass with etching ground *and smoke, sketched designs upon it. Through the glass thus exposed by the scratches, the photogenic paper receives the light, and the design, which the sun may be said to print, may be multiplied with perfect identity for ever! . . . This is a real and valuable discovery, applicable to a thousand purposes. . . . The first report of the discovery in France alarmed the painters from nature; next, the specimens of etched plates and printed impressions alarmed the engravers; this further discovery has replaced it, as an art, in the hands of its professors. But, since the sun has turned printer, we fear that the* devils *will ultimately suffer. It is curious and interesting to hear of scientific men already seeking to apply the process to self-registers of thermometric, barometric, and magnetic variations. We shall watch with interest the new disclosures and applications of this suddenly noised abroad discovery.*

March 28, 1839
(Talbot, in London, to Herschel)

Today I tried my bromine paper to copy my neighbour's house. Notwithstanding the unfavoured weather the result was very encouraging. In some places the individual bricks are given which compose his facade. I am therefore very desirous of ascertaining the proper

mode of *fixing a Bromine picture, without injuring the delicate shades; I wish you would make some experiments thereon.* . . .[26]

March 30, 1839
(N.B. March 30, 1839 Talbot purchased "1 Dr. Crystallized Gallic Acid Bottle" for 1/6d).

(Letter to the editor of the Literary Gazette, *from Talbot. In this issue there is also a description of Talbot's new kind of sensitive paper which was paper washed with nitrate of silver, then bromide of potassium, and again with nitrate of silver. This paper was called by Talbot both "Bromide" and "Bromine" paper.)*

In the Literary Gazette *of last Saturday there is a statement in which I cannot acquiesce: I therefore trust you will allow me to trespass a moment on your columns, and to explain my reasons for dissenting from it. It is stated that some gentlemen have made a considerable improvement upon my art of photogenic drawing, and, indeed, that this discovery was made by several persons simultaneously.*

I fully expect that great improvements will *hereafter be made, which I have never so much as thought of;— but this is not one of them: it is not different from my method, but is the same thing which I have executed long before.*

I have no doubt whatever that the gentlemen who proposed it imagined it to be a new process hitherto overlooked; and, although this is a mistake, I should not have considered it worth while to say anything on the subject, if they had not gone so far as to apply for a patent; which, however, I understand, has been since abandoned. I greatly regret that they did not do me the honour to read my memoir on this subject, presented to the Royal Society on the 31st of January, which has been since printed and freely distributed, as well as reprinted in two periodical journals: in which, Section 7 describes the photogenic pictures obtained by painting on glass, *which, as I have there remarked, "resemble more than any others the productions of the artist's pencil: and for such they have been generally mistaken;" because they give, not mere outlines only, but all the details of the figures perfectly well shaded. . . ."*

March 30, 1839
(The Times; article titled, "Character of M. Arago" taken from "Timon's Etudes sur les Orateurs.")

Were he [Arago] not one of the Academie des Sciences *he would belong to the* Academie Française; *for he is a master of the secrets of language as well as of the secrets of the heavens. . . .*

Arago's excellent report on railroads has set in motion more ideas than all the schemes of commissioners and Ministers put together. This report is a masterpiece of elucidation and analysis.

When M. Arago rises, the whole chamber is in an attitude of curiosity, attends, and is silent. The spectators lean forward to see him. His stature is tall, his hair curling, and his fine 'meridional' head sways the assembly. There is in the muscular contractions of his temples a power of will and reflection which manifests a superior mind. . . . M. Arago speaks only on questions he has prepared, combining the attraction of knowledge with the interest of the circumstance. Thus his discourses possess both generality and actuality, and are addressed at the same time to the reason and the passions of his audience . . . he takes science between his hands, strips it of its asperity and technical forms, and renders it so neat and so perceptible that the most ignorant [?] delighted to see and comprehend it. His animated and expressive pantomime adds to the effect of the oratorial allusion. There is something luminous in his demonstrations . . . light seems to sparkle forth from his eyes, his lips, and the tips of his fingers. . . . When he confines himself to the narration of facts, his eloquence has but the natural graces of simplicity; but when confronted with science he deeply observes her to visit her secrets, and to reproduce her wonders, then his admiration begins to clothe itself in splendid language, his voice becomes animated, his words acquire a colouring, and his eloquence is as great as his subject.

April 5, 1839
(From Talbot's notebook February 6, 1839
to June 2, 1840)

Ammonia poured on Gallic Acid turns orange-red: water added, turned green, but whenever shaken it became browner & nearly opaque. After standing a day, it was brownish red, but water added made it green; the spectrum viewed thro' this showed only red & green; no yellow. Alcohol flame not visible thro' it.

Ammonia poured into very weak aqueous solution of gallic acid, upper stratum became red, next yellow, next green. . . .

Dilute gallic acid, & dilute nit. silver mixed turn dark in daylight (I believe Mr. Reade discovered this).*

**It is essential to use distilled water. The mixture of dilute solutions of gallic acid & nit. silver is colourless if kept in the dark; but the addition of pump water speedily renders it deep red. The immersion of a glassrod that has [been] dipped in ammonia has the same effect, & sometimes renders the whole quite opaque. This is a striking experiment, the mixture of 2 limpid liquids producing opacity. . . .*[27]

April 6, 1839
(The Athenaeum)

The interest excited by the new art—Photogenic Drawing—still continues. Mr. Cooper, the chemist, has prepared photogenic drawing paper, and Mr. Ackerman a photogenic drawing box, for the use of amateurs and artists. In the meantime, discovery goes forward. Mr. Talbot, in his first Report, paragraph 7 (ante, p. 115), refers to shadow pictures, formed by exposing paintings on glass to solar light. This idea has been carried out by Mr. William Havell, who has in this way produced some admirable etchings, and who last week obligingly addressed us to a full explanation of this process. . . . While on this subject, we may observe that some of our contemporaries continue to argue respecting the discoveries of Mr. Fox Talbot and M. Daguerre, as if a doubt existed as to priority. There can be no doubt on the subject. Mr. Talbot himself states that for four or five years his attention has been directed to his discovery; whereas there is abundant proof that M. Daguerre had made great progress in his discovery—had indeed produced many drawings, more than a dozen years since. But we repeat, that the processes are entirely different, and the results different; and having seen specimens of all, including among the best those of Mr. Talbot, Sir John Herschel, and Mr. Havell, we distinctly state that those of M. Daguerre far excel any which have been produced in this country.

(Letter to the editor of the Literary Gazette from J. T. Wilmore, 23 Polygon, Clarendon Square dated April 2, 1839, published April 6, 1839)

The interest which you have taken in the question of priority of invention . . . induces me to offer to your attention what I certainly claim to have been with me an original invention, whatever unpublished priority may be claimed by Mr. Fox Talbot. I herewith send you two specimens of works which I have executed, without the slightest idea that any one before me had ever thought of the process by which I produced them. If it be a subject of reproach that a man, having made a discovery which he believes to be valuable, attempts to secure a personal benefit by a patent, it will apply to hundreds of inventions for which patents have been obtained. I did, certainly, with two other artists, attempt to secure one for the particular application of this new art. . . . Our object was to have united with us as many artists as a patent would allow, viz. twelve. Self-protection prompted this,—for the new art, as it was spoken of, threatened us with the loss of our occupation [engraving]. . . . The charge comes with an ill grace from one

who, by his own shewing, has kept from the world for five years a discovery which has made such progress in other hands in five weeks! Why Mr. Talbot should have felt sore, and jealous of the improvements and discoveries which they have made upon his invention, in consequence of his disclosures, I cannot understand, and still less seeming to claim all that others do: what he did disclose was only an amusement—a plaything. Others, and among them Mr. Havell and myself, have endeavoured to found upon it an art.... The inventions were our own, and we first disclosed their processes; he as a painter, I as an engraver. I am sorry for the soreness Mr. Talbot has shown, for I feel under great obligations to him for what he did disclose ... if Mr. Talbot had not shown what he could do, and how he did it, neither my productions nor Mr. Havell's could ever have been heard of. If he claims, however, all that the new art has produced, or may produce in other hands, which he did not publish before, nor claim until afterwards, he will find others beside me to refuse his claims. . . .

April 10, 1839
(Talbot, at Lacock, to Herschel)

I send the enclosed not as being a very well chosen subject, but as a specimen of fixation by Iodine.... I have sent an account of your diminished pictures to the Literary Gazette where you will find considerable vituperation of me by an artist of the name of Wilmore....[28]

April 13, 1839
(The Literary Gazette)

(It is with great pleasure we insert the following letters, which continue to unfold discoveries and improvements in an art which may almost be considered as magical, and the importance of whose eventual results it is impossible to over-estimate. Mr. Talbot's, Sir John Herschel's, and Mr. Downing's communications all tend to the same issue, and to complete the elucidation of this engrossing topic.—Ed. L. G.)

Lacock Abbey, Wilts, April 8, 1839.

Dear Sir,—I have the greatest dislike to controversy, which I regard as a complete waste of time. I consider it sufficient to have stated, once [and] for all, in your widely circulated journal, that I discovered the art of obtaining photogenic pictures from glass in the year 1834, along with the other processes, of which it is but a slight variation.... But, since that account [to the Royal Society on January 31] seemed to have been already in some measure forgotten by the public, I stated it again, and in a fuller manner. How could I do otherwise, when I found that a patent had been applied for this identical process? . . .

I should take blame to myself for not having dwelt longer on this particular point, in my memoir to the Royal Society, if it had not been that the memoir was written under circumstances which would have pleaded excuse for much more considerable omissions ... for I was threatened with the loss of all my labour, in case M. Daguerre's process proved to be identical with mine, and in case he published it at Paris before I had time to do so in London. I was obliged, therefore, to use all possible expedition in drawing up a statement, and exhibiting specimens to the Royal Society. If I had known that M. Daguerre intended to keep his process so long a secret, I would certainly not have written on the subject in so imperfect and hasty a manner. But I had no choice; at least, I thought I had none, which comes nearly to the same thing. But I never supposed for a moment that this memoir would be mistaken for a regular treatise written by me on the Photogenic art, or as containing all the facts which I was acquainted with.... Thus, for instance, I have said nothing of perhaps the most important application of which the new art is susceptible (that of taking portraits from the life with a camera obscura), because I have not yet accomplished this, although I see no reason to doubt its practicability.... [Goes on to state that Herschel has been successful in enlarging and reducing etchings and quotes a letter he received from Herschel about making photographs on glass written on March 27.]

... I have communicated these details of Sir J. Herschel's recent experiments, believing that you will view with interest the important extension which the art of photogenic drawing upon glass is likely to receive, and remain, dear Sir, &c. H. FOX TALBOT

(Letter written April 11, 1839 to the editor of the Literary Gazette, published April 13, 1839)

Sir,—My name having been lately frequently published, as seemingly connected with the party who attempted to secure a patent to themselves ... I beg to explain, that I knew nothing of their proceedings till after the attempt had been made, and then expressed my decided disapprobation and opposition to the whole affair. The art of etching on glass was practiced many years ago, and specimens printed and published by Mr. Blake, the celebrated artist and engraver: "its application to photography very readily suggested itself."

I am, Sir, your obedient humble servant,

WM. HAVELL

April 13, 1839
(From Talbot's notebook February 6, 1839
to June 25, 1840)

Bromine paper, is greatly increased in sensibility by washing it with saturated solutn. of gallic acid; And it becomes quite black, which is an advantage. Washed with water—then with bromide potash, & washed out, it seemed tolerably fixed.—

Common phot. paper dipped in boiling salt water saturated, grew buff yellow & seemed pretty well fixed. Saturd. salt, cold, put on bromine paper keeps it nearly white, ... wd. serve to fix it. Call Bromine paper washed with Gallic acid, Gallic paper. Gallic paper is tolerably well fixed by cold salt water. The contact of a glove darkens gallic paper, & probably any anima C substance; linen lace does not. ...[29]

————

April 13, 1839
(Corsair. A Gazette of Literature, Art, Dramatic Criticism, Fashion and Novelty, *New York*)

"The Pencil of Nature A New Discovery"

Here is a revolution in art; and, that we may not be behindhand in revolutions, for which we have so imitative a taste, no sooner does one start up in Paris, but we have one in London too. The Dagueroscope and the Photogenic revolutions are to keep you all down, ye painters, engravers, and alas! the harmless race, the sketchers. ... Every church will show itself to the world with out your help. ...

Talk no more of "holding the mirror up to nature"— she will hold it up to herself. ... What would you say to looking in a mirror and having the image fastened!!... Any one may walk about with his patent sketch-book. ...

But what too, if the great business of the sun be to act register likewise, and to give out impressions of our looks, and pictures of our actions. ...

But if genius could really be schooled to severe discipline, the new discovery, by new and most accurate forms, might greatly aid conception. If this view be correct, we may have fewer artists; but those few, who will "spurn delights and live laborious days," will arrive at an eminence which no modern, and possibly no ancient master has reached.

Both, in the merely imitative walk, and that chiefly for scientific purposes, ... the practice of art, as it now exists, will be nearly annihilated—it will be chiefly confined to the coloring representations made by the new instruments—for it is not presumed that color will be produced by the new process.

————

April 13, 1839
(Letter from Theresa Digby, a relative, to Talbot stating that on April 12th she had shown the Queen photogenic drawings and that the Queen admired the exactness of the ribbons more than those of ferns and grapes)

The gauze ribbon [a photogenic drawing] she [Queen Victoria] said was very curious, and she must try to do some herself. ...[30]

————

April 27, 1839
(Talbot, at Lacock, to Herschel)

... I have discontinued lately the use of hyposulphite as a fixer, in consequence of having spoiled some pictures with it, without being able exactly to ascertain why— But I think it arises from something in the paper, since others made at the same time were properly fixed—Probably a few experiments directly made for the purpose, would show the cause of failure, and the way to avoid it in future. When you are in Paris you will no doubt have an opportunity of seeing Daguerre's pictures. I shall be glad to hear from you, what you think of them. Whatever their merit, which no doubt is very great, I think that in one respect our English method must have the advantage. To obtain a second view, Daguerre must return to the same locality & set up his instrument a second time; for he cannot copy from his metallic plate, being opaque. But in our method, having first obtained one picture by means of the Camera, the rest are obtainable from this one, by the method of re-transferring which, by a fortunate and beautiful circumstance rectifies both of the errors in the first picture at once viz. the inversion of right for left; and that of light for shade. N.B. I have found that the camera pictures transfer very well, & the resulting effect is altogether Rembrandtish.[31]

————

April 30, 1839
(Talbot's notebook February 6, 1839 to June 25, 1840)

To obtain soft camera pictures. Wet the original picture (or that first obtained in the Camera). Place it as an object to be viewed by a second camera by transmitted light;—(it shd. be placed between 2 glasses to prevent its tearing). This second camera sh.d give images of the same size as the objects.[32]

————

May 9, 1839
(Herschel, in Paris, to Talbot)

... It is hardly saying too much to call them [daguerreotypes] miraculous. Certainly they surpass anything I could have conceived as within the bounds of reasonable expectation. The most elaborate engraving falls far short of the richness & delicacy of execution. Every gradation of light & shade is given with a softness & fidelity which sets all painting at an immeasurable distance.

His times also are very short—In a bright day 3ᵐ suffices for the full effect up to the point where the light becomes excessive. In dull or rainy days & in the interior

of an apartment (for copying sculptures and pictures) from 5 to 10ᵐ are requisite.

The beautiful effect of River Scenes in rain must be seen to be appreciated. Sculptures are rendered in the most minute details with a beauty quite inconceivable.

In scenes of great detail, every letter in distant inscriptions—every chip in the corner of every stone in every building is reproduced & distinctly recognizable with a strong lens all the paving stones in distant [?] are faithfully rendered.

In short if you have a few days at your disposition I cannot counsel you better than to come & see. Excuse this exultation,. . . .[33]

May 15, 1839
(Letter from Sir Thomas Moore to Lady Elisabeth Feilding)

We however enjoyed ourselves very much [at Lacock Abbey], for both Talbot and his collaborateur, the Sun, were in high force & splendour, and I promised to write something about their joint doings, if I could but get paper sensitive enough for the purpose. . . .[34]

May 18, 1839
(Letter to the editor of The Literary Gazette, dated May 14, 1839, from Alfred Smee, Bank of England.)

Various have been the methods detailed for the preparation of paper which can be acted upon with facility by the powerful agency of the light from the sun; yet not withstanding all that has been written on this interesting subject, the practical student in this art finds that great difficulties occur in every department of photogenic drawing.

May 19, 1839
(Talbot's notebook February 6, 1839 to June 25, 1840)

A camera photograph (or camerograph) on good paper washed in warm water & left in a drawer unfixed for 18 days seems uninjured; but one on coarse paper seems spoilt.[35]

May 21, 1839
(Letter from Constance, at Lacock, to Talbot)

I have been labouring hard at the photographs without much success for though some of the pictures were fully good I spoilt them afterwards with the iodine. I ought to have begun my study of the art while you were at hand to assist me in my difficulties. As it is however I shall have gained experience by any unsuccessful attempts, and therefore not wholly wasted my time and strength. I set the camera today to take my favourite view near

the Cauldron; but I believe I failed in getting the right focus, for the outline is sadly indistinct though the general idea is perfect in its resemblance. Yesterday and Saturday were not bright enough for the camera and Sunday was only bright during the hours of Church and preceeding when I was not ready for work. . . .[36]

May 31, 1839
(Letter from G. Butler to Talbot)

You are an errant cheat or, at best, an aider and abettor in deception. Upon opening your packet of Photogenic drawings, I was so completely taken in by your lace-picture that, like a dutiful husband, I was actually handing it over to Mrs. Butler as a lace pattern—intended for her,—before I discovered my mistake. And the leaves! and the Abbey tower! And then we set ourselves to work to read all about it,—and felt more & more indebted to you for having furnished us with so interesting and exquisite a product of your inventive genius.[37]

(Printed brochure to accompany Talbot's exhibition of 92 photogenic drawings. See below and opposite page.)

A BRIEF DESCRIPTION
OF THE

PHOTOGENIC DRAWINGS
EXHIBITED AT THE MEETING OF THE

BRITISH ASSOCIATION,
AT BIRMINGHAM,

IN AUGUST, 1839,

BY H. F. TALBOT, ESQ.

CLASS I.

Images obtained by the direct action of light, and of the same size with the object.

1. The Great Seal of England, copied from an engraving with the Anaglyptograph.
2. Reverse of the same.
3, 4. Copies of Lithography.
6 to 15. Copies of Lace, of various patterns.
16. Muslin.
17, 18. Calico.
19. Copy of a Wood Engraving.
20, 21. Coats of Arms, taken from old painted glass.
22. Copy of a Berlin pattern.
23. Jessamine.
24. Grass.
25 and 26. Grass. *Aira caryophyllea.*
27, 28. *Bromus maximus,* native of Genoa.
29. *Agrostis.*
30. Coltsfoot (*Tussilago farfara*). The winged seeds are represented flying away.
31. *Veronica.*
32. *Sisymbrium Cumingianum.*
33, 34. Fern.
35. Campanula.
36. *Kitaibelia vitifolia.*
37. *Orobus vernus.*

August 31, 1839
(Report of the Birmingham Meeting of the British Association, The Athenaeum)

... The present degree of sensitiveness of the photogenic paper was stated [by Talbot] to be as follows: it will take an impression from a common argand lamp in one minute, which is visible though weak. In ten minutes the impression is a pretty strong one. In full daylight the effect is nearly instantaneous.... In copying a coloured print the colours are visible on the photograph, especially the red, which is very distinct. Some descriptions of photogenic paper show this more than others; but no means have yet been found of fixing those colours, and sunshine reduces them all to an uniformity of mere light and shade. Sir John Herschel has formed images of the solar spectrum, in which the change of colour is from end to end of the spectrum, but most clearly at the red end....

September 8, 1839
(Talbot, in London, to Herschel)

I believe you have not seen any of my photographic attempts with the Solar Microscope. I therefore enclose 4 specimens of magnified lace. I have great hopes of this branch of the Art proving very useful, as for instance in copying the forms of minute crystallization which are so complicated as almost to defy the pencil.

Have you tried M. Daguerre's plan yet [details first published August 19], and with what success? I have not yet had leisure to make the attempt—The first part of his process, exposing silver to the vapour of iodine, has long been known to me, but the sensibility to light had not appeared to me sufficient. I described to Section A at Birmingham the variable Newtonian rings which I obtained last year from this process—I expect to be able to compete with M. Daguerre in drawing with the Solar Microscope, when a few obvious improvements have been adopted. By the way did he show you anything remarkable of this kind?[39]

September 10, 1839
(Herschel, in Slough, to Talbot)

I have not tried Daguerre's process—but I yesterday succeeded in producing a photograph on glass having very much the character of his results—being dark on a bright ground as in nature, not reversed as to right & left, and having much the appearance of being done on polished silver. The process is delicate and very liable to accident in the manipulation, as it consists in depositing on the glass a perfectly uniform film of muriate of silver [silver chloride]—(by subsidence from water)—drying it—then washing it with nitrate to render it sensitive (which it does, NB) To do this without injuring the film requires great precaution. When placed glass foremost in the focus of a Camera this takes the image with much greater sharpness than paper.—It fixes with a wash of hypo sulphite of soda poured over it, quite easily & completely. The whole of the [unreduced] muriate is carried easily away and the reduced silver forms a brilliant metallic film on the glass which adheres firmly & will bear considerable friction. The glass being then smoked or black varnished the effect is as described.

But if the varnish be omitted there seems no reason why impressions should not be taken from it ad infinitum provided the film can be got thick enough....[40]

September 12, 1839
(Talbot, at Lacock, to Herschel)

I am much obliged to you for the description of your new method of making a picture on glass. Do not publish it at present, for the following reason. Some one has lately taken out a patent for improvements in photogenic drawing. I am not acquainted sufficiently with the facts, to be able to judge whether he has any fair right to do

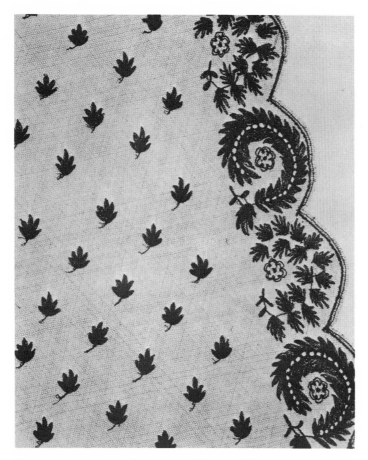

Photogenic drawing of lace, c. 1839, probably made with the solar microscope. On October 9, 1839 Talbot wrote to J. W. Lubbock: "I will look out and send you some pictures with the Solar Microscope (magnified lace; 100 & 400 times magnified in surface) which I made about 3 months ago. Herschel says he saw nothing like them in Paris, & Robert Brown says the same."

so, i.e. whether he has himself invented anything new, or only intends to reap what others have sown; but having conversed with a lawyer on the subject I find there is nothing to prevent him from monopolizing the Daguerreotype (in England) if he is so disposed—Now, until he enrols his specification, which he may delay 5 months longer, he is at liberty to claim as his own any improvement that you or I or any one else may publish, and prevent us from employing it without his permission. Those things only are safe, which were published previously to the date of the patent. Such is the state of the law at present, and there is no help for it, that I know of, it behooves us therefore to describe no new process, applicable to the arts, before next year. . . .

Among various speculations which I had noted down in my journal, respecting the probable nature of the Da-

guerreotype I find one that came pretty near to the mark: viz. to expose a silver plate to vapours of iodine (for this part of the process I have been acquainted with more than a twelvemonth) and then, to make the photographic picture on this plate, and place it in a galvanic battery, so that it should be one of the poles of the battery. I then expected that if the electrolyte were a solution of silver, the metal would precipitate more abundantly—on some parts of the plate than on others, & thus render the picture more visible, & also fix it; but I never had leisure to try this experiment. . . .[41]

September 14, 1839
(The Times)

The first experiments made in this country with the instrument and process of M. Daguerre were exhibited yesterday by M. St. Croix, who has just arrived from Paris, in the presence of a select number of scientific men and artists. . . . The invention is a great improvement on photogenic drawing, inasmuch as the representations of existing objects are more perfect, the minute details more accurately preserved, and to a slight degree the tints of colour secured. . . .

September 23, 1839
(Talbot's notebook, February 6, 1839 to June 25, 1840)

Some good camera views obtained thus: wash glazed writing paper with amm. nitr. silver (using no salt) then with brom. pot. & wash well in water. Wash this w. paper with ammon. silver (diluted with 4 or 5 times its bulk of water) the view is taken in ¼ hour or ½ hour, then washed at once with the same brom. pot. left on it—1 minute, then washed off with water. Found these views to be fixed, & to make good transfers, probably owing to the small quantity of silver put on them the 2nd time.[42]

Between September 23 and October 16, 1839
(From Talbot's notebook, February 6, 1839 to June 25, 1840)

Portraits. take 1 inch lens belonging to microscope, form D [probably daguerreotype] type picture, & throw magnified image of the same on paper. This diminishes the time of the person's sitting, at the expense of the subsequent operations.[43]

October 4, 1839
(Letter from Lady Elisabeth Feilding to Talbot)

[Sir Augustus Calcott, "a great painter!"] thinks your discovery may be rendered very important to art . . . he is very indignant that Arago with his usual nationality

pretends entirely to overlook your papers and gives the credit of the discovery to Daguerre. . . .[44]

October 4, 1839
(Letter from Constance to Talbot, in London)

Do you not feel proud of your brilliant success, & flattered by the communications which Lady Elisabeth makes to you today?[45]

October 5, 1839
(Letter from Talbot, in London,
to Lady Elisabeth Feilding)

I shall be very happy to be acquainted with Sir Augustus Calcott, but I believe there will be hardly time during my present stay in London as I am anxious to leave it as soon as I can. . . . There can be no doubt of the great injustice of M. Arago—he does not seem to recollect that candour would be as great an ornament to his character as scientific eminence, and that the want of it, when conspicuous and evident to the whole scientific world, must result in injury to his own reputation—already his absurd nationality, in declaring the French to be the inventor of the steam engine has called forth "de vives reclamations" on this side of the Channel; and half the President's speech (at Birmingham) the other day was occupied in defending Cavendish against his unfair and unreasonable attacks. M. Biot on the contrary is very friendly in all his communications to me. I have made acquaintance with M. St. Croix who exhibits the Daguerre process at the Adelaide Gallery—he certainly makes bungling work sometimes, but at other times he succeeds, enough to let one see that it is not very difficult to execute it very well but the chief embarrass[ment] is, that London plated copper will not answer (nobody knows why) and that it is therefore necessary at present to import the plates from Paris—If M. Arago knew this, he would say that it was a new proof that the invention was 'vraiment Francaise' since the Art itself evinced an antipathy to England. . . .[46]

October 8, 1839
(Talbot, in London, to Lubbock)

These are only to convey some idea of the tone &c of pictures obtained with an operaglass & reversed afterwards. The time of year was unfavourable (latter part of September)—in summer I expect considerable improvements will be made. If I can attain to the level of common amateur sketching I shall be satisfied since my present process is very easy & seldom fails. I am sure 50 sheets of paper may be prepared in an hour or two. I have never yet tried the paper with a really *good camera, because such are rarely to be met with in London. Consequently it is to be hoped the merits of the paper process are not yet fully developed. . . . The patentees (so called) have commenced an action against the Adelaide Gallery [Antoine Claudet's daguerreotype studio].*[47]

Not dated, probably October 1839
(Letter from Lady Elisabeth Feilding to Talbot)

I wish very much you would choose the very best Camera Obscura that is to be had, & let me give it to you. I am sure your discovery would be perfect [?] if you had a better instrument to work with, & it is worth anything to your celebrity to possess such a one. . . .[48]

October 15, 1839.
(The Art-Union)

PARIS.—The Daguerreotype.—. . . . The changes and improvements proposed are so numerous, that we are able to notice only the most important. Amongst these is the production of portraits, which is said to have perfectly succeeded. . . . An officer in the Ministére des Finances [Hippolyte Bayard] has made another discovery, which is considered altogether superior to the Daguerreotype. The drawings obtained by the Camera Obscura are fixed upon paper, which, however, has no particular colour, but is white, although it has undergone a certain preparation. The drawings can not only be exposed to the air without injury, but they may be also handled. This certainly, as well as the absence of the opaque ground, and the metallic lustre of the drawing by Daguerre's procedure, are improvements of great value. [sic]

October 26, 1839
(The Athenaeum)

It has excited some surprise that, after the eager and natural curiosity of the public respecting the discovery of M. Daguerre while it remained a secret, so little interest should now be taken in the subject. The truth is, that the public were led to believe that the process was so extremely simple that once known it could be practised without difficulty—so simple indeed that M. Daguerre could not be protected by patent rights, and therefore the French government consented to grant him an annuity. Whereas, without meaning in any way to undervalue the discovery or its important consequences, it now turns out that the process is very delicate and complicated, requiring great skill and care in the manipulator; and so easily can M. Daguerre protect his interests, that he has had a patent taken out in England, in the name of Mr. Miles Berry, of Chancery Lane, not only for

the manufacture of the Daguerréotype, but for the use of the instrument. How far such a proceeding was contemplated by the French government—how it can be justified by the letter of the agreeement—how far such a patent can, under the circumstances, be maintained, we must leave others to determine—we merely state as a fact what has been much and generally disbelieved. Persons indeed, to whom M. Daguerre was known, and who had read the trumpetings in the foreign journals of the liberality of the French government in making this discovery public for the benefit of the civilized world, could not be persuaded that he was a party to such a proceeding, and therefore addressed a letter to him on the subject—but his answer, which we now publish, is conclusive:

18th Oct. 1839

Sir,—In answer to your letter of the 4th instant, respecting the process of the Daguerréotype and the patent obtained in England for the same in the name of Mr. Miles Berry, Chancery Lane, previous to any exhibition thereof in France, I beg to state that it is with my full concurrence that the patent has been so obtained, *and that Mr. Miles Berry has full authority to act as he thinks fit under proper legal advice.*

I would add that if you will take the trouble to read attentively the articles of the agreement between me and the French government, you will see that the process has been sold, not to the civilized world, but to the Government of France for the benefit of my fellow countrymen. . . .

Daguerre

————

October 29, 1839
(The Times)

A new method of producing photogenic drawings was yesterday exhibited to a small circle of scientific persons. The drawings produced, which combine the minute exactness detailed in Daguerre's tables with the powerful contrast of the light and shadow of an original drawing, are effected by means of Indian ink. Unfortunately, the preparation of these new photogenic plates is rather complicated, requiring the science of a chymist [sic] as well as the skilful hand of an artist, and the inventor (Dr. Schafhaeutl, of Munich) has not yet correctly ascertained how long these plates will remain sensible to the action of light. . . .

————

November 3, 1839
(Talbot, at Lacock, to Lubbock)

I can make a very perfect picture with the Solar Mi-

croscope in 3 minutes on paper, & from that original any number of copies. I believe I told you my paper is sensitive to moonlight, it takes 10 minutes to obtain a visible impression. . . .

Do you know anything of a pretended discovery by M. Schafhaeutl of Munich which is mentioned by several papers as infinitely transcending Daguerre? . . . and how did Niepce engrave those plates 12 years ago? he must have known more than he ever communicated. Several weeks ago I discovered 3 methods of fixing a photogenic drawing on silver plate, one of which gives the lights in their right places, & is in my opinion very beautiful in effect; the other 2 ways give lights for shades.[49]

————

November 10, 1839
(Letter from J. B. Biot to Talbot, at Lacock. Translated from the French)

I asked M. Arago whether he has spoken about your sensitive paper in the manner that someone had written to you about. . . .Scientists sometime gossip like old women but, unfortunately, their gossip spreads over Europe instead of being confined to the home.

I received your letter in which you speak of your new paper that is sensitive to lunar radiation. . . . You must be further ahead, Sir, than anyone in this line [discovering a process suitable for travelers]—do not allow yourself to be overtaken.

There is a M. Bayard over here who has presented to the Academy of Fine Arts some prints of this kind, made in a camera obscura. The effect appeared to be very satisfactory for the purpose I have just mentioned, although they were far inferior to those produced by Daguerre. . . .

If you were able to give us a sensitive paper which could also be rapidly imprinted, travellers and artists would be under a great obligation to you. The rapidity of operation is not only convenient but is a condition of success, since if action is prolonged, the shadows change and the paper can no longer reproduce it according to what one sees in each instant. Since you have been able to obtain extreme sensitivity, do try and solve the difficulty of the immediate reproduction of light and shade and everyone will congratulate you.[50]

————

December 7, 1839
(Talbot, at Lacock, to Herschel)

I enclose a little sketch of the interior of one of the rooms in this house, with a bust of Patroclus on a table. There is not light enough for interiors at this season of the year, however, I intend to try a few more. I find that a bookcase makes a very curious & characteristic picture: the different bindings of the books come out, & produce considerable illusion even with imperfect exe-

cution. *I will write to Town & enquire whether Daguerre has yet enrolled the specification of his patent. Six months are allowed, but that time must be nearly expired. The last I heard of it was, that he had by his agent applied to the Lord Chancellor for an injunction to restrain the Adelaide Gallery from showing the process; but although the application was* exparte, *the Chancellor refused to do so. I do not know whether this portends, that the patent will not be sustained. In a subject in which common sense enters in so very small a proportion as it does in our Patent Laws, it would be unsafe for anyone but a Lawyer to hazard an opinion. I do not learn from your letter whether you have yourself experimented on the Daguerrotype—I have procured all the apparatus from Paris, but not yet have had leisure to attempt a single picture. . . . I am sorry that your great astronomical work should oblige you to withdraw your attention entirely from Photography, I trust however that you will occasionally revert to the latter as an amusement, especially as the experiments require only occasional superintendence, & during the greater part of the time, execute themselves. . . . I enclose some bits of my paper, which requires to be washed with nit. silver to make it sensitive, and I shall be glad if you could spare me a bit of yours, in order that an accurate comparison may be made of their respective sensibilities and other qualities. I believe they differ in one respect, for you say that yours, if washed with silver solution and not then used, darkens spontaneously whereas mine remains white, but loses its sensibility & has therefore to be washed again when used. I rather deprecate a too hasty disclosure of this method, as I am convinced we are only on the threshold of what may be done—Although the perfection of the French method cannot be surpassed in some respects, yet in others the English is decidedly superior. For instance in the capability of multiplication of copies, & therefore of publishing a work with photographic plates. . . .*[51]

My dear friend and most admired Magician,
 ... Latent pictures, really existing, but invisible. *It is impossible to imagine, where this may end; or what immeasureable extent of subjects it may embrace....*

George Butler, former Headmaster, Harrow School, to Talbot, March 25, 1841[1]

4.

Invisible Images

During that short interval between Arago's announcement in the Académie des Sciences of Daguerre's process and Talbot's display of his photogenic drawings at the Royal Institution on January 21, Paul Cézanne was born. The birth of the father of modern painting on January 19, 1839, was simultaneous with the birth of photography. If one wants to believe in miracles, it is as if a power from above knew that once "the sun began to draw" a new kind of artist must appear on earth if painting was to survive.

Cézanne's approach to image making was not at all like that of Talbot, but their results, at times, have a remarkable relationship. It has been said that

Cézanne did not think he had to choose between feeling and thought, between order and chaos. He did not want to separate the stable things which we see and the shifting way in which they appear; he wanted to depict matter as it takes on form, the birth of order through spontaneous organization.[2]

Talbot's invention was a means to unlabored, nearly automatic, organization of matter. He knew he could not separate the stable from the kinetic. The formation of his pictures depended on the billions of constantly moving light rays that fill the air, and they show a world with wind and water and sunshine and shadows and children *trying* to stand still. Merleau-Ponty, the French philosopher, said Cézanne tried to capture "the vibration of appearances," and so too did Talbot. Talbot did not seek a literal reality. He, like Cézanne, tried to seize a moment in its most complete, fullest expression. Cézanne pondered before he made each brush stroke, laboriously add-

ing color upon color so that every inch of the canvas spoke of light and air and form and style. Talbot used a machine that miraculously changed the concept of time and quickened image making, but he, too, sought a visual truth never before explored. Talbot, like Cézanne was

... not satisfied to be a cultured animal but assimilates the culture down to its very foundations and gives it a new structure: he speaks as the first man spoke and paints [photographs] as if no one had ever painted [photographed] before.[3]

Talbot was never satisfied only to know the appearance of things; he always had to understand the "ultimate nature" of whatever he studied. He had not been satisfied with the traditional methods of picture making so he created a new process for picture making. Talbot's photographs have a purity and an intensity that raised the question that began Chapter 1—do these first photographs, in some sense, go to "the farthest reach of the future"? Talbot's photographs are acts of discovery; they are primitive and unassuming. He asked nature to reveal itself and to help him.

No more is it a question of speaking of space and light; the question is to make space and light, which are there, speak to us.[4]

Talbot, like Cézanne, was able to make "space and light" speak directly to him in a wondrous and original way. It is in this sense that Talbot's photographs go to "the farthest reach of the future."

Talbot intuitively knew that the pictures he made carried in them the clues to the nature of photography. It is

the reason why he photographed so vigorously in 1839 and 1840 while he was trying to improve his process of photogenic drawing. He was fully aware of the potential of his two-step process—the utilization of a negative to produce any number of positives that could magically and beautifully delineate aspects of the world. He knew, however, that before it could captivate an audience, photogenic drawing had to be significantly improved. Talbot was certain that the more he allowed "space and light" to speak to him, express itself in a variety of ways on the salted paper (scientifically and esthetically), the closer he would come to finding the better method he sought. He bought a daguerreotype camera to make paper negatives and commissioned other cameras to be constructed. Sculpture, flowers, the Abbey, farm implements, bridges, ladders, reflections, trees, carts, archways, jars, bookcases, clocktowers, breakfast tables, woodhouses, walls, carriages, faggots, decanters, chintz, urns, bas reliefs were photographed by him, all from different angles, in various settings, with different lighting. The subject itself was always subordinate to the exploration of space and light. Or, in other words, Talbot's subject matter was photography itself. As inventor, he had the right to this "subject." All responsible photographers after Talbot had to consider subject matter, content and form of their pic-

"Cart, in orchard" dated April 26, 1840.

tures in much greater depth if they were to make images of lasting value. It was not enough just to let the sun draw.

It was distressing for Talbot to read in the press that his drawings were of "the same character as those of M. Daguerre and his process another version of Daguerreotypy." Distressing because, in fact, he was second with the announcement. Although Talbot revealed his discovery only two weeks after Daguerre, the initial enthusiasm, world adulation (mixed, of course, with some "grave reservations") and the honored title of "inventor" were all directed toward the Frenchman.

In Talbot's letter to the editor of *The Literary Gazette* of January 30, 1839, he stated that he did "not profess to have perfected an Art, but to have *commenced* one; the limits of which it is not possible at present to ascertain." Although he suggests hands more skilled than his will "rear the superstructure," he intended to take his photogenic drawing process further than where he had left it in 1835 and make it more competitive with the beautiful daguerreotype. The following letter of September 1840 shows Talbot was not able to give as much time to his researches in photography as he wished:

... I have not been able this summer to give more than a desultory and divided attention to the subject—I had & still have the intention of making a little photographic tour, in search of objects more picturesque than my own immediate neighbourhood supplies. A great desideratum is more sensitive paper, in order that the tourist may make many sketches in one day with one instrument. ... Or, what would come to the same, an improved object glass allowing [?] large aperture ... I cannot say I have much improvement to boast of, of late, but the art remains in status quo since April or May.[5]

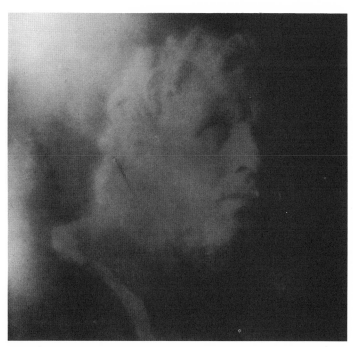

Patroclus, probably January 13, 1840. A favorite subject, Talbot photographed the bust seven more times that year: January 14, February 27, February 29, April 9, April 19, April 28 and August 9.

Talbot could not separate the act of making photographs from understanding laws of nature. He saw this union as beneficial not just for him, but also for all who were to follow.

It would hardly be believed how different an effect is produced by a longer or shorter exposure to the light, and also, by mere variations in the fixing process, by means of which almost any tint, cold or warm, may be thrown over the picture, and the effect of bright or gloomy weather may be imitated at pleasure. All this falls within the artist's province to combine and to regulate; and if, in the course of these manipulations, he nolens volens, *becomes a chemist and an optician, I feel that such an alliance of science with art will prove conducive to the improvement of both.*[6]

Perhaps "an alliance of science with art" was indeed what Talbot meant by "a little bit of magic realised:—of natural magic."

Day after day (he listed over 175 photogenic drawings finished between November 1839 and September 1840) Talbot made images that were truly haunting. Unable to place the pictures taken around home in some art historical context, he thought the difficulty might rest in their unconventional subject matter. Frequently he wrote in letters that he must find more "picturesque" subjects. But it was the compositions that were so unusual. The long exposures gave the trees and shrubbery a wild look as they blew in the wind during the half hour or more exposure. The randomness with which the lens focused, and related objects that fell into its view, also unnerved Talbot. The pictures themselves seemed woven, so much was the image part of the fibers of the writing paper. But he kept on making these uncanny, colorful negatives and positives, and he kept on looking at them.

Each of Talbot's photogenic drawings had the key to his search for a better technique—each had an invisible, as well as a visible, life. It was on September 20 and 21 that Talbot made one of his most brilliant discoveries. The next letter he wrote to Herschel after the one just quoted, read as follows:

I remember that I said in my last letter to you, that Photography remained in status quo. *It happened singularly enough that immediately afterwards I discovered a process to which I have given the name of calotype.*[7]

This new technique allowed a short exposure to produce a latent image that could be brought out—developed—by the use of certain chemicals. Talbot wrote, "I know of few things in the range of science more surprising than the gradual appearance of the picture on the blank sheet especially the first time the experiment is witnessed."[8] All photographers share in the wonder of watching a print appear in the developer. Talbot's amazement was compounded by the excitement of discovery.

The name calotype derives from the Greek *kalos.* Although *kalos* can mean beautiful, it also means "that which is good or useful." Talbot wrote, "I have named the paper thus prepared *Calotype paper* on account of its great utility in obtaining the pictures of objects with the camera obscura."[9] The calotype process reduced exposures from perhaps an hour to a few minutes or even a few seconds, depending, of course, on the strength of the sunlight. Photographs of people were now possible. Calotype is the foundation of modern photography.

In photogenic drawing, a piece of sensitized paper was exposed to light, either in the camera, solar microscope or with an actual object placed upon it, until the image appeared clearly on the paper. Next it was fixed, sometimes waxed, and then placed in a wooden printing frame against another piece of photogenic drawing paper and exposed to the sunlight for however long was necessary for a positive picture to be clearly seen on the second sheet of paper. Calotype paper, on the other hand, was given a short exposure and the "latent image" was brought out by gallic acid*, fixed, waxed and printed in the same manner as photogenic drawings. The method Talbot used to discover the latent image is fascinating and his notebooks survive to tell the story in his own words:

N.B. Whenever "gallic acid" appeared in the notebook during this period, Talbot later cut it out of the page.

Sept. 20. 2 W [twice treated Waterloo silver bromide paper] washed with nit. silv. & [gallic acid] *is very sensitive, and turns very black. W paper also answers, but in a less degree. It also renders yellow paper (or fixed with much iodine) sensitive, which wd be very useful if found manageable.*

Sept. 21. [Gallic acid] *increases the sensibility of W or Bromine paper, but much more that of yellow or Iodine paper. The exciting liquid composed of*
 1 part by measure nit. silv. common strength
 1 acetic acid
 1 [gallic acid] *strong solution*

Sept. 22. Prep. of paper. First, wash with nit. silv. usual strength. Dry at fire. Dip in dish of iod. pot. for ½ minute. Wash. Dry at fire. There must not be too much nit. silv. else the paper changes spontaneously as soon as it is touched by the exciting liquid (which is that described yesterday) Use. When excited gives a picture in 5' cloudy weather exhibiting even the tiles on the roof etc. etc.

Sept. 23. The same exciting liquid was diluted with an equal bulk of water, and some very remarkable effects were obtained. Half a minute suffices for the Camera. The paper when removed is often perfectly blank but when kept in the dark the picture begins to appear spontaneously, *and keeps improving several minutes, after which it should be washed & fixed with*

* A derivative of tannic acid, $C_6H_2(OH)_3CO_2H$.

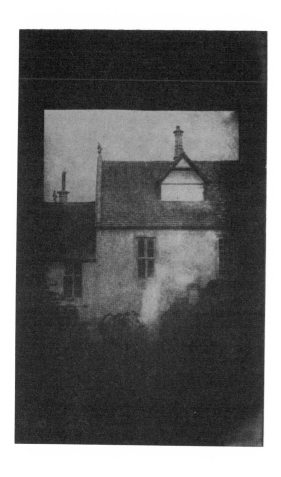

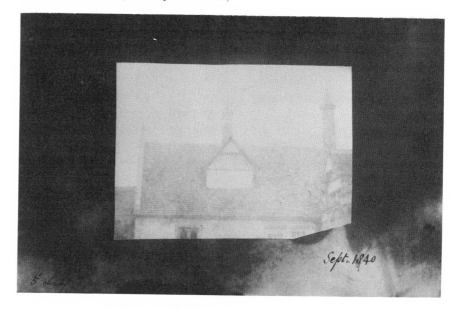

The second earliest surviving calotype, dated on the border "Sept. 1840" and the exposure time written as "3' cloudy." (See notebook entry for September 24.)

The earliest calotype, dated "Sept. 1840" and the exposure time written as "5' cloudy." (See notebook entry for September 22.)

iod. pot. . . . The same exciting liquid restores or revives old pictures on W. paper which have worn out, or become too faint to give any more copies. Altho' they are apparently reduced to the state of yellow iodide silver of uniform tint, yet there is really a difference & a kind of latent *picture which maybe thus brought out. . . . Revived a picture made last May . . . twice plunged in hot water and once in iod. pot. without destroying the (latent) representation, to say nothing of the lapse of time. A camera picture made yesterday in 2', & which was faint the spontaneous action having been stopped by fixing it with iodine, was washed with the exciting liquid & revived, or rather, the spontaneous action recommenced as if it had not been interrupted. . . .*

Sept. 24. I find 8 seconds enough for a strong impression of the outline of the house, in cloudy weather. Also the lighter tiles on the roof are very plainly depicted. If the impression is not strong enough, I find it may be strengthened by immersion in iod. pot. & then more of the G [gallic acid] wash. In 3 minutes a singular picture was obtained, the sky fiery red especially by transmitted light against which the roof almost white contrasted as if covered with snow. . . .

Sept. 26 . . . The sensitive paper (G washed) contains no soluble matter, hence it wd be possible to take copies on it from photographs wetted and rendered transparent with boiling water.

This sens. paper takes a feeble impression, but which is speedily brought out by a second wash of G . . . 10" at sunset in the darkest weather produces an invisible impression wch can be brought out. This washed G paper would evidently be useful in the Camera because it would keep a certain time, & perhaps need not be brought out the same day that it was used. . . .

October 1 . . . Washed G paper kept several days & is then very sensitive when exposed at the window, & brought out with G & spont. [spontaneous action]. Doubtful whether it can be used in the Camera.

October 2. I find that it can. And some hours may be allowed to elapse before it is brought out.

October 11. . . . A bit of the same paper (kept 10 days) placed in the camera, seemed as good as ever.[10]

After years of searching for a really sensitive paper, in September 1840 Talbot found that gallic acid in conjunction with silver nitrate made a very fine photographic paper. Of greatest importance was his discovery of the existence of the latent image and the means to make it visible. This discovery became a central concept of the photographic medium.

Talbot had never been satisfied with photogenic draw-

ing; he was thrilled by the calotype. His first results, "fiery red" sky against an "almost white" roof, and the like, were exciting in their variety of visual effects. They were, however, not that noticeably different in appearance from photogenic drawings. It was the time required to make a picture that was so different. He was most delighted in the calotype's suitability for portraiture. The first one he names on the list he kept was "C's portrait, without sun, 5'—small—Oct. 6." The thrill of recording, translating, impressing someone's countenance on a sheet of paper, the exhilaration Talbot experienced can hardly be imagined. The best way to ascertain his feelings is to enjoy and study the hundreds of portraits he took. Most

"C. E. & R. 1'30" [1 minute 30 seconds] Oct. 13 [1840]."
The first calotype group portrait, Ela on left, Constance center, and Rosamond on right.

"Mme Amél. 3' [minutes] Oct. 13 [1840]." This photograph of Madame Amélina Petit, the governess of Talbot's sisters and his daughters, had a three minute exposure and is one of the earliest calotype portraits in existence.

of these were of his family, some of friends. None resemble formal portraits in a studio, normally associated with the Victorian style. He loved natural settings and many of the earliest portraits show an individual against dense foliage or groups paused on the lawn. Later he used plain settings and even hung a light-colored curtain as a backdrop. It is fascinating to follow Talbot's development as a photographer and the degree of confidence he soon attained. Whereas many of the earliest portraits were taken at a distance, as if to de-emphasize the face lest the sitter should move during the usual 30-second to five-minute exposure, later he took clear, expressive close-ups of his children and others and made bold, graceful compositions such as the one of his mother on a chaise longue (see p. 137).

An exception to the style of his first portraits is the earliest confirmed portrait on paper in existence. The photograph of Constance, dated October 10, 1840 (another picture at Lacock Abbey, very faint and undated, may have been the one taken on October 6), must be considered one of photography's masterpieces (see p. 132). Her eyes are lifted towards an inner, as well as an outer, world; light clothes her and forms her image. A shadow falls across her nose, highlights on her shoulder. Even the

creases caused by Talbot's haphazard folding of the print to fit into an envelope serves to frame her beauty. Constance sat for 30 seconds letting light pour over her and bounce off. She is tranquil, pausing to let nature work. One senses she, being Talbot's wife, considers herself to be participating in "a little bit of magic realised:—of natural magic." Her rapport is with nature, not the cold, glaring optical device. She is noble, she is sensual and her paper portrait taken soon after the calotype process was discovered defied anyone from that day on to deny that photography is an art capable of conveying the most subtle, the most stirring, emotions and sensitivities.

Another close-up, undated but very early, is absolutely bewitching (see p. 132). A hand (no body, no background) appears lilac in a violet void. Folds of flesh over knuckle on pinky; fourth and fifth fingers awkwardly touch—this is no classical hand. This is a hand of man. A strange hand. Probably Talbot's hand. A study of a hand, not as Rembrandt would draw it, poised and expressive of some action, but posing for the camera, upright and steady. For scrutiny. A self-portrait (perhaps) of the most curious kind.

To see how trees appear in winter and in spring; to make careful compositions and then discover how much more is in the picture than was originally considered; to work with geometric shapes; to explore perspective; to understand how different materials reflect and absorb light; to attempt characteristic and telling portraits; to study plants; to use the camera while traveling; to record objects seen in the microscope and the telescope—all these and more were of interest to Talbot, the photographer. Of importance, too, was the making of pictures fully resolved, consisting of traditional painterly subject matter, properly composed, and carefully illuminated—photographs that had the same sentiment and attitude as paintings.

In a letter written to Herschel on March 13, 1841, a time when only Talbot and those closest to him could use the calotype process (details were not revealed until June) his excitement (in addition to his perpetual restlessness) is conveyed:

... What a pleasant residence Collingwood [Herschel's home] appears to be; lakes and old oak trees are very much to my taste, and I am now looking out for a country house for the summer, because I find or fancy that the air of this neighbourhood [Lacock] is not very salubrious, at least for a long time together.

The House agents in London offer so many to one's notice in every part of England that it is quite l'embarras du choix & ends in deciding upon nothing.

I expect in less than a month to be able to publish the process of the Calotype tho' I don't yet know whether it can be sent to the R. Society. I enclose a few more specimens. I must now

really transport my apparatus to some locality where picturesque objects are to be met with, such as a cathedral, or a seaport Town, for my own neighbourhood is not particularly suited to the Artist, and offers no great variety of subjects. ... The portrait was done in the shade in 3 minutes. The footman opening the carriage door is also a good likeness, done in 3 minutes sunshine. The elm tree in 1 minute, camera 15 inches focal length, diamr. of object glass 1 inch.[11]

Talbot's uncertainty as to whether he could publish his calotype process in the Transactions of the Royal Society was due to his application for a patent. He explained this in his letter to Herschel, sent immediately prior to the one above:

I have taken a patent for the Calotype, but nevertheless intend that use of it shall be entirely free to the scientific world. I was going to send a paper to the Royal Society, explaining the process, but having been told that there are doubts whether the paper would be printed in the Transactions (on account of the patent) I have written to Christie [Secretary of the Royal Society] to request him to let me know from authority whether such is the case. If so, I shall not send the paper at all, but communicate it to some other scientific body, probably the French Institute. There appears to be no end to the prospect of scientific research which photography has opened up. ...[12]

"Footman at carriage door 3' [minutes] large—Oct. 14 [1840.]."
J. B. Biot, the French scientist, wrote to Talbot on June 14, 1841:
"Mr. Wheatstone has given me, on your behalf, some fine photogenic prints in which we [Académie des Sciences, Paris] have especially admired the striking character of the figure of your servant opening the door of your carriage."

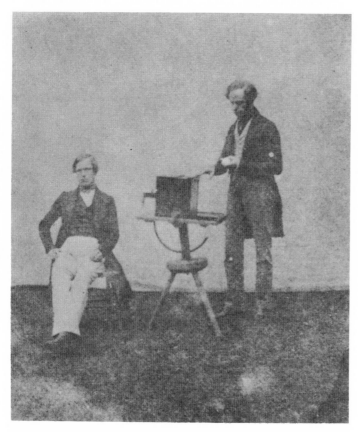

Henneman photographing Pullen, c. 1842.

Herschel's reply is as follows:

Many thanks for your very interesting & numerous specimens of the new Process—Of the Portraits, that done in the Shade in 3ᵐ in some lights & [viewed] at a proper distance has quite a real air—The leaning figure is also very good, Both are much superior in effect to the Daguerreotype portraits—of the Landscapes the view at Clinton—the snow scene & projecting window piece at Lacock Abbey strike me most, & are very superior to any you have before produced—You are quite right in patentizing the Calotype—With the liberal interpretation you propose in exercising the patent right, no one can complain—And I must say, I never heard of a more promising subject for a lucrative patent of which I heartily give you joy.—I see a Mr. Wollcott has taken out a patent for photographic portraits in 25 Seconds by a "reflecting apparatus"—He has opened rooms at the Polytechnic Inst., Regt St.—I do not know the nature of his process—Probably some travestie or piracy of Daguerreotype. . . .[13]

Talbot never charged amateurs (those making photographs for pleasure) more than two guineas (later reduced to one guinea or gratis) for a calotype license. This was a trifling sum for anyone who could afford the photographic apparatus and paraphernalia. He knew that the British government would not grant him a stipend to help defray the costs of his experiments or honor him in any way for his discovery as the French government had Daguerre. Experience had taught him that there was nothing to prevent other individuals from patenting parts of his invention and then charging *him* to use it. Because Talbot felt it could be the foundation of a new and profitable industry, he patented the process.

The series of events leading up to the announcement of the calotype process were very different from the announcement of photogenic drawing, but in some ways nearly as suspenseful. Owing to the fact that Talbot decided to patent the calotype, he could not disclose the details until the patent was accepted. Once more, however, an action by Daguerre forced Talbot's hand before he was ready. On January 4, 1841, Arago rose in the Académie des Sciences and made an incredible announcement: M. Daguerre had made photography instantaneous: he could capture movement. Arago said that Daguerre could photograph moving objects in one or two seconds. And again, the world was staggered and Talbot was shocked. (It must be noted that Daguerre's claim *could not* be proved and on July 5 Arago had to apologize to the Académie for conveying unfounded information.) Was Daguerre a second time going to take away his glory? Talbot quickly wrote two letters to Jean Baptiste Biot, his friend and a brilliant French scientist, giving him some idea of the calotype process without providing the details. Talbot asked Biot to present these letters to the Académie, but Biot was reluctant to present only a sketch of the technique and not the full details to his eminent sci-

Hotel Canterbury, Paris.

entific assembly. He wrote Talbot the following letter on January 24:

If he [Daguerre] publishes before you, the discovery belongs to him scientifically, since one must always attribute it to the first person who publishes, when any idea of communication and plagiarism is impossible. There would remain for you the knowledge that you had also discovered it and, in the eyes of men of science who know your personal character, you would also be considered as one inventor. But in the eyes of the public you could only hope to have the title of second inventor, since you published later. This is not unjust since the persons who have only imperfect processes or have not yet even arrived at this stage, can still announce it and reserve the right to publish it later.

This is why I beg you, in your own interest as well as that of science, not to forego, by your desire to perfect the details, the legitimate honour that must be given to you for such an important improvement on your first processes. You will still be able to add to it later, after you have assured for yourself the incontestable right of possession by publishing. You will gain nothing by waiting and will only find yourself faced by claims of simultaneous research.

If you agree with these reflections, may I receive from you a decisive reply before the 1st February. If it only contains the nature of your process, with some details similar to those in your last letter, you can be certain of incontestable priority.

You will not be surprised I hope to find me insisting on this point; I would say as much to M. Daguerre if I had the same relationship with him. As regards questions of nationality, I find them so petty when considered in conjunction with the progress of scientific discoveries, that I put them out of my mind.

I shall be extremely happy if I have managed to persuade you.[14]

The arguments with which Talbot answered Biot's letter are not known, but the elderly French scientist had only the two original, and to his mind inadequate, letters to present to the Académie on February 1. On February 9 Biot wrote to Talbot:

In accordance with your wishes, I communicated to the Academy all the scientific parts of your last two letters during the session held on Monday the first of February. . . .

I have not thought it necessary to try to understand those . . . reasons that you gave me for still holding up the publication of your process for some time. . . . An inventor can always keep secret his discovery for as long as he wishes without having to account for his reasons to anyone and without being obliged to fix in advance such or such a date for publication. . . .

The announcement of your results, however, determined someone, who believed he had something analogous, to publicize his claim. This took place during yesterday's session and I hasten to let you know about it.

The person concerned is M. Bayard, who is employed in finance and of whom I have occasionally spoken to you as a person who has been occupied for a long time with photogenic

Brighton, December 1845 or January 1846.

prints without, I believe, any precise or general knowledge of chemistry or physics. His pertinacity and determination has led him to make a large number of prints on sensitive paper by means of a camera obscura. Our artists have expressed great satisfaction with these prints.[15]

Biot then proceeded to tell Talbot that on February 8, a letter, in which Hippolyte Bayard disclosed *his* process, was read at the Académie. Bayard, an independent inventor, developed a process that produced direct positive photographs. The French had already, however, forced Talbot to take action. On February 5 he had written a letter to the editor of the *Literary Gazette*, the weekly that had taken such a keen interest in his earlier process. The publication of this letter was the first time the British public learned of the calotype process. In it Talbot stated that he had made a discovery the previous September which greatly increased the light sensitivity of paper. So great was the improvement that a picture could be obtained in one minute that had formerly taken an hour. He said that the shortest time he had succeeded in taking a picture was eight seconds, but it was not only the rapidity that was improved but also the sharpness and distinctness in the outlines of the objects. Talbot felt the need to state explicitly that just because the paper was more sensitive, it was not more difficult to fix the image. (It is interesting for us today to imagine the questions one would ask in 1841 concerning photography.) Talbot described to the public the uses he saw for his invention. It would be, he stated, invaluable to the traveler who wished to fill his

album with landscape or architectural views but who was either ignorant of drawing or "wearied with the multiplicity of [copying] its minute details." He continued by saying that his invention was suitable for the taking of portraits and that they would undoubtedly be one of the most important applications of the new process.

On February 19 Talbot wrote a second letter to the editor of the *Literary Gazette*. The specifications for his patent for "Obtaining pictures or representations of objects" were entered on February 8 and he proceeded to give further details about the calotype process. He said that during the previous September a curious accident occurred whereby a moist piece of his photographic paper, after having been exposed in the camera for a very short period of time, seemed to have "developed itself by a spontaneous action." Later Talbot used paper in a dry state in the camera and followed the exposure with "a chemical process analogous to the foregoing." He said of the "developing" of the negative that:

The operator ought to watch the progress of the picture, until, in its strength of colour, sharpness of outline, and general distinctness, it has reached in his judgment the most perfect state. At that moment he stops further progress by washing it over *with a fixing liquid. This is washed off with water, the picture is then dried, and the process is terminated.*

On June 10 Talbot presented a paper to the Royal Society describing the details of his discovery. Many people before this time had seen examples and commented favorably on them. Queen Victoria had been shown some calotypes by Caroline in November 1840 and she expressed her delight with them and her wish to place them in the album with the photogenic drawings Talbot had previously presented her. Biot wrote to Talbot after having received a portrait that:

. . . It was not only some of my colleagues who wished to see it; it was passed from hand to hand and everyone was astonished by the air of individuality one noticed in the figure and the very lifelike stance. . . .[16]

For the first part of the year 1841 only Talbot and those very close to him, such as Constance and Henneman, his valet, knew the details of the calotype and could use it. Talbot often requested one of them to print his negatives and each in different ways tried hard to please him. Correspondence from Constance to Henry shows the cautious beginnings of the first woman photographer:

Probably the earliest paper photograph of London, June 1841.

Henneman chopping wood dated March 16, 1841.

As soon as the weather cleared I made two copies of the little picture—the first fifteen minutes, the second thirty minutes but in neither case did the sun shine through without interruption. I then washed and dried them and afterwards proceeded to fix, which I did with much anxious care but with no sure feeling that I was doing right. I dipped my brush into the bottle itself. Was that right or ought I to have poured some out? After waiting a few minutes and watching with anxiety, I dried them at the fire but I am not sure whether I ought not to have washed them first. As soon as they became dry I put them into a basin of water, stirred them a little, took them out, dried and pressed them. I shall be impatient to hear how my clumsy performance succeeded for though the process is not a difficult one, it requires practice to do it well.[17]

And the second:

I have set up her Majesty in the window; but as the day is very dark I am doubtful in regard to the results—I intend to give her a couple of hours & if that fails try her again some other day.[18]

It is quite possible that even some of the earliest photographs are not by Talbot at all, but rather by Henneman or Constance. But it is wrong to assume that Talbot was not an active photographer up until 1846. There is adequate evidence to confirm much of his picture-making activity. Although he only rarely signed his negatives, often he did date them and make references to them on lists, in notebooks and letters. It is possible, therefore, to analyze *some* of his pictorial concerns in particular years.

In a picture Talbot made in March 1841, for example, of Henneman pretending to saw in front of the woodshed, Talbot's fascination is with light, geometry, and story-

telling. The photograph, bluish red, was taken as the sunlight fell diagonally across Henneman and the shed. The strong vertical parallel planks of the building radiate with the light and assume a graphic strength not achieved in Talbot's earlier works. A picture made of London in June is his earliest attempt at a panoramic view. The photograph, quite red, showing St. Paul's Cathedral in the distance and wharfs and low buildings in the foreground exhibits an elegant sense of pictorial space. On August 21, 1841, Talbot made two fine pictures. In one, a servant stands before the massive haystack made familiar in one of Talbot's later photographs, gripping a broom. Every object in the picture—the wheelbarrow wheel, the handle of the spade and the roofline of the barn and chimney— seem orchestrated to balance and form the image.

In the other photograph, Lady Elisabeth also grasps a handle, of an umbrella, and her pose and the absence of any background make her appear quite enigmatic. We see

"Pullen by the Haystack" dated August 21, 1841.

only how she presents herself to the world, the richness of her garb, the satin, the lace. The following year Talbot continued to eliminate the backgrounds from the photographs he made of his mother, but often included one strong pictorial element, an eccentric contoured chaise longue or a richly patterned upholstered chair. He learned to become adept at eliminating incidental materials from his compositions. The best of these are objects on tables and shelves, whether covered with crockery or supporting only two or three carefully placed articles. This was a motif begun during his earliest photogenic drawing experiments and it still proved exciting to him while editing his photographs for inclusion in *The Pencil of Nature*. On September 6, 1841, he photographed a teapot, sugar bowl and candlestick. Each member of the trio is allowed to catch the light and cast a shadow, creating a unity among the distinct objects. Talbot's aim in many of these studies was to examine the manner in which various surfaces—china, glass, silver, leather—impress themselves on photographic paper. The outcome was that in addition to satisfying his primary objective, his knowledge of pictorial space was always increasing.

During the summer of 1841, while happily fulfilling

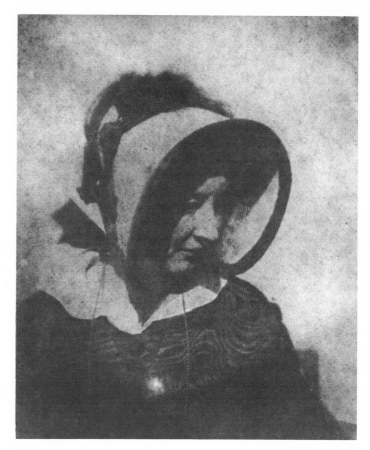

Caroline, c. 1841.

Lady Elisabeth Feilding dated August 21, 1841.

the roles of country squire and creative photographer, Talbot was distressed to learn that his paper on the calotype had not been published in the *Transactions* of the Royal Society. On July 1 he expressed his frustration in a long letter to Herschel:

On the 10th June I read my paper to the R. Socy describing my Calotype process, and shortly after I sent you some remarks on it with specimens of the substances employed. I hope you received them, and if you try the process and find any difficulties (as some of my friends have done) I shall be happy to add any further explanations. On my return to Town from a little rustication, I found that the Council had rejected the paper from the Transactions. On enquiring the cause, I was told that they understood the paper to have been printed elsewhere previously to its being read to the Society. A very erroneous supposition; and it is greatly to be lamented that [in] a body like the Royal Society such a system of secrecy, or mystery, should prevail, as not to give the author of a paper any intimation whatever of such an objection being made, nor ask him for an explanation. Dr. Roget whom I have found in Town (most of the others being dispersed for the summer) is of the opinion that the Council are in error & ought to reverse the decision, and that it would be well if I wrote them a circular

letter pointing out the mistake—A most irksome task—&
which I hesitate to undertake. . . . I am sorry that the body
whose office it is to encourage science in England, encourages
it in this way—such is the case.

All the photographs you sent me done with vegetable juices
were positive. Is this the case universally?

Yours very truly
H. F. Talbot

It is a nice point to determine which is the most sensitive to
light, my Calotype paper, or the Daguerreotype improved by
Claudet's process. I am sensitive to simple *moonlight; he has*
not yet made the trial, which I throw out as a challenge to all
photographers of the present day: viz. that I grow dark in
moonlight before they do.[19]

The mention of Antoine Claudet in the letter raises a point not previously mentioned. After August 1839 many individuals, including Claudet, worked steadily to devise a viable means of daguerreotype portraiture. The problem, of course, was the length of exposure time. The Americans John Johnson and Alexander Wolcott had the greatest success. Having only Daguerre's instructions, they made a profile, ⅜-inch square, on October 6, 1839.[20]

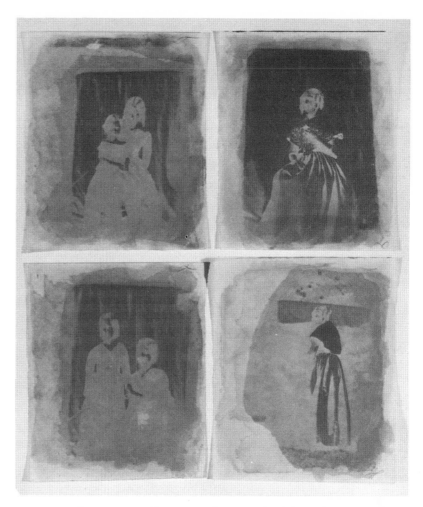

Negatives illustrating Talbot's use of curtain backdrops for portraiture and some of the poses he asked his family to assume.

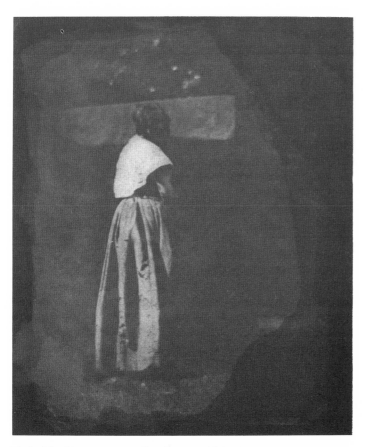

Probably Constance or Caroline, c. 1841–2.

They succeeded in finding a satisfactory technique for photographic portraiture by devising a camera that relied on a concave mirror to reflect the image onto the daguerreotype plate. They opened a daguerreotype studio in New York in March 1840. The camera was patented in the United States in May. Richard Beard, an English coal merchant, bought the rights to the Johnson/Wolcott camera and opened the first portrait studio in London at the Polytechnic Institute in March 1841. Daguerre sold a license to Claudet, a Frenchman living in London, and he set up the second daguerreotype studio in London. He increased the sensitivity of Daguerre's original process by using a combination of chlorine and iodine vapor and in this way arrived at exposures short enough for portraiture.

Observing that the daguerreotype was indeed becoming a commercial enterprise, Talbot acknowledged that he

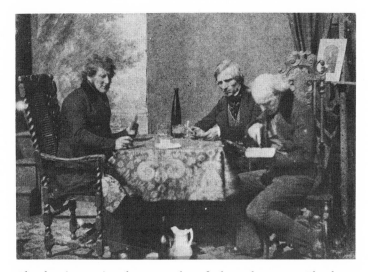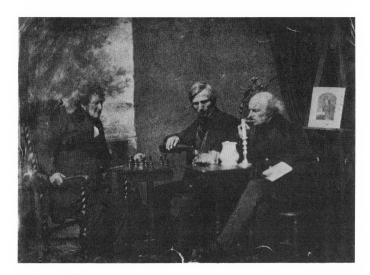

Claudet, (*center*) and two unidentified gentlemen in Claudet's studio, c. 1845. Talbot sometimes
photographed in Claudet's studio. In April 1845 he wrote to his mother: "Today I made a
picture of a boy with a cage and a grey parrot at Claudet's. It will make a very pretty *Tableau Flamand.*"
These two photographs cannot be definitely attributed to Talbot, but it is likely that they are by him.

too must commercialize his invention. In August 1841 he sold his first license to Henry Collen, a miniature painter, to practice the calotype professionally in London. From concentrating on "the ultimate nature" of the photograph and the utilization of an "infinitesimal part" of the "Solar flood of light" Talbot gradually became concerned in 1841 with the potential for capitalizing on his invention. Of all the relationships he had developed with the medium, commercialization was the one at which he was by far the most inept.

The daguerreotype portraits made at Beard's and Claudet's studios and the calotype portraits done by Collen all cost approximately one guinea, but *copies* of calotype portraits were much less expensive (about five shillings each). The public wanted the perfection of the polished copper plates presented in their handsome leather cases. Coarse paper prints, no matter how glorious the *chiaroscuro*, were not what the market demanded. Talbot received 30 per cent of Collen's income from calotype portraits, later reduced to 25 per cent (on par with the daguerreotype license conditions). There were no profits for Collen or Talbot, whereas Beard and Claudet were doing extremely well. By March 1842 Collen was £21.10 in debt to Talbot, having been paid for only 59 portraits and 38 copies. Collen was not a very good portrait photographer and even tried painting over his positives to enhance them. Lady Elisabeth commented in numerous letters that she considered Collen to be ineffectual in promoting photography on paper. By the end of 1842 Henry Collen was considering leaving the business (although he did not do so until more than a year later), and

Talbot was forced to consider who should be the next person to practice it professionally in London.

Talbot was not blind to the fact that he himself could do much to focus attention on the utilitarian and esthetic characteristics of his own process. Most of his efforts to introduce the calotype into other countries, however, were done inefficiently and on much too small a scale. Caroline and Horatia, for example, took calotypes with them on their trip to Italy from December 1841 to May 1842 and provided instructions on how to make them to certain Italian scientists. Talbot himself brought the process to Germany in 1842 while visiting his uncle William Fox-Strangways, the 4th Earl of Ilchester, a respected diplomat. Sir David Brewster, one of Talbot's closest friends, introduced the calotype into Scotland in 1841, but in 1843 wrote, "You will scarcely believe how little the art is known in Scotland."[21] He added in his letter that a Mr. [Robert] Adamson had decided to take up calotype photography as a profession. No license was necessary as Talbot did not, on Brewster's advice, patent the calotype in Scotland.

It was in 1843 that David Octavius Hill, the painter, and Robert Adamson began a collaboration which would secure for themselves a place not only in the history of photography but also in the history of art. Their pictures are considered to be among the most outstanding examples of the art of photography; Alfred Stieglitz reproduced their pictures in his enlightened publication *Camera Work*. Hill was a trained artist who was convinced that the calotype could be used for creative expression.

Talbot also knew intuitively that his process in the

hands of artists could result in masterful images. He felt, however, that he himself might not be able to achieve the standard he sought. In March 1843 he made a picture titled "The Open Door" that, however, reversed his thinking and from that time on was certain that he could give form to his creative instincts—that he, too, could be an artist despite his miserable failure at the drawing board. The caption to this photograph which is Plate VI in *The Pencil of Nature* states:

A painter's eye will often be arrested where ordinary people see nothing remarkable. A casual gleam of sunshine, or a shadow thrown across his path, a time-withered oak, or a moss-covered stone may awaken a train of thoughts and feelings, and picturesque imaginings.

Talbot realized that the camera could help all people capture the "gleam of sunshine" or "time-withered oak" and

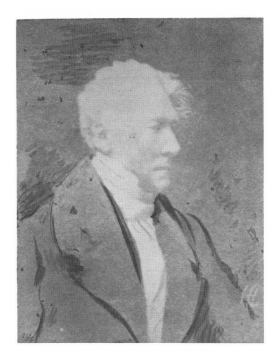

Heavily retouched calotype portrait of the Earl of Beverley, by Henry Collen c. 1842. Collen's initials appear at the bottom right. According to Sir David Brewster, some of Collen's portraits were skillfully done. He wrote to Talbot on March 22, 1842: "Mr. Collen has been so kind as to send me one of his calotypes which astonished me and all who have seen it. Dr. Adamson to whom I have just shown it despairs of ever coming near it." Dr. Adamson was the brother of Robert Adamson, the Scottish calotypist, who collaborated in the 1840s with the painter David Octavius Hill.

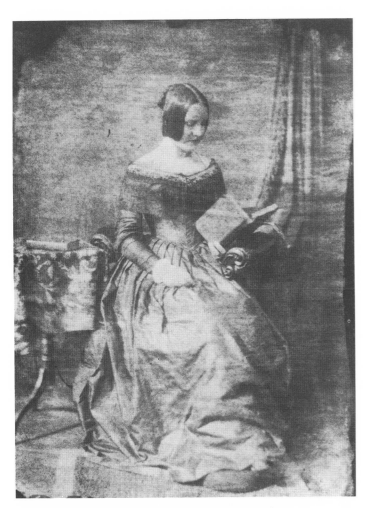

Varnished portrait of a young woman reading, by Antoine Claudet, taken in his London studio, c. 1845.

in so doing allow the artist locked within them to become manifest. Photography opened up the *possibility* for those who could not draw, write, compose or sculpt to focus and convey their "picturesque imaginings." "The Open Door" was a symbolic title for all "non-draftsmen" to make images of eloquence and power.

Something else of consequence also occurred in March 1843. Talbot decided to publish a series of calotypes of cathedrals. He had been thinking of a topic since 1842 but could not decide what might be suitable for a first publication. During that year he photographed mostly his family and knew that pictures of Ela, Rosamond and Matilda, no matter how charming, would not do. He decided to go to France for a photographic tour of cathedral towns and for another purpose, too.

Talbot had taken out a patent in France for the calotype on August 20, 1841. He was quite right in assuming that the soft, almost impressionistic quality of the paper negative would have great appeal to French artists. There was, however, quite a long delay before the French started to use it, perhaps out of loyalty to Daguerre or simply for lack of information. Once they did, however, in the late 1840s and 1850s, they became the masters of the medium. Mlle. Amélina Petit, a Frenchwoman who had a close relationship to Talbot, having lived in his household first as the governess to his half-sisters Caroline and Horatia, and then, as governess to his own daughters, kept him informed about photographic matters in France. In lengthy letters she complained of the lack of knowl-

"The Open Door" March 1, 1843.

edge in her country concerning his invention and made suggestions to him on how to encourage the wider use of paper photographs, on passports, for example. She introduced Talbot to the Marquis of Bassano (J. H. Maret), a wealthy gentleman anxious to learn and exploit paper negatives in France. By March 1843 a provisional agreement was made between the two and Talbot promised to come to Paris shortly to teach the Marquis photography.

On May 12 Talbot and Henneman arrived in Calais, and then passed quickly through Paris to Rouen. This was to be the starting point for the cathedral project. He wrote to his mother soon after arriving:

The first view of Rouen is very fine, from the top of a hill . . . not more than a mile from the city. . . . A new suspension bridge crosses the river before my windows. . . . Weather grown extremely stormy and rainy—nothing to be done in Calotype until it clears up—I think of stopping 2 or 3 days here—This Hotel is pretty comfortable, but the charges are such as only princes can pay.[22]

Talbot's Rouen series is soft and dreamlike. He was excited by many scenes besides the cathedral. Through (most probably) his own hotel window, Talbot allowed the dark window frame to divide his picture frame and enhance the white light through the ethereal curtains. In the distance, a masthead occupies one part of the grid that Talbot's tight composition has created. The masthead appears in a second photograph of Rouen, of the harbor with the fine sailing ships and new suspension bridge in view. The ships and foreground trees are out of

focus and serve to draw the viewer to a close examination of the well described bridge (see p.148). Another picture of the bridge is a vignette created by the uneven coating of the paper. The bridge becomes a vortex that appears to be pulling the emulsion from the edges of the paper. All three are delicate and imaginative images.

Actually Talbot's pursuit of cathedrals was usually thwarted by bad weather and uncooperative officials and the publication never materialized. The reason the pictures discussed above were taken but none were made of Rouen Cathedral is explained in a letter to Constance:

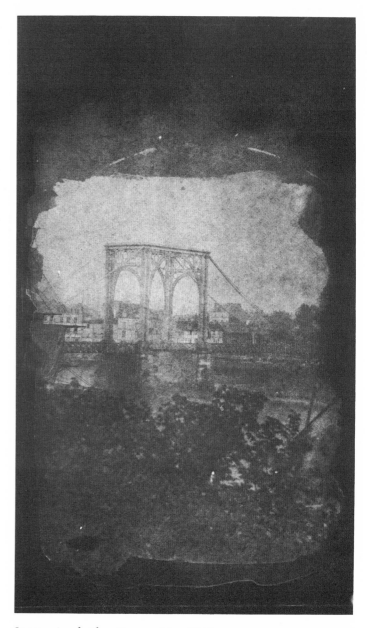

Suspension bridge, Rouen, May 1843.

I asked permission to draw the Cathedral but was entirely refused. . . . I suppose that it is a monopoly belonging to somebody, & I was interfering with vested rights![23]

Talbot returned to Paris, accompanied by Henneman. There he continued to photograph with a fervid eye. From his hotel window, Talbot studied how light transforms the world, moment by moment. He watched the sun slowly move across the sky and saw how gradually one building after another on the street fell into shadow. He saw on one of these buildings already in shadow that "a single shutter standing open projects far enough forward to catch a gleam of sunshine" and that "they have been watering the road, which has produced two broad bands of shade upon it, which unite in the foreground."[24] The photograph had been composed; it was the waiting for the light—the supreme photographic ritual—that makes many of his Paris photographs as marvelous as they are.

On June 7 he wrote to Constance:

I have begun to teach the calotype to the Marquis of Bassano and his friends. Today we took four views of the Tuileries. The weather was indifferent. . . . The Marquis and his friends have taken for a month an isolated and lofty house that stands in the Place du Carousel fronting the Tuileries. This house will soon be pulled down by the government, as it disfigures the place. In the meantime, it has become our workshop. . . . Tell the children I found all their kisses upon my letter when I opened it this morning.[25]

The Marquis had high hopes but little ready cash for the promotion of the business. Mlle. Amélina kept him informed of the Marquis' progress. By December she re-

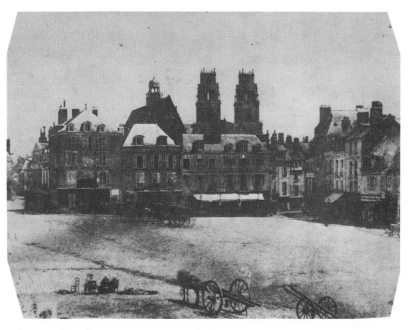

Orleans, taken between June 14 and June 17, 1843.

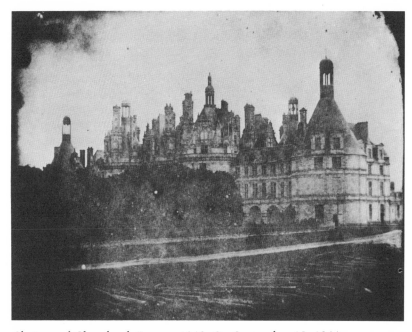

Chateau of Chambord, France, 1843. On September 15, 1844 Talbot's mother wrote from Mount Edgcumbe: "Lord Mount Edgcumbe was much struck with your having told him that the view of Chambord was bad because it was such a rainy day, as if you could not have remained there till the weather was clear, particularly with such an interesting object before you. He thinks if you had more perseverance your success would be more complete and that if he were you he would persevere to *pertinacity*. There is no doubt if you were an artist instead of an amateur your art would soon be at the summit of perfection."

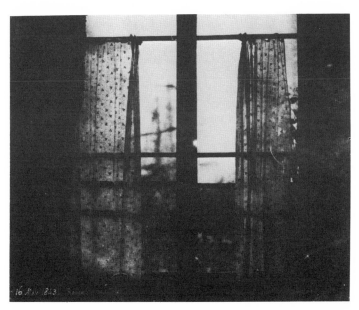

Looking toward the harbor, Rouen, dated May 16, 1843.

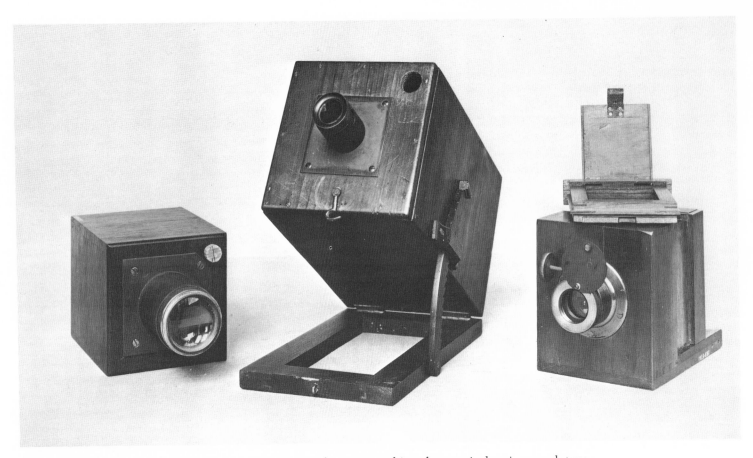

Three of Talbot's cameras. (*Left*) One of Talbot's very early cameras taking photogenic drawing or calotype negatives 4¾₆ in. square. The lens slides in a sleeve for focusing and there is a hole above and to one side of the lens which was used for viewing the paper during focusing. The aperture of the single uncorrected lens is about f/3. (*Center*) A camera in the form of a wooden box, 9½ × 7¾ × 8 in., blackened on the inside. The camera can be tilted on a rack and held in position by a ratchet. The lens (focal length about 12 in.) moves in a sleeve for focusing. A focusing hole above the lens is closed by a cork. The paper size is 7¼ in. square. (*Right*) A french mahogany camera of the sliding-box type fitted with a Chevalier lens (focal length 7½ in.; f/6) inscribed *Photographe à verres combinés.* The lens is focused by rack and pinion. The camera takes photographs on paper 2½ x 3 in. The image is focused by means of a glass focusing screen. The paper is held in a dark slide. The Fox Talbot Collection at the Science Museum, London, has sixteen cameras of different types used by Talbot.

gretted to report that no work was taking place at the Marquis' Carousel workshop and a few months later stated "It is equivalent to total abandonment . . . fiasco after fiasco.[26]

The week after teaching the Marquis of Bassano, Talbot had again immersed himself in picture making. He used two wooden sliding box cameras with ground-glass focusing screens. One took photographs about 3 by 3½ inches and the other "whole plate" (6½ by 8½ inches) negatives. He traveled to Orleans where he succeeded in taking a fine detail of the cathedral, beautifully composed. In a letter to Horatia dated June 14, Talbot informed her of his activities.

However today was a grand exception to the usual rule ["weeping skies"] *and I made a good many pictures, . . . I lost no time in looking for views and rambling about the streets unknown to me.*[27]

In a second photograph of the cathedral Talbot positioned himself across the town square and depicted it integrated among the buildings, but rising above the other rooftops. The square's many blurs were the camera's rendering of people, animals and vehicles in motion. Ghostlike are three peasants and a horse who remained still during the long exposure. It is a strange photograph in that the viewer is faced with four chairs and three people, two high-wheeled carts and one horse. One figure is seen both

Earliest example of phototypesetting.
Talbot patented this process in 1843.

of the technique. Simply titled "Photography," the patent was entered on June 1, 1843. Briefly, it covers the following points:

1. Making the negative more transparent by immersing it in near-boiling hyposulphite of soda and by waxing.
2. A method of keeping the sensitive paper warm during exposure in the camera.
3. A new method of preparing the paper whereby the silver nitrate and gallic acid are *not* used in conjunction, but rather applied in separate operations, producing a paper Talbot called io-gallic and having a longer shelf life than regular calotype paper.
4. A specially prepared paper that can be used for making positives (Talbot generally used regularly prepared photogenic drawing paper) and has good keeping qualities.
5. A method of controlling the intensity of the highlights and shadows of the positive print through various combinations of washes, fixes and exposure to light.
6. A method of giving more softness and "pleasing artistical effect" to his negatives (which in many cases were not printed but left as pictures in and of themselves) by placing a sheet of white or colored paper behind the waxed negative.
7. The enlarging of daguerreotype or calotype portraits or other small photographs by means of lenses to throw a magnified image on a sheet of calotype paper.
8. The application of photography to printing by arranging movable letters to form pages and then copying them with the camera. (This heralds the present day phototypesetting technique).
9. The production of uniform, stable and attractive photographs that can be used in "photographic publications."

The final point discussed in Talbot's 1843 patent is perhaps the most crucial. Producing books with photographs and the marketing of individual prints would begin an important new era in both publishing and photography.

leaning over and sitting upright during the several minutes needed to make the picture—a peculiarly photographic vision. There is neither the feeling that the camera has stopped motion nor that it is depicting reality. The viewer feels that by squinting his eyes or pronouncing magic words many more photographic ghosts could be made to appear on the surface of the print.

Talbot continued to enjoy photographing after his return from the Continent. In September he photographed in Oxford with calotype, having previously made pictures in the city with the photogenic drawing process. When the weather was favorable, Talbot rarely had difficulty in choosing subjects. In a letter to his mother dated September 6, he appears to be most prolific:

The weather has been exceedingly fine both Monday, Tuesday & today, and I have made about twenty views each day, some of which are very pretty—but the number of picturesque points of view seems almost inexhaustible. . . .[28]

The following month Talbot signed the specifications for his second photographic patent. All the recent photographic activity did not detract, but rather encouraged, him to continue experimentation and the improvement

5.

The Pencil of Nature

In the year 1843, photography for most people was the daguerreotype portrait. David Octavius Hill and Robert Adamson had just begun their celebrated collaboration. Notable French calotypists such as Gustave LeGray, Edouard Baldus, Henri LeSecq, Charles Nègre and Charles Marville did not start producing significant work until the early 1850s. Even Maxime DuCamp's journey to the Middle East with Gustave Flaubert to photograph the ancient monuments, considered to be part of the dawning of photography, took place between 1849 and 1851. Roger Fenton's faded salted paper prints of Russia, so much themselves like relics of a long lost past, date from 1852. In America, the calotype process was not introduced until 1849 and appeared strange and crude to a people so devoted to the delicate lines and tones of the daguerreotype.

The daguerreotype had, between 1839 and 1843, gone through many developments, each one an attempt to further vary and enhance the already enchanting daguerreotype image. The Americans excelled all others in the production of outstanding daguerreotypes. They believed that each new invention should be patented and devised methods and machines for one-second exposures, polishing, electrotyping and engraving the metal plates, chemically induced backgrounds, hand and stencil coloring of the images and copying the daguerreotypes. People were pleased with the daguerreotype; like the steam engine and the railroad, it seemed to reflect the glory of living in a technological age.

Talbot knew that the calotype could not compete with the daguerreotype in the field of portraiture. The da-

guerreotype in its leather case, with its velvet and gold trimmings, was a precious object worthy and capable of preserving one's countenance from generation to generation. Salted paper prints (technically Talbot used the word "calotype" only when referring to the negative, but the term is commonly used today to denote both positives and negatives, however, "salted paper print" is a more precise phrase to refer to the positive pictures) could compete with, and excel, the daguerreotype in most other areas. To communicate this fact, however, Talbot needed a vehicle. Having given up the idea of publishing just studies of cathedrals, he decided instead that a book, issued in parts, with an illuminating *text* and a variety of actual *photographs*, would be the most persuasive and forthright method.

The Pencil of Nature, Talbot's declaration of paper photography as a vital new medium, is an inspiring and sagacious work. In the history of photography and of publishing it is a seminal achievement. Even today, Talbot's words and pictures give anyone interested in modern visual communications much to reflect on. For Talbot was a genius and his ideas show a profound understanding of the power of mechanically produced images. *The Pencil of Nature* was meant as a stimulus for exploring the world photographically and encouraged readers to think creatively about the uses of the medium. Just as Talbot had been committed to laying a satisfactory technical foundation for photography, so now he felt he must lay a theoretical foundation for the function, too.

When Talbot conceived the idea of publishing views of

Title page of *The Pencil of Nature*, published 1844.

paper we could supply, and then going direct to a well known Chemist for various chemicals not in general use, soon aroused suspicion as to his vocation; he lived alone with an old house-keeper in a tolerably good house which had been a School, where there was a large room without windows, but a skylight in the play ground; this he used for his experiments, and always kept securely locked; prying neighbours and others [his house-keeper thought he was a most mysterious person, his hands being stained all shades from brown to black; he never appeared in public unless well gloved] who made inquiries about him soon came to the conclusion that he was engaged in forging Foreign Bank Notes or some such nefarious pursuit. My fellow apprentice, Harrison, & myself were often questioned [at Lovejoy's] as to what we knew about him, but for a long time he kept his own counsel and we were all in the dark. Of course there was no special make of paper suitable for the purpose in those days and he was trying all kinds of chemicals upon such as we could procure for him; at last Fourdriniers introduced the now well known Cream woven papers, which I believe were then as now largely made by Hollingsworths at Maidstone; these seemed to answer well, & to our great delight my friend Harrison, myself, and the Chemists assistant, Tom Malone, were invited to spend an evening with him, when he showed us all the nature of his occupation and explained what he was engaged in endeavouring to accomplish.[1]

The Reading Establishment started operations during the winter of 1843–1844. The first objective was the printing of the plates for part one of *The Pencil of Nature*, but there were many other purposes that the Establishment would fulfill. Reading was to be a center where many activities would simultaneously take place. Nega-

cathedrals, he must have simultaneously thought of establishing a printing works. The mass production of prints from negatives was a natural extension of the calotype process and perhaps its most important advantage over the daguerreotype. Soon after Talbot's excursions to France and Oxford, he began looking for a location and chose Reading, halfway between Lacock and London and on the newly established Great Western Railroad line. At the end of 1843 Henneman was sent to convert a former private school at Russell Terrace into a photographic studio and printing plant. John Henderson, a young man living in Reading at the time and later to assist Henneman on some of his projects, wrote an account of Henneman's arrival in Reading:

A rather amusing incident occurred soon after his settling down here; Reading was a comparatively small Town at that time, and any new resident was sure to cause some attention, especially if a Foreigner; his constant visits to our shop [Lovejoy's Library], where he purchased every kind of writing

Printing negatives at the Reading Establishment.

tives by Talbot and others were to be printed and the pictures distributed for sale in bookstores, print shops and stationers. Individuals could bring sculptures or paintings, maps or engravings, valuable documents or themselves to be photographed and then supplied with any number of positives. Those interested in learning the craft could sign up for group or individual lessons and the price of the instruction included the necessary license to practice the calotype as an amateur. Photographs were to be made to aid the artist and these were called "studies from nature." Nobleman and gentleman could commission Nicolaas Henneman to come to their country estates to photograph the grounds and buildings. Publishers could request particular photographs made to serve as frontispieces or plates within their books. (The first publication to include a photograph was the *Record of the Death Bed of C.M.W.*, 1844, a privately published booklet that contains a calotype of a statue of the deceased as a frontispiece. Henderson wrote: "Henneman & I were sent over to Bearwood [the home of John Walter, proprietor of *The Times* and father of the deceased] to take copies of a beautiful Marble bust of Miss Catherine Walter, whose recent death had caused great grief to all who knew the Family."[2]) Lawyers would find the copying services invaluable and collectors and art dealers could have their treasures recorded for security purposes.

The milliner's window.

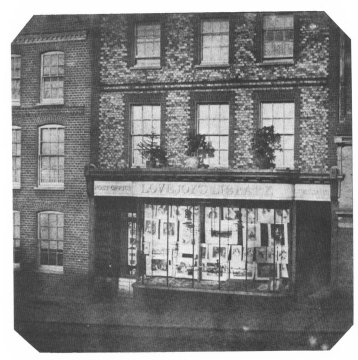

Lovejoy's Library, Reading where photographs from the Reading Establishment were sold, and paper supplies purchased. Photograph possibly by Nicolaas Henneman, c. 1845.

Cover of *Punch*, December 27, 1845.

80

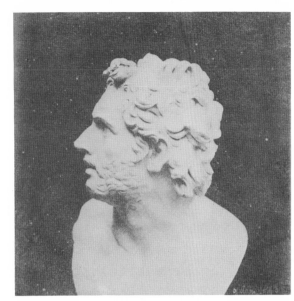

"Bust of Patroclus"
Plate 5 in *The Pencil of Nature*
(far left).

"Bust of Patroclus"
Plate 17 in *The Pencil of Nature*,
dated August 9, 1840 *(left).*

Until 1843 Talbot was vacillating between various methods of fixing prints. In that year he finally decided that Herschel's method using sodium hyposulphite (today called sodium thiosulphite) would produce prints with the most stability and uniformity. The reason he had not wholeheartedly adopted this method previously was that its use with photogenic drawings, made by long exposure, sometimes removed too much of the silver and in Talbot's words was "apt to destroy the more delicate shadows." Stability and uniformity were of vital importance if Talbot was to be successful in his sale of photographs and photographic books. The warm sepia color of hypo fixed salted paper prints is far more common than the assorted pastels representative of the work prior to 1843. Most "Talbot" prints circulated today were mass produced, either at the Reading Establishment or at Henneman's London and Kensal Green premises and many, as will later be seen, were not by him at all.

While Henneman was ordering the supplies and equipment to outfit the Reading Establishment and train his assistants, Talbot was sorting through his negatives and positives for the pictures he wanted for *The Pencil of Nature*. He chose those that were visually far more easily resolved than his earliest images. He wanted his audience to feel comfortable with the composition so that their attention would be drawn to the superb detail that the photographic medium was capable of executing. The photographs of Patroclus, for example, reproduced in *The Pencil of Nature* are close-up details without any backgrounds, showing the surfaces and contours of the bust clearly. Earlier studies of this statue include geometric shapes caused by extraneous lighting that suggest dark

hallways and secret places. This kind of ambiguous image Talbot tried to eliminate from the first book published with photographs. Each was an attempt to address a specific topic, but sometimes Talbot's enthusiasm either for a particular image or his urge to relate an old family legend resulted in text and photograph having little relationship. And because every detail within Talbot's photographs could not possibly be within the control of the photographer—and many times Talbot pointed this out in the text as part of the marvel of photography—the photographs in *The Pencil of Nature*, with their shadows, clocks, reflections, and open doors, had much mystery for "the Gentle Reader," to whom the work was dedicated.

The text is written in a conversational style. There is no grandiloquence, even when Talbot is making enlightened observation. For example, he foresaw photography by invisible radiation, an extremely advanced concept for his time, but his words have an air of innocent questioning:

Now, I would propose to separate these invisible rays from the rest [of the spectrum], by suffering them to pass into an adjoining apartment through an aperture in a wall or screen partition. This apartment would thus become filled (we must not call it illuminated) with invisible rays, which might be scattered in all directions by a convex lens placed behind the aperture. If there were a number of persons in the room, no one would see the other: and yet nevertheless if a camera were so placed as to point in the direction in which any one were standing, it would take his portrait, and reveal his actions.

For, to use a metaphor we have already employed, the eye of the camera would see plainly where the human eye would find nothing but darkness.

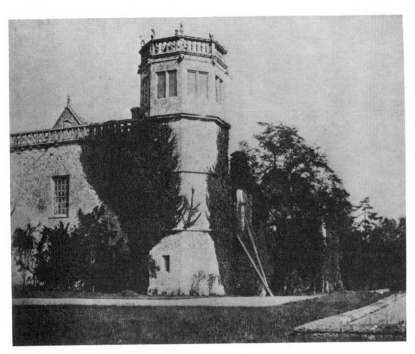

"The tower of Lacock Abbey" Plate 19 in *The Pencil of Nature.*
Two versions of this photograph appear in various copies of
the book, one with 1 ladder and the other with 2 ladders.
It is possible that the negative was damaged during the
many printings and the scene had to be re-photographed,
the new negative being used for the remaining copies.

*Alas! that this speculation is somewhat too refined to be
introduced with effect into a modern novel or romance; for
what a* dénouement *we should have, if we could suppose the
secrets of the darkened chamber to be revealed by the testi-
mony of the imprinted paper.*

The "Introductory Remarks" explain something of the
nature of the plates included and Talbot's hopes for the
future of photography. The "Brief Historical Sketch of the
Invention of the Art" is an exceptionally useful document
for the photographic historian, for it outlines the steps
leading to his discovery in a most lively and absorbing
manner. He tells it as a story—of successes, interruptions,
expectations, and disappointment (that Daguerre an-
nounced his discovery first). It is unfortunate that he did
not continue the story in a subsequent number of the
work, as he promised he would do.

There are 24 photographs in *The Pencil of Nature,* all
of which were probably originally taken by Talbot, except
for Westminster Abbey, Plate 22 which was taken by
Henneman. Sometimes a negative would tear or become
unusable after many printings. Then Henneman would
go back to the scene and rephotograph it as closely as

possible. If the scene could not be rephotographed, a copy
negative from a positive would be made. Plate XIX, "The
Tower of Lacock," for example, sometimes shows one
ladder resting against the Abbey and sometimes two. The
printing of the plates went quickly as Henneman had
three assistants. By June 1844 the publishers were able to
send out the following notice:

On the third of June will be published No. I. of
The Pencil of Nature. By H. Fox Talbot, Esq., F.R.S., &c.
&c.

Copy of one page of the handwritten
manuscript of *The Pencil of Nature.*

This is the first work ever published with photographic plates, that is to say, plates or pictures executed by Light alone, and not requiring for their formation any knowledge of drawing in the Operator.

They are obtained by merely holding a sheet of prepared paper for a few minutes (or sometimes only for a few seconds) before the object whose picture is wished for; using a lens or glass to throw the light upon the paper. A full account of this new Art has been laid before the Royal Society and the Academy of Sciences at Paris.

It has been often said, and has passed into a proverb, that there is no Royal Road to Learning of any kind. However true this may be in other matters, the present work unquestionably demonstrates the existence of a royal road to drawing, *presenting little or no difficulty. Ere long it will be in all probability frequented by numbers who, without ever having made a pencil-sketch in their lives, will find themselves enabled to enter the field of competition with Artists of reputation, and perhaps not unfrequently to excel them in the truth and fidelity of their delineations, and even in their pictorial effect; since the photographic process when well executed gives effects of light and shade which have been compared to Rembrandt himself.*

Each Number will contain Five Photographic Plates, together with Descriptive Letterpress, price 12s. To be completed in Ten or Twelve Numbers, royal quarto. The present Number includes some account of the Author's first discovery of the art. *London: Longman, Brown, Green, and Longmans.*[3]

The Pencil of Nature was published in six parts between June 1844 and April 1845. Two hundred copies of Number 1 were ready by June, and a further 85 completed by the end of the year. Sales for Part 1 were apparently good, 90 having been sold by July. One hundred and fifty copies of Part 2 were ready by its publishing date of January 1845 and it is probable that 150 copies were produced of each of the final parts.[4] Even though the numbers produced were not great, *The Pencil of Nature* moved Beaumont Newhall, the leading American photographic historian to state, "Its importance in the history of photography is comparable to that of the Gutenberg Bible in printing."[5]

The first plate in the book is "Part of Queen's College, Oxford." Talbot had a very special affection for Oxford and pictures of the town appear more often than any other subject. He discussed his feelings in the caption accompanying Plate XVIII.

Those who have visited Oxford and Cambridge in vacation time in the summer must have been struck with the silence and tranquility which pervade those venerable abodes of learning. Those ancient courts and quadrangles and cloisters look so beautiful so tranquil and so solemn at the close of summer's evening, that the spectator almost thinks he gazes upon a city of former ages, deserted, but not in ruins: abandoned by man, but spared by Time. No other cities in Great Britain awake feelings at all similar. In other towns you hear at all times the busy hum of passing crowds, intent on traffic or on pleasure— but Oxford in the summer season seems the dwelling of the Genius of Repose.

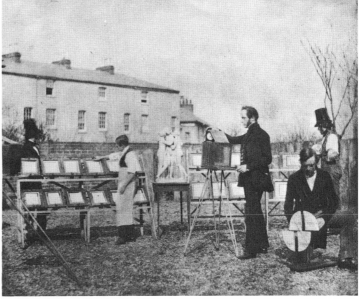

Panorama showing activities of the Reading Establishment—copying paintings, portraiture, printing negatives and photographing sculpture. The photograph on the left, taken by Henneman, shows Talbot on the right removing a lens cap. The photograph on the right, taken by Talbot, shows Henneman holding a timer.

"Articles of Glass" Plate 4 in *The Pencil of Nature.*

Perhaps Talbot thought his paper sensitive enough to capture the "Genius of Repose" or at least an equivalent of it. Or, he could have merely wanted to make a document of a famous location that many people had heard of and only a few had seen. In fact, Talbot remembered Constance's great excitement the first time he brought home photogenic drawings in July 1840 of Oxford, a place she had never visited. Finally, however, he may have reasoned that he would like the first plate in the book to incorporate two of his great loves—antiquity, as embodied in the Saxon Church of St. Peter, and learning, as symbolized by Oxford itself.

The text accompanying Plate I begins: "This building presents on its surface the most evident marks of the injuries of time and weather, in the abraded state of the stone...." The picture specifically draws the reader's attention to photography's ability to depict the texture of a surface, as crucial to the rendering of the subject as is a faithful representation of the forms and spatial relationships. Talbot realized, and William M. Ivins, Jr. noted in *Prints and Visual Communications* (1953), that this was an area in which the camera greatly excelled artists' sketches.

Plate XIII is another view of Queen's College and Talbot is surprised that so much information could be obtained by close inspection *after* the photograph was taken:

In examining photographic pictures of a certain degree of perfection, the use of a large lens is recommended.... This

magnifies the objects two or three times, and often discloses a multitude of minute details, which were previously unobserved and unsuspected. It frequently happens moreover—and this is one of the charms of photography—that the operator himself discovers on examination, perhaps long afterwards, that he has depicted many things he had no notion of at the time. Sometimes inscriptions and dates are found upon the buildings, or printed placards most irrelevant, are discovered upon their walls: sometimes a distant dial-plate is seen, and upon it—unconsciously recorded—the hour of the day at which the view was taken.

Obviously, in a painting, every detail has been scrupulously selected and incorporated by the artist, while photography, by its very nature, is without bias. Talbot wrote of the camera: "the instrument chronicles whatever it sees, and certainly would delineate a chimney-pot or a chimney-sweeper with the same impartiality as it would the Apollo of Belvedere."[6]

Talbot's reference to "the hour of the day" is significant. The clock makes the viewer aware that photography does and does not depict actuality. Auguste Rodin, the sculptor, said that it is the artist who is truthful, while the photograph is mendacious; for, in reality, time never stops cold. Talbot realized the photograph was an illusion, but one with a very special relationship to the physical world. Another pregnant reference is that things "most irrelevant, are discovered." The photographer, by focusing on the commonplace, either consciously or unconsciously, changes the entire meaning of what was, or was not, pictorially and historically significant.

Plates III, IV and VIII show articles on shelves. If these were just to illustrate photography's recording ability,

"Articles of China" Plate 3 in *The Pencil of Nature.*

then why three examples? The reason is that Talbot wanted to demonstrate how the paper negative captures the nuances of different materials, in this case china, crystal and leather-bound books. (For photography students trained under Moholy-Nagy's New Bauhaus methods, this would seem like a first year assignment, as would the making of photograms.) He wrote: "The photogenic images of glass articles impress the sensitive paper with a very peculiar touch, which is quite different from that of the China. . . ."As with his photograms, Talbot carefully constructed these pictures and they display a deep sensitivity to line and form. Light acts on each material in a dissimilar way, but Talbot's hand is apparent in the formation of each picture. He has isolated his subjects so that he could control light and shade, form and content, and the dynamics within the full frame.

To Talbot, the copying of works of art and the subsequent distribution of these reproductions to disseminate knowledge concerning art, was one of the most important functions of his invention. In the panorama of the Reading Establishment showing Talbot in the center removing a lens cap and Henneman on the right timing an exposure, three things are being photographed. One is a painting, another a sculpture, and the third, a man. This is one example of Talbot's steadfast belief in photography's ability to form an alliance with the so-called "high" arts. Many of his earliest photogenic drawings and calotypes were of sculpture and copies of engravings and certainly his project to photograph cathedrals was a way of honoring fine Gothic and Romanesque architecture. Four of the plates in *The Pencil of Nature* relate specifically to art subjects: Plate XI "Copy of a Lithographic Print" illustrating the ability to enlarge or reduce in scale "yet preserving all the proportions of the original"; Plate XXIII "Hagar in the Desert" showing that "Fac-similes can be made from original sketches of the old master, and thus they may be preserved from loss, and multiplied to any extent"; and Plates V and XVII both titled "Bust of Patroclus."

Talbot showed great foresight in including two pictures of the bust of Patroclus. The readers of *The Pencil of Nature* were naïve about how the camera sees. By including two versions taken from different vantage points, he demonstrated a lesson that he wanted the public to learn:

. . . since in the first place, a statue may be placed in any position with regard to the sun, either directly opposite to it, or at any angle; the directness or obliquity of the illumination causing of course an immense difference in the effect. And when a choice has been made of the direction in which the sun's rays shall fall, the statue may be then turned round on its pedestal, which produces a second set of variations no less considerable than the first. And when to this is added the

"A Scene in a Library" Plate 8 in *The Pencil of Nature.*

change of size which is produced in the image by bringing the Camera Obscura nearer to the statue or removing it further off, it becomes evident how very great a number of different effects may be obtained from a single specimen of sculpture.

With regard to many statues, however, a better effect is obtained by delineating them in cloudy weather than in sunshine. For, the sunshine causes such strong shadows as sometimes to confuse the subject. To prevent this, it is a good plan to hold a white cloth on one side of the statue at a little distance to reflect back the sun's rays and cause a faint illumination of the parts which would otherwise be lost in shadow.

Having covered the major points in the caption to the first "Bust of Patroclus" and demonstrated that he was indeed an expert technician, Talbot was free to propagandize his invention in the second:

It has often been said, and has grown into proverb, that there is no royal road to learning of any kind. But the proverb is fallacious: for there is, assuredly, a royal road to Drawing; and one of these days, when more known and better explored, it will probably be much frequented. Already sundry amateurs have laid down the pencil and armed themselves with chemical solutions and with camerae obscurae. Those amateurs especially, and they are not few, who find the rules of perspective difficult to learn and to apply—and who moreover have the misfortune to be lazy—prefer to use a method which dispenses with all that trouble. And even accomplished artists now avail themselves of an invention which delineates in a few moments the almost endless details of Gothic architecture which a whole day would hardly suffice to draw correctly in the ordinary manner.

There is one photograph in *The Pencil of Nature* that excels all the others, is unquestionably a work of art, and has been copied and reproduced many time. "The Haystack" (see p. 156) is an imaginative and bold image. Its strong geometric shapes and *chiaroscuro* arouse emotion and interest. The bits of straw, both on the ground and of the haystack, create a dense and detailed pattern. The ladder leaning up against the massive haystack appears "positive" whereas its shadow, falling against a high-lighted area is "negative," reminding one of the nature of the photograph itself. It is interesting to note that Alfred Stieglitz's "The Steerage" (1907), long considered one of the great "breakthroughs" in photography because of its concern with geometry, was only revolutionary because of the "radical" words Stieglitz used in his description of the picture and the sense *he* had of its meaning:

A round straw hat, the funnel leaning left, the stairway leaning right, the white draw-bridge with its railings . . . a mast

Cart and ladder, c. 1841.

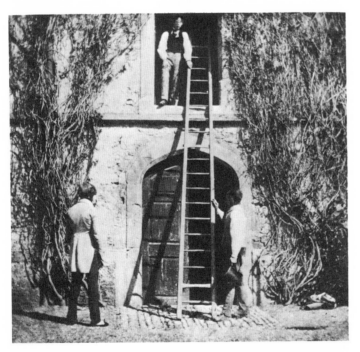

"The Ladder" Plate 14 in *The Pencil of Nature.* The circumstances under which this photograph was taken were recalled by Thomas Malone at a meeting of the Photographic Society and printed in the *Photographic Journal* for November 15, 1860: "On one occasion . . . Mr. Collen, an artist, was experimenting with Mr. Talbot, and it was proposed that they should take a ladder & a loft door, which was very much above the level of the ground. Mr. Talbot of course pointed the camera up, and produced a very awkward effect, from the peculiar manner in which the lens was placed with reference to the object. Mr. Collen said, 'You are not going to take it so, surely!' Mr. Talbot replied, 'We cannot take it any other way,' and then Mr. Collen said, 'As an artist, I would not take it at all.'"

cutting into the sky, making a triangular shape. I stood spellbound for a while, looking and looking. Could I photograph what I felt, looking and looking and still looking? I saw shapes related to each other. I saw a picture of shapes and underlying that the feeling I had about life. And as I was deciding, should I try to put down this seemingly new vision that held me. . . . Rembrandt came into my mind and I wondered would he have felt as I was feeling.[7]

What questions Talbot asked himself while standing before his haystack are not known, but certainly Rembrandt, master of light, was a pervasive influence throughout his life and he could easily have seen as much in "The Haystack" as Stieglitz did in "The Steerage."

When *The Pencil of Nature* appeared, portraiture was the most popular form of photography. It seems surprising that only one plate shows human beings, and that can best be considered a portrait of a ladder, not a person! Talbot was particularly fond of ladders, but still, one does not expect to see one as the center of the composition surrounded by three faceless men as the companion to a text that discusses portraiture. "The Ladder" (Plate XIV) is the antithesis of a studio portrait: wild vines growing

Carriage and ladder.

on the side of the building, a strong shadow cast by the ladder, two men with their backs to the camera and one, up in the loft, so situated that his face cannot be seen. No colonnades, no rich velvets, no grand poses. When Talbot took the picture, he received advice from Henry Collen, a professional painter and the first licensee of the calotype, who was visiting him at Lacock. Perhaps it was Collen's suggestion that a third person be included to "balance" the composition, as there is no other apparent reason why the well-dressed figure on the left (who looks like Henneman) should be in a barnyard scene. Collen had criticized Talbot for taking a photograph with such an unconventional perspective and said *he* would not take a picture like that. Talbot's feelings on the subject were quite definite: "It is however a pity that artists should object to the convergence of vertical parallel lines since it is founded in nature and only violates the *conventional* rules of Art."[8] The picture intrigued Talbot and he thought it would be more interesting than any one of the scores of photographs he took of his children, wife, sisters, and mother. Any one of the latter would seem to have been a better illustration to the text that accompanies the plate, but perhaps Victorian propriety would not permit exposing his family in this manner:

Portraits of living persons and groups of figures form one of the most attractive subjects of photography.... I have observed that family groups are especial favourites: and the same five or six individuals may be combined in so many varying attitudes, as to give much interest and a great air of reality to a series of such pictures. What would not be the value to our English Nobility of such a record of their ancestors who lived

a century ago! On how small a portion of their family picture galleries can they really rely with confidence!

The first part of this quote correctly predicts the rise of the family snapshot, a great democratic institution, whereas the second part suggests that perhaps Talbot was not, in fact, thinking about the proletariat.

Talbot had a wondrous sense of adventure and purpose while creating this very first book of photographs. His aim had been to familiarize the public with the potential of paper negatives, but *The Pencil of Nature* began a new era of publishing. The quotation that opens the book reveals one of Talbot's strongest ambitions:

Juvat ire jugis qua nulla priorum Castaliam molli devertitur orbita clivo.

Vergil Georgics, III, 293

("Joyous it is to cross mountain ridges where there are no wheel ruts of earlier comers, and follow the gentle slope to Castalia." Castalia was a spring dedicated to the muses and a fountain of wisdom and knowledge in Greek mythology.)

As each part of *The Pencil of Nature* was issued, re-

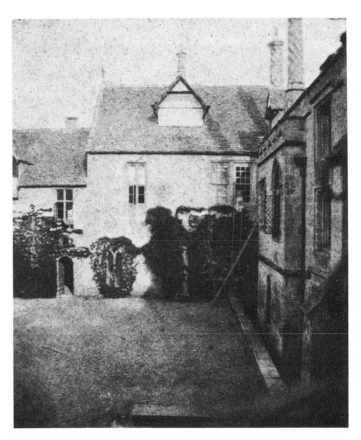

View in the stable court, Lacock Abbey, showing two ladders with a man standing on furthest ladder working, c. 1842.

views often quite perceptive, appeared in the popular press. *The Times* (London) review of September 6, 1844, especially pleased Talbot:

> *The little work now presented to the public is the first attempt to publish a series of plates or pictures of the new art of photogenic drawing, without any aid whatever from the artist's pencil.*
>
> *Such is the modest preface with which the author of this work introduces his very beautiful and valuable discovery. A discovery, it may be justly termed, for though the public has long been acquainted with general principles of photography, as exhibited in M. Daguerre's invention, still it has been reserved for Mr. Talbot to devise a new and totally different application of the same principle, which bids fair to eclipse all former discoveries on the subject.*

The Athenaeum's review of February 22, 1845, showed the most imagination:

> *Geology has, in the progress of its wide investigations, discovered records of the rains which fell thousands of years since. Photography has already enabled us to hand down to future ages a picture of the sunshine of yesterday, or a memorial of the haze of today—such are the results of recent investigation.... The experiment of photographically illustrated books is now before the world; and all who see Mr. Talbot's publication will be convinced that the promise of the art is great, and its utility and excellence, in many respects, of a high order.*

The last part of *The Pencil of Nature* was issued in April 1845. Talbot did not, however, wait until his first photographic publishing enterprise was completed before embarking on his next one. He wanted to photograph

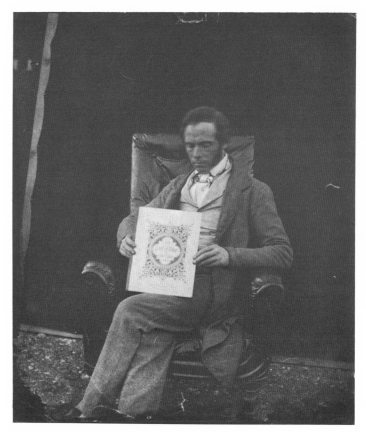

Henneman holding a copy of *The Pencil of Nature.*

Shed at Lacock, c. 1841.

sites and landmarks mentioned in the writing of Sir Walter Scott and in October made a trip to Scotland. He probably took with him three cameras, one of which, because of the curvature of the lens, made circular pictures. The work eventually formed the body of Talbot's second book printed at the Reading Establishment, called *Sun Pictures of Scotland.* It included 23 views of Scotland with no text. The pictures, for the most part are not exceptional. Generally, rather than seeking to make imaginative, poetic images, he made literal, staid representations. There are, however, two very lovely pictures (see p. 186). Perhaps the problem was that from 1834 to October 1844 Talbot made photographs whose subject matter was primarily photography, or how light acts on surfaces. A sense of exploration and discovery was deeply felt in all these pictures; the plates in *The Pencil of Nature* were made at this time. When Talbot used his camera *to illustrate* the writings of Sir Walter Scott, he failed. He could not make "equivalents" to the emotions and sentiments expressed; he could not take this next step and his pictures became prosaic.

Sun Pictures of Scotland was published in the summer of 1845 and sold for one guinea to subscribers, many of

whom were solicited by Lady Elisabeth. The list of 103 names included, among others, the Queen, the Duke of Devonshire, Madame Lionel de Rothschild (who bought 5 copies), Lord Dudley Stuart (2 copies), Mr. and Mrs. J.D. Llewelyn (a relation to Talbot), Mr. Calvert Jones, Sir David Brewster and Mr. George Bridges. Three of the subscribers were outstanding calotypists and two of them, Jones and Bridges, were directly involved with the Reading Establishment.

After *Sun Pictures of Scotland*, prints were produced for only three more publications. *The Talbotype Applied to Hieroglyphics* (1846) contained three calotypes and was the first instance of the use of photography in the field of Egyptology.[9] The June 1, 1846, issue of the *Art-Union* carried a sample calotype and two pages of favorable editorial comment. Unfortunately, some of the 7,000 pictures distributed faded[10] and consequently made many people reluctant to purchase or commission calotypes. (The Reading Establishment was not a successful business enterprise. After the first few months of operation, Henneman complained about the lack of business and had to dismiss staff. Photographs placed in shops sold only moderately well and their price of one to five shillings hardly covered the cost of production.[11]) The final publication, *Annals of the Artists of Spain* (1847), was issued in an edition of 25 and contained 67 photographs of sculpture and engravings. This proved to be a difficult assignment for Henneman and he did not finish it until after he moved his premises to London in 1846.

It is extremely important to discuss the work of Calvert Jones and George Bridges as many of their images have been attributed to Talbot. The situation becomes ludicrous when, for example, calotypes of Italy taken in the mid-1840s are captioned "by Fox Talbot" when in fact there is no record that he was even in the country during that decade. Furthermore, there are letters, lists and other documents that state which pictures printed at Reading were by Jones, Bridges or Henneman. Confusion does arise as not every photograph has proper documentation, but the situation is not nearly as chaotic as dealers in 19th century photographs and others have lead the public to believe. There is no longer any need to be quite so ambivalent about the authorship of most calotypes taken in Rome, Florence, Naples, Pompeii, Malta, Swansea, Dublin, Hampton Court or on board the H.M.S. *Superb*. Finally, it is possible now to approach the work of Jones and Bridges critically and evaluate it and place it in its proper historical perspective.

The Reverend Calvert Jones (c.1804–1877) was one of the first to go "wild" over photography. He did not practice as a clergyman, rather, he dedicated himself to music and art before becoming committed, for a short period, to photography. He came from a wealthy Swansea family

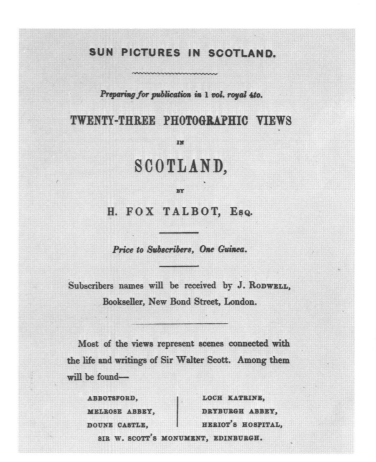

Publication notice for *Sun Pictures of Scotland*, 1845.

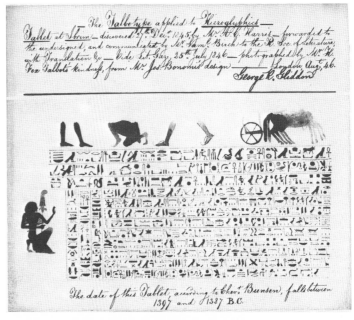

The first of three plates from *The Talbotype Applied to Hieroglyphics*, photographed 1846, probably by Nicolaas Henneman.

and was probably introduced to Talbot through Christopher Rice Mansel Talbot, Talbot's Welsh cousin who was a classmate of Jones at Oriel College, Oxford.

In July 1845 Henry Talbot arranged to go on a photographic excursion with Jones. Jones, in letters to Talbot dating from 1843, had shown that he was not only eager to learn the calotype process, but also wanted to become proficient at it. He was planning to go to the Continent at the end of 1845 and was to take a camera with him and make views of the places he visited. Talbot thought the best method of instructing Jones and of helping him avoid difficulties while on his own would be for them to photograph together over an extended period. Talbot wrote to Constance on July 29: "We [Talbot, Jones and Henneman] took twelve views of York to-day, most of them good. Crowds of admiring spectators surrounded the camera wherever we planted it."[12] At the beginning of August they were photographing in Clifton (near Bristol) and soon after they apparently parted, only to meet again in early September at Mount Edgcumbe, Caroline's home in Devon. In the interim, Jones photographed at Hampton Court and described his group of photographs as an "essay," perhaps the first use of the term in connection with photography. In December, Jones left for Malta and Italy and the negatives he made there he sent to Henneman for printing at the Reading Establishment.

Calvert Jones understood intuitively how to make photographs. Rarely does his work not present some unex-

Calvert Jones in York, 1845.

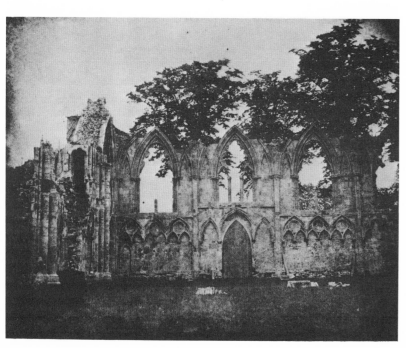

Ruins in York with a ghost figure of a woman on left, 1845.

pected or unusual positioning of people, design or perspective. A few of his pictures can be considered among the finest and most imaginative images made in the 19th century. Two of these, bright orange (Jones sometimes had difficulty in getting specific chemicals and had to make do with others) were taken in Naples, May 30 and 31, 1846. (see p. 144) The first, "Villa Reale, Naples" shows a young girl silhouetted against the white base of an Appololike sculpture; exposure five minutes. The second is the "Statue of the Fawn bound," exposure seven minutes. There is nowhere on earth that resembles the place depicted in these photographs. A dream world of symbols and queer relationships was created during the minutes the lens glared impassionately at the scene before it. These photographs naïvely ask questions pertaining to life and death, time and motion. "Cowpers Summer-house," Olney, Buckinghamshire, is superbly composed and includes a picket fence, tall fir trees and a cottage with an open window. It is an enormously positive, life-affirming photograph, not only because the pickets and the trees and the roof of the house point and

pull upwards, but because "light" is present in a spiritual sense. One can clearly see the light, feel it and take joy in it. It seems to illuminate this world and let us transcend it, too. Some of Talbot's photographs, especially of trees in the forest, (see p. 189) have this quality, also.

Jones was a painter before he became a photographer and this fact accounts somewhat for the quality of his pictures. But there certainly is more involved. He, like all the early photographers, had seen so few photographs when he began to use the camera that he worked with an innocent blend of "meticulous care" and "come what may." One need only to compare "Villa Reale" or "Statue of the Fawn bound" to a typical 19th century painting to realize how radical, how extraordinary, how important to the development of the visual arts these early photographs were.

Jones' photographs can normally be identified without too much difficulty, not because of any pervasive pictorial style, but because they differ from others technically. There is a strip usually along the long edge of his negative caused by some peculiarity of his camera or plate holder. He generally wrote on his negatives and numbered them on the bottom; his handwriting can be identified. (This is important because Jones met Christopher "Kit" Talbot and George Bridges in Malta in March 1846 and they traveled and photographed together in Pompeii, Naples and Rome until May.) Also, in the Lacock Abbey Manuscript Collection there are many letters from Jones listing the titles and numbers of his photographs. Jones considered his negatives "wonderfully perfect and beautiful" and asked Talbot to buy them in order that "the art I am so fond of repay me the trouble it occasions." Talbot did not want to purchase the negatives but arranged with Jones to have his work sold through the Reading Establishment and thus receive a percentage of the price of each print sold. In July 1846 Jones listed and sent Talbot 22 small calotypes and 102 larger ones, made in Malta and on the Continent between December 1845 and May 1846. He then continued to photograph in Swansea, Ilfracombe, Worcester, Dunster, Minehead and Cardiff. He made delicate studies of the Ellen Simpson barque, fishing boats, old houses and churches, harbors, piers, sailors and beggars. At some time, too, he apparently visited Ireland and took pictures of the Bank of Ireland; St. George's Church, Dublin; Wellington Monument in Phoenix Park and Trinity College.

The Reverend George Bridges apparently was given a letter of introduction to Talbot by Caroline[13] and in December 1845 came to Lacock to discuss photography with him. Talbot was in London but Lady Elisabeth greeted him and promised to inquire of her son if it would be possible for Bridges to learn the calotype process immediately. He planned to leave shortly to meet Jones and

Calvert Jones in front of York Minster, 1845.

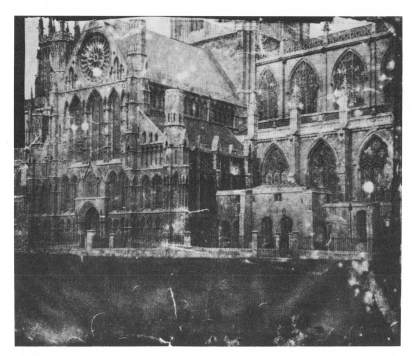

York Minster, 1845.

"Kit" Talbot in Malta and then go to Italy with them before he set off on his own for an extended tour of Greece and the Holy Land. Talbot wrote his mother on December 13 informing her that he had no objection to Henneman teaching George Bridges, but that he must "promise us in return some good Syrian views, especially Jerusalem."[14]

PHOTOGRAPHS BY
REV. CALVERT JONES

"House of Tragic Poet Pompeii" 1846.

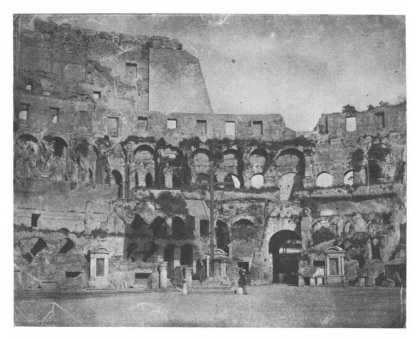

The Forum, Rome, probably May 1846.
The man in the center may be Kit Talbot.

"House of the Vestals Pompeii" 1846.

"House of Sallust Pompeii" 1846.

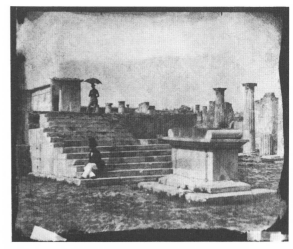

"Temple of Venus Pompeii" 1846. The men
in the photographs are probably Kit Talbot and
Rev. George Bridges.

Porta della Ripetta, Rome, probably May 1846.

The Ponte Vecchio, Florence, 1846.

"Olney Church, Bucks" [Buckinghamshire.]

"82. Rape of the Sabines (2nd view) Florence" 1846.

"Cowpers Summer-house Olney—Bucks."

PHOTOGRAPHS BY REV. CALVERT JONES

Wellington Monument in Phoenix Park, Dublin.

"Sailors" c. 1846–7.

Ships at Swansea c. 1846–7.

St. Georges' Church, Dublin.

Bank of Ireland, Dublin.

"Garden of Benedictine Convent Catania Padre Cafici"
March or May 1846.

"Catania. Benedictine Convent" March or May 1846.

"Etna—Cone & running Lava.
Taken from 'Casa Inglese' " March or May 1846.

"Lettiga travelling Sicily" 1846.

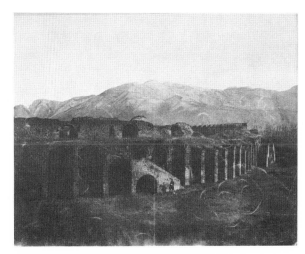

Catania. Mt. Etna in distance, 1846.

PHOTOGRAPHS BY
REV. GEORGE BRIDGES

Bridges was very uncertain about his technique when he left England and was delighted that Jones, who had more experience than he, could continue instructing him in Malta. In his letters during the years he was traveling, he wrote of the difficulties of getting and utilizing chemicals, papers, cameras, and lenses and certainly Sicily and the Middle East in the 1840s could hardly have been problem free in other ways as well. He still made marvelous pictures that, unlike Jones', seem to have a certain consistency in style. Apparently he tried to make two negatives of every scene and supposedly when he returned to England in 1852 he had done 1,700 pictures,[15] the whereabouts of most of these are unknown. While in Etna, Catania and the surrounding areas Bridges made some "Two score of good negatives" which he did send to Talbot for printing by Henneman, and some of these are available for study. They show that Bridges enjoyed making images rich in information. People are generally present in his photographs and they stare out of the frame and confront the viewer with a magnetic pull; it is hard to be detached from these phantoms of the past. Specters in shepherds' or monks' clothing seem always to be beckoning the viewer to visit an unknown place, be it a mountain, monastery or ancient ruin. In one photograph, "Lettiga travelling, Sicily," the carriage is waiting with one white horse and one black to take us away. Perhaps the viewer is so willing to linger in the never-never world of Bridges' pictures because they are, quite simply, very good. Bridges usually signed his name on a diagonal at the bottom right corner of the negative. On the left he wrote the title of the photograph.

The many people who practiced the calotype process in the 1840s and early 1850s were almost exclusively amateurs for whom the license fee associated with the patent was not a deterrent. If one purchased three guineas' worth of iodized paper "warranted to keep any length of time in any climate, without change" from the Reading Establishment, the license would be given to the prospective photographer free. Obviously, many of the amateurs, once attaining a certain degree of proficiency would have liked to set up small businesses or merely feel free to sell prints. This was not allowed under the terms of the license. Thus, Talbot's patent did stifle the development of paper photography in England. One wonders, however, how successfully the calotype would have competed commercially during the golden years of the daguerreotype. Would more talents such as Hill's and Adamson's have surfaced had there been no patent in England as there was none in Scotland? Many creative individuals did use the process for their own pleasure and purposes. Talbot, if one reads his writings carefully, was frequently arguing for "personal photography," *The Pencil of Nature* being the most obvious exposé. The number of people who practiced paper photography in Britain during these early years is not known but there were scores more than normally assumed. A few names of the more well-known come to mind: J. D. Llewelyn, Henry Collen, Antoine Claudet, Jones, Bridges, Philip Delamotte, Roger Fenton, Peter Fry, Robert Hunt, Hugh Welch Diamond (and the other members of the Photographic Club founded in 1847), Thomas Keith, C. G. Wheelhouse, William Collie, O. G. Rejlander, James Mudd, Samuel Smith and Henneman. Gradually, more and more salted paper prints are surfacing, uncovered in attics, local history collections, Windsor Castle, photographers' studios and photographic societies. Many are to be found pasted in albums, one to a page, with an obscure name pencilled underneath. If records could be found to show who came to Reading to learn calotype or where Henneman went to teach it ("Where Five or more persons in one Town, form a Class for instruction, an Artist is sent to teach them, at a small additional charge"), a much better understanding of amateur photography in England in the 1840s could be derived. Amateurs were, for the most part, calotypists, not daguerreotypists, and quite well to-do.

Advertisement for iodized (sensitized) paper.

6.
Positives and Negatives in the New World

The name of William Henry Fox Talbot is as unfamiliar today in the United States as it was during his own lifetime. His inventions were not used and the history of early American photography is based on the practice of daguerreotypy. Attempts were made to introduce the calotype into the States, but these were total failures. One of the first efforts was made by Edward Anthony, a most influential figure in 19th century American photography. (The firm E. and H. T. Anthony and Company was the major photographic supply house in the United States for over half a century.) A civil engineer by training, Anthony learned the daguerreotype process from Samuel F. B. Morse and established himself as a portrait photographer in Washington, D.C., in 1843.[1] In 1846 the Rev. George Bridges introduced Talbot to the American R. K. Haight who spoke of Anthony as "a gentleman well qualified to extend to the New World the beautiful invention which you have endowed the Old World."[2] The following month, December 1846, Talbot wrote to Anthony inquiring whether he thought it advisable to introduce the calotype into the United States and apply for an American patent. Anthony replied:

I should be well pleased to introduce your invention to the American public, but I am not willing to make a speculation

of it; and if any arrangement is effected between us, it must be such a one, as that, while each party receives his just share of the proceeds, neither shall be subjected to the risk of less.[3]

Talbot knew that although the calotype was free in America for anyone to use, still it was hardly known or practiced. To advertise his invention, send representatives to the various states, and export supplies would cost considerable sums, and the only way Talbot felt able to contemplate such a proposition was to patent the process and hope for an income from it.

It was not surprising that Talbot's process was not popular in America if one recalls how photography was first introduced. In 1839 the authoritative President of the National Academy of Design and the inventor of the telegraph, Samuel F. B. Morse, was in Paris and was shown the daguerreotype by Daguerre himself. A close friendship was established between the two men and when Morse returned home, he became a staunch advocate of the Frenchman's process. A letter written by Morse to Daguerre gives insight into an important reason why *photography* meant daguerreotype in America in the early years:

Notwithstanding the efforts made in England to give another the credit which is your due, I think I may with confidence

97

assure you that through the United States your name alone will be associated with the brilliant discovery which justly bears your name. . . . Should any attempts be made here to give to any other than yourself the honor of this discovery, my pen is ever ready in your defense.[4]

One month after Anthony received Talbot's letter, he arrived in England from France. In a series of letters from Anthony, in London, to Talbot, in Lacock, the American tried to convince the British inventor to patent his process in the United States. Anthony's idea was that Talbot should sell the patent to him outright. Talbot was not a good entrepreneur and one of the things that characterized his behavior throughout his life was his poor business decisions. In this instance Talbot could not decide if he wanted to give up all rights to his invention. While he waited for Talbot's answer, Anthony went to the Reading Establishment to learn the paper negative process from Henneman. At the end of February 1847, however, Anthony could wait no longer for Talbot's decision and returned home. By the time Talbot was issued the American patent on June 26, 1847, Anthony was no longer interested in purchasing it. The following is a letter he wrote to Talbot on August 30, 1847:

My declining however to make an absolute purchase of the entire patent rightly will not in my opinion be prejudicial to your interests. On the contrary it is my decided conviction that a much larger sum might be realized by selling exclusive rights for different states at prices proportioned to their relative importance.[5]

Anthony then suggested the prices Talbot could charge the individual States, e.g. Massachusetts, New York (exclusive of the city), Washington, D.C., Louisiana, Ohio (the top price of $1000), or Iowa (only $150, the minimum). Anthony also agreed to act as Talbot's agent, taking a 20 per cent commission on each license sold. Talbot, however, seemed once again to have lost interest and did not sign any agreement with Anthony.

For two and a half years Talbot gave little thought to America until one day in February 1849 he received a letter from the Langenheim brothers, notable photographers in Philadelphia. William and Frederick had seen a copy of *The Pencil of Nature* and were excited by the salted paper prints. They began experimenting with the process and after a little while were able to write a pamphlet containing a description of Talbot's original invention, subsequent improvements and their own experiences with making paper negatives. Although their February letter was ostensibly written for permission to dedicate their publication to Talbot and to publish some "Talbotypes," another name for calotypes, they also expressed the desire to act as Talbot's agents in the United States and to teach calotype. In the letter they put forth the following conditions upon which an agreement could be based:

1. *We sell the Patent right in your name and behalf to every purchaser* personally *so that he may exercise it throughout the United States. We would not advise, to sell it for a certain State because the Americans are a locomotive race and we are sure that a great many more rights would be sold in the proposed way.*
2. *We receive for our trouble twenty five per cent of the amount of the Sales.*
3. *We pay for the necessary advertisements, hand bills, cards, etc., so that you will receive the net amount of 75 per cent.*
4. *Every 3 or 6 months, as you may desire, we render an account of the Sales (under oath if required) and forward the amount either in a letter of Exchange, or by paying it over to whom you may appoint.*
5. *We sell the Patent right to every one at a fixed price. We would advise not to put this price too high, because it would deter a great many from buying; while if the price is low, hundreds will buy it, even if they should never exercise it, to any great extent; and we are confident that the ultimate result will be greater than under a high price.—We should advise about from Fifty or One Hundred dollars as the standard gross price.*

We submit the above propositions to your kind consideration, hoping that they may receive your sanction, not so much on account of our mutual pecuniary interest than to enable us to serve in bringing your brilliant discoveries into general use, which would place your name much higher than that of Mr. Daguerre's, and your art, if properly applied, possesses extraordinary advantages over the Daguerreotype.[6]

In May 1849 William Langenheim came to England to complete negotiations with Talbot. Whereas previously when dealing with Edward Anthony on the same subject, Talbot wanted to keep some control over his patent, now his attitude had changed. He preferred to sell the patent outright and on May 12, 1849, Talbot wrote to his wife:

You know I had a patent in the U.S.A. for my invention of photographic pictures. I sold it yesterday for a large sum to an American gentleman (Langenheim) who expects to make his fortune by this purchase. I hope he may as he seems a very amiable and intelligent person.[7]

The Langenheim brothers appeared delighted with their "deal." They were the first to obtain publicity for Talbot's invention in the States. They proudly wrote to Talbot that a long article on photography appeared in the *Daily National Intelligencer*, a Washington, D.C., newspaper, and that the calotype was highly praised. The article ran a full two and a half columns and was a thoughtful appraisal of the merits of the calotype compared to the prized daguerreotype. Although articles such as this had appeared in European periodicals, it was significant that the American public should read that:

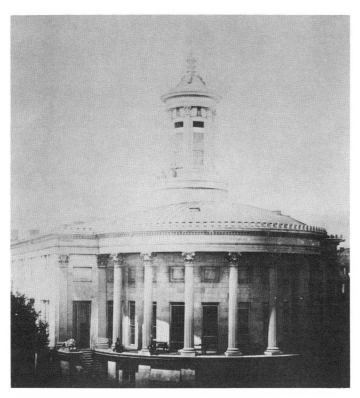

The Merchants' Exchange Building, Philadelphia, "Talbotype from *Nature* Aug. 16, 1846—by W.&F. Langenheim Philad.ᵃ Exchange."

The admiration with which the first announced form of the art was received appears, however, to have thrown a complete eclipse upon the equally-deserving invention of Talbot; it remained almost unnoticed and its author almost unknown. There is luck in science, as in nearly everything else—particularly love, war, and politics.

It was not only Talbot who was unlucky, though, concerning the calotype in the New World, whose citizens did not know how to judge paper prints. In Langenheim's words "The productions are so new to everyone that they do not know whether to pronounce them good, bad or indifferent, a tercium comparationis being entirely wanting."[9] The calotype would have been a wonderful tool for exploring the vast, primordial distances of America. It traveled well and was not as difficult or as dangerous as the daguerreotype to use. It could have helped the expanding population discover the land, frontier towns and cities, as the wet-collodion began to do a decade later. Paper was not as expensive as copper plates, most of which came from Paris. Nor did the calotype, as did the daguerreotype, need the high quality imported glass for protection. True, paper prints were coarser and less refined than daguerreotypes, but surprisingly, the qualities

. . . independently of each other, Daguerre and Talbot found out the art of fixing upon metal and upon paper the light of the sun. The former has obtained the more immediate success; but the other has, perhaps, hit upon the better form of the discovery.

And later in the article that:

. . . in the Talbot-type, the picture is first obtained in a negative delineation; and that from this, by the means already described, positive pictures are taken at will. . . . If this seems, at the first glance, a disadvantage, it is really the contrary. For, from one impression, without any further sitting, and at any distance of time, the original picture may, at little expense, be multiplied almost without end; while the Daguerreotype can be but imperfectly copied, and with no diminution of the original expense.

Nor is this the only superiority of the Talbot-type already apparent; its effects are, in many respects, more pleasing; it is capable of larger representations; the pictures occupy less room; and its application to paper permits them to serve for the illustrations of books . . .[8]

However the United State's attitude toward photography was not to change easily. The author of the article in the *National Intelligencer* described the problems in the following way:

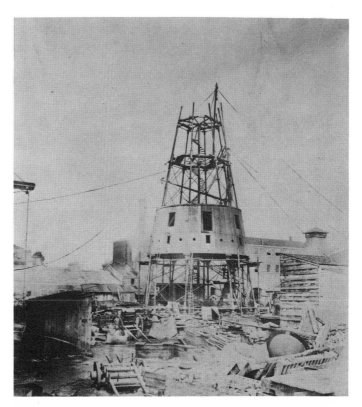

A lighthouse under construction, "Talbotype from *Nature*, August 14, 1849—by W.&F. Langenheim Philad.ᵃ Exchange."

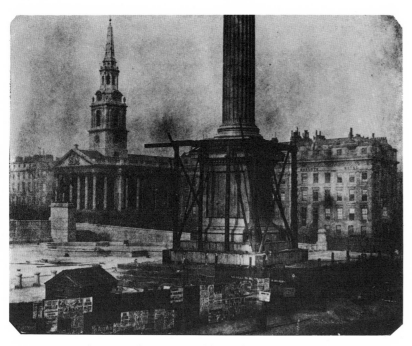

"Nelson's Column in Building" late 1843.

ruptcy? Or did Talbot knowingly allow the firm to fail? There are many letters that are missing between Talbot and Langenheim, and these letters alone could give evidence to Talbot's part in the incident. It is certain, however, that one of the reasons the firm of Langenheim did go bankrupt was because of their purchase of the calotype patent. A letter written to Talbot on June 13, 1854, by Frederick Langenheim, who had just returned to Philadelphia from three years in South America, stated: ". . . the firm of W.&F. Langenheim not alone not having made any money by the Patent but lost all they possessed."[11]

The Langenheims were not the only people who were unable to make the calotype a viable commercial enterprise. Henry Collen was never able to run his London studio profitably. Antoine Claudet, who acquired the license after Collen in 1844, found it added little income to his daguerreotype business. One of his quarter annual reports shows that he was paid five pounds for calotype portraits, 25 per cent of which went to Talbot. By 1846 he was considering giving up paper photography and in 1847 he did so. He always remained an admirer of Talbot and a supporter of his rights as an inventor.

Talbot was faced with the problem of finding an ex-

of practicality and reproducibility did not have sufficient appeal in pioneer America. The people loved only the photographs that reminded them of expensive miniatures; that were solid and had a feel of permanence and craftsmanship about them. The public was devoted to their exquisite daguerreotypes. Although the Langenheim brothers knew there was room for both the daguerreotype and the calotype in the immense continent, they could not convince enough people of this.

By November 1849, six months after purchasing Talbot's patent, the brothers were afraid of going bankrupt. They had already paid Talbot $3000 and had two more installments left. They appeared to have sold only five licenses; they had hoped to sell at least 200. They begged Talbot to postpone their last two payments or to keep the money already paid to him and take back the patent. They asked only that the states which had already purchased the licenses (Georgia, Florida, Alabama, Louisiana and Texas) be allowed to practice it, and they hoped they would be allowed to continue with it in the city of Philadelphia.[10]

Something very strange occurred at this point. Talbot did not answer the Langenheims' letter of November nor apparently the following one written in December. His failure to reply resulted in the closure of the firm of W.&F. Langenheim. Did Talbot give the letters to his lawyers who neglected to answer? Was Talbot away at the time; did he never receive them? Did the letters go astray and arrive after the brothers had declared bank-

Wellington Statue on Decimus Burton's Arch,
Hyde Park Corner, London, c. 1844.

perienced and competent calotypist to be the new London licensee. Henneman had been complaining for several months how poorly business was in Reading and that it was operating at a loss. Talbot offered Henneman the London license on terms that would establish a new relationship between the two men. On December 10, 1846, Talbot signed a lease on part of 122 Regent Street, London. The agreement with the owner, John Newman, indicated that Talbot planned to erect a photographic studio on the roof and his intention was clear from the start: he did not want to be responsible for another business but would convert and furnish the premises and pay the rent for the first two years. He asked Henneman and Thomas Malone, the bright young chemist who had helped at Reading, to run the business with the option to take it over completely in two years. Talbot agreed to act as surety, assuring Newman that he would pay the rent if Henneman and Malone should fail to do so during their first five years as tenants. After that, Talbot freed himself from obligation or liability. The only other promise he made to Henneman, the senior partner, was that if anyone infringed on the calotype patent, thus threatening his livelihood, he would prosecute.

Who was Nicolaas Henneman? Over and over his name appears in this book and in histories of photography. It is clear that his relationship with Talbot was not at all the usual servant-master kind. His role in the invention of photography could have been significant or minor.

Henneman was born in Heemskert, Holland, on December 8, 1813, to a laborer named Arie and his wife, Pieternel Klaas Waagemeester. The record of his birth shows that his first name was actually Klaas. Little is known of his early years but by 1830 he was serving as a valet to a Dutch ambassador in the Hague.[12] When in 1834 Talbot began his photographic researches, Nicole, as he was called, was there.

Henneman was undoubtedly an intelligent and likable man. John Henderson who helped him during the Reading days wrote: "Henneman was nothing like the typical Dutchman, but a lively, volatile fellow who had lived much in Paris, & became more of a Frenchman; at all time knowing several Foreign languages, he was rather deficient in English. . . ."[13] Henneman was respected by Talbot as a companion as well as a valet and taken along on most of his trips. Henderson also said of Henneman that he had a "keen eye for beautiful scenery." It is certain that Henneman made some of the earliest photographs.

The opening of the Sun Picture Rooms on Regent Street in May 1847 was a great event for Henneman. After years of serving others, he now had the opportunity to make an independent life and Talbot encouraged him by showing confidence in his and Malone's abilities. (Henneman was

at Reading at least up until the end of April. On April 20 he took a portrait of the author Mary Russell Mitford and one of her dog who, in Henneman's words sat "as still as if he was dead" for four minutes.) Talbot wrote his wife, just before the Sun Picture Rooms were to open, that he felt Nicole did not need him at the opening. Caroline, lady-in-waiting to Queen Victoria, too, displayed her fondness for Henneman by asking the Queen to appoint him "photographer ordinary to Her Majesty," an honor readily bestowed. Talbot was distinctly delighted that *Henneman's* establishment should have this added prestige and accompanied his friend to the Lord Chamberlain's office to complete the necessary papers.

The partnership between Henneman and Malone appeared to be a sensible one. Henneman was experienced as a photographer and charming with the public. Malone was an expert chemist who could solve technical problems and would work to improve the process. Both of them were enthusiastic and determined to make their business a success. Brochures issued by Henneman invited the public to visit the Sun Picture Rooms to see photographs of Rome, Sicily, Pompeii (a pleasure to "Historian, Scholar and Poet"), Paris, Florence, Naples and Malta as well as pictures of "palaces and consecrated spots" ("dear to the hearts of every Englishman") such as Windsor Castle, Eton College, Oxford, Cambridge, etc. There were views of Scotland ("with reminiscences of the immortal Genius of Sir Walter Scott") and many, many other photographs made by Talbot, Henneman, Jones and Bridges. The brochure noted that individuals could have their portraits taken or their possession copied or learn

Waterloo Bridge, London, c. 1844.

To Mr. N. HENNEMAN,

Sun Picture Rooms,

122, REGENT STREET, LONDON.

SIR,

Understanding that the Patentee of the Photographic process, known as the Talbotype or Calotype, has no objection to that process being used by Amateurs, who pledge themselves to use it BONA FIDE, FOR THE PURPOSE OF AMUSEMENT ONLY; (and that they will purchase from your Establishment the Iodised Paper belonging to the said Patent Invention, which they may require) and also that they will not make any such use of the Art as to interfere injuriously with your Establishment, but will immediately discontinue any such use of it, on your requesting them to do so. Now, I being desirous of practising the aforesaid Patent Invention as an Amateur only, and without any view to profit, either directly or indirectly, am willing to give you the pledge and assurance above mentioned.

Witness my hand, at this day of in the year 184

Witness to Signature

The standard form to be signed after 1847 by an individual desiring to make calotypes for non-commerical purposes.

photography themselves. They also offered a daguerreotype copying service. If one wanted to make calotypes for noncommercial purposes, he needed only to sign the standard form (see illustration above).

The partners worked diligently at developing their young enterprise. They were faced, however, with stiff competition from daguerreotypists and with complaints that their pictures faded. A letter from Malone to Talbot, July 26, 1849, explains the situation:

. . . Mr. A. Taylor of Guy's Hospital has spoken of the fading publicly at the Royal Institution & at Lord Rosse's Soiree where our own pictures were exhibited & much admired. . . . A scientific amateur Mr. Vernon Heath . . . lately sold his camera "in disgust" because he could not fix his sun pictures. A clergyman taught by us also complains that after all the care he has bestowed upon his pictures they fade. I fear that our business has been injured by the prevalence of the idea of the fading—We are constantly cross-examined upon the subject.[14]

Malone had been experimenting for some time to solve the problem of fading. In the same letter Malone ex-

pressed his wish to show Talbot the results of his experiments as soon as possible so that Talbot could judge their accuracy. Malone visited Talbot and together they carried out a number of experiments. By December they were able to draft a patent specification; Malone's results and Talbot's improvements on them, plus Talbot's own discoveries over the past few years. The patent No. 12,906, simply titled "Photography" was entered on December 19, 1849, and enrolled June 19, 1850, in the name of Talbot and Malone.

The patent contained four major points, none of which were to revolutionize photography:

1. The production of negatives and positives on unglazed porcelain surfaces coated with egg white.

2. The conversion of negative photographic images on glass covered with films of albumen, gelatin or other animal or vegetable substances into positive ones by placing the glass on a dark surface. (Similar to Herschel's description of 1839 and the method of making ambrotypes or

positive glass collodions announced by Scott Archer in 1851.)

3. Improved fixation by use of caustic potash.

4. Production of photographic images upon polished steel plates using iodized albumen and gallo-nitrate of silver.

It was Frederick Scott Archer, not Talbot, Malone, Herschel, nor anyone else who has so far figured in the story, who made the next great photographic breakthrough. Archer, an orphan born in Bishops Stortford, Hertfordshire, learned photography from Dr. Hugh Welch Diamond in 1847 in order to aid him in his work as a sculptor.[15] Archer's invention of 1851 combined the fineness of detail of the daguerreotype with the versatility of the calotype.

The year 1851 was momentous for photography: at the Great Exhibition in the Crystal Palace thousands of people were introduced to photography for the first time. Visitors to the fairy-tale glass corridors and rooms saw 700 daguerreotypes and calotypes from six nations.[16] The newly perfected stereoscope was on display and, at the end of the year, examples done by Scott Archer's recently published wet-collodion process. Sometimes called the wet-plate process, it consisted of the following steps: collodion is made by dissolving gun-cotton in ether containing a little alcohol. This is then iodized by treating it with a saturated solution of potassium iodide in alcohol. The iodized collodion is then poured on to a glass plate and the excess removed by tilting the plate. Once an even coating has been obtained the plate is sensitized by dipping it into a silver nitrate solution. After one or two minutes the plate is removed and, while still wet, placed in the dark slide of a camera and exposed. Immediately after exposure the plate is developed with pyrogallic acid solution or ferrous sulphate solution. The developed plate is fixed either with sodium thiosulphate solution or potassium cyanide solution.

In just over a decade (1840–1851), photography developed into a popular activity, attracting businessmen and artists alike. Technically, it could meet the needs of both groups. The individuals who picked up cameras felt like pioneers, but pioneers are not discoverers, the ones who first step foot on virgin soil. They have primitive maps to help them, but what they do and where they go is still unrestricted and untried. The work of the French calotypists, for example, is imaginative, moving and subtle, but of a different nature from Talbot's. The pictures were made by men who saw their efforts as contributions to a newly established medium—almost a cause—and as such they joined together, discussed each others' imagery and used it for a variety of different purposes. Talbot was a photographer very much on his own.

The Royal Exchange, London, c. 1844.

The first formal "photographic society" was the Société Héliographique founded in Paris in February of 1851. The French also showed great foresight in setting up the *Commission des monuments historiques* to make photographic records of architectural monuments and appointing the skilled and sensitive artists Gustave LeGray, Henri LeSecq, Edouard-Denis Baldus, Hippolyte Bayard and Mestral the same year. The Daguerrean Association of New York was also established in 1851. The organization to involve Talbot most, however, was The Photographic Society of London, today called The Royal Photographic Society. It was founded in 1852 and is the oldest photographic society in existence.

While the Great Exhibition was attracting thousands to its great halls, Englishmen were meeting at restaurants and private clubs to evaluate the state of photography. They concluded that when the Exhibition was over, there would be many more people interested in the art and the science of the new medium. They were aware that Archer's new unpatented process could revolutionize photography and that other inventions and developments were also of consequence.

During the winter of 1851–1852, those who took the lead in the preliminary discussions regarding the formation of a photographic society were Roger Fenton, Charles Vignoles, Peter Fry, Robert Hunt and a few others. Talbot was not aware of any such plans until March 4, 1852, when he met with Robert Hunt in London. A letter writ-

ten the following day by Hunt to Peter Fry gives an excellent account of Talbot's first reactions:

. . . His patent right, he says, his engagements compel him to maintain, and he also says the Vice-Chancellor's decision in the case of Talbot v. Colls *is clear that a man cannot practice the Calotype, for his own amusement even, without a license from the patentee, but he has no wish to act on this. Eventually I got Mr. Fox Talbot to a definite proposition. He says, if a Photographic Society is formed upon a very respectable basis, he will give a license to every member of the Society to practice the Art; with the following conditions:—*

1st. The Society shall by its Council engage not to trade in photographs, and any member without a proper trading license, who shall be known to trade, to be expelled.

2nd. Members to be allowed to exchange photographs among themselves to any extent.

3rd. If a member desires to import any foreign photographs, that he may do so upon having them stamped by the Assistant Secretary of the Society and paying a small fee—say 2s. 6d.— to the funds of the Society.

4th. That if a member does not make copies of his negatives himself he shall employ the Patentee's accredited agent to do so.

5th. That, at the Society's rooms, a member may sell positives of any striking character on condition that the transaction is through the Secretary; and that 10 per cent be paid to the Society. Mr. Fox Talbot considers a fund may thus be formed for the benefit of the Society.

I must say that Mr. Fox Talbot clearly desires to make no profit by his process where it is used for amusement only or for scientific enquiry. He appears quite disposed to put as few restrictions as possible on the progress of photography. He tells me that he has spent £7000 in his patents, etc., on the Art, and that he is under engagement to Hanneman [Henneman], Knight and others that prevent his doing more than this.[17]

The court case that Hunt referred to was an injunction granted to Talbot on January 22, 1852, to restrain the photographer Richard Colls from making photographic portraits on paper (almost certainly by the calotype process) without a license. Talbot's action was the standard procedure taken by a patent holder against any infringers. Talbot's patents infuriated all photographers who wanted to make money from using paper negatives. It is paradoxical that his patent should arouse so much antagonism in his fellow countrymen while the patent for the daguerreotype, in effect until August 14, 1853, did not receive the same scathing attacks. The Englishmen who desired to form The Photographic Society practiced and believed in photography on paper but were determined not to organize themselves until Talbot forfeited all his rights. Some disagreed on principle with patents, others did not. The point, quite simply was that although these men were amateurs, they wanted the right to use photography commercially, if they so desired, without paying Talbot to do so.

Talbot met with Hunt in March, full of good intentions to help form a society that would bring honor to his invention. In a letter to him dated March 24, 1852, Talbot wrote of his ideas to help establish a photographic society, but his postscript reveals his awareness that the founders of the society did not treat him with friendship:

Dear Sir,

The only proposal I have to make is that a Committee of five gentlemen should be named by the meeting, whom on my return to Town in the course of two or three days, I would meet, and have no doubt we should be able to arrange everything in a satisfactory manner.

I have already stated to you that my desire is to give a free permission to the members of the Society to exercise the art for their amusement, they on their part acknowledging my rights as inventor and patentee.

There is another novelty that might be connected with the Society, but on the other hand it might be undertaken as quite a separate concern, that is the formation of a photographic gallery, the exhibitors to be members of some club or society, and to have the right of selling the pictures they exhibited as members of the Association.

Many persons are desirous of purchasing beautiful specimens, for instance foreign photographs, but have not the means except by parting with their own, and it is not always easy to effect an exchange.

Yours truly,
H.F. Talbot

Private
I assure you that I have the best wishes for the formation of a prosperous society, but it appears to me that there is not much reciprocity of feeling on the part of those who would naturally take a leading part in it. However, I have done all that lay in my power.[18]

The meeting apparently went well, sufficiently so that Hunt approached the Society of Arts in April for permission to use the Society's large room for the inauguration of The Photographic Society. First, however, it was again decided to bring maximum pressure upon Talbot to relinquish his patents and some individuals threatened not even to bother about Talbot and to practice the wet-collodion professionally without a license. Upon hearing of the latter, Talbot's response was as follows:

This will give me the opportunity of obtaining the decision of a Court of Law & of showing to the world that I claim no more than I have a right to claim under the existing patent laws. Should it prove on the other hand that I have been misled by my legal advisers (whose advice I have always followed) I shall submit most readily to the Court. You cannot think how glad I shall be to have the question of my rights finally settled by a competent tribunal.[19]

As the photographic community in Britain grew, Talbot was more and more unjustly maligned although his later actions were not always faultless. New photographers cared little for events of 1839; they only knew that in their opinion photography should be free for all to practice.

In April and May of 1852 Talbot sought the advice of his uncle, Lord Lansdowne, Charles Wheatstone and (through Wheatstone) Lord Rosse, President of the Royal Society.[20] It was decided that Talbot should withdraw his patent rights (except for professional portraitists) and this should be done in an appeal from

a numerous & influential body of gentlemen representing Science and Art. . . . I should undoubtedly expose myself to ridicule by relinquishing the patent right merely because a body of artists object to it as well as to all other patents, on principle.[21]

In July 1852 Sir Charles Eastlake, President of the Royal Academy and Lord Rosse addressed a letter to Talbot already agreed upon in advance, on behalf of the "many lovers of science and art" who hoped to see more British people using cameras. They expressed regret that restrictions on photography inhibited its improvement and that other countries, notably France, had made greater strides in using the paper negative. Talbot's reply of July 30 was published together with Rosse's and Eastlake's letter in *The Times* for August 13, 1852. Part of Talbot's response was as follows:

. . . Ever since the Great Exhibition I have felt that a new era has commenced for photography, as it has for so many other useful arts and inventions. Thousands of persons now become acquainted with the art, and, from having seen such beautiful specimens of it produced in England and France, have naturally felt a wish to practice it themselves. A variety of new applications of it have been imagined, and doubtless many more remain to be discovered.

I am unable myself to pursue all these numerous branches of the invention in a manner that can even attempt to do justice to them, and, moreover, I believe it to be no longer necessary, for the art has now taken a firm root both in England and France, and may safely be left to take its natural development. I am as desirous as anyone of the lovers of science and art, whose wishes you have kindly undertaken to represent, that our country should continue to take the lead in this newly-discovered branch of the fine arts; and, after much consideration, I think that the best thing I can do, and the most likely to stimulate to further improvements in photography, will be to invite the emulation and competition of our artists and amateurs by relaxing the patent right which I possess in this invention. I therefore beg to reply to your kind letter by offering the patent (with the exception of the single point hereafter mentioned) as a free present to the public, together with my other patents for improvements in the same art, one of which has been very recently granted to me, and has still 13 years

unexpired. The exception to which I refer, and which I am desirous of still keeping in the hands of my own licensees, is the application of the invention to taking photographic portraits for sale to the public. This is a branch of the art which must necessarily be in a comparatively few hands, because it requires a house to be built or altered on purpose, having an apartment lighted by a skylight, &c. , otherwise the portraits cannot be taken indoors, generally speaking, without great difficulty.

With this exception, then, I present my invention to the country, and trust that it may realize our hopes of its future utility.

Underlining this statement are two of Talbot's most deeply held beliefs. First, he was morally obligated to Henneman whose livelihood depended chiefly on taking portraits, and second, besides portraiture, there were many other ways of earning a living with a camera. Talbot did not even seem to like portrait studios, perhaps because they reminded him of the daguerreotype and he was not disposed either to propagate or visit them.

Henneman's business began to do well only during the Great Exhibition. In 1851 he made 504 portraits compared with 92 in 1848, 133 in 1849, and 295 in 1850. For July 1851 the figure is 105 against 27 in July the year before. Henneman was the official photographer for the Great Exhibition, making all the illustrations for the three huge volumes that served as the catalogue called the *Report of the Juries of the Great Exhibition.* Talbot was presented with 15 complimentary copies of the *Report* for having waived his patent rights, but had some harsh words to say about the administrators of the Exhibition. In a letter dated October 1 he wrote, "Henneman is hard at work making photographs of the building for the Royal Commissioners and Executive Committee but they are so extraordinarily stingy notwithstanding they have a surplus of £200,000 and make such hard conditions that it is doubtful whether he will earn anything by his labour."[22] He tried to persuade the committee to increase its payments to Henneman and, when he failed, personally gave his former valet £200.[23]

Henneman's business continued to improve until 1854 when a court ruled against Talbot and established that the wet-collodion process was not covered by the 1841 calotype patent (discussed in the next chapter). The following year, 1855, Henneman took only 314 portraits compared to 833 the year before the Laroche court case. Before the decision, Henneman had valued his business at between £4000 and £5000. After December 1854 there were, he claimed, about 20 photographers on Regent Street alone and that his business was not worth more than £2000 or £3000.[24] He had so much business at the time of the Great Exhibition that he acquired premises in Kensal Green, outside central London, for the printing

of negatives. By 1855, however, he was forced to close both the London and Kensal Green operations.

Henneman was severely disappointed by the failure of his business and returned to Holland. In 1857 he was offered a job by a Canadian-born photographer, Oliver Sarony, who had settled in Scarborough. Sarony was one of the most successful photographers in England (it was estimated that he made about £10,000 a year[25]) but Henneman did not profit from the association which lasted less than two years. In December 1858 Henneman wrote a melancholy letter to Talbot from Albion Terrace, Kings Road, Chelsea, stating that he was unemployed and "necesity [sic] compels me to take the liberty to sugest [sic] some plan by which I could earn something to suport [sic] my family (a wife & four children)".[26] He offered to help Talbot develop commercially photoglyphic engraving, invented and patented in the 1850s. The letter shows Henneman despondent, not knowing where to turn or what to do. Talbot could not use Henneman's assistance, however, until the mid-1860s when he was responsible for getting negatives and glass positives from photographers such as Francis Bedford, William England, Vernon Heath, Oscar Rejlander, John Mayall and others for use in photo-mechanical engraving.

In the 1860s Henneman was working in Birmingham for a *carte-de-visite* photographer named Thrupp. From there he wrote to Talbot in an unsteady hand his most distressed letter:

[*Sic*]:
. . . *I am here in a Situation till July, I was obliged to take it as London is over stacked with photographers they advertise themself as first rate Artist at 30/[shillings] a week I do get four pound here but I am sory to say it does not suit my health I am pretty well shut up for 8 hours in a room, by stretching my arms out I can tuch the walls both ways so I cant call it a room but a Closet then all the Chemicals are kept in that I got to coat develope wash fix etc all in this place—I was in hopes of getting out of Photography by buying Mr Hallams boarding House but I lost it for want of a sum at a certain day I have been thinking of writing to your sister the Countess of Mt Edgecumbe to ask her if trough her interest at Court she would be able to get mee some kin of Situation I know they are generaly got by valets, butlers etc of noblemen . . . perhaps you would be kind enough to ask her Ladyship what she thinks about it, as for the kind of Situation of course I mean such as messenger in the Foreign Office, ther are a great many such places where there is no talent required but, the principal recommendation being trust worthy . . . I know you will if you can by any means assist me to something in that way as photography does injure my health I must try to get out of it before it is too late The Doctor told me three or four years ago it was to trying for my constitution. . . .*[27]

Although Henneman's role in the early days of photography is only partially known, it is apparent that the medium he helped nurture in the end failed to support him. But in this respect, he was not alone. Talbot in the 1850s was involved in harsh legal battles concerning his patents that left him embittered and uninterested in making photographs and in the people who now preoccupied themselves with photography. For him, as for Henneman, the invention they worked so diligently to develop was truly a positive and negative one.

7.

"The Farthest Reach of the Future"

Talbot, like many other Victorians, seems to us to have done too much in his lifetime. Perhaps, as Steiner suggests, he needed less sleep, but why did he work quite so hard all those waking hours? The answer is in his letters and papers. They reveal a man consumed by the idea of cultural evolution and the advancement of civilization. If mankind's intellectual and technological needs were not in his power to satisfy, who else would fulfill those needs? It was the responsibility of the upper-class Victorian to provide leadership in all areas and also set a high moral tone, so that good would prevail over evil. The pursuit of "truth" was a righteous and popular occupation. "Truth," it should be noted, came in the form of answers to practical questions—new machinery, mathematical proofs, derivations and definitions of words, rules of behavior, technology. The 19th century gentleman did not work for the sake of work alone. His efforts had to take shape in a book, scientific paper, poem, butterfly collection. Recognition of such contributions was the greatest reward he could hope for.

Talbot's earliest years were spent on the country estates of his family and friends, houses hundreds of years old and possessing vast libraries holding volumes heavy in human wisdom. As a boy he was forced to devour these texts, literally make them part of himself. But not only had he a great deal of history to learn, he also had to know exactly how far advanced was human understanding of nature. How else could he fulfill his obligation to take it one (or two or three) steps further? To know as much as possible about those things that seemed vital and significant was the key to a meaningful life. Inspiration to do creative work derived from a rich tapestry, meticulously structured, of one's own acquired knowledge. For Talbot, and those like him, judicious study and stringent dedication to completing one's own self-defined tasks resulted in continual affirmation of the beauty of life and the meaning of human existence.

His education taught him to memorize theories, phrases and formulae. It was designed to help him learn to concentrate and have confidence in his own abilities. He and his peers were made to believe that with "a little application" they could do almost anything. What the Victorians called "application" we today might term mental anguish. True, 150 years ago it was possible to acquire a much larger percentage of the information then available than it is today, but still the tasks set by some of these learned gentlemen were formidable. Talbot's life, however, was ordered to maximize his time for contemplation and thought. His income came not from his labors but from the tenants who worked his land and from his

investments; his children were cared for by a governess; servants catered to his needs; Constance had her rightful duties and rewards. The Abbey was set in a pleasant rural environment. Holidays were spent in areas of even greater natural beauty than Lacock—the Lake District, the West Country—but were still considered times for productive activity. Building a sand castle with his children would have been an exercise in understanding engineering principles. Talbot's work was also his pleasure. When the two are inseparable, with "a little application" plus, preferably, a little genius as well, perhaps one could get a good night's rest and still make prodigious contributions to society.

There was no period in Talbot's adult life that he did not do concentrated work resulting in scientific or literary papers or patented inventions. In the 1850s, for example, even faced with frustrating law suits, he still made major contributions in photography, Assyrian translations, mathematics and most importantly, photo-engraving.

In June 1851 Talbot showed a wide-eyed audience at the Royal Institution his method for producing instantaneous photographs. He took a picture of a piece of printed paper fastened upon a wheel that was made to revolve as rapidly as possible. This was the first successful attempt on record to make a split-second photograph. He did it by using an electric discharge to light the moving subject, foreseeing the eventual rise of the electronic flash. He wrote a complete description of the method for the December 6, 1851, issue of *The Athenaeum* under the title "On the Production of Instantaneous Photographic Images." In the second paragraph he stated: "From this experiment the conclusion is inevitable, that it is in our power to obtain the pictures of all moving objects, no matter in how rapid motion they may be, provided we have the means of sufficiently illuminating them with a sudden electric flash." Talbot then described how he sensitized the albumenized glass plates for the experiment, to which he gave the name amphitypes because they appear either positive or negative, according to the light in which they were held. Talbot spoke of the amphitypes in a letter to Herschel as an "intermediate between the Daguerreotype process, and photography on paper, and partakes of the nature of both." On June 12, 1851, he applied for a patent for both his method of making amphitypes and for taking high-speed photographs.

The last purely photographic invention was "The Traveller's Camera" of 1854. The invention delighted Talbot far more than its merits seemed to deserve. He had always maintained that the "traveller" or non-studio photographer wanted much greater convenience in his camera equipment than early inventions could provide. When the hand-camera finally became a popular item in the 1880s,

the thousands who immediately took up photography proved him to be right. Talbot's "Traveller's Camera" was a single unit composed of the camera and two tanks, one containing a solution of nitrate of silver for sensitizing the glass plate and the other tank containing gallic acid to develop the negative. It was designed to eliminate carrying the cumbersome dark tent and other paraphernalia needed by a wet-plate photographer; everything needed was contained in a compact unit. (The plates were relatively small and if Talbot had continued in photographic research he probably would have devised an effective enlarging device. Many of his photographic discoveries are logical extensions of prior ones.)

The "Traveller's Camera" was given freely to the public; for the first time Talbot did not patent what he considered a practical (as opposed to purely scientific) invention. His attitude towards the medium as it evolved was becoming progressively more cynical, his desire to photograph was abating and his belief in the merit of patenting inventions was waivering.

In the 1830s and 1840s, no one displayed more vision and understanding of photography than Talbot. From 1851 to 1854, however, he was gripped by a preoccupation concerning it that caused immeasurable harm to his public image. In his desire to be recognized as the inventor of negative/positive photography, he argued that Scott Archer's wet-collodion process was fundamentally the same as his calotype process and thus covered by his patent. Operating under this assumption, he felt justified in prosecuting any photographer who without a license sold portraits on paper made from a developed negative. In the Talbot *v*. Colls case of 1852, Talbot angered many people, but still his right to bring an injunction against a professional portraitist using calotype without a license seemed to be within the terms of the law. When, however, he attempted the same action against those using the wet-collodion, many people protested.

In April 1854 a man was sent by Talbot's solicitors to the photographic studio of John Henderson on Regent Street. He requested that his portrait be taken and the photographer complied. A month later Henderson received a Bill of Complaint alleging that he had infringed on the patent of William Henry Fox Talbot. It was necessary for Talbot and his lawyers to provide evidence as to the merit of their complaint, so before the injunction was granted to Talbot on May 26, he had submitted affidavits sworn by Nicolaas Henneman, Sir David Brewster and Sir John Herschel in support of his case. Since November of the previous year Talbot had been asking various individuals if they would come to his defense if he was forced to take "infringers" of his calotype patent to court. The statements Talbot sought on the affidavits were a) Talbot was the inventor of the calotype process

ON THE PRODUCTION OF INSTANTANEOUS PHOTO-GRAPHIC IMAGES.

[From the *Athenæum*.]

It will probably be in the recollection of some of your readers that in the month of June last a successful experiment was tried at the Royal Institution in which the photographic image was obtained of a printed paper fastened upon a wheel, the wheel being made to revolve as rapidly as possible during the operation.

From this experiment the conclusion is inevitable, that it is in our power to obtain the pictures of all moving objects, no matter in how rapid motion they may be, provided we have the means of *sufficiently* illuminating them with a sudden electric flash. But here we stand in need of the kind assistance of scientific men who may be acquainted with methods of producing electric discharges more powerful than those in ordinary use. What is required, is, vividly to light up a whole apartment with the discharge of a battery:—the photographic art will then do the rest, and depict whatever may be moving across the field of view.

I had intended to communicate much earlier the details of this experiment at the Royal Institution, but was prevented from doing so at the time,—and soon afterwards I went on the Continent in order to observe the total solar eclipse of the 28th of July. This most interesting phenomenon I had the pleasure of witnessing at the little town of Marienburg, in the north-eastern corner of Prussia. The observations will appear, I believe, in a forthcoming volume of the Transactions of the Royal Astronomical Society. Among other things, I was enabled to make a satisfactory estimate of the degree of darkness during the total obscuration; which proved to be equal to that which existed one hour after sunset the same evening, the weather being during that evening peculiarly serene, so as to allow of a just comparison.

This Continental journey having effectually interrupted my photographic labours, I have only recently been able to resume them. I shall, therefore, now proceed to describe to you exactly the mode in which the plates were prepared which we used at the Royal Institution: at the same time not doubting that much greater sensibility will be attained by the efforts of the many ingenious persons who are now cultivating the art of photography. And it is evident that an increased sensibility would be as useful as an augmentation in the intensity of the electric discharge.

The mode of preparing the plates was as follows.—

1. Take the most liquid portion of the white of an egg, rejecting the rest. Mix it with an equal quantity of water. Spread it very evenly upon a plate of glass, and dry it at the fire. A strong heat may be used without injuring the plate. The film of dried albumen ought to be uniform and nearly invisible.

2. To an aqueous solution of nitrate of silver add a considerable quantity of alcohol, so that an ounce of the mixture may contain three grains of the nitrate. I have tried various proportions, from one to six grains, but perhaps three grains answer best. More experiments are here required, since the results are much influenced by this part of the process.

3. Dip the plate into this solution, and then let it dry spontaneously. Faint prismatic colours will then be seen upon the plate. It is important to remark, that the nitrate of silver appears to form a true chemical combination with the albumen, rendering it much harder, and insoluble in liquids which dissolved it previously.

4. Wash with distilled water to remove any superfluous portions of the nitrate of silver. Then give the plate a second coating of albumen similar to the first; but in drying it avoid heating it too much, which would cause a commencement of decomposition of the silver. I have endeavoured to dispense with this operation No. 4, as it is not so easy to give a perfectly uniform coating of albumen as in No. 1. But the inferiority of the results obtained without it induces me for the present to consider it as necessary.

5. To an aqueous solution of prot-iodide of iron add *first* an equal volume of acetic acid, and then ten volumes of alcohol. Allow the mixture to repose two or three days. At the end of that time it will have changed colour, and the odour of acetic acid as well as that of alcohol will have disappeared, and the liquid will have acquired a peculiar but agreeable vinous odour. It is in this state that I prefer to employ it.

6. Into the iodide thus prepared and modified the plate is dipped for a few seconds. All these operations may be performed by moderate daylight, avoiding however the direct solar rays.

7. A solution is made of nitrate of silver, containing about 70 grains to one ounce of water. To three parts of this add two of acetic acid. Then if the prepared plate is rapidly dipped once or twice into this solution it acquires a very great degree of sensibility, and it ought then to be placed in the camera without much delay.

8. The plate is withdrawn from the camera, and in order to bring out the image it is dipped into a solution of protosulphate of iron, containing one part of the saturated solution diluted with two or three parts of water. The image appears very rapidly.

9. Having washed the plate with water it is now placed in a solution of hyposulphite of soda; which in about a minute causes the image to brighten up exceedingly, by removing a kind of veil which previously covered it.

10. The plate is then washed with distilled water, and the process is terminated. In order, however, to guard against future accidents, it is well to give the picture another coating of albumen or of varnish.

These operations may appear long in the description, but they are rapidly enough executed after a little practice.

In the process which I have now described, I trust that I have effected a harmonious combination of several previously ascertained and valuable facts,—especially of the photographic property of iodide of iron, which was discovered by Dr. Woods, of Parsonstown, in Ireland, and that of sulphate of iron, for which science is indebted to the researches of Mr. Robert Hunt. In the true adjustment of the proportions, and in the mode of operation, lies the difficulty of these investigations; since it is possible by adopting other proportions and manipulations not very greatly differing from the above, and which a careless reader might consider to be the same, not only to fail in obtaining the highly exalted sensibility which is desirable in this process, but actually to obtain scarcely any photographic result at all.

To return, however, from this digression.—The pictures obtained by the above-described process are negative by transmitted light and positive by reflected light. When I first remarked this, I thought it would be desirable to give these pictures a distinctive name, and I proposed that of *Amphitype*, as expressive of their double nature,—at once positive and negative. Since the time when I first observed them, the Collodion process has become known, which produces pictures having almost the same peculiarity. In a scientific classification of photographic methods, these ought therefore to be ranked together as species of the same genus. These Amphitype pictures differ from the nearly related Collodion ones in an important circumstance, viz., the great hardness of the film and the firm fixation of the image, which is such that in the last washing, No. 10, the image may be rubbed strongly with cotton and water without any injury to it; but, on the contrary, with much improvement, as this removes any particles of dust or other impurity, and gives the whole picture a fresh degree of vivacity and lustre. A daguerreotype picture would be destroyed by such rough usage before it was completely fixed and finished.

In examining one of the Amphitype pictures, the first thing that strikes the observer is, the much greater visibility of the positive image than of the negative one; which is at least in the proportion of *ten* to *one*,—since it is not rare to obtain plates which are almost invisible by transmitted light, and which yet present a brilliant picture full of details when seen by reflected light.

The object of giving to the plates a second coating of albumen, as prescribed in No. 4, is chiefly in order to obtain this well-developed positive image; for it is a most extraordinary fact, that a small change in the relative proportions of the chemical substances employed enables us at pleasure to cause the final image to be either entirely negative or almost entirely positive. In performing the experiment of the rotating wheel the latter process must be adopted; since the transmitted or negative image is not strong enough to be visible unless the electric flash producing it be an exceedingly bright one.

I now proceed to mention a peculiarity of these images which appears to me to justify still further the name of Amphitype, or, as it may be rendered in other words, "ambiguous image." Until lately I had imagined that the division of photographic images into *positive* and *negative* was a complete and rigorous one, and that all images must be of either the one or the other kind. But a third kind of image of a new and unexpected nature is observed upon the Amphitype plates. In order to render this intelligible, I will first recall the general fact that the image seen by transmitted light is negative and that by reflected light positive. Yet, nevertheless, if we vary the inclination of the plate, holding it in various lights, we shall not fail speedily to discover a position in which the image is positive although seen by transmitted light. This is already a fact greatly requiring explanation. But the most singular part of the matter is, that in this new image (which I call the *transmitted positive*), the brightest objects (viz. those that really are brightest, and which appear so in the *reflected positive*) are entirely wanting. In the places where these ought to have been seen, the picture appears pierced with holes, through which are seen the objects which are behind. Now, if this singularity occurred in all the positions in which the plate gives a positive image, I should be satisfied with the explanation that the too great brightness of the objects had destroyed the photographic effect which they had themselves at first produced. But since this effect takes place in the *transmitted positive* but not in the *reflected positive*, I am at a loss to suggest the reason of it,—and can only say that this part of optical science, dependent upon the molecular constitution of bodies, is in great need of a most careful experimental investigation.

The delicate experiment of the revolving wheel requires for its success that the iodide of iron employed should be in a peculiar or definite chemical state. This substance presents variations and anomalies in its action which greatly influence the result. Those photographers, therefore, who may repeat the experiment will do well to fix their principal attention upon this point. It is also requisite in winter to warm the plates a little before placing them in the camera. In pursuing this investigation, I have been much struck with the wide field of research in experimental optics which it throws open. By treating plates of albumened glass with different chemical solutions, the most beautiful Newtonian colours, or "colours of thin plates," may be produced. And it often happens that the landscapes and pictures obtained by the camera present lively though irregular colours. These not being in conformity with nature are at present useless; with this exception, nevertheless, that in many pictures I have found the colour of the sky to come out of a very natural azure blue. I hope soon to have the leisure requisite for pursuing this very interesting branch of inquiry, and in the mean time I venture to recommend it to the notice of your scientific readers.

I am, &c.,

H. F. TALBOT.

Nov. 27.

JAMES HOLMES, TOOK'S COURT, CHANCERY LANE.

Reprinted from *The Athenaeum,* December 6, 1851.

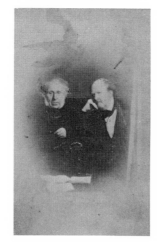

Sir David Brewster and
Talbot taken by J. Moffat
with magnesium light,
March 1864.

Sent to Mr. Bailey by Sir David Brewster the day after taken

Sir David Brewster and Fox Talbot — one of the first Photographs taken by the Magnesium Light — March 1864. The portrait of Mr. Fox Talbot is the first he ever sat for. ——

and the collodion process involved the same scientific and photographic principles as the calotype process, both having as their final result a positive photograph on paper; b) the development of a latent image was a leading feature of the calotype process; c) development of a latent image was a new idea. Another point that Talbot asked Herschel to comment on was Herschel's use of gallic acid in photography as early as 1839. This was important as Henderson's defense included an affidavit from Robert Hunt mentioning that both Herschel and the Rev. Joseph Bancroft Reade, a Fellow of the Royal Society, the Royal Astronomical Society and a founding member of the Microscopical Society, had used gallic acid in photography before the plaintiff, thus throwing in doubt Talbot's right to patent the calotype process in the first place.[2] Herschel, whose friendship for Talbot was still strong, could in good conscience make a sworn statement only on certain points in question. He was willing to state before the court that he "did not use Gallic Acid for the purpose of developing a dormant picture" and that he considered the leading feature in the calotype process to be the discovery of the latent image and a mode of making it visible. He said that "such invention was a new one to the best of my judgment and belief, and that it was of great importance in Photography and that it has continued to be used by Photographers ever since the time of its publication."[3] He wisely refrained, however, from any mention of the wet-collodion process, declaring that he knew very little about it and that he could not tell if a wet-plate photographer used parts of Talbot's process or not.

Even though Herschel did not discuss the collodion process in his affidavit, Brewster and Henneman did, and the three statements were sufficient for the Vice Chancellor to rule that an injunction should be made against

Henderson preventing him from selling paper photographic portraits. The injunction stated that Henderson was "restrained under the penalty of five thousand pounds . . . from in any manner using exercising or putting in practice the invention of the plaintiff . . . or resembling the same or any part thereof, in the preparation of portraits . . . or selling any photographic portraits on paper . . . until further order of the Court."[4] The inclusion of the words "resembling the same or any part thereof" were quite out of the ordinary and led Henderson to believe he had grounds to contest the case.

The case of Talbot *v.* Henderson was not heard immediately because Talbot was involved in yet another legal tangle. In May 1854 Talbot had commenced an action against Martin Laroche. Laroche was a volatile man who had no intention of allowing Talbot to stop him from engaging in his profession of portraitist using the wet-plate method. Laroche wrote a letter on June 27 to the editor of *The Photographic Journal*, the official publication of The Photographic Society, which stated that he had requested his solicitors to enter a caveat against Talbot's application for an extension of his 1841 patent (patents were granted for fourteen years and Talbot had just applied to renew it). He hoped that he would "meet with the well-wishes and support of all who are interested in the art of photography," which he did. Laroche's letter was discussed at length in the Society and published in *The Photographic Journal* for July 21 with comments by many of the Society's members. After the Henderson injunction was awarded, there appeared in the press the following harassing notice:

Photographic Portrait—Collodion process—CAUTION-Talbot v. *Henderson—His honour Vice Chancellor Wood has this*

day issued an injunction to restrain the defendant from making and selling Photographic Portraits by the above process without the license of the patentee. . . . All infringers of the patent rights will be proceeded against.[5]

Professional portrait photographers took their stand firmly behind Laroche in his action against Talbot. Most of them did not moderate their contempt for Talbot, unlike Roger Fenton, first Secretary of the Photographic Society. A highly respected professional photographer specializing in landscape, architecture and copying of works of art and thus not bound by any patent restrictions, he was reported as saying that:

he felt much respect for Mr. Talbot's persevering researches, and for the great services which he had rendered to the art, and would have gladly assisted in any plan by which their sense of those services could have been manifested. He thought, that had it not been for this claim to the monopoly of the collodion process, the Society was so far bound by the concession made at the commencement of its existence (by which the patent was abandoned, with the exception of its use for taking portraits), that it would not have expressed an opinion as to the validity of the patent, nor opposed its renewal, but the circumstances were now widely altered.[6]

John Mayall, the successful American daguerreotypist working in England, said that in his opinion the credit for the invention of photography should go to the Rev. Reade and that the Society should never, at the commencement of its existence, have made any compromise "between Mr. Talbot's claims and the independence of the art." He proposed that the Society as a body enter a caveat against Talbot's renewal of his patent.

Mayall could not have objected to patents on principle as he himself had the previous year been granted one for a device to make a particular type of vignette daguerreotype portrait.[7] Perhaps he was indirectly arguing that in the 1850s the second generation of inventors should be free to make their mark. Daguerre's patent for England expired August 14, 1853. Mayall had operated his daguerreotype business under license since he arrived in England in 1846 and was probably tired of restraints. He had none to contend with when he worked in Philadelphia and undoubtedly did not want any when he started making collodion portraits.

At the same meeting at which Mayall aired his views, a Mr. Marshall was reported as saying "that when a man was placed in a position in which the acquisition of wealth was not of importance to him, and endowed with abilities of a high order, those talents were given to him as a trust which he was bound to administer for the benefit of his fellow-men, and that it was wrong and selfish for any one so placed to take out a patent at all."[8] As much as this sounds like reverse bigotry and religious eccentricity, he was not entirely misguided. Considering Talbot's true goals in life, it would have been better had he not bothered with patents at all. In later years they only provided the grounds for accusing Talbot of "bad will" toward the photographic community.

Finally it was decided that the Council of the Photographic Society should "forward a memorial to the Privy Council, in deprecation of any extension of existing, or alleged existing patents relative to Photography, upon the ground that many processes are claimed in the patents, which have been invented subsequently to the sealing of such patents."[9] In the end, the Society stood behind Laroche and against Talbot.

The case of Talbot *v.* Laroche was heard before a jury between December 18 and 20, 1854. It was to determine if Talbot was the inventor of the calotype process and thus had the right to patent it, and secondly, to determine if the use of the wet-collodion to make portraits for sale was an infringement of Talbot's patent. The star witness for the defense was J. B. Reade who testified that he did photographic experiments using galls (gallic acid, an essential part of Talbot's process) in 1837. The date was actually 1839 as conclusively argued in the study of the Rev. Reade in *J. B. Reade and the Early History of Photography* by Derek Wood, but for those gathered in the courtroom, it was damaging evidence given by a respected scientist against Talbot. (In later years Dr. Hugh Welch Diamond, a physician who specialized in caring for the mentally ill and an early photographer himself, said that "Mr. Reade was given to hallucinations.")[10] This "startling" courtroom declaration preceded the next key witness for the defense, Andrew Ross, a lensmaker. He stated to a hushed audience that in 1839 the Rev. Reade told him that he made a discovery of the use of galls in photography. When Talbot was then cross-examined and asked if he had heard via Ross that Reade was using galls in his photographic experiments in 1839, he stated that he had. Great excitement broke out in the courtroom and Talbot's enemies considered they had won a great battle. What these passions obscured was that Talbot's claims were based on the use of gallic acid to *develop a latent image.* (He had purchased it, for some purpose, as early as 1834.) Reade had not used gallic acid in this manner and so, when the final decision in the case was handed down, it stated that Talbot was "the first and true inventor within the meaning of the patent laws." All the other evidence on the properties of gallic and pyro-gallic acid (used as a developer in the wet-collodion process), and on the other similarities shared by the two methods led to the decision that Archer's method was substantially different from Talbot's and that Laroche was not guilty of any infringement.

Why should such passions be raised concerning Tal-

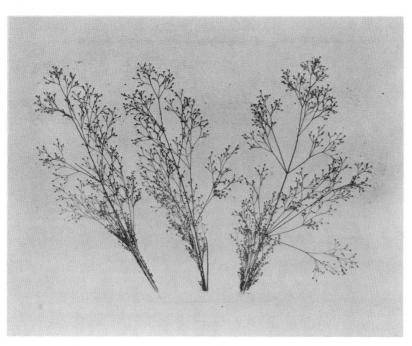

Example of earliest type of photoglyphic engraving, without ground, pre-1852.

bot's legal rights? It was not even Talbot but rather Daguerre who set the precedent of photographic patents in England. Why, then, when hundreds of other inventions were being protected without protest, were his photographic patents considered to be such a notable exception?

A patent protects an invention for only one reason: it allows the inventor to exploit and profit from it. The drive to make money, so clearly expressed by many photographers, was absent from Talbot's whole character. His station in life, his upbringing, his goals made it impossible for him to operate successfully as an entrepreneur. If English photographers who wanted to become commercial had seen an effort on the inventor's part truly to promote photography, bring it dramatically to the public, even get rich by it, they probably would have wished him well. What they observed, however, was that Talbot wanted the patents to protect something much more fundamental. Talbot sought recognition as the inventor of the most far-reaching method known of capturing light rays and converting them to pictures. He had every right to take out his patents, but it was not the way to gain the commendation he so justly deserved. "The owl of Minerva begins its flight when dusk is falling."

Businessmen were best suited to take the invention to every community. Because they were interested in profits, the license awarding 25 percent of their income to the patentee was naturally a deterrent. They were also unsure as to how successfully the calotype would compete with the already proven daguerreotype portrait. And although Talbot believed that science and technology ought to support the inventor who needed to earn a living directly from his discoveries, by patenting the calotype he essentially kept photography in the hands of the upper classes who practiced it as a hobby. Although it was not as costly to make calotypes as daguerreotypes, it was still an expensive pastime if one had no hope of reimbursement. And the recording of those thousands of faces for whom no artist would raise pencil, pen or brush was the most viable livelihood for a photographer.

For Talbot, the "idea" of photography was always of utmost importance. His true interest became apparent when he argued that the wet-collodion process was covered by his patent: he failed to realize that it had been granted not for his "idea," but for his process. He also, in this instance, proved himself to be hypocritical. Although he often publicly wished independent inventors well, he sometimes belittled their contributions or claimed (sometimes justly, sometimes not) that their contributions were not original but borrowed from his own. This same situation developed again two years after the Laroche case in relation to Talbot's immensely important invention of photoglyphic engraving.

Talbot started seriously experimenting to find ways of photographically etching printing plates in 1850 or 1851, a subject he had given thought prior to this time. Distressed that his salted paper prints often faded, he sought to make a permanent print that could be produced in large quantities. The application to book illustration was apparent and enticing. Difficult as the task before him was, he had good results within months and is considered by experts both in America and Europe to be the man who laid the foundation for halftone reproduction technique and photogravure. It is remarkable that Talbot not only invented photography as we know it today, but also the means of printing photographs by the millions. Dr. D. B. Thomas, Keeper, Science Museum, London, put Talbot's achievement in perspective when he said

One of the banes of the early photographers was the fading of their calotype or albumen photographs. This serious drawback gave rise to pigment processes in which the image is made not of silver but of a permanent pigment. The basis of all pigment processes is the discovery made by W. H. F. Talbot in 1852 that gelatin sensitised with potassium bichromate changes its physical character on exposure to light....[11]

And Eugene Ostroff, Curator of Photography, Smithsonian Institution, Washington, D.C., said in his definitive two-part article on the history of photomechanical reproduction:

Talbot ingeniously overcame this primary obstacle [tonal fi-

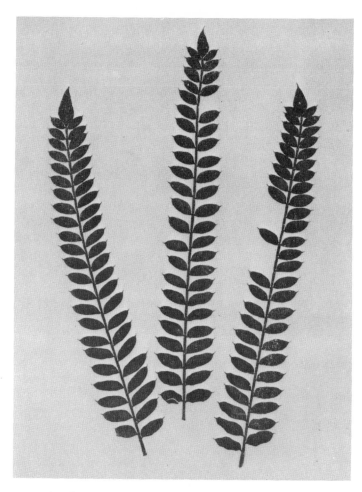

Example of photoglyphic engraving with resin ground, made between 1852–1864.

delity] by introducing the concept of contact, cross-line screens to produce, in the printing plate, ink-holding elements sufficiently small that ink would be protected during the ink-wiping operation. These and other features introduced by him established the basis of photogravure as we know it today.[12]

Ostroff uses the term "photogravure" to mean "those methods which divide an image—usually a continuous tone—into a uniform or random pattern of tiny components for printing purposes." Photogravure is an intaglio process (ink is carried in the etched depressions on the plate) of which the halftone process is the most commonly known.

Being able to provide a good tonal range in order to give fullness and depth to the picture was Talbot's most difficult problem. In a letter to Herschel he mentions this fact:

I enclose a trifling specimen of my new invention of photographic engraving on steel—It is a camera view of the Pantheon at Paris. At first the Camera pictures offered great difficulty in the Engraving, in consequence of halftints being imperfectly given (because the degradation of light on the Steel plate follows quite a different law from what it does in a common photograph). We are gradually getting over this, and if I only had time at my disposal I should soon I have no doubt arrive at something more worth showing to you. On this specimen can be read with a lens the inscription Aux grande Hommes la patrie reconnaissante.[13]

The invention, as outlined in the patent "Engraving" dated 1852 called for a steel plate to be coated with a solution of potassium bichromate and gelatin. Aquatint was used on the plate before an object or a positive transparent photograph (usually on glass) was placed on it and exposed to light. The unhardened (unexposed) emulsion was washed away with water, then the plate was dipped in alcohol and dried. It was then etched with platinum chloride.

Also described was a method of making a "screen" on the prepared printing plate by exposing it first to a number of layers of gauze or other finely woven fabric laid in a crisscrossing pattern before it was exposed to the final subject. By using this cross-line screen small "cells" were created that held the ink during the "wiping off" stage. The plates were printed on normal presses like plates etched by hand. The procedure, although theoretically sound, did not always work well in practice.

When Talbot did get good impressions, he sent examples to friends and colleagues who commented, in most cases, favorably on the new technology. Roger Fenton said, "I hope that the honour of finally solving this question [fading photographs] will by your researches be won for this country. It would be a rare good fortune for the same hand to have commenced & completed the structure of the photographic art."[14] Robert Hunt commented that "they are exceedingly delicate and beautiful and even in its present state the process appears applicable for many very important purposes."[15] And Herschel said "this great step will render possible the *publication* of miniature books—even of miniature facsimiles of original Mss &c.&c. and I congratulate you on having arrived at so great a result in itself independent of the innumerable applications which it is capable of."[16] The ability to produce permanent photographic prints thrilled Talbot, the antiquarian who dedicated much of his life to the study of "remains," parts and pieces, phrases and fragments left by one civilization in trust to another. That the "sun picture" could now be permanent and mass produced (like books) gave the middle-aged inventor great satisfaction.

Talbot's original method of making photoglyphic engravings was unreliable and he continued to experiment in order to find a procedure that would assure high quality

and consistent results. Again, through ingenious experimentation, he developed a considerably improved method for making photomechanical reproductions. Copper as well as steel was used for the printing plates. To etch them he used ferric chloride, a much less expensive compound than bichloride of platinum. To break up the image on the plate, he dusted onto the emulsion a small amount of finely powdered copal and, unlike his earlier process, used three baths of different strengths to etch the plate. This gave him more control and resulted in plates that had a good range of tone. The resulting prints were suited to book illustration and thus had a good commercial value. He again took out a patent but before doing so, he had many conflicts to resolve.

Prior to the Laroche and Henderson court cases, Talbot believed it was appropriate for him to patent particular inventions. In 1852, for example, he felt certain that photoglyphic engraving should be protected by law. After the legal entanglements, however, in 1854, he began to realize the difficulty in both precisely defining one's invention and also of defending it against infringers. In 1856 he was again faced with a situation in which he felt someone was infringing his patent for photoengraving. He now was wary of legal confrontations and proceeded very cautiously. In two letters to his friend William Robert Grove, a distinguished barrister, later a judge, and a scientist of note, he expressed his dilemma.

Athenaeum [Club]
Wedny Dec 17

Dear Grove

I had no time to mention to you, when I met you accidentally on Tuesday evening, that some troublesome business had brought me to Town for a few days; in short, that I am again compelled to contemplate taking legal proceedings against certain persons who are infringing a patent belonging to me—I have little doubt that on perusing this, your first impulse will be to advise me to abandon the patent in question, to whatever subject it may relate—I am aware of your strong opinions upon this subject, and they have had considerable weight with me in coming to a decision upon this question.—I was until lately the possessor of two patents, which have not been hitherto the subject of any legal proceedings whatever, and which have not been brought under your notice, although you are perhaps acqainted with one of them, viewed as a matter of Scientific discovery—When the time came for paying the fee to government on these patents (at the end of the 3d year) I resolved to abandon one [of 1851] of these patents and retain the other [of 1852]. This may be viewed as a compromise of opinion—I did not go entirely to the lengths you appeared to advise, but I adopted your opinion to a great extent—The patent which I have retained, relates to improvements in engraving—This invention cost me a good deal of time & trouble, (but I do not complain of that, for that is generally the case with all inventns

[sic] that are worth anything) and I took a patent for it in October 1852. When I had done so (it is the old story ever again) other parties came forward resolved to profit by my invention; and they have formed a company & taken out a patent [referring to Paul Pretsch who invented an electroengraving process which he patented in England in 1854 as Photogalvanography and set up a company to print plates in 1856]—Their specification is published and has been sent to me. It contains the chief part of my own invention, from which it is evidently borrowed—It takes about half of my patented process, and then conducts the engraving very differently. I first consulted Carpmael [Talbot's patent advisor] about this matter who informed me without hesitation it therefore was a clear case of infringement. I then wrote a friendly letter of remonstrance to the patentee (knowing a little of him previously). He replied very civilly, but decidedly, that he felt sure he had a right to employ my invention, provided he did so for a different pur-

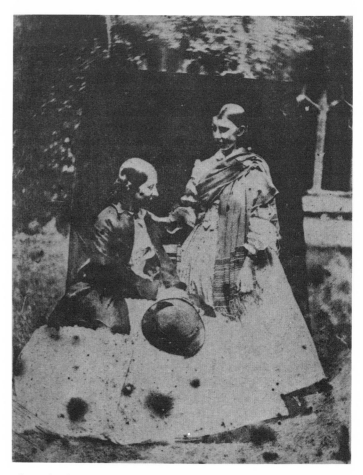

Photoglyphic engraving made from a photograph of Talbot's daughters probably taken by Talbot in the cloisters at Lacock Abbey in the mid-1850s. Normally, Talbot borrowed other photographers' negatives (i.e., Bedford, England, Nottage, Blanchard, Vernon Heath, Rejlander, Mayall) to make positives on glass, necessary for his engraving process.

pose. *I am assured that such is not the law—Moreover, the* purpose *is substantially the same,* viz. *to procure beautiful engravings of complicated objects. According to the best judgment we can form, the patent right is a valuable one—I trust therefore that you approve of my intention of vindicating my right to it—I will not trouble you further on the subject at present, as I shall have other opportunities.*[17]

Thursday

Dear Grove
Having a great deal of writing to do this evening before I leave Town, I cannot accept your kind invitation to dinner—In your letter you do not advert to the fact that the patent in question was taken by me long before either your advice to me or my own experience—The question is, whether having taken it I shall support it or not—It should seem that the answer to that question must depend on circumstances. Is it worth supporting or not? Is it a scientific curiosity or an important new manufacture? Upon these points you shall receive information.[18]

Talbot did not want to create a situation whereby the photographic and scientific communities would be forced again to take sides in the determination of the rights of the claimants. Also, he wanted to make it very clear to Paul Pretsch that he felt no malice toward him, that indeed it was not a personal matter at all. He did not want to bring the issue into court immediately as he himself had done very little, due to poor health and a desire to further improve the process, to establish an industry based on the invention. Pretsch had, on the other hand, set up a company—the Patent Photogalvanographic Company—and was producing illustrations. Roger Fenton was one of its executives and in 1856, for example, the company began to produce *Photographic Art Treasures* printed from intaglio copper plates made by Pretsch's own patented process. Talbot started a correspondence with him saying he had no wish "to deprecate your ingenious experimentation but merely to establish my own rights in the matter as an inventor" and said he was "desirous of proceeding in the most amicable manner."[19] Talbot suggested the possibility of Pretsch taking out a license from him, but in truth, he was more concerned about recognition than any sum gained. Pretsch replied in a letter that it would be best if their respective lawyers settled the questions between them and closed by expressing sincere admiration "for your most valuable labors." The Patent Photogalvanographic Company could not sustain its substantial financial losses, and it was forced to close in 1857, but this turn of events was not because of Talbot's claim.

Talbot's invention came most noticeably to the attention of the public in the fall of 1858 when the *Photographic News,* under the editorship of the brilliant young

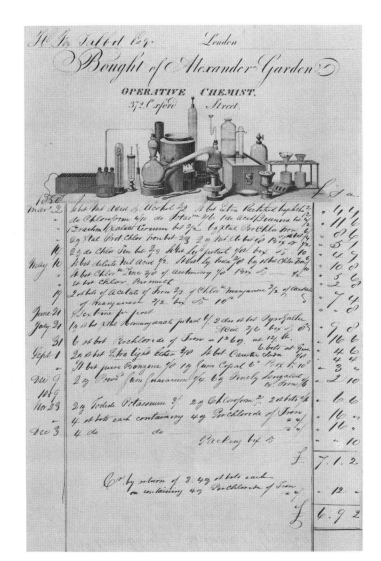

Bill from 1858 for chemicals purchased by Talbot
from Alexander Garden.

physicist and chemist William Cookes, ran an article in its October 22 issue on photoglyphic engraving followed three weeks later by actual examples. Quite a novelty for the year 1858! The examples chosen were all from photographs by Soulier and Clouzard (Talbot almost always solicited other people's photographs for his photoglyphic engravings; he himself rarely, if ever, photographed) of seven architectural subjects taken in Madrid, Seville, Granada, Vallodolid, Prague and Paris. On September 16 of the following year another reproduction was issued with the journal, a picture of the Tuileries in Paris. The only other time a photoglyphic engraving was produced and distributed was in 1863 for a report published by Charles Piazzi Smyth, Astronomer Royal of Scotland and

himself an accomplished photographer. The picture was Mount Guajara in Tenerife.

Talbot realized the significance of photoreproduction and continued to experiment until his death. In the early 1860s he still wanted to establish a printing company and hire Henneman in some professional capacity. A financial enterprise was not, however, sufficient enticement to keep him from becoming more and more absorbed in spectral analysis, committed once again to mathematical research and devoted to the study of ancient Assyrian texts.

Talbot challenged himself constantly. Every solution he derived generated tenfold new questions. When an idea or an event fascinated him, he forgot all else and dedicated himself to it. (Constance once wrote to her husband: "I rather think you must have indulged too much in your fasting propensities—I know that you forget to eat when you are busy—& get exhausted before you are aware. . . .")[20] Behind the closed doors of a study, Talbot could be the passionate and gallant knight saving that fairest of all maidens—"Truth"—from a life of obscurity and darkness. He was an astonishing man with a superior capacity for integrated, concentrated and original thought.

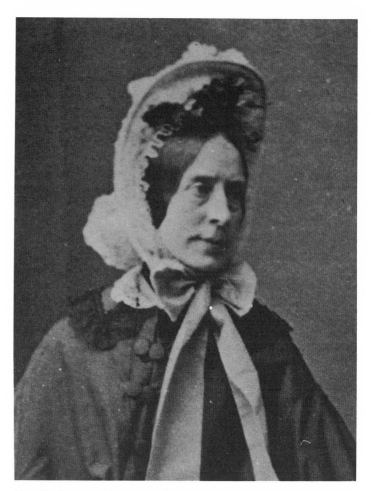

Detail of a carte-de-visite of Constance Talbot, c. 1860 by the Edinburgh photographer E. W. Dallas.

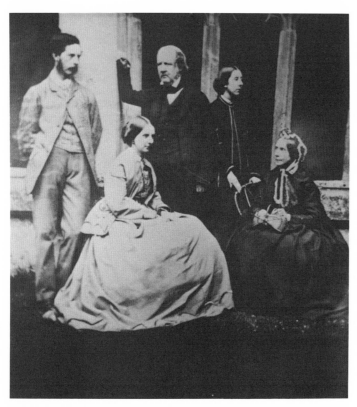

Photographer unknown. A family portrait in the cloisters, c. 1866. *L-R.* Charles Henry, Rosamond, Henry, Ela, Constance.

Metaphysics served his spiritual needs and the icons of his belief were the manifestations of nature: the stars and the moon, nightingales, crystals and the leaves of plants. Daily he needed time for quiet, meditative thought ("The meeting of the B. Association is a brilliant one, but I get easily tired with the racket and with talking to people.")[21] He needed to be, he liked to be, alone.

Talbot's children did not possess his brilliance and his son, Charles Henry, seemed even to rebel, in a 19th century manner, against his father's values. Not an exceptional student, as the time came for him to attend Cambridge, he developed a condition which he claimed made it difficult for him to concentrate or to read at any length. Doctors suggested plenty of physical activity with little mental exertion. He appeared lazy. Talbot wrote to the Master of Trinity College concerning his son:

He is often unwell, but even when well he finds himself almost incapacitated from reading. It is a thing to be pitied

116

and not blamed for it does not arise from idleness. Never having experienced anything of the sort myself, I cannot well understand his state of mind. He says "I experience a complete want of mental energy—the effort of serious thinking is what I cannot stand; and the attempt to do so confuses my head."[22]

Not thinking seriously was not living for the elder Talbot. He could have hardly understood his own son, yet his words show tenderness and love.

At the time of his death in September 1877, Talbot was completing an Appendix to the English edition of *A History and Handbook of Photography* by G. Tissandier edited by John Thomson. He had been asked to comment on his contributions to photography and photoengraving. Photographers and printers were using the derivatives of his inventions but few remembered, or even cared particularly, how their medium began. When John Thomson himself walked around the streets of London focusing his camera on the street life he saw, he was trying to capture something "real" about the way working class people survive in London town. He did not need to ask what was the ultimate nature of the photograph as Talbot had to. Thomson needed to concern himself only with the subject and the problems (both technical and artistic) inherent in making a picture. When, for example, Timothy O'Sullivan and Alexander Gardner had photographed dead bodies on the bloody battlefields of Antietam and Gettysburg less than 25 years after the discovery of the calotype process, they used their equipment like the soldiers used their guns—hoping it would do the job. Who invented photography and how it came into being was not pertinent. When Carleton Watkins, William Henry Jackson or Eadweard Muybridge climbed a peak in the great American West with their weighty apparatus and saw the sun breaking through the clouds and the whole world flooded with light and "God's hand" so apparent in the perfection of the landscape, they had enough to do to approximate and interpret the magnificence in front of them. Theirs was a sufficiently rare and personal experience, and they did not need to ask questions about the origin of their medium when they were trying to pay homage to the origin of the world. Julia Margaret Cameron, a contemporary of Talbot, had her own ideas about the nature of photography: "My aspirations are to ennoble photography and to secure for it the character and uses of High Art by combining the real and the ideal and sacrificing nothing of Truth by all possible devotion to Poetry and beauty."[23] She wrote these words to Herschel in 1861, only twenty-one years after he had received a letter describing another noble struggle—Talbot's attempt to capture some of those "Solar rays" before they "pass away in space."

Within Talbot's lifetime, photography had come to mean many different things to different people. Dr. Dia-

mond made calotype portraits of the mentally ill and Nadar recorded brilliantly, on wet-collodion plates, the most notable Frenchmen of his day. Beginning in the 1850s, Oscar Rejlander and Henry Peach Robinson made pictures that were designed to elevate the viewer's sentiments whereas nothing could be more mundane than the millions of *cartes-de-visite* that were handed from friend to friend. Roger Fenton, after genteely documenting Russia, the Crimean War, English architecture and landscape, made pristine still lifes of meticulously arranged flowers, fruits and ceramics. These contrast markedly with the horrifying images of human skeletons strewn on the grounds of the Secundra Bagh in Lucknow

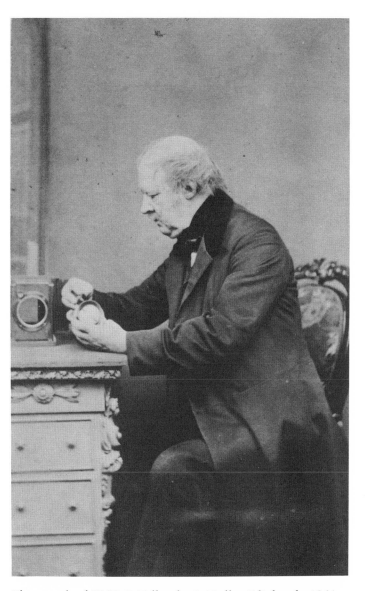

Photograph of W. H. F. Talbot by J. Moffat, Edinburgh, 1864.

made by Felice Beato in 1858 after the Indian Mutiny or the pictures of the victims of the Madras Famine of 1876-1878 by William Willoughby Hooper. The importance to scientific research of the early photographs of the moon and of microbes equalled the substantial changes that occurred in art history with the mass distribution of photographic copies of works of art.

During Talbot's lifetime, Alfred Stieglitz was born. So were Eugène Atget, F. Holland Day, Jacob Riis, Lewis Hine, August Sander, Gertrude Käsebier, Clarence White, Edward Curtis, Arnold Genthe, Hugo Erfurth. Masters of the medium, they helped to define and direct photography as it entered the 20th century. Yet they probably barely recognized the name Fox Talbot or knew what his photographs—the very foundation of camerawork—looked like.

Talbot's photographs are "a little bit of magic realized." They are not Cameron's "inner man," Robinson's "high art," Gardner's "battlefield," Stieglitz's "equivalents" nor Hine's "good and bad." They are pieces of paper blatantly soaked in chemicals. They are weird and wonderful "sun pictures"; they are artifacts. They were not made with any obligation either to subject or to form. They are unexpected images; they surprise; they are quiet and sometimes they reach depths of great intensity. They are about light (*photo*) forming two-dimensional patterns (*graph*), yet they move the viewer in the same way that, throughout time, certain works on paper, canvas or cave walls have moved us. It is not because they necessarily manifest fine technique, sophistication or artistry. It is because they present themselves in an original and vigorous manner. They are examples of a vision that "in some sense goes to the farthest reach of the future."

The photographs in this book were made by someone who (up to a certain time) had never seen another person's photographs. That in itself would make them an interesting subject to study, but knowing that Talbot, a strange genius who did not care about "conventional rules of Art" was the force behind them, makes the investigation enormously challenging. A cultured man, Talbot's sense of pictorial composition was obviously developed by an awareness of fine painting. His recurring use of natural forms in his pictures was related to his love and study of botany. But his personal search, crossing all disciplines, was for a more integrated society where the scientist, the artist and the historian would appreciate and be inspired by the others' discoveries. He was thrilled that photography might play an integral role in this cross-fertilization of ideas. Talbot's invention is the start of modern visual communications, of a new way of seeing and thinking about the world. The photographs in this book are the first examples of this very special blending of nature and technology, scientific principles and artistic expression. As a group, these first impressions by William Henry Fox Talbot represent the powerful and poetic beginning of a new age.

SUN PICTURES

The photographs in the following section are reproduced the same size as the original unless dimensions are given in the caption (vertical first).

Photographs for which there is additional explanatory material are identified by an asterisk in parenthesis (*). The notes for these photographs are found on page 193.

A caption that appears in quotations is Talbot's own description of the particular photograph.

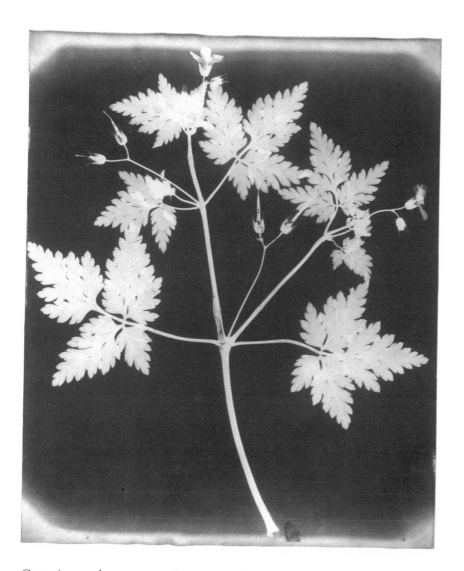

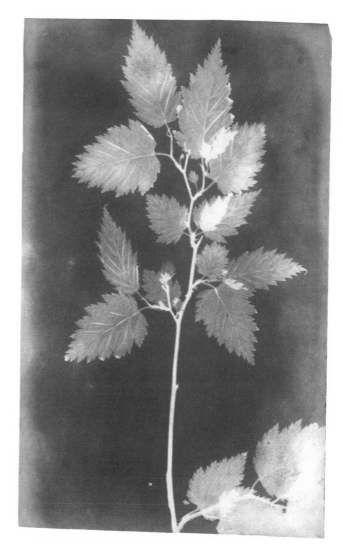

Geranium robeutanum, photogenic drawing, c. 1839, 9 × 7½ in.

Photogenic drawing, c. 1839, 4½ × 3½ in.

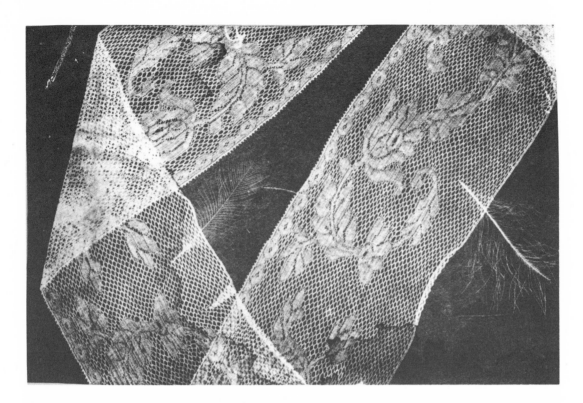

A ribbon of lace
and feathers, c. 1839,
size unknown.

"Fly's wings"
photomicrograph made with
the solar microscope, probably
January 11, 1840, 4 × 5 in.

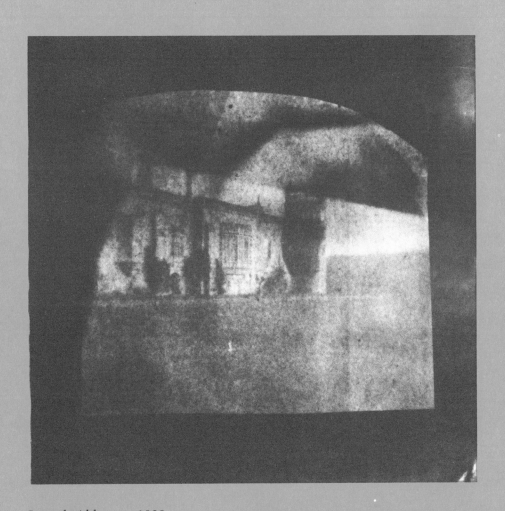

Lacock Abbey, c. 1839.

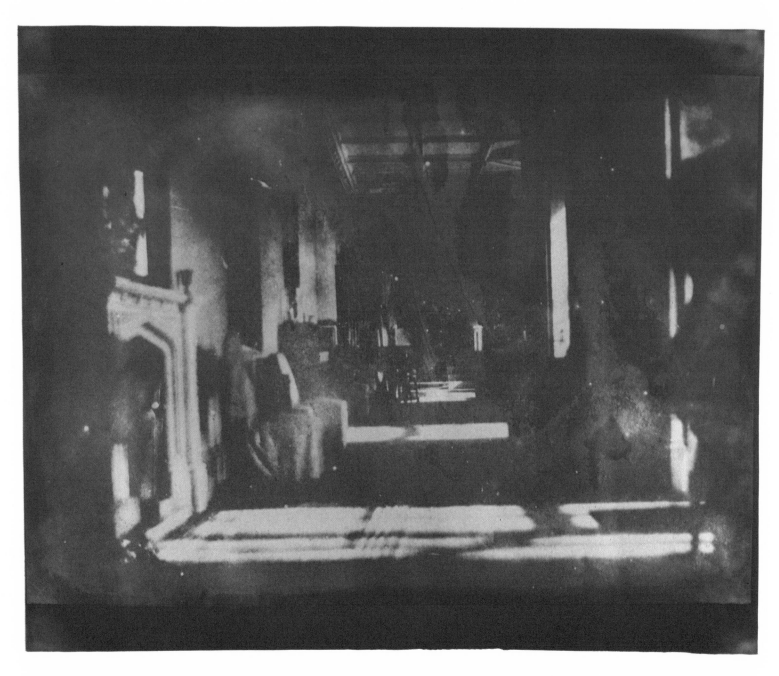

"Interior S. Gallery" Lacock Abbey, November 23, 1839 or March 2, 1840, 7⅜ × 9 in.

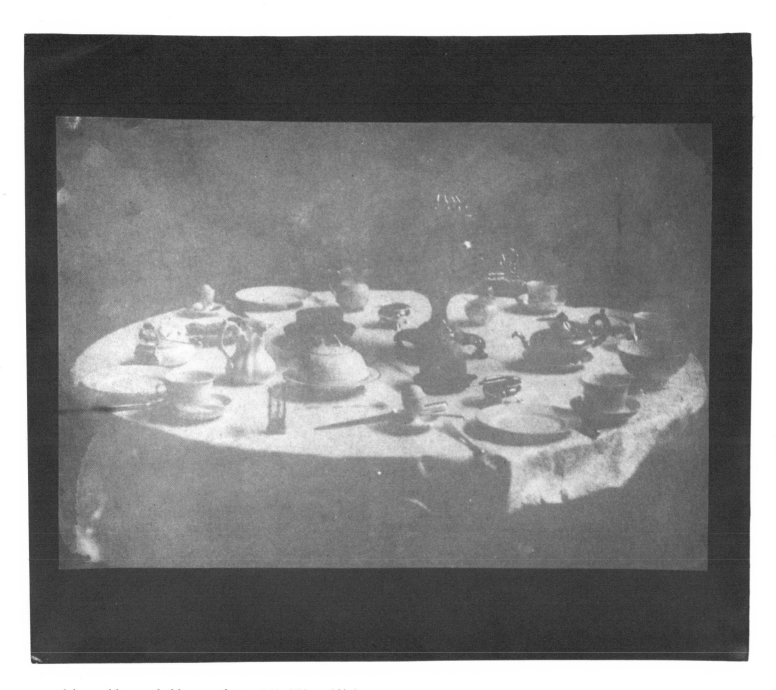

"Breakfast table" probably March 2, 1840, 7¾ × 8¾ in.

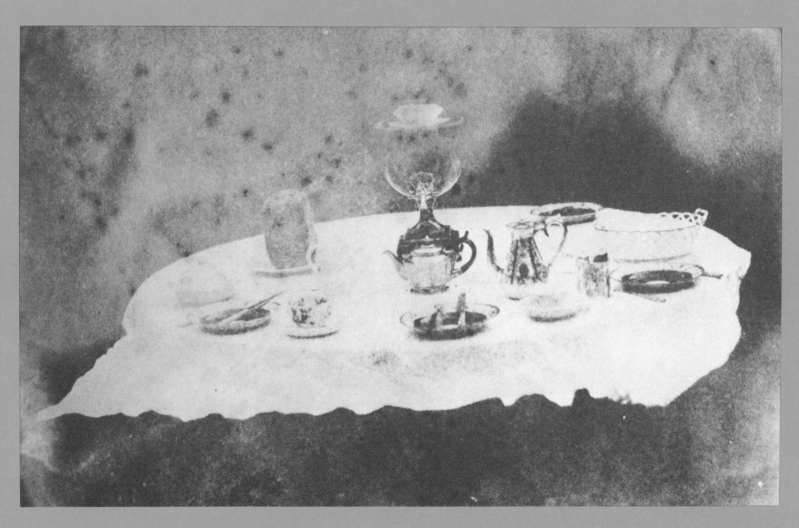

"Table, Urn, etc." probably April 16, 1840.

"Large Patroclus"
probably February 29, 1840,
7⅜ × 9 in.

"Vase with Medusa's head"
May 22, 1840 or August 4, 1840,
7¼ × 9 in.

"Wheel & c." February 24, 1840, 7⅜ × 9 in.

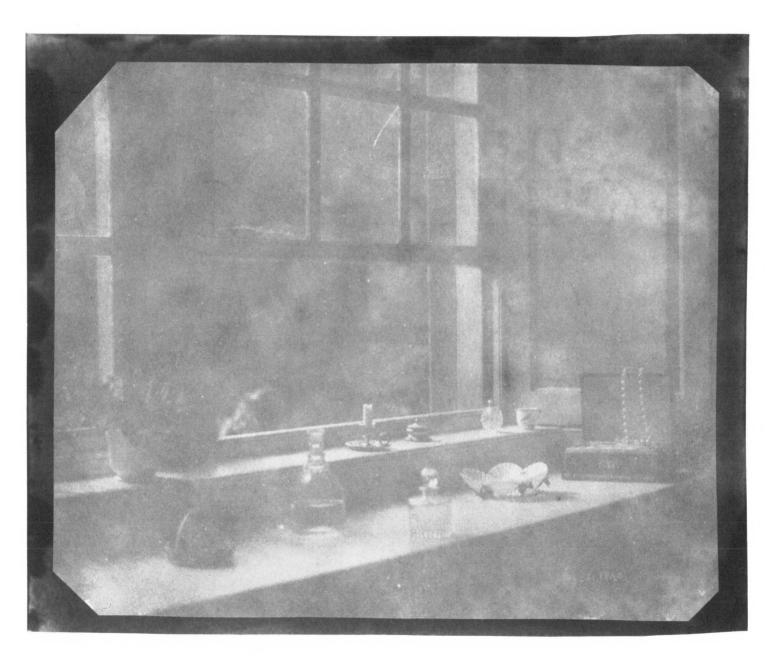

"Windowseat" dated May 30, 1840, 7¼ × 8⅞ in.

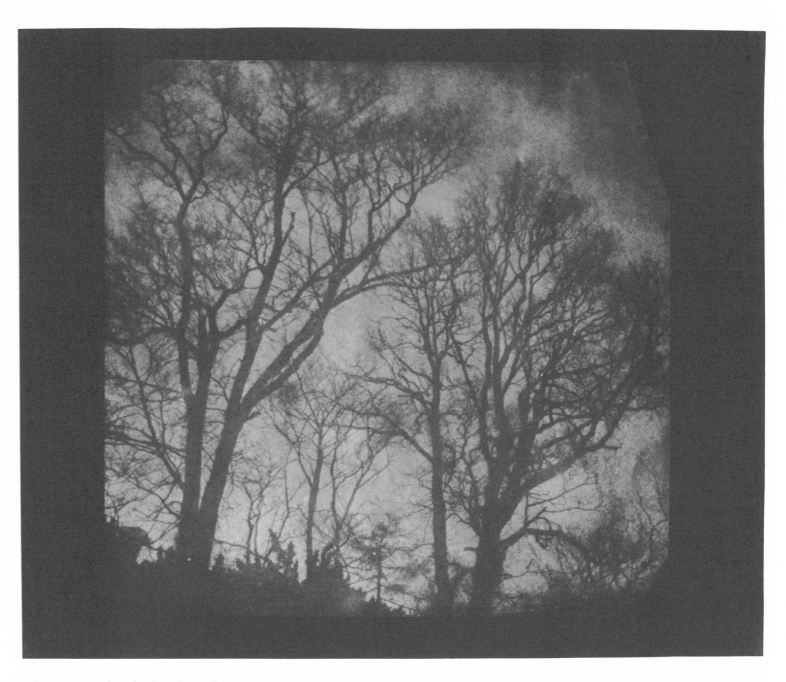

"Tree in woodyard" dated April 5, 1840, 6¾ × 6¾ in.

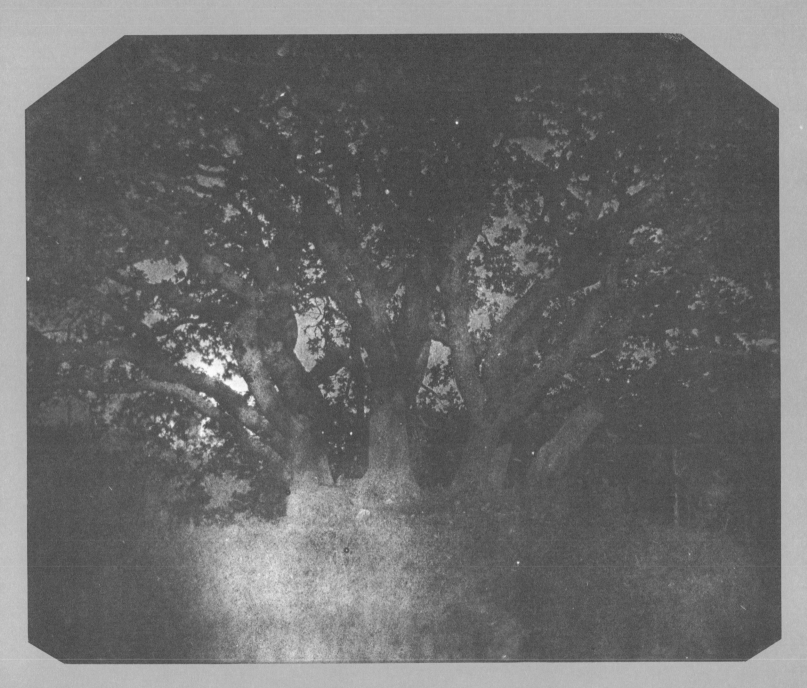

"Group of trees. . ." probably June 1, 1840, 7¼ × 8⅞ in.

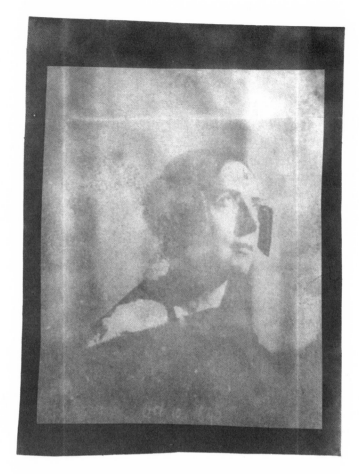

"C's [Constance] portrait, 30" blue glass"
dated October 10, 1840. This is the earliest
confirmed photographic portrait on paper.

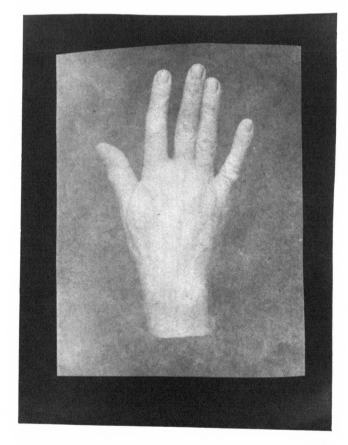

Hand, c. 1841.(*)

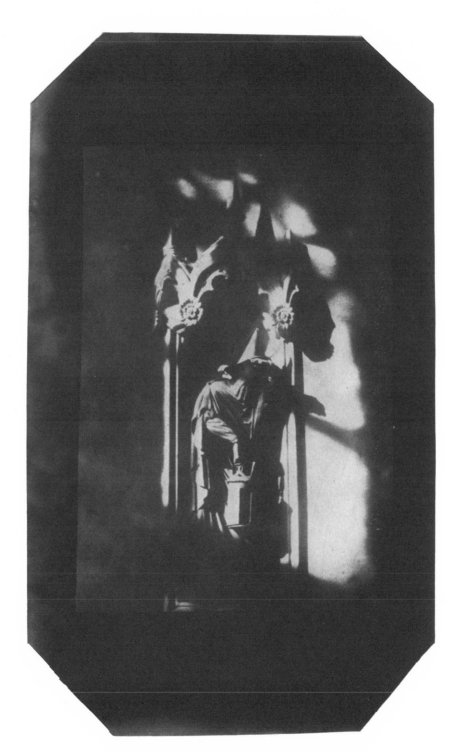

"Diogenes small
with g. [gallic acid]"
September 29, 1840.

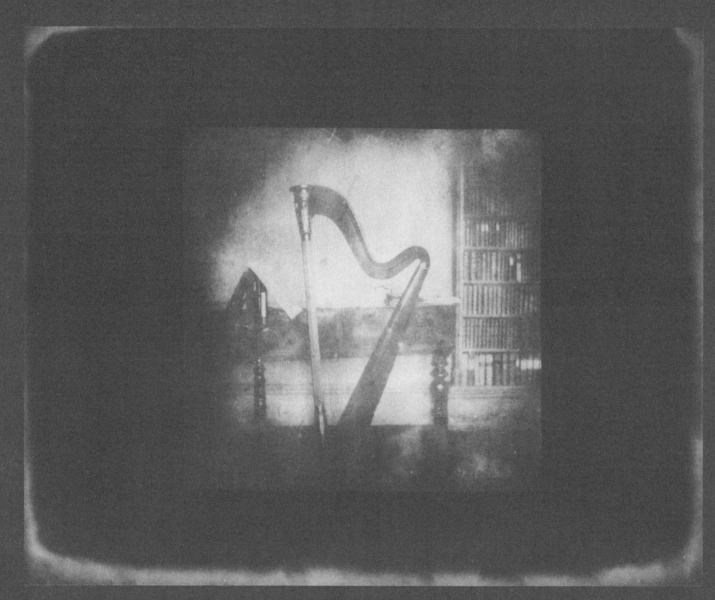

"Harp" 21 minute exposure, dated October 16, 1840, 5 × 5⅛ in.

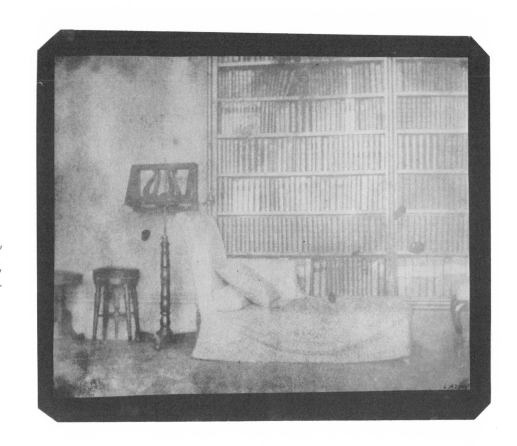

"Chintz chair"
probably May 3, 1840,
7⅜ × 9 in.

"Eve" dated April 29,
1840, 6¼ × 7¾ in.

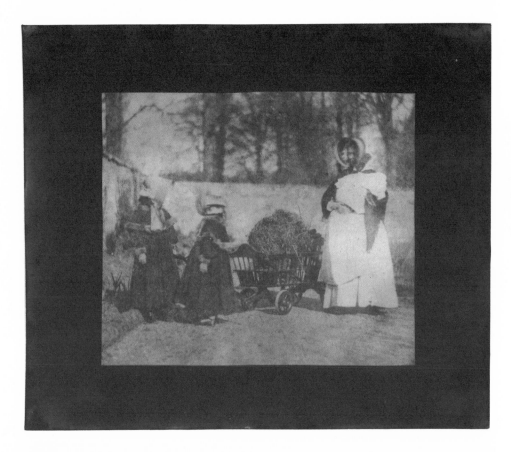

Talbot's daughters and infant
Charles Henry carried by nursemaid,
dated April 5, 1842, 7⅜ × 8¾ in.

Group on lawn, probably summer
of 1841, 6⅝ × 8 in.(*)

Lady Elisabeth on *chaise longue,* dated April 20, 1842, 7¹/₁₆ × 8¹¹/₁₆ in.

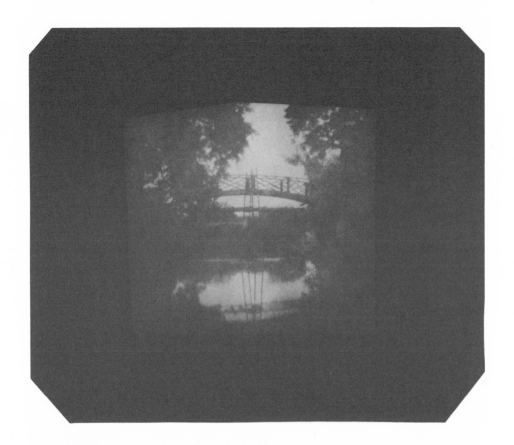

"Bridge, with ladders small"
dated August 24, 1840, 7⅛ × 8½ in.

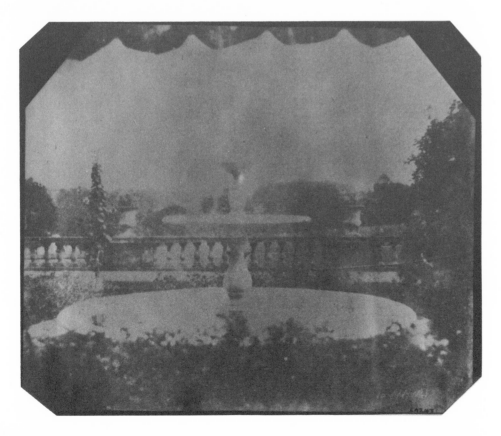

Fountain,
dated September 16, 1841, 7¼ × 9 in.

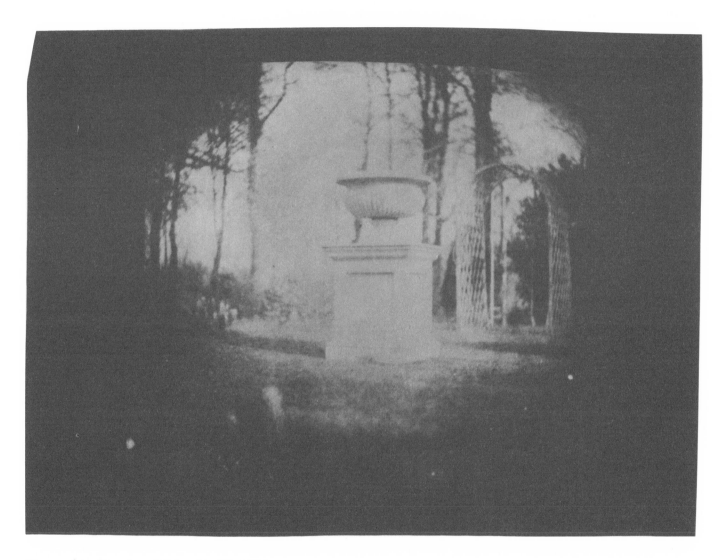

Urn and trellis, dated February 22, 1841.

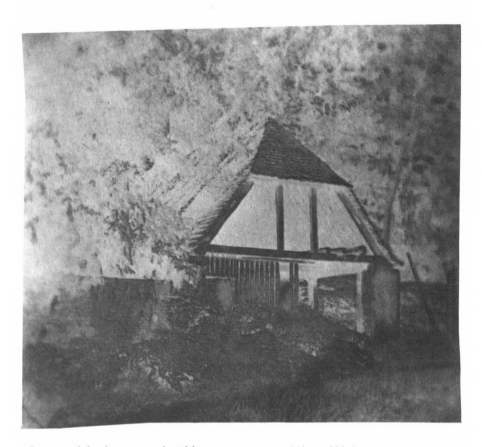

The woodshed at Lacock Abbey, a negative, 3¼ × 3¾ in.

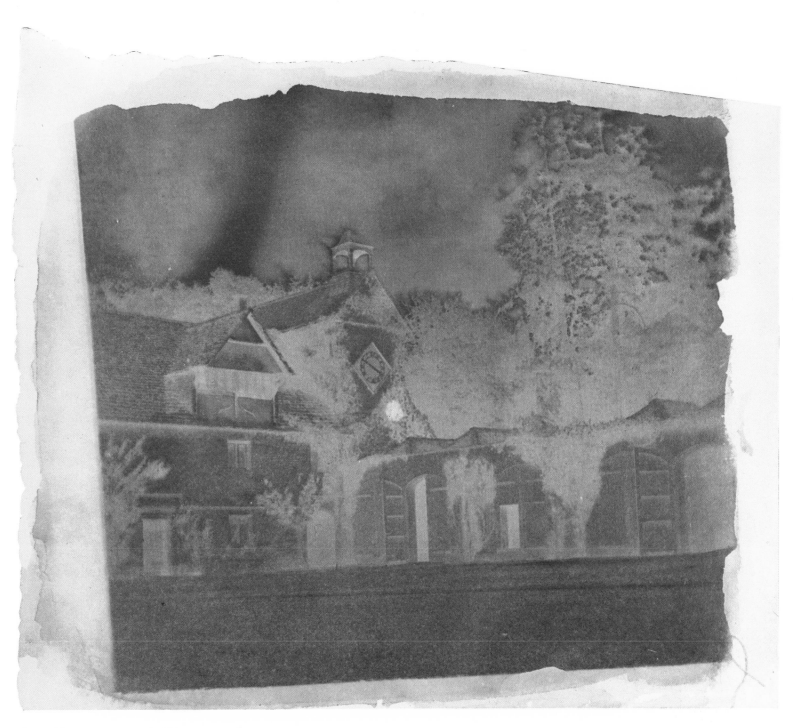

The stable court at Lacock Abbey, a negative.

Part of Lacock Abbey,
c. 1841, 6¾ × 8³/₁₆ in.

Trees and chapel
at Carclew dated August 30, 1841,
4½ × 7½ in.

"Chapel at Carclew," August 30, 1841, 7⅜ × 9 in.

Rev. Calvert Jones.
"Statue of the fawn bound.
Naples May 31, 1846
7 minutes hot sun," 6³/₁₆ × 8¹³/₁₆ in.

Rev. Calvert Jones.
"Villa Reale Naples, May 30, 1846.
Five minutes; Good sun.
No diaphram," 6³/₁₆ × 8³/₈ in. (*)

Paris intersection, May 1843, 7½ × 8¾ in.

"The Boulevards of Paris" May 1843.

Suspension bridge,
Rouen, May 1843.
Negative and positive,
5¾ × 8 in.

"The Harbour at Rouen" May 16, 1843.

Cathedral, Orleans,
June 14–17, 1843, 7¼ × 8⅞ in.

Cathedral, Orleans,
June 14–17, 1843, 6⅜ × 8 in.

Henry VII Chapel, Westminster Abbey, London.

"China on four shelves"
a negative, 6 × 7³/₁₆ in.

Glass on four shelves,
a negative, 5¾ × 8 in.

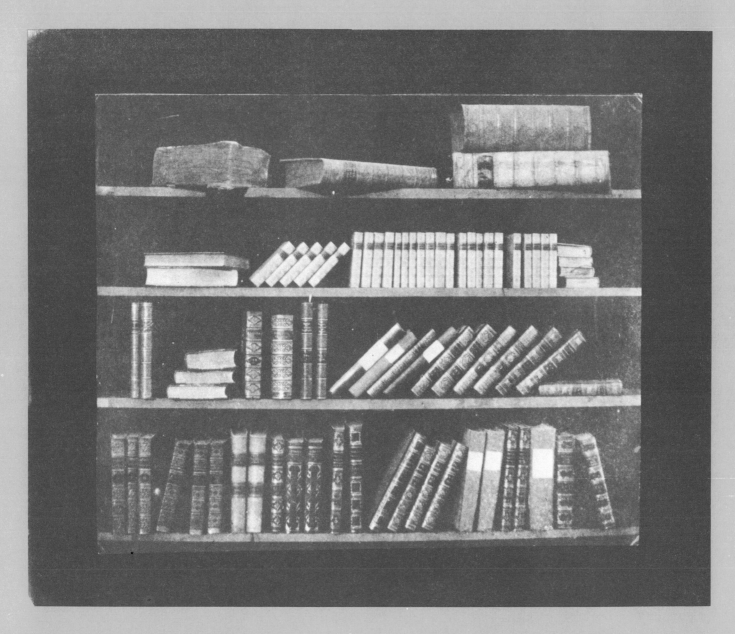

Books on four shelves, 7⅜ × 8⅞ in.

Broom and shovel, 7¼ × 8⅞ in.

Rake and basket
dated February 23, 1841,
5⅞ × 8⅝ in.

"The Broom" (title unconfirmed).

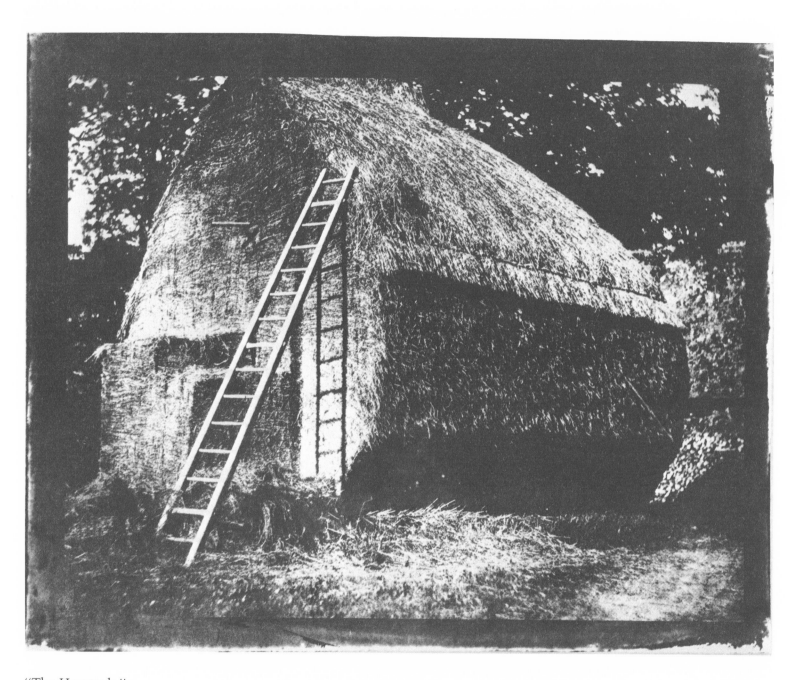

"The Haystack."

156

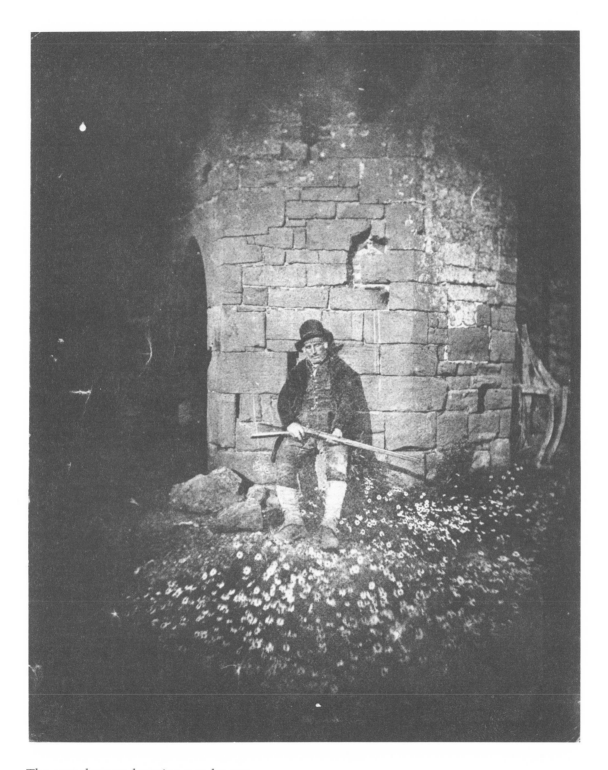

The gamekeeper, location not known.

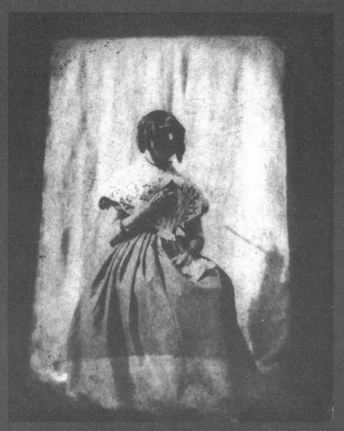

Possibly Caroline.

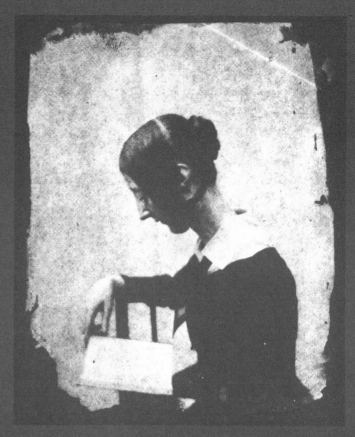

Horatia reading.

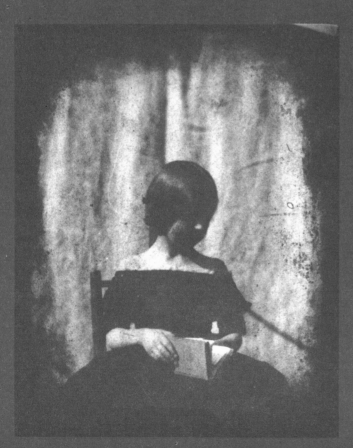

Ela (?) holding book, probably 1842, 4½ × 3⅝ in.

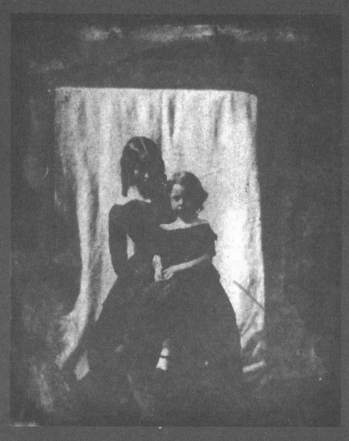

Rosamond and unidentified woman,
probably 1842, 4½ × 3¾ in.

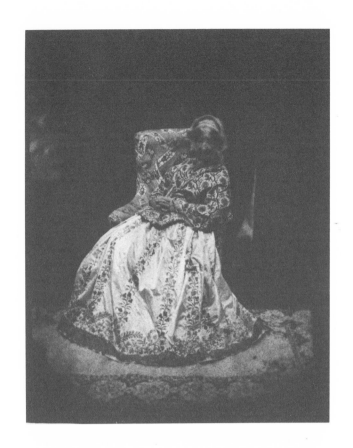

Lady Elisabeth,
probably October 25, 1844,
4¾ × 3¾ in.

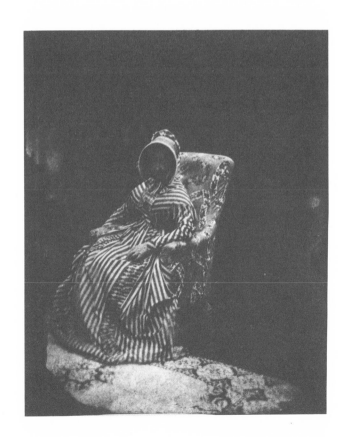

Lady Elisabeth,
c. 1844, 4½ × 3¾ in.

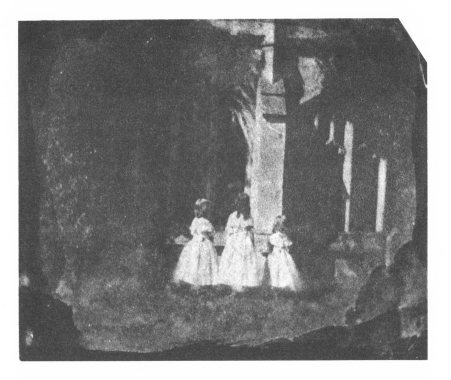

Rosamond, Ela and Matilda, 1843.

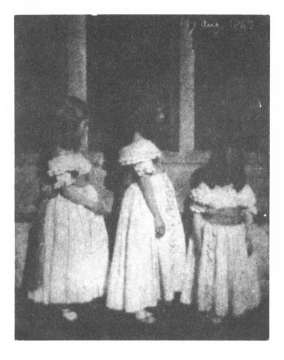

Rosamond, Ela, and Matilda
dated August 17, 1843.

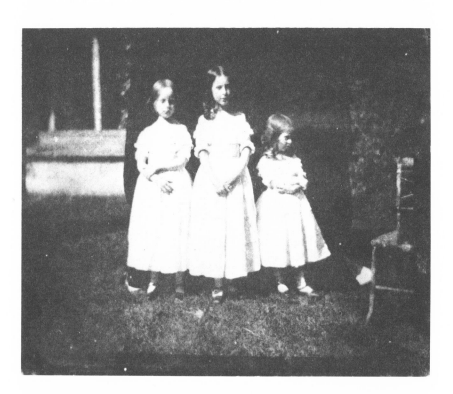

Rosamond, Ela and Matilda, 1843.

Matilda dated August 17, 1843.

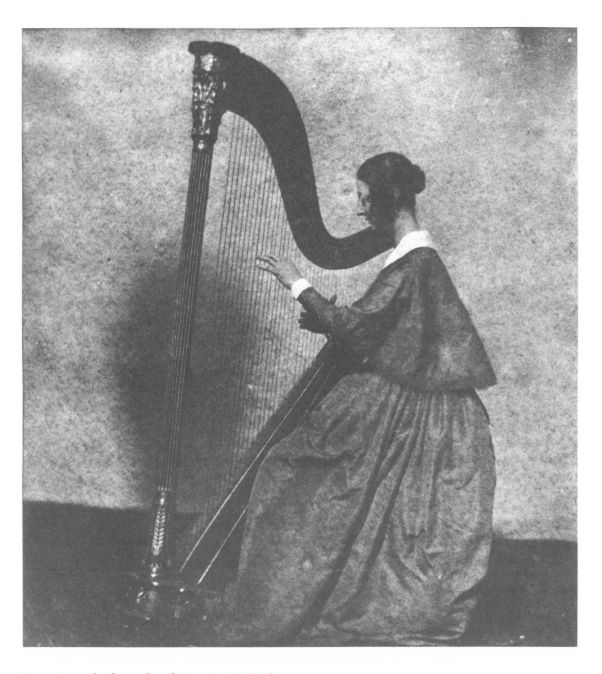

Horatia at the harp dated May 1, 1843 (*)

Kit Talbot and
Lady Charlotte Talbot
at Lacock Abbey,
c. 1844, 6⅝ × 8 in.

Kit Talbot, Lady Charlotte
his wife, and their son
at Lacock Abbey,
c. 1844, 6⅝ × 8 in.

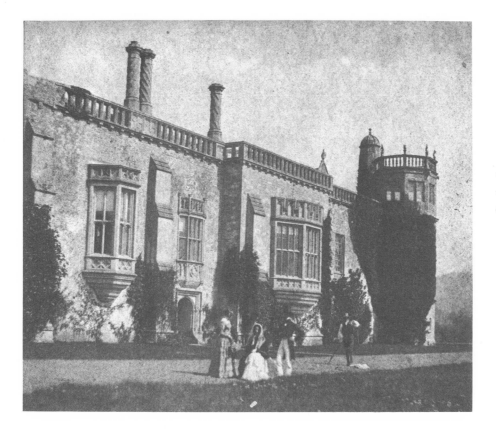

"South Front of Lacock Abbey"
with Sharington Tower at rear,
6¾ × 8 in.

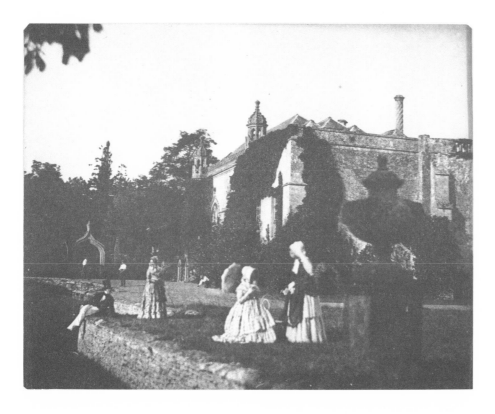

Family group and gardeners
on the south-west front
of Lacock Abbey, 6½ × 8¼ in.

Man on bridge.

Man and woman
by side of water.

"Mount Edgcumbe Battery" a view toward Plymouth, Devon, probably September 1845.

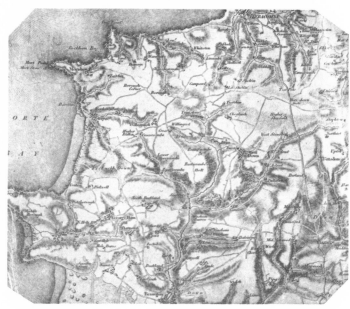

Map of the
Ilfracombe area, Devon,
6⅞ × 8⅛ in.

Toy locomotive.

A copy of a plate
from a botanical treatise,
8⅜ × 6⅛ in.

"The Three Graces."

Porcelain doll.

Rocking horse at Lacock Abbey.

"Two Deer."

"Dancing Figures."

Grasses, 2⅞ × 3¾ in.

"Honeysuckle shed"
probably June 1, 1840,
6 × 7⅞ in.

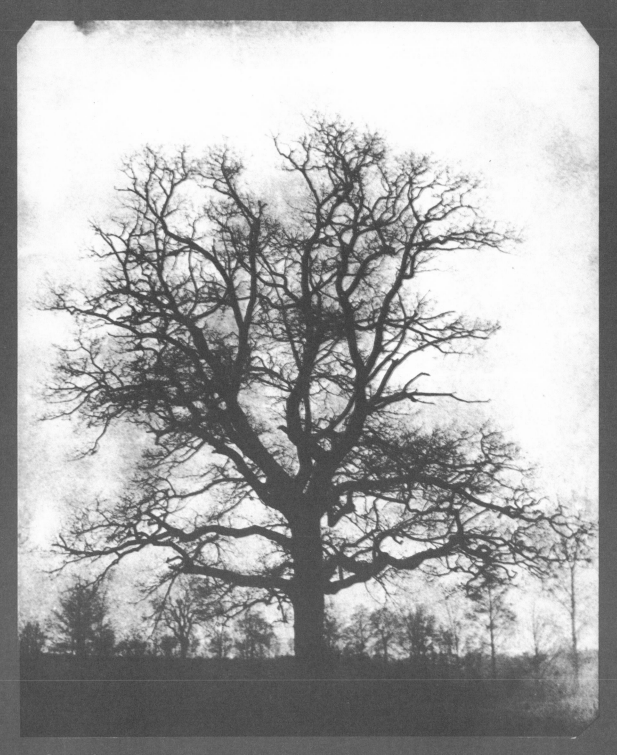

"Leafless Oak Tree."

"Flowers in Vase."

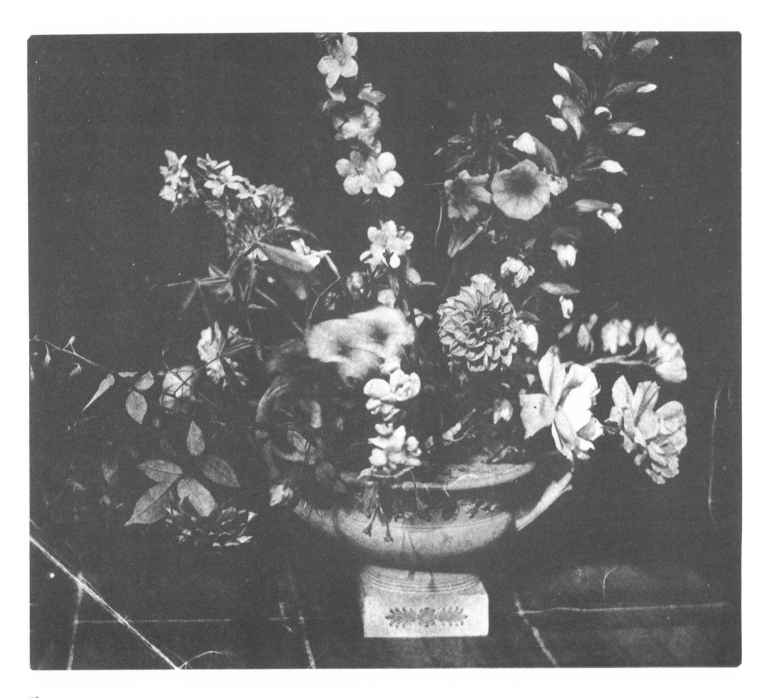

Flower arrangement.

"A bush of Hydrangea in flower."

Window and rosebush, c. 1841–43.

Window and ivy, c. 1841–43.

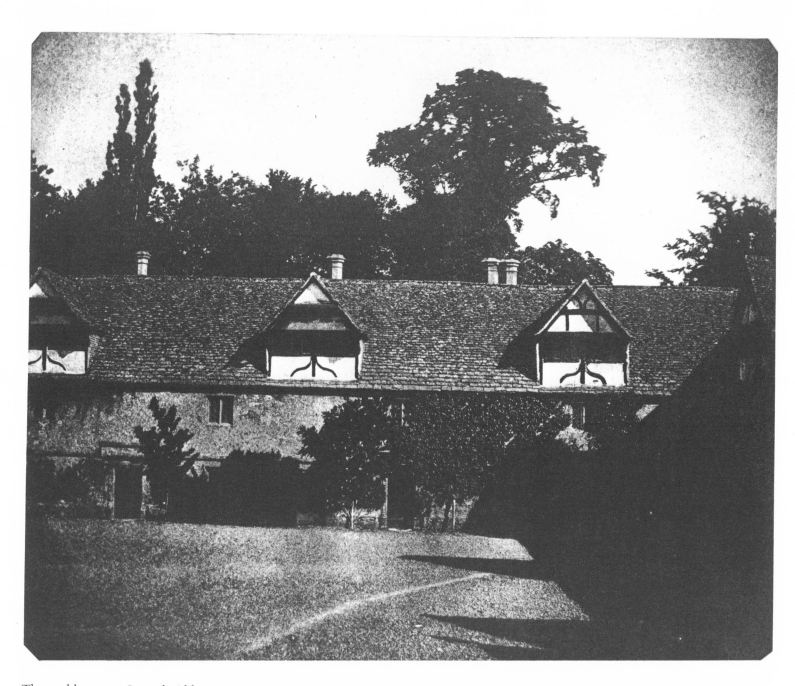

The stable court, Lacock Abbey.

"Cheshire Eaton Hall Gateway copied from St. Augustine's Gate, Canterbury."

Oxford High Street, September 1843.

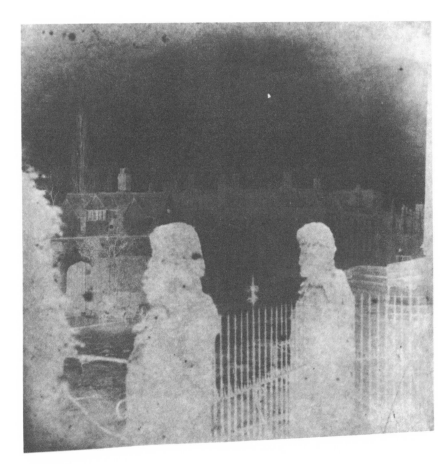

Oxford, All Souls College from above,
probably July 1840.(*)

From the Sheldonian Theatre, Oxford, September 1843.
Negative, 6¾ × 6¾ in.

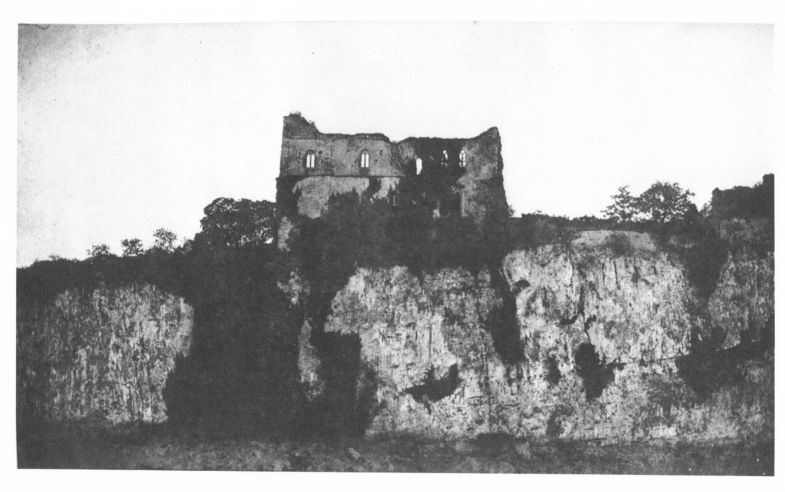

Usk Castle, Monmouthshire, August 1844.(*)

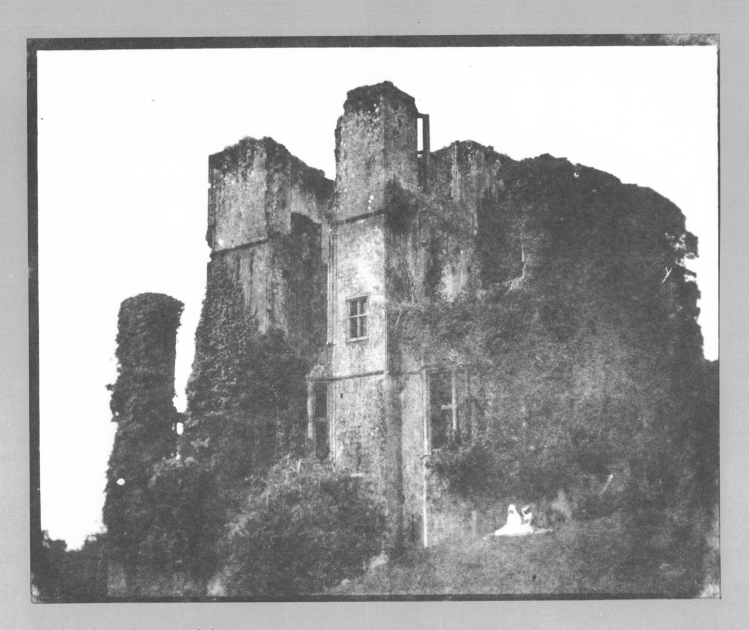

Kenilworth Castle, Warwickshire.

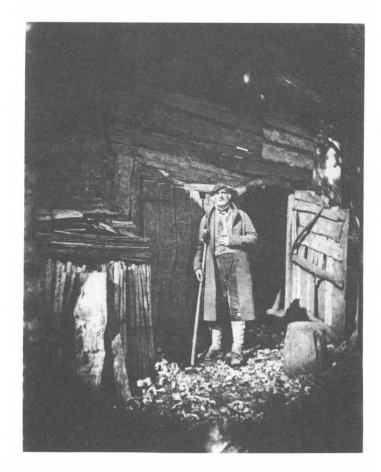

Studies of a group of laborers,
probably in or near the village of Lacock.
All are approximately 7⅜ × 6 in.

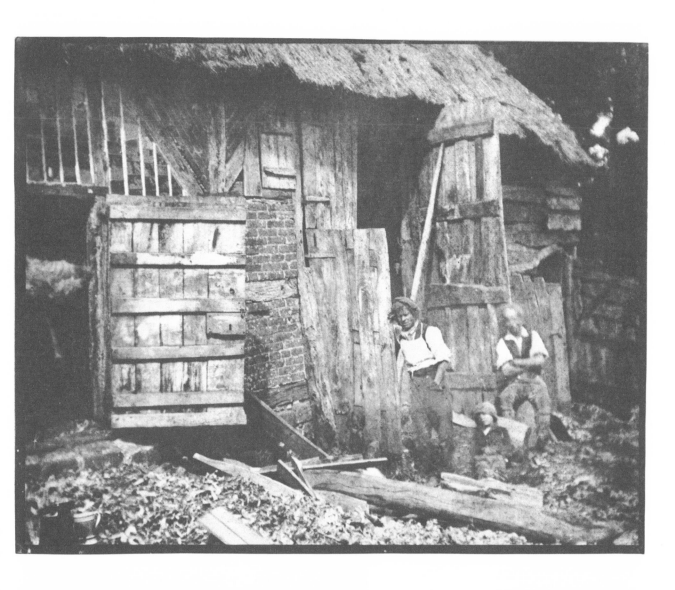

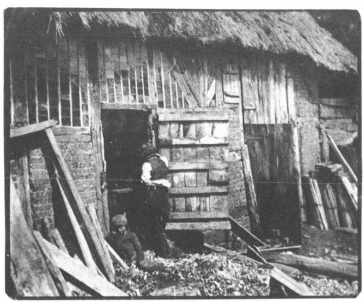

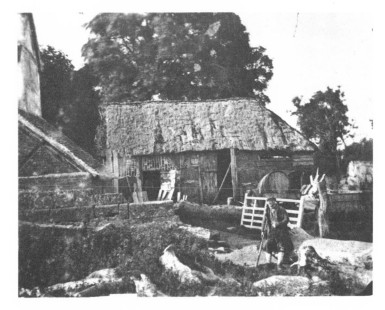

Theale, Berkshire.

Christchurch Gateway,
Canterbury, 6½ × 8 in.

Unidentified archway, 5¾ × 7½ in.

Tree on hill, 3⅞ × 3 in.

"Coley Avenue, Reading"
by Talbot or Nicolaas Henneman,
8 × 7½ in.

Coley Avenue, Reading. As Henneman also photographed in Reading,
this picture could be either by Talbot or his assistant.

"A Mountain Rivulet which flows
at the foot of Doune Castle" 1844,
Plate 20 in *Sun Pictures of Scotland*,
3¼ × 4⅛ in.

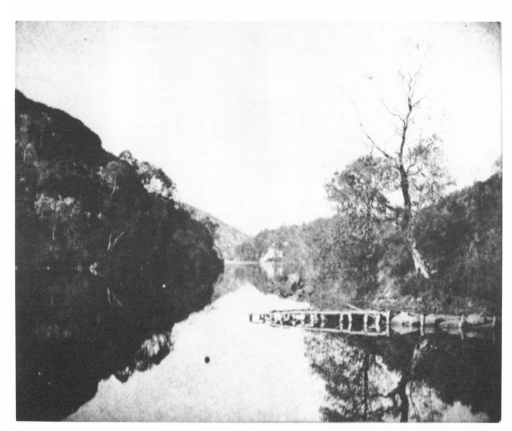

"Scenery of Loch Katrine" 1844,
Plate 16 in *Sun Pictures of Scotland*,
3⅜ × 4³/₁₆ in.

A waterfall,
7¼ × 8⅞ in.

Trees and reflections,
6½ × 7½ in.

Ruined castle in distance, 6¼ × 7¾ in.

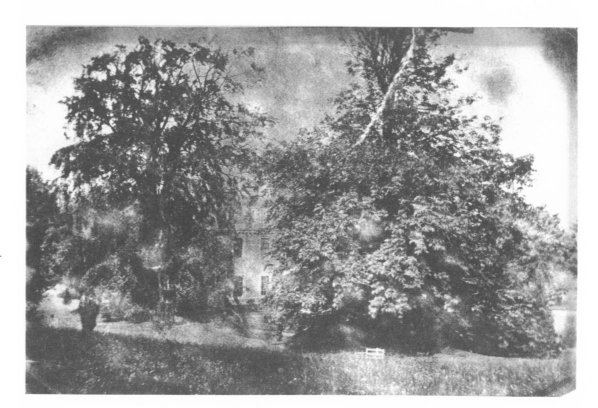

House hidden behind trees.

"Beech Trees, Lacock Abbey."(*)

"Trees," 3½ × 4½.

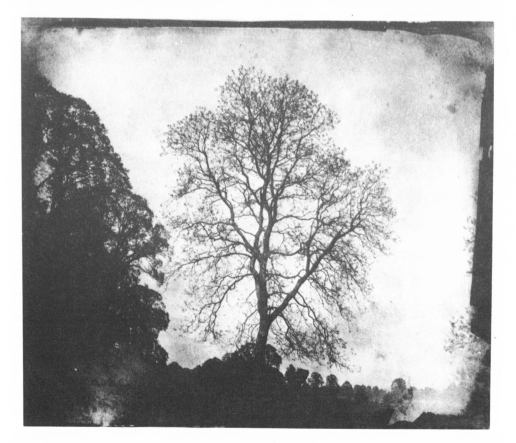

"Ash Tree in Ugbrook Park, Devon"(?), 7⅜ × 8⅞ in.

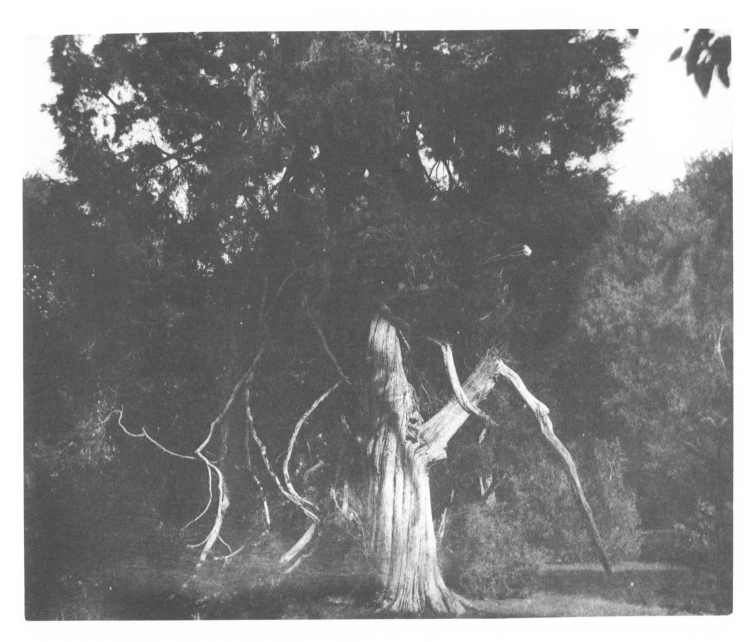

An aged evergreen tree, possibly in the grounds of Mount Edgcumbe.

A bush.

NOTES TO SUN PICTURES

Page 132, right

A palmist, when shown a portrait of Talbot and this early faded print of a hand, without knowing who Talbot was, commented as follows:

This is the hand of a man who could tune into the universe; who had psychic powers. Perhaps he did not recognize these powers, but he was extremely creative and this came from the same source. He could have been a scientist or an inventor.

It is a hand that writes. He wrote factual and detailed material, but saw it as mystery and intrigue. He could have written mystery stories.

The hand shows someone concerned with the future. The position of the fingers reflects this. Something has happened and he is concerned how it will turn out. This is the hand of someone who cared about history.

A serious, intelligent and philosophical man. Severe, not sociable, not sentimental. If he married, he would choose a woman based on her intelligence.

He was a man of determination. When he was younger he did not have much confidence but as the years passed, he gained more and more. Someone kept interrupting him. Although he had determination, he could also be swayed. But because he had determination he did finish things and accomplished a great deal.

The author's intuition (even before showing the palmist the photograph) was that the hand belonged to Talbot.

Page 136, bottom

In a letter to Talbot from his cousin "Kit" (Christopher Rice Mansel Talbot) dated September 15, 1841, we learn that during the summer of 1841 Talbot was photographing groups arranged on the lawn, single portraits, tables covered with ornaments and had previously made some fine studies in Oxford.

Page 144

One of the best methods of identifying the photographs of Calvert Jones is by the writing in the margin on the bottom of the pictures. On July 13, 1846 he wrote to Talbot: "I think it w^d. be much better if the description of the particular view were placed (even written in Pencil) under each in front." Quite often the title of the photograph is accompanied by a number which coincides with lists of his photographs that he sent to Talbot for printing at the Reading Establishment.

Christopher Rice Mansel Talbot was in Naples with Jones. On May 3, 1846 on black bordered stationery (his wife, Lady Charlotte, had just died) he wrote the following letter to Talbot:

I did a few Talbotypes for you, but did not find out till after a great many failures a very simple fact which ought to be known by every experimenter, namely that the solutions will not keep, and ought to be made fresh at least once a fortnight. Gallic acid especially decomposes. If you have not left England, I imagine you will have received the parcel of negatives I did for you. As for Jones, he has thought of nothing else since he left England, and I fear you will have had a surfeit of Malta [Bridges was also there photographing with them]—Still I should like to see a few of mine reversed whenever you can do it, for they will serve to remind me of scenes connected with a portion of my existence which however painful, I would not forget.

One of the most curious characteristics of the two photographs on page 144 is their bright orange/red color. Although Jones did not write about this, the Rev. George Bridges did discuss it in a letter to Talbot from Malta on May 1, 1847:

I cannot discover why they sometimes turn so red in the washing, & the hyp. sulph. bath . . . After all really the copying process seems the present difficulty—To get a good colour with any degree of certainty—& to be sure that you fix permanently—sometimes in the same water & process they come out

[?] a warm sepia—sometimes black—oftener red, & ill defined—Why?

<div align="center">(Letters from the Lacock Collection)</div>

Page 161

The watermark on the negative reads J. WHATMAN TURKEY MILL 1842. On May 1, 1843 Talbot also photographed his other half-sister, Caroline, playing the harp. Caroline Augusta, the wife of the 3rd Earl of Mount Edgcumbe, was a lady-in-waiting to Queen Victoria. On November 4, 1843 she wrote from Windsor Castle to her mother: "If you have any new Calotypes I wish you would send me a few—& the less you double them up the better.... Send if you can the Spanish nuns [?] in the Cloisters, me playing the harp, & some of the Oxford views."

<div align="center">(Letter from the Lacock Collection.)</div>

Page 177, left

Talbot photographed in Oxford in July 1840, two months before he discovered the calotype process. The following letter from Constance to Talbot, dated July 29, 1840 relates to this trip:

You have a lovely sun today for Oxford—& I expect on your returning to see wonderful pictures of all those beautiful buildings which I know only from description.

<div align="center">(Letter from the Lacock Collection)</div>

Page 178

On August 22, 1844 Lady Elisabeth wrote the following letter to her son who was on a photographic trip to Monmouthshire:

My Dear Henry

Owing to the improvement in the post office since the said road has been opened to Exeter, Caroline received your Talbotypes at Eleven o'clock the morning after you despatched them! She was very much pleased & is quite of another opinion to you about the world in general, which she thinks is now only beginning to understand them. As you cannot have much to do in the Evening at [?] the Beaufort Arms which is a sort of generic name for all the Inns in that district, I hope you will give us the fruits of your leisure, if you are not too tired with the day's work to write. I think you will repent having gone without a single book into those remotenesses, particularly if there should be a rainy day—though probably Monmouthshire is much improved in civilization since I travelled in it more than forty years ago, & may produce a circulating library or Booksellers' shop.... I shall narrowly watch Porter [a servant in Talbot's household responsible for sensitizing paper and other photographic chores] (at least as far as his productions) for I believe he is excessively idle.

<div align="center">(Letter from the Lacock Collection.)</div>

Page 189

In a letter to Talbot dated March 25, 1841 George Butler made some suggestions about suitable subjects for photography:

What I should like to see, wld be a set of photogenic Calotype drawings of Forest Trees, the Oak, Elm, Beech, & taken, of course, on a perfectly calm day, when there showed not one breath of wind... This would be the greatest stride towards effective drawing & printing that has been made for a Century. One Artist has one touch for foliage, another has another. Photograph-togenic drawing would be a portrait; it would exhibit the touch of the great Artist, Nature..."

<div align="center">(Letter from the Lacock Collection.)</div>

NOTES TO TEXT

CHAPTER 1

1. Maurice Merleau-Ponty, "Eye and Mind," *The Essential Writings of Merleau-Ponty*, ed. A. L. Fisher (New York, 1969), p. 273.

2. George Steiner, "Give the Word," *The New Yorker* (November 21, 1977), p. 224.

3. William Henry Fox Talbot, *The Pencil of Nature* (London, 1844–1846).

4. Janet Burnett-Brown, "History of Lacock Abbey," *Lacock Abbey, Wiltshire* (The National Trust, England, 1974), p. 6.

5. *Ibid.* p. 5.

6. *Ibid.* p. 7.

7. Manuscript Collection, A. & J. Burnett-Brown, Lacock Abbey, Wiltshire, housed at the Fox Talbot Museum, Lacock. (Subsequently cited as "Lacock Collection.")

8. Herschel Collection, Royal Society, London, March 4, 1833.

9. Lacock Collection.

10. *Ibid.*

11. Herschel Collection, Royal Society, April 30, 1840.

12. H. F. Talbot, *Hermes—or Classical and Antiquarian Researches* (London, 1838), pp. 33–34.

13. H. Fox Talbot, *English Etymologies* (London, 1847), preface.

14. Copyright Royal Institution, London, October 1, 1847.

15. *Proceedings of the Royal Society*, No. 35 (1838), pp. 102–103.

16. *Ibid.*

17. H. F. Talbot, "Experiments on Light," *The London and Edinburgh Philosophical Magazine and Journal of Science*, 3rd series, V, No. 29 (November 1834), p. 325.

18. H. F. Talbot, "On the Optical Phenomena of certain Crystals", *Philosophical Transactions of the Royal Society of London for the Year 1837*, Part 1, p. 25.

19. Lacock Collection, April 8, 1821.

20. Herschel Collection, Royal Society.

21. *Ibid.*

22. Department of Prints and Drawings, Metropolitan Museum of Art, New York. Accession no. 36. 37. Translated from the French.

23. *Ibid.*

24. Lacock Collection, May 29, 1834.

25. *Ibid.*, December 11, 1834.

26. *Ibid.*, December 10, 1835.

27. *Ibid.*, May 27, 1808.

28. Lacock Collection, quoted in J. Dudley Johnston, "William Henry Fox Talbot, F. R. S., Materials Towards a Biography, Part 1," the *Photographic Journal* (January 1947), p. 5.

29. Lacock Collection, quoted in H. J. P. Arnold, *William Henry Fox Talbot Pioneer of Photography and Man of Science* (London, 1977), pp. 29–30.

30. Lacock Collection.

31. Lacock Collection.

32. Lacock Collection.

33. Lacock Collection.

34. Lacock Collection.

35. Lacock Collection.

36. Lacock Collection.

37. Lacock Collection, undated letter to Mr. Thomas Kaye Bonney, Talbot's former tutor.

38. Lacock Collection.

39. Lacock Collection, November 17, 1832.

40. Lacock Collection.

41. Lacock Collection.

CHAPTER 2

1. Lacock Collection, January 22, 1855.

2. Talbot, *Pencil of Nature*, Part 1.

3. *Ibid.*

4. *Ibid.*

5. Beaumont Newhall, *Latent Image: The Discovery of Photography* (New York, 1967), p. 53.

6. Talbot, *Pencil of Nature*.

7. Information given in "Workshop in Early History of American Photography 1839–1880" conducted by Floyd and Marion Rinhart, July 11–22, 1977, at the University of Georgia.

8. H. F. Talbot, "Some Account of the Art of Photogenic Drawing," *London and Edinburgh Philosophical Magazine* XIV (March 1839), p. 198.

9. Lacock Collection.

10. Talbot, *Pencil of Nature*.

11. *Literary Gazette*, (March 30, 1839), p. 202.

12. *London and Edinburgh Philosophical Magazine*, XIV (March 1839), p. 210.

13. Lacock Collection.

14. *Ibid.*

15. *Ibid.*

16. *Literary Gazette* (February 2, 1839), p. 74.

17. Lacock Collection, September 7, 1835.

18. Lacock Collection, dated only "Monday."

19. George Basalla, William Coleman and Robert Kargon (editors), *Victorian Science: A Self-Portrait from the Presidential Addresses of the British Association for the Advancement of Science* (New York, 1970), p. 9.

20. Lacock Collection, April 14, 1857.

21. T. A. Blanco White, *Patents for Inventions and the Protection of Industrial Designs* (London, 1974), p. 26.

22. Lacock Collection.

23. Helmut and Alison Gernsheim, *L. J. M. Daguerre: The History of the Diorama and the Daguerreotype* (New York, 1968), pp. 82–84.

CHAPTER 3

1. Herschel Collection, Royal Society.

2. Fox Talbot Collection, Science Museum, London.

3. Herschel Collection, Royal Society.

4. *Ibid.*

5. *Ibid.*

6. Fox Talbot Collection, Science Museum.

7. *Ibid.*

8. Herschel Collection, Royal Society.

9. Fox Talbot Collection, Science Museum.

10. Lacock Collection.

11. *Ibid.*

12. Herschel Collection, Royal Society.

13. Fox Talbot Collection, Science Museum.

14. Herschel Collection, Royal Society.

15. Fox Talbot Collection, Science Museum.

16. *Ibid.*

17. Herschel Collection, Royal Society.

18. Fox Talbot Collection, Science Museum.

19. Herschel Collection, Royal Society.

20. Lacock Collection.

21. Fox Talbot Collection, Science Museum. Reprinted in *Phot. J.* (September 1937), pp. 529–531.

22. Lacock Collection.

23. Herschel Collection, Royal Society.

24. Fox Talbot Collection, Science Museum.

25. Herschel Collection, Royal Society.

26. *Ibid.*

27. Fox Talbot Collection, Science Museum.

28. Herschel Collection, Royal Society.

29. Fox Talbot Collection, Science Museum.

30. Lacock Collection.

31. Herschel Collection, Royal Society.

32. Fox Talbot Collection, Science Museum.

33. *Ibid.*

34. Lacock Collection.

35. Fox Talbot Collection, Science Museum.

36. Lacock Collection. Quoted in "Etching, Engraving and Photography: History of Photomechanical Reproduction" by Eugene Ostroff, *Journal of Photographic Science*, Vol. 17, No. 3 (1969), p. 78.

37. Lacock Collection.

38. Fox Talbot Collection, Science Museum.

39. Herschel Collection, Royal Society.

40. Fox Talbot Collection, Science Museum.

41. Herschel Collection, Royal Society.

42. Fox Talbot Collection, Science Museum.

43. *Ibid.*

44. Lacock Collection.

45. *Ibid.*

46. Royal Photographic Society Collection.

47. Herschel Collection, Royal Society.

48. Lacock Collection.

49. Herschel Collection, Royal Society.

50. Fox Talbot Collection, Science Museum.

51. Herschel Collection, Royal Society.

CHAPTER 4

1. Lacock Collection, March 25, 1841.

2. Merleau-Ponty, "Cezanne's Doubt," p. 238.

3. *Ibid.*, p. 244.

4. Merleau-Ponty, "Eye and Mind," p. 273.

5. Herschel Collection, Royal Society, September 1, 1840.

6. *Literary Gazette*, February 5, 1841.

7. Herschel Collection, Royal Society, March 17, 1841.

8. *Literary Gazette*, February 19, 1841.

9. Gaston Tissandier, *A History and Handbook of Photography*, ed. John Thomson, 2nd and revised edition with Appendix by Henry Fox Talbot (London, 1878).

10. Fox Talbot Collection, Science Museum. Notebook June 26, 1840–April 23, 1843.

11. Herschel Collection, Royal Society.

12. Herschel Collection, Royal Society, March 17, 1841.

13. Herschel Collection (304 *bis*), Royal Society, March 17, 1841.

14. Fox Talbot Collection, Science Museum. Translated from the French.

15. *Ibid.*

16. *Ibid.*

17. Lacock Collection. Quoted in *Phot. J.* (December 1968), pp. 365–366.

18. Lacock Collection, March 28, 1841.

19. Herschel Collection, Royal Society.

20. Floyd and Marion Rinhart, "Wolcott and Johnson; their camera and their photography," *History of Photography*, Vol. 1, No. 2 (April 1977), p. 129.

21. Lacock Collection, May 9, 1843.

22. Lacock Collection.

23. *Ibid.*, May 22, 1843.

24. Talbot, *Pencil of Nature*.

25. Lacock Collection.

26. *Ibid.*, October 10 [1844?].

27. *Ibid.*, June 14, 1843.

28. Lacock Collection.

CHAPTER 5

1. V. F. Snow and D. B. Thomas, "The Talbotype Establishment at Reading 1844–1847," *Phot. J.* Vol. 106, No. 2 (February 1966), p. 60.

2. *Ibid.*, p. 61.

3. Fox Talbot Collection, Science Museum.

4. Snow and Thomas, p. 66.

5. Introduction by Beaumont Newhall in *The Pencil of Nature* (reprinted New York, 1968).

6. Talbot, *Pencil of Nature*, text accompanying Plate II.

7. Dorothy Norman, ed., "Alfred Stieglitz: Four Happenings" (1942) in *Photographers on Photography*, ed. Nathan Lyons (New Jersey, 1966), p. 129.

8. Herschel Collection, Royal Society, October 26, 1847.

9. Ricardo A. Caminos, "The Talbotype Applied to Hieroglyphics," *J. of Egyptian Archaeology*, Vol. 52 (1966), p. 68.

10. Arnold, p. 161.

11. D. B. Thomas, *The First Negatives* (London, 1964), p. 32.

12. Lacock Collection.

13. Arnold, p. 150.

14. Lacock Collection, December 13, 1845.

15. *Ibid.*, October 26, 1852.

CHAPTER 6

1. Robert Taft, *Photography and the American Scene* (reprinted New York, 1964), p. 52.

2. Lacock Collection, November 2, 1846.

3. *Ibid.*, December 15, 1846.

4. Quoted in Richard Rudisill, *Mirror Image: The Influence of the Daguerreotype on American Society* (Albuquerque, 1971), p. 46.

5. Lacock Collection.

6. Fox Talbot Collection, Science Museum, February 5, 1849.

7. Lacock Collection.

8. Editorial titled "A New Art: Talbotype," *Daily National Intelligencer* (Washington, D.C., May 12, 1849).

9. Fox Talbot Collection, Science Museum, November 18, 1849.

10. *Ibid.*

11. Fox Talbot Collection, Science Museum.

12. Private correspondence from a living relative of Henneman, April 25, 1975.

13. Snow and Thomas, p. 58.

14. Fox Talbot Collection, Science Museum.

15. Helmut and Alison Gernsheim, *The History of Photography* (London, 1969), p. 197.

16. *Ibid.*, p. 179.

17. J. Dudley Johnston, *The Story of the R.P.S.* (London, 1946), p. 2. Privately published.

18. *Ibid.*, p. 3.

19. Royal Photographic Society Collection, April 30, 1852.

20. Arnold, p. 190.

21. Fox Talbot Collection, Science Museum. Draft letter, Talbot to Wheatstone, May 29, 1852.

22. Lacock Collection.

23. *Ibid.*, November 17, 1851.

24. R. Derek Wood, "The Involvement of Sir John Herschel in the Photographic Patent Case, Talbot v. Henderson, 1854," *Annals of Science*, XXVII, No. 3 (September, 1971), p. 262.

25. Gernsheim, *History of Photography*, p. 297.

26. Fox Talbot Collection, Science Museum, December 21, 1858.

27. *Ibid.*, March 30, 1866.

CHAPTER 7

1. Steiner, p. 221.

2. Wood, pp. 239–245.

3. Wood, pp. 243–257.

4. Wood, p. 244.

5. Wood, p. 258.

6. *Journal of the Phot. Soc.* (July 21, 1854), p. 4.

7. Gernsheim, *History of Photography*, p. 148.

8. *Journal of the Phot. Soc.* (July 21, 1854), p. 3.

9. R. Derek Wood, "J. B. Reade, F.R.S., and the Early History of Photography," Part I and II, *Annals of Science*, XXVII, No. 1 (March 1971), pp. 13–83.

10. *Ibid.*

11. D. B. Thomas, *The Science Museum Photography Collection* (London, 1969), p. 74.

12. Eugene Ostroff, "Photography and Photogravure: History of Photomechanical Reproduction," *Journal of Phot. Science*, XVII, No. 4, (1969) p. 102.

13. Herschel Collection, Royal Society, May 18, 1854.

14. Lacock Collection, May 5, 1854.

15. *Ibid.*, May 11, 1853.

16. Herschel Collection, Royal Society.

17. Copyright Royal Institution.

18. *Ibid.*

19. Lacock Collection, May 1856.

20. *Ibid.*, October 6 [1844].

21. *Ibid.*, September 24, 1854.

22. Trinity College Collection, Cambridge University, May 26 [1861].

23. In an album dedicated "To Sir John F. W. Herschel from his Friend Julia Margaret Cameron With a grateful memory of 27 years of friendship Fresh Water Bay Isle of Wight November 26th 1864. September 8th 1867 completed and restored with renewed devotedness of grateful friendship," reprinted in Sotheby's Belgravia catalogue for sale October 18, 1974.

CHRONOLOGY

1800

February 11:

William Henry Fox Talbot, son of Lady Elisabeth Fox-Strangways and William Davenport Talbot, born at Melbury, the home of his maternal grandparents, in Dorset, England.

July 31:

William Davenport Talbot dies.

1804

Lady Elisabeth marries Captain (later Rear Admiral) Charles Feilding.

1808

Caroline Augusta born. Eldest daughter of Lady Elisabeth and Charles Feilding.

1808-11

Attends Rottingdean School.

1810

Henrietta Horatia Maria born. Second daughter of Lady Elisabeth and Charles Feilding.

1811-15

Attends Harrow School.

1815-18

Receives private tuition.

1818

Enters Trinity College, Cambridge.

1820

Receives the Porson Prize for his translation of part of *Macbeth* into Greek.

1821

Is graduated from Trinity College, Cambridge, as Twelfth Wrangler.

1822

"On the Properties of a certain Curve derived from the Equilateral Hyperbola" published in Gergonne's *Annales Mathematiques.* *

Elected a member of the Royal Astronomical Society.

1824

Invited to join the Athenaeum Club, London.

1825

Receives Master's degree from Cambridge University.

Works with François Arago at Paris Observatory.

1826

"Some experiments on Coloured Flames" published in *Edinburgh Journal of Science.*

1827

Moves to Lacock Abbey, ancestral home in Wiltshire.

** Talbot published over fifty papers on scientific and mathematical subjects in addition to those on photography. He also published approximately 70 translations from the Assyrian. Only a few are listed in the chronology.*

1829

Elected to the Fellowship of the Linnean Society.

1830

Legendary Tales in Verse and Prose, collected by H. Fox Talbot published in London by James Ridgeway.

1831

March 21:

Elected to the Royal Society.

December 6:

Caroline, Talbot's half-sister, marries the Earl of Mount Edgcumbe.

1832

February 2:

Admitted as a Fellow of the Royal Society.

December 10:

Elected to Parliament as a Liberal member. Sits in House of Commons 1833–1834.

December 20:

Marries Constance Mundy of Markeaton, Derbyshire, in All Souls' Church, Langham Place, London. Honeymoons in Richmond, Surrey, at the home of Lord Landsdowne.

1833

Publishes four papers in the *Philosophical Magazine:* "Remarks on chemical changes of colour," "Remarks upon an optical phenomenon, seen in Switzerland," "On a method of obtaining homogeneous light of great intensity," and "Proposed philosophical experiments (on the velocity of electricity; and proposed method of ascertaining the greatest depth of the ocean)."

June-December:

Takes Constance on Continental tour. In October while sketching on the shores of Lake Como, the "idea" for photography is conceived.

1834

January:

Begins photographic experiments.

May:

Purchases gallic acid, acetic acid and other chemicals from Potter & Wright, Chemists, London.

August-November:

Continental tour. While in Geneva continues photographic experiments, discovering *cliché-verre* and potassium iodide as a fixing agent.

November:

"Experiments on light" published in the *Philosophical Magazine.*

December:

Laura Mundy writes to Talbot thanking him for the "shadows."

1835

February 28:

Idea for "positives" from "negatives" first recorded in notebook.

April:

Ela Theresa, Henry's and Constance's first daughter born.

Summer:

Makes photographs with little cameras nicknamed "mousetraps" by his wife.

August:

Earliest extant negative dates from this time.

"On the nature of light" published in the *Philosophical Magazine.*

September:

Last reference to photogenic drawing in notebook until 1839.

Trip to Wales; may or may not have taken "mousetraps."

1836

Elected a member of the Council of the Royal Society.

Annual meeting of the British Association held in Bristol; many eminent scientists stay at Lacock Abbey.

"On the optical phenomena of certain crystals" published in two parts in *Philosophical Transactions.*

"Reasearches in the Integral Calculus," Part 1, published in two parts in *Philosophical Transactions;* (Part 2, 1837).

1837

The Royal Society awards Talbot the Bakerian Prize for his two papers on the optical phenomenon of crystals; gives the Bakerian lecture of the year.

Sir David Brewster dedicates his *Treatise on the Microscope* to Talbot.

Visits his uncle William Fox-Strangways in Germany.

March 25:

Rosamond Constance, second daughter, born.

September 2:

Rear Admiral Charles Feilding dies.

1838

Hermes—or Classical and Antiquarian Researches published in two parts by Longman, Orme, Brown, Green & Longmans, London. *Hermes* No. 2, 1839.

March:

"On a new property of the iodine of silver" published in *Philosophical Magazine.*

December:

Receives the Royal Medal from the Royal Society for his work in integral calculus.

1839

January 7:

Daguerre's process announced.

January 25:

Shows photogenic drawings at the Royal Institution.

January 31:

Presents "Some Account of the Art of Photogenic Drawing" to the Royal Society.

February 1:

Herschel suggests the use of hypo to Talbot.

February 2:

Charles Wheatstone writes letter to Talbot using the word "photographic."

February 21:

"An Account of the Processes employed in Photogenic Drawing" read before the Royal Society. Talbot is thus the first to give freely to the world details of a photographic process.

February 25:

Matilda Caroline, third daughter, born.

March:

Begins to use potassium bromide in conjunction with silver nitrate to sensitize paper.

March 30:

Purchased "1 Dr Crystallized Gallic Acid Bottle."

April:

Details of photogenic drawing first published in the United States. (*The Journal of the Franklin Institute,* Vol. 27, p. 264.)

August 19:

Daguerre reveals details of his process.

September:

The Antiquity of the Book of Genesis—Illustrated by Some New Arguments, Longman, Orme, Brown, Green & Longmans, London.

1840

Between January 30 and February 8 the word "calotype" first appears in notebook.

At Her Majesty's request, appointed Sheriff of the County of Wiltshire.

July:

Photographs in Oxford

September 22, 23:

Uses gallic acid to develop a latent image.

October 1:

Patent 8650 for "Producing or obtaining motor-power."

October 6:

Records taking a portrait, exposure five minutes.

1841

February 5 and 19:

Writes two letters to the *Literary Gazette* discussing the calotype.

February 8:

Patent 8842 for "Obtaining pictures or representations of objects."

May 6:

Pass to photograph at Windsor Castle.

June 10:

Communicates "The Process of Talbotype (Formerly called Calotype) Photogenic Drawing" to the Royal Society.

August 20:

Calotype patent sold in France to Moses Poole for ten years. Transferred to Talbot's name June, 1843.

December 9:

Patent 9167 for "Coating or covering metals with other metals, & colouring metallic surfaces."

1841-42

Caroline and Horatia travel in Italy from December to May and show calotypes to friends and leading scientists.

1842

Charles Henry, only son, born.

Receives the Rumford Medal from the Royal Society for photographic discoveries.

May-June:

With Henneman in Germany.

Reads paper "On the Improvement of the Telescope" at the British Association meeting.

November 25:

Patent 9528 for "Coating or covering metals with other metals."

1843

Specially orders Whatman Turkey Mill paper, watermarked 1840.

May-June:

With Henneman photographs in Calais, Rouen, Orleans and Paris. Teaches the Marquis de Bassano the calotype.

June:

Patent 9753 "Photography."

September:

Photographs in Oxford.

1843-44

During the winter sets up printing establishment at 55 Baker Street, Reading, and puts Henneman in charge. (Closed 1847).

1844

January:

Record of the Death Bed of C. M. W. by John Walter, Jr., privately published. Frontispiece a photograph printed at Reading. First publication to include an actual photograph.

June (to April 1846.)

Six numbers of *The Pencil of Nature* produced containing a total of 24 photographs.

October:

Photographic tour of Scotland.

1845

March 3:

Patent 10,539 for "Obtaining motive-power; application of motive-power to railways."

April:

Photographs at Claudet's London studio.

Summer:

Sun Pictures of Scotland published, 23 photographs, no text.

July and September:

Photographic tour of York, Bristol and Devon with Calvert Jones and Henneman.

1846

Lady Elisabeth dies.

The Talbotype Applied to Hieroglyphics published, contains 3 photographs.

Tours the Rhine valley and Switzerland carrying photographic equipment.

Christopher Rice Mansel Talbot, Calvert Jones, and George Bridges travel and photograph together in Malta and Italy.

December:

Signs lease for 122 Regent Street; Nicolaas Henneman made responsible for "Sun Picture Rooms."

December 7:

Patent 11,475 "Obtaining and Applying Motive Power."

1847

Annals of the Artists of Spain by Sir William Stirling published, 67 photographs.

English Etymologies, John Murray, London.

1848

Henneman and Thomas A. Malone buy Regent Street business from Talbot.

1849

May 11:

Sells calotype patent for America to Langenheim brothers.

December 19:

Patent 12,906 "Photography" with Thomas A. Malone.

1850

Horatia marries Thomas Gaisford.

1851

Horatia dies in childbirth.

June:

First public demonstration of high speed photography.

June 12:

Patent 13,664 "Photography."

December 6:

"On the Production of Instantaneous Photographic Images" published in *The Athenaeum.*

1852

Henneman acquires property in Kensal Green to build a printing establishment.

January 22:

Court grants Talbot an injunction restraining Richard Colls from producing and selling photographs on paper.

August 13:

The Times carries a letter written by Talbot dated July 30 relinquishing all his patent rights for photography except that of professional portraiture.

October 29:

Patent 565 for [photoglyphic] "Engraving".

December 13:

Patent 1,046 "Obtaining motive power."

1854

Notes on Assyrian inscriptions, privately printed.

May:

Injunction against John Henderson preventing his making portraits for sale by the wet-collodion process.

Summer:

In Paris, Lyon and Turin, apparently the first time back in Italy since he conceived of the idea of photography.

November 27:

Description in the *Literary Gazette* of his invention called "The Traveller's Camera."

December 18–20:

Talbot *v.* Laroche patent case heard. Decided that Talbot was the true inventor of the positive/negative process that utilizes the concept of the latent image, but that the wet-collodion process invented by Scott Archer was not covered by calotype patent.

1855

Awarded Grande Médaille d'Honneur by the international jury of L'Exposition Universelle in Paris for his contributions to photography.

1856

Bellino's Cylinder. The Cylinder of Esarhaddon. A Portion of the Annals of Ashurakhbal. Privately printed.

1857

Inscription of Tiglath Pileser I., King of Assyria B.C. 1150—As Translated by Sir Henry Rawlinson, Fox Talbot, Esq., Dr. Hincks, and Dr. Oppert. Published by the Royal Asiatic Society.

"On Fermat's theorem" published in the *Transactions* of the Royal Society of Edinburgh.

1858

Elected Honorary Fellow of the Royal Society of Edinburgh.

April 21:

Patent 875 "Improvements in the art of engraving."

1859

Elected Vice-President of Royal Society of Literature.

June 16:

Matilda Caroline, Talbot's only child to marry, weds John Gilchrist-Clark.

1861

"Early Researches on the Spectra of Artificial Light from Different Sources" published in *Chemical News.*

1863

University of Edinburgh confers honorary degrees on Lord Palmerston and Talbot.

1864

"On Fagnani's theorem" and "On the theory of numbers" published in *Transactions* of the Royal Society of Edinburgh.

1864-65

Purchases house in Edinburgh. Sold in 1872.

1865

Photoglyphic engraving wins prize at Berlin International Photographic Exhibition.

1866

"On the Eastern Origin of the Name and Worship of Dionysus" and other articles published in the *Journal of the Royal Society of Literature.*

1867

Cited as *"un des inventeurs de la photographie"* and receives medal from Société Française de Photographie.

"Note on confocal conic sections," "Researches on Malfatti's problem," and "Some mathematical researches" (cubic equations); published in the *Transactions* of the Royal Society of Edinburgh.

1868

"Note on *Vellozia elegans* from the Cape of Good Hope," published in the *Transactions* of the Edinburgh Botanical Society.

1868-69

Unanimously offered, but refused, Presidency of the British Association for the Advancement of Science.

1871

"On a Method of estimating the Distance of Some of the Fixed Stars," a report given to the meeting of the British Association.

1872

"Note on anomalous spectra," "Note on the early history of spectrum analysis," "On a new mode of observing certain spectra" published in the *Proceedings* of the Royal Society of Edinburgh.

1873

Made an Honorary Member of the Photographic Society of London.

1875

"Essay towards a general solution of numerical equations of all degrees having integer roots" published in the *Transactions* of the Royal Society of Edinburgh.

1876

"Commentary on Deluge tablet," "Notice of a very ancient comet," and "The revolt in Heaven" published in the *Transactions* of the Society of Biblical Archaeology.

1877

Writes an appendix (completed by his son) to the second edition of the English translation of G. Tissandier's *History and Handbook of Photography,* edited by John Thomson.

September 17:

Dies at Lacock Abbey.

APPENDIX I

A.D. 1841 Nº 8842.

Photographic Pictures.

TALBOT'S SPECIFICATION AND DISCLAIMER.

TO ALL TO WHOM THESE PRESENTS SHALL COME, I, WILLIAM HENRY FOX TALBOT, of Lacock Abbey, in the County of Wilts, Esquire, send greeting.

WHEREAS Her present most Excellent Majesty Queen Victoria, by Her
5 Letters Patent under the Great Seal of Great Britain, bearing date at Westminster, the Eighth day of February, in the fourth year of Her reign, did, for Herself, Her heirs and successors, give and grant unto me, the said William Henry Fox Talbot, Her especial licence, full power, sole privilege and authority, that I, the said William Henry Fox Talbot, my exōrs, adūtiors, and assigns, or
10 such others as I, the said William Henry Fox Talbot, my exōrs, adūtiors, or assigns, should at any time agree with, and no others, from time to time and at all times during the term of years therein expressed, should and lawfully might make, use, exercise, and vend, within England, Wales, and the Town of Berwick-upon-Tweed, my Invention of " IMPROVEMENTS IN OBTAINING
15 PICTURES, OR REPRESENTATIONS OF OBJECTS ;" in which said Letters Patent is contained a proviso, that I, the said William Henry Fox Talbot, shall cause a particular description of the nature of my said Invention, and in what manner the same is to be performed, to be inrolled in Her said Majesty's High Court of Chancery, within six calendar months next and immediately after the date
20 of the said in part recited Letters Patent, as in and by the same, reference being thereunto had, will more fully and at large appear.

· NOW KNOW YE, that in compliance with the said proviso, I, the said William Henry Fox Talbot, do hereby declare the nature of my said Invention,

Note: Anyone attempting to make calotypes will find that they must experiment to arrive at the correct proportion of chemicals to suit today's materials. Joel Snyder, Associate Professor at the University of Chicago and an expert on antique processes, found that he had to use more than three times the amount of glacial acetic acid than called for in Talbot's 1841 patent in order to obtain satisfactory results.

and the manner in which the same is to be performed, are fully described and ascertained in and by the following statement thereof (that is to say):—

The first part of my Invention is a method of making paper extremely sensitive to the rays of light. For this purpose I select the best writing paper, having a smooth surface and a close and even texture. 5

First Part of the Preparation of the Paper.—I dissolve one hundred grains of crystallised nitrate of silver in six ounces of distilled water, I wash one side of the paper with this solution with a soft camel hair brush, and place a mark upon that side by which to know it again. I dry the paper cautiously at a distant fire, or else I leave it to dry spontaneously in a dark place. Next, I 10 dip the paper in a solution of iodide of potassium, containing five hundred grains of that salt dissolved in one pint of water, I leave the paper a minute or two in this solution, I then take it out and dip it in water, I then dry it lightly with blotting paper and finish drying it at a fire; or else I leave it to dry spontaneously; all this process is best done in the evening by candle light. 15 The paper thus far prepared may be called, for the sake of distinction, "iodized paper." This iodized paper is scarcely sensitive to light, but, nevertheless, it should be kept in a portfolio or some dark place till wanted for use; it does not spoil by keeping any length of time provided it is kept in a portfolio, and not exposed to the light. 20

Second Part of the Preparation of the Paper.—This second part is best deferred until the paper is wanted for use; when that time is arrived, I take a sheet of the iodized paper, and wash it with a liquid prepared in the following manner:—Dissolve one hundred grains of crystallised nitrate of silver in two ounces of distilled water, to this solution add one-sixth of its volume of strong 25 acetic acid; let this mixture be called A. Dissolve crystallized gallic acid in distilled water as much as it will dissolve (which is a very small quantity); let this solution be called B. When you wish to prepare a sheet of paper for use, mix together the liquids A and B in equal volumes. This mixture I shall call by the name of gallo-nitrate of silver. Let no more be mixed than is intended 30 to be used at one time, because the mixture will not keep good for a long period. Then take a sheet of iodized paper and wash it over with this gallo-nitrate of silver with a soft camel hair brush, taking care to wash it on the the side which has been previously marked. This operation should be performed by candle light. Let the paper rest half a minute, and then dip it 35 into water, then dry it lightly with blotting paper, and lastly, dry it cautiously at a fire, holding it a considerable distance therefrom. When dry the paper is fit for use, but it is advisable to use it within a few hours after its preparation. (Note, that if it is used immediately the last drying may be dispensed with,

and the paper may be use moist). (Note 2nd, instead of using a solution of gallic acid for the liquid B, the tincture of galls diluted with water may be used, but it is not so advisable.

Use of the Paper.—The paper thus prepared, and which I name " calotype 5 paper," is placed in a camera obscura, so as to receive the image formed in the focus of the lens, of course the paper must be screened or defended from the light during the time it is being put into the camera. When the camera is properly pointed at the object, this screen is withdrawn, or a pair of internal folding doors are opened, so as to expose the paper for the reception of the 10 image. If the object is very bright, or the time employed is sufficiently long, a sensible image is perceived upon the paper when it is withdrawn from the camera. But when the time is short, or the objects dim, no image whatever is visible upon the paper, which appears entirely blank. Nevertheless, it is impressed with an invisible image; and I have discovered the means of causing 15 this image to become visible. This is performed as follows:—I take some gallo-nitrate of silver, prepared in the manner before directed, and with this liquid I wash the paper all over with a soft camel hair brush, I then hold it before a gentle fire, and in short time (varying from a few seconds to a minute or two), the image begins to appear upon the paper. Those parts of the 20 paper upon which light has acted the most strongly become brown or black, while those parts on which light has not acted remain white. The image continues to strengthen and grow more and more visible during some time. When it appears strong enough, the operation should be terminated and the picture fixed.

The Fixing Process.—In order to fix the picture thus obtained, I first dip it 25 into water, I then partly dry it with blotting paper, and then wash it with a solution of bromide of potassium, containing one hundred grains of that salt dissolved in eight or ten ounces of water. The picture is then washed with water, and then finally dried. Instead of bromide of potassium, a strong 30 solution of common salt may be used, but it is less advisable. The picture thus obtained will have its lights and shades reversed with respect to the natural objects; videlicet, the lights of the objects are represented by shades, and vice versâ. But it is easy from this picture to obtain another, which shall be conformable to nature; videlicet, in which the lights shall be represented by 35 lights, and the shades by shades. It is only necessary for this purpose to take a second sheet of sensitive calotype paper, and place it in close contact with the first, upon which the picture has been formed. A board is put beneath them, and a sheet of glass above, and the whole is pressed into close contact by screws. Being then placed in sunshine, or daylight, for a short time, an image

or copy is formed upon the second sheet of paper. This image or copy is often invisible at first, but the image may be made to appear in the same way that has been already stated. But, I do not recommend that the copy should be taken on calotype paper, on the contrary, I would advise that it should be taken on common photographic paper. This paper is made by washing good 5 writing paper first with a weak solution of common salt, and next with a solution of nitrate of silver, since it is well known, having been freely communicated to the public by myself, in the year One thousand eight hundred and thirty-nine, and that it forms no part of the present Invention, I need not describe it here more particularly; although it takes a much longer time to 10 obtain a copy upon this paper than upon calotype paper, yet the tints of the copy are generally more harmonious and agreeable. On whatever paper the copy is taken, it should be fixed in the way already described. After a calotype picture has furnished a good many copies, it sometimes grows faint, and the subsequent copies are inferior. This may be prevented by means of a 15 process which revives the strength of the calotype pictures. In order to this, it is only necessary to wash them by candle light with gallo-nitrate of silver, and then warm them. This causes all the shades of the picture to darken considerably, while the white parts are unaffected. After this the picture is, of course, to be fixed a second time. The picture will then yield a second 20 series of copies, and a great number of them may frequently be made.

(Note.—In the same way in which I have just explained that a faded calotype picture may be revived and restored, it is possible to strengthen and revive photographs which have been made on other descriptions of sensitive potographic paper; but these are inferior in beauty, and, moreover, the result 25 is less to be depended upon; I therefore do not recommend them.

The next part of my Invention consists in a mode of obtaining positive photographic pictures, that is to say, photographs in which the lights of the object are represented by lights, and the shades by shades. I have already described how this may be done by a double process; but I shall now describe 30 the means of doing it by a single process. I take a sheet of sensitive calotype paper, and expose it to daylight until I perceive a slight but visible discoloration or browning of its surface. This generally occurs in a few seconds. I then dip the paper into a solution of iodide of potassium, of the same strength as before, videlicet, five hundred grains to one pint of water. This 35 immersion apparently removes the visible impression caused by the light (nevertheless, it does not really remove it, for if the paper were to be now washed with gallo-nitrate of silver it would speedily blacken all over). The paper when taken out of the iodide of potassium is dipped in water, and then

lightly dried with blotting paper, it is then placed in the focus of a camera obscura which is pointed at an object; after five or ten minutes the paper is withdrawn and washed with gallo-nitrate of silver, and warmed as before directed; an image will then appear of a positive kind, namely, representing 5 the lights of the object by lights, and the shades by shades. Engravings may be very well copied in the same way, and positive copies of them obtained at once (reversed, however, from right to left). For this purpose a sheet of calotype paper is taken and held in daylight to darken it as before mentioned, but for the present purpose it should be more darkened than if it were 10 intended to be used in the camera obscura. The rest of the process is the same. The engraving and the sensitive paper should be pressed into close contact with screws, or otherwise, and placed in the sunshine, which generally effects the copy in a minute or two; this copy, if it is not sufficiently distinct, must be rendered visible, or strengthened with the gallo-nitrate of silver, as 15 before described.

I am aware that the use of iodide of potassium for obtaining positive photographs has been recommended by others, and I do not claim it here by itself as a new Invention, but only when used in conjunction with the gallo-nitrate of silver, or when the pictures obtained are rendered visible or strengthened subsequently 20 to their first formation. In order to take portraits from the life, I prefer to use for the object glass of the camera a lens whose focal length is only three or four times greater than the diameter of the aperture. The person whose portrait is to be taken should be so placed that the head may be as steady as possible, and the camera being then pointed at it, an image is received on the 25 sensitive calotype paper. I prefer to conduct the process in the open air, under a serene sky, but without sunshine; the image is generally obtained in half a minute or a minute. If sunshine is employed, a sheet of blue glass should be used as a screen to defend the eyes from too much glare, because this glass does not materially weaken the power of the chemical rays to affect 30 the paper. The portrait thus obtained on the calotype paper is a negative one, and from this a positive copy may be obtained in the way already described.

I claim, first, the employing gallic acid or tincture of galls, in conjunction with a solution of silver, to render paper which has received a previous pre- 35 paration more sensitive to the action of light.

Secondly, the making visible photographic images upon paper, and the strengthening such images when already faintly or imperfectly visible by washing them with liquids which act upon those parts of the paper which have been previously acted upon by light.

Thirdly, the obtaining portraits from the life by photographic means upon paper.

Fourthly, the employing bromide of potassium, or some other soluble bromide, for fixing the images obtained.

The next part of my Invention is a method of obtaining photogenic images upon copper. For this purpose I take a plate of polished copper, and expose it to the vapour of iodine or bromine, or of these two substances united, or of either of them, in union with chlorine; or else I dip the plate of copper into a solution of some of the above-mentioned substances in alcohol, ether, or other convenient solvent. By this means the copper surface becomes sensitive to light; a photogenic image is then to be formed upon it in the usual manner. The plate is then to be exposed to the vapour of sulphuretted hydrogen, or of one of the liquid hydro-sulphurets. This vapour produces various colors upon the surface of the copper, but it acts differently or produces a different color on those parts of the surface which have been exposed to light, and on those which have not been so exposed, consequently a colored photogenic image is obtained, and as this image is not destroyed by a subsequent exposure to light, no further fixing process is requisite. Instead of the vapour of sulphuretted hydrogen, other vapours or liquid solutions which color the surface of copper (as, for instance, iodine, bromine, and chlorine) may be employed, but with less advantage.

With respect to this branch of my Invention, I claim the above-mentioned methods of rendering a surface of copper sensitive to light, and the method of rendering the photogenic image colored and permanent by subsequent exposure to vapours or liquids, which act differently on those parts of the surface that have been exposed and those not exposed to light.

The next part of my Invention is as follows :—A smooth surface of steel, platina, or other suitable metal, is coated with an extremely thin layer of silver; the silver is then made sensitive to light by the methods now well known, and a photogenic image is received upon it; the plate, with the image, is then placed in a horizontal position, and a solution of acetate of lead in water is poured upon it; a galvanic current is then made to pass through the plate and the solution, which causes a colored film to precipitate upon the plate.

With respect to this branch of my Invention, I claim the application of the colored films produced by a solution of lead when acted on by galvanism to the purpose of obtaining photogenic images, which are colored or otherwise diversified.

The next part of my Invention is a method of obtaining very thin silver

plates or surfaces, for the purpose of economy in the processes of photography in which such are used, and also for the greater convenience of transport in travelling. For this purpose, I precipitate on a polished metal plate a thin layer of copper, by the galvanic process now well known by the name of electrotype; I then cement or glue a sheet of paper or card to the back of this layer of copper, and when it is dry I remove the paper with the layer of copper adhering; this copper is then silvered by dipping it into any suitable solution of silver.

The last part of my Invention consists in transferring photogenic images from paper to metal. In order to this the metallic surface is made sensitive to light; the paper photograph is then placed on it with a sheet of glass in front, and the whole is pressed into firm contact by screws, or otherwise, and exposed to sunshine. A photograph on metal is thus obtained, which is afterwards to be fixed, and to be otherwise treated according to the effect intended to be obtained.

I have already described the means of transferring the image on one description of sensitive paper to another description of sensitive paper; and with respect to this branch of my Invention, I claim the transferring photogenic pictures obtained upon sensitive paper to a metallic surface, or to a different kind or quality of sensitive paper; I do not confine myself to the precise weights and measure of the substances employed in these processes which I have mentioned, since they may be varied according to circumstances; but I have mentioned those which I have found on the whole to be the most convenient.

In witness whereof, I, the said William Henry Fox Talbot, have hereunto set my hand and seal, this Twenty-ninth day of July, One thousand eight hundred and forty-one.

WILLIAM HENRY (L.S.) FOX TALBOT.

AND BE IT REMEMBERED, that on the Twenty-ninth day of July, in the year of our Lord 1841, the aforesaid William Henry Fox Talbot came before our said Lady the Queen in Her Chancery, and acknowledged the Specification aforesaid, and all and every thing therein contained and specified, in form above written. And also the Specification aforesaid was stamped according to the tenor of the Statute made for that purpose.

Enrolled the Seventh day of August, in the year of our Lord One thousand eight hundred and forty-one.

DISCLAIMER.

In the Matter of a Patent granted to William Henry Fox Talbot, of Lacock Abbey, in the County of Wilts, Esquire, for his Invention of "IMPROVEMENTS IN OBTAINING PICTURES, OR REPRESENTATIONS OF OBJECTS," bearing date at Westminster, the Eighth February, One thousand eight hundred and forty-one, to which a Specification was duly enrolled.

DISCLAIMER proposed to be filed by the said William Henry Fox Talbot, pursuant to the provisions of the Statutes in that behalf, that is to say :—

I, the said William Henry Fox Talbot, do hereby disclaim the following part of the said Specification, that is to say, the part thereof commencing with the words, "The next part of my Invention is a method of obtaining photogenic images upon copper," and extending from those words and including the same continuously to the end of the said Specification. My reasons for such Disclaimer are, that the parts of my said Invention so disclaimed being of a separate character, and independant of the first and principal parts of my said Invention, as described in the said Specification, and more of a scientific than a practical nature. I am advised that in any action brought for an infringement of the said Patent objections may be raised, which would require evidence to be adduced in support respectively of those parts of my said Invention which I disclaim, thereby adding to the expense and difficulty of such action; and therefore, although I still fully believe that I am the first and true Inventor of the said parts of the said Invention, yet I consider it advisable to disclaim them, as aforesaid.

In witness whereof, I, the said William Henry Fox Talbot, have hereunto set my hand and seal, this Sixth day of March, in the year of our Lord One thousand eight hundred and fifty-four.

W. H. F. TALBOT. (L.S.)

To the Clerk of the Patents of England.

This is to certify, That William Henry Fox Talbot, of Lacock Abbey, in the County of Wilts, Esquire, has applied to me for leave to file with you the above written Disclaimer of a certain Invention for which Letters Patent were

duly granted to him under the Great Seal of the United Kingdom, dated the 8th day of February 1841, a Specification to which was duly enrolled; and having considered the said application, and no caveat having been entered against the same, I have accordingly granted leave to the said William Henry Fox Talbot to file his said Disclaimer, pursuant to the Statute in such case made and provided.

And I hereby also certify that any action may be brought in respect of any infringement committed prior to the filing of this Disclaimer, notwithstanding the entry or filing of the same, and pursuant to the Statute in that case made and provided.

Temple, Febr 27th, 1854.

A. E. COCKBURN.

Entered and filed with the Clerk of the Patents of England, this Eighth day of March 1854.

Great Seal Patent Office.

AND BE IT REMEMBERED, that on the Sixth day of March, in the year of our Lord 1854, the aforesaid William Henry Fox Talbot came before our said Lady the Queen in Her Chancery, and acknowledged the Disclaimer aforesaid, and all and every thing therein contained and specified, in form above written. And also the Disclaimer aforesaid was stamped according to the tenor of the Statute made for that purpose.

Enrolled the Eighth day of March, in the year of our Lord One thousand eight hundred and fifty-four.

LONDON:
Printed by GEORGE EDWARD EYRE and WILLIAM SPOTTISWOODE,
Printers to the Queen's most Excellent Majesty. 1856.

APPENDIX II

DESCRIPTION

OF

MR. FOX TALBOT'S NEW PROCESS

OF

PHOTOGLYPHIC ENGRAVING.

EXTRACTED FROM THE "PHOTOGRAPHIC NEWS,"
OCTOBER 22ND, 1858.

LONDON:
PETTER AND GALPIN, LA BELLE SAUVAGE YARD,
LUDGATE HILL, E.C.

PHOTOGLYPHIC ENGRAVING.

WE have been favoured by Mr. Fox Talbot with the following description of his new invention, taken from the specification of the patent which has just been enrolled.

" The process described in this specification, to which I have given the name of 'Photoglyphic Engraving,' is performed in the following manner:—

" In this invention, I employ plates of steel, copper, or zinc, such as are commonly used by engravers. Before using a plate its surface should be well cleaned; it should then be rubbed with a linen cloth dipped in a mixture of caustic soda and whiting, in order to remove any remaining trace of greasiness. The plate is then to be rubbed dry with another linen cloth. This process is then to be repeated; after which, the plate is in general sufficiently clean.

" In order to engrave a plate, I first cover it with a substance which is sensitive to light. This is prepared as follows:—About a quarter of an ounce of gelatine is dissolved in eight or ten ounces of water, by the aid of heat. To this solution is added about one ounce, by measure, of a saturated solution of bichromate of potash in water, and the mixture is strained through a linen cloth. The best sort of gelatine for the purpose is that used by cooks and confectioners, and commonly sold under the name of gelatine. In default of this, isinglass may be used, but it does not answer so well. Some specimens of isinglass have an acidity which slightly corrodes and injures the metal plates. If this accident occurs, ammonia should be added to the mixture, which will be found to correct it. This mixture of gelatine and bichromate of potash keeps good for several months, owing to the antiseptic and preserving power of the bichromate. It remains liquid and ready for use at any time

during the summer months; but in cold weather it becomes a jelly, and has to be warmed before using it: it should be kept in a cupboard or dark place. The proportions given above are convenient, but they may be considerably varied without injuring the result. The engraving process should be carried on in a partially darkened room, and is performed as follows:—A little of this prepared gelatine is poured on the plate to be engraved, which is then held vertical, and the superfluous liquid allowed to drain off at one of the corners of the plate. It is held in a horizontal position over a spirit lamp, which soon dries the gelatine, which is left as a thin film, of a pale yellow colour, covering the metallic surface, and generally bordered with several narrow bands of prismatic colours. These colours are of use to the operator, by enabling him to judge of the thinness of the film: when it is very thin, the prismatic colours are seen over the whole surface of the plate. Such plates often make excellent engravings; nevertheless, it is perhaps safer to use gelatine films which are a little thicker. Experience alone can guide the operator to the best result. The object to be engraved is then laid on the metal plate, and screwed down upon it in a photographic copying frame. Such objects may be either material substances, as lace, the leaves of plants, &c., or they may be engravings, or writings, or photographs, &c., &c. The plate bearing the object upon it is then to be placed in the sunshine, for a space of time varying from one to several minutes, according to circumstances; or else, it may be placed in common daylight, but of course for a longer time. As in other photographic processes, the judgment of the operator is here called into play, and his experience guides him as to the proper time of exposure to the light. When the frame is withdrawn from the light, and the object removed from the plate, a faint image is seen upon it—the yellow colour of the gelatine having turned brown wherever the light has acted. This process, so far as I have yet described it, is, in all essential respects, identical with that which I described in the specification of my former patent

for improvements in engraving, bearing date the 29th October, 1852.

" The novelty of the present invention consists in the improved method by which the photographic image, obtained in the manner above described, is engraved upon the metal plate. The first of these improvements is as follows:—I formerly supposed that it was necessary to wash the plate, bearing the photographic image, in water, or in a mixture of water and alcohol, which dissolves only those portions of the gelatine on which the light has not acted: and I believe that all other persons who have employed this method of engraving, by means of gelatine and bichromate of potash, have followed the same method, viz., that of washing the photographic image. But however carefully this process is conducted, it is frequently found, when the plate is again dry, that a slight disturbance of the image has occurred, which, of course, is injurious to the beauty of the result; and, I have now ascertained, that it is not at all necessary to wash the photographic image; on the contrary, much more beautiful engravings are obtained upon plates which have not been washed, because the more delicate lines and details of the picture have not been at all disturbed. The process which I now employ is as follows:—When the plate, bearing the photographic image, is removed from the copying frame, I spread over its surface, carefully and very evenly, a little finely-powdered gum copal (in default of which common resin may be employed). It is much easier to spread this resinous powder evenly upon the surface of the gelatine, than it is to do so upon the naked surface of a metal plate. The chief error the operator has to guard against is, that of putting on too much of the powder: the best results are obtained by using a very thin layer of it, provided it is uniformly distributed. If too much of the powder is laid on it impedes the action of the etching liquid. When the plate has been thus very thinly powdered with copal, it is held horizontally over a spirit lamp in order to melt the copal; this requires a considerable heat. It might be sup-

posed that this heating of the plate, after the formation of a delicate photographic image upon it, would disturb and injure that image; but it has no such effect. The melting of the copal is known by the change of colour. The plate should then be withdrawn from the lamp, and suffered to cool. This process may be called the laying an aquatint ground upon the gelatine, and I believe it to be a new process. In the common mode of laying an aquatint ground, the resinous particles are laid upon the naked surface of the metal, before the engraving is commenced. The gelatine being thus covered with a layer of copal, disseminated uniformly and in minute particles, the etching liquid is to be poured on. This is prepared as follows:—Muriatic acid, otherwise called hydrochloric acid, is saturated with peroxide of iron, as much as it will dissolve with the aid of heat. After straining the solution, to remove impurities, it is evaporated till it is considerably reduced in volume, and is then poured off into bottles of a convenient capacity; as it cools it solidifies into a brown semi-crystalline mass. The bottles are then well-corked up, and kept for use. I shall call this preparation of iron by the name of perchloride of iron in the present specification, as I believe it to be identical with the substance described by chemical authors under that name—for example, see 'Turner's Chemistry,' fifth edition, page 537; and by others called permuriate of iron—for example, see 'Brande's Manual of Chemistry,' second edition, vol. ii. page 117.

" It is a substance very attractive of moisture. When a little of it is taken from a bottle, in the form of a dry powder, and laid upon a plate, it quickly deliquesces, absorbing the atmospheric moisture. In solution in water, it forms a yellow liquid in small thicknesses, but chestnut-brown in greater thicknesses. In order to render its mode of action in photographic engraving more intelligible, I will first state, that it can be very usefully employed in common etching; that is to say, that if a plate of copper, steel, or zinc is covered with an etching ground, and lines are traced

on it with a needle's point, so as to form any artistic subject; then, if the solution of perchloride of iron is poured on, it quickly effects an etching, and does this without disengaging bubbles of gas, or causing any smell; for which reason it is much more convenient to use than aquafortis, and also because it does not injure the operator's hands or his clothes if spilt upon them. It may be employed of various strengths for common etching, but requires peculiar management for photoglyphic engraving; and, as the success of that mode of engraving chiefly turns upon this point, it should be well attended to.

" Water dissolves an extraordinary quantity of perchloride of iron, sometimes evolving much heat during the solution. I find that the following is a convenient way of proceeding :—

" A bottle (No. 1) is filled with a saturated solution of perchloride of iron in water.

" A bottle (No. 2) with a mixture, consisting of five or six parts of the saturated solution and one part of water.

" And a bottle (No. 3) with a weaker liquid, consisting of equal parts of water and the saturated solution. Before attempting an engraving of importance, it is almost essential to make preliminary trials, in order to ascertain that these liquids are of the proper strengths. These trials I shall therefore now proceed to point out. I have already explained how the photographic image is made on the surface of the gelatine, and covered with a thin layer of powdered copal or resin, which is then melted by holding the plate over a lamp. When the plate has become perfectly cold, it is ready for the etching process, which is performed as follows:— A small quantity of the solution in bottle No. 2, viz., that consisting of five or six parts of saturated solution to one of water, is poured upon the plate, and spread with a camel-hair brush evenly all over it. It is not necessary to make a wall of wax round the plate, because the quantity of liquid employed is so small that it has no tendency to run off the plate. The liquid penetrates the gelatine wherever the light

has not acted on it, but it refuses to penetrate those parts upon which the light has sufficiently acted. It is upon this remarkable fact that the art of photoglyphic engraving is mainly founded. In about a minute the etching is seen to begin, which is known by the parts etched turning dark brown or black, and then it spreads over the whole plate— the details of the picture appearing with great rapidity in every quarter of it. It is not desirable that this rapidity should be too great, for, in that case, it is necessary to stop the process before the etching has acquired sufficient depth (which requires an action of some minutes' duration). If, therefore, the etching, on trial, is found to proceed too rapidly, the strength of the liquid in bottle No. 2 must be altered (by adding some of the saturated solution to it) before it is employed for another engraving; but if, on the contrary, the etching fails to occur after the lapse of some minutes, or if it begins, but proceeds too slowly, this is a sign that the liquid in bottle No. 2 is too strong, and too nearly approaching saturation. To correct this, a little water must be added to it before it is employed for another engraving. But, in doing this, the operator must take notice, that a very minute quantity of water added often makes a great difference, and causes the liquid to etch very rapidly. He will therefore be careful, in adding water, not to do so too freely. When the proper strength of the solution in bottle No. 2 has thus been adjusted, which generally requires three or four experimental trials, it can be employed with security. Supposing then, that it has been ascertained to be of the right strength, the etching is commenced as above mentioned, and proceeds till all the details of the picture have become visible, and present a satisfactory appearance to the eye of the operator, which generally occurs in two or three minutes; the operator stirring the liquid all the time with a camel-hair brush, and thus slightly rubbing the surface of the gelatine, which has a good effect. When it seems likely that the etching will improve no further, it must be stopped. This is done by wiping off the liquid with cotton wool, and

then rapidly pouring a stream of cold water over the plate, which carries off all the remainder of it. The plate is then wiped with a clean linen cloth, and then rubbed with soft whiting and water to remove the gelatine. The etching is then found to be completed.

" I will now describe another etching process, very slightly differing from the former, which I often use. When the plate is ready for etching, pour upon it a small quantity of the liquid (No 1—the saturated solution). This should be allowed to rest upon the plate one or two minutes. It has no very apparent effect, but it acts usefully in hardening the gelatine. It is then poured off from the plate, and a sufficient quantity of solution (No 2) is poured on. This effects the etching in the manner before described : and, if this appears to be quite satisfactory, nothing further is required to be done. But it often happens, that certain faint portions of the engraving—such as distant mountains or buildings in a landscape—refuse to appear; and as the engraving would be imperfect without them, I recommend the operator, in that case, to take some of the weak liquid (No. 3) in a little saucer; and, without pouring off the liquid (No. 2) which is etching the picture, to touch with a camel-hair brush, dipt in liquid (No. 3), those points of the picture where he wishes for an increased effect. This simple process often causes the wished-for details to appear, and that, sometimes, with great rapidity, so that caution is required in the operator, in using this weak solution (No. 3) especially, lest the etching liquid should penetrate to the parts which ought to remain white: but, in skilful hands, its employment cannot fail to be advantageous, for it brings out soft and faint shadings which improve the engraving, and which would otherwise probably be lost. Experience is requisite in this, as in most other delicate operations connected with photography; but I have endeavoured clearly to explain the leading principles of this new process of engraving, according to the method I have hitherto found the most successful."

H. F. TALBOT.

BIBLIOGRAPHY

PRIMARY SOURCES OF ORIGINAL
TALBOT MATERIAL

Fox Talbot Museum, Lacock, Wiltshire
Science Museum, London
Royal Society, London
Royal Photographic Society, London
Royal Scottish Museum, Edinburgh
Smithsonian Institution, Washington, D.C.

BOOKS AND PRIVATELY PRINTED WORKS BY TALBOT

Legendary Tales in Verse and Prose. London: James Ridgway, 1830.

Hermes—or Classical and Antiquarian Researches. London: Longman, Orme, Brown, Green & Longmans, 1838. No. 2, 1839.

The Antiquity of the Book of Genesis—Illustrated by Some New Arguments. London: Longman, Orme, Brown, Green & Longmans, 1839.

The Pencil of Nature. London: Longman, Brown, Green & Longmans, June 1844 to April 1846 (issued in six parts). Reprinted New York: Da Capo Press, 1969, introduction by Beaumont Newhall.

Sun Pictures in Scotland. Published by subscription, 1845.

English Etymologies. London: John Murray, 1847.

Notes on the Assyrian Inscriptions. Privately printed, 1854.

Bellino's Cylinder. The Cylinder of Asarhaddon. A Portion of the Annals of Ashurakhbal. Privately printed, 1856.

Inscription of Tiglath Pileser I King of Assyria 1150 B.C.—As translated by Sir Henry Rawlinson, Fox Talbot Esq., Dr. Hincks and Dr. Oppert. London: Royal Asiatic Society, 1857.

ADDITIONAL PUBLICATIONS
FROM THE READING ESTABLISHMENT
AND THE SUN PICTURE ROOMS

The Talbotype Applied to Hieroglyphics, 1846.

Annals of the Artists of Spain by Sir William Stirling, 1847.

Talbotypes or Sun Pictures, Taken from the Actual Objects Which They Represent. London: Nicolaas Henneman, 1847.

BOOKS ON TALBOT AND LACOCK ABBEY

Arnold, H. J. P. *William Henry Fox Talbot Pioneer of Photography and Man of Science.* London: Hutchinson Benham, 1977.

Booth, Arthur. *William Henry Fox Talbot: Father of Photography.* London: Arthur Barker, 1965.

Bowles, Rev. W. L. and Nicholls, J. B. *Annals and Antiquities of Lacock Abbey.* London: J. B. Nicholls and Son, 1835.

Gilchrist-Clark (later Talbot), Matilda. *My Life and Lacock Abbey.* London: Allen & Unwin, 1956.

Jammes, André. *Photography: Men and Movements* Vol. 2—*William H. Fox Talbot Inventor of the Negative-Positive Process.* New York: Macmillan Publishing Co., Inc., 1974.

Lacock Abbey-Wiltshire, The National Trust, 1974.

Thomas, D. B. *The First Negatives.* London: HMSO, 1964.

ARTICLES

Beckers, A. "Talbot's American Patent." *British Journal of Photography,* August 2, 1889, pp. 510–511.

Bull, A. J. "Fox Talbot's Photoglyphic Engraving." *The Photographic Journal,* August 1934, pp. 432–433.

Caminos, Ricardo A. "The Talbotype Applied to Hieroglyphics." *The Journal of Egyptian Archaeology,* Vol. 52, 1966.

Clark-Maxwell, W. G. "The Personality of Fox Talbot." *The Photographic Journal,* August 1934, pp. 428–430.

Coe, Brian. " 'Sun Pictures' Modern Preparation." *Camera*, September 1976, pp. 22–23.

———"Printing Talbot's Calotype Negatives." *History of Photography*, July 1977, pp. 175–182.

Gernsheim, Helmut. "Talbot's and Herschel's Photographic Experiments in 1839." *Image*, No. 8, 1959, pp. 132–137.

Gill, Arthur T. "Another Look at Fox Talbot's '1839' Camera." *The Photographic Journal*, October 1966, pp. 344–345.

———"Calotype Correspondence." *The Photographic Journal*, June 1975, pp. 284–285.

———"Portraits of Fox Talbot." *The Photographic Journal*, July 1975, pp. 303–305.

Jeffrey, Ian. "British Photography from Fox Talbot to E. O. Hoppé." *The Real Thing*. London: Arts Council of Great Britain, pp. 5–24.

Johnston, J. Dudley. "Sidelight on Fox Talbot." *The Photographic Journal*, January 1941, pp. 24–26.

———"William Henry Fox Talbot, F.R.S.—Materials Towards a Biography." *The Photographic Journal*, January 1947, pp. 3–13. Part II, December 1968, pp. 361–371.

Lambert, Herbert. "Fox Talbot's Photographic Inventions." *The Photographic Journal*, August 1934, pp. 430–432.

Lassam, R. E., "Fox Talbot: New Horizons." *The Photographic Journal*, July 1975, pp. 300–301.

———"Fox Talbot, A Brief Biography." *Camera*, September 1976, p. 21.

Newhall, Beaumont. "William Henry Fox Talbot." *Image*, June 1959.

Ostroff, Eugene. "Early Fox Talbot Photographs and Restoration by Neutron Irradiation." *The Journal of Photographic Science*, September-October 1965, pp. 213–227.

———"Talbot's Earliest Extant Print, June 20, 1835, Rediscovered." *Photographic Science and Engineering*, November-December 1966, pp. 350–354.

———"Etching, Engraving and Photography: History of Photomechanical Reproduction." *The Journal of Photographic Science*, Vol. 17, No. 3, 1969, pp. 65–80. "Photography and Photogravure." Vol. 17, No. 4, 1969, pp. 101–115.

———"The Calotype and the Photographer." *The Journal of Photographic Science*, Vol. 26, 1978, pp. 83–88.

Snow, V. F. and Thomas, D. B. "The Talbotype Establishment at Reading 1844–1847." *The Photographic Journal*, February 1966, pp. 56–67.

Talbot, M. T. "The Life and Personality of Fox Talbot." *Journal of the Royal Society of Arts*, June 23, 1939, pp. 826–830; also *The Photographic Journal*, No. 79, 1939, pp. 546–549.

Ward, John. "The Fox Talbot Collection." *Camera*, September 1976, pp. 23–24.

———"The Fox Talbot Collection in the Science Museum." *History of Photography*, October 1977, pp. 275–287.

White, Harold. "William Henry Fox Talbot, The First Miniaturist." *The Photographic Journal*, November 1949, pp. 247–251.

———"Fox Talbot 1800–1877." *Photography* (London), January 1950, pp. 6–9.

———"Fox Talbot-Founder of Modern Photography." *Amateur Photographer*, February 8, 1950, pp. 92–94.

———"Fox Talbot's '1839' Camera." *The Photographic Journal*, December 1966, p. 106.

Wood, R. D. "J. B. Reade, FRS and the Early History of Photography. Part 1. A Re-assessment on the Discovery of Contemporary Evidence." *Annals of Science*, March 1971, pp. 13–45. Part 2. "Gallic Acid and Talbot's Calotype Patent." March 1971, pp. 47–83.

———"The Involvement of Sir John Herschel in the Photographic Patent Case, Talbot v. Henderson, 1854." *Annals of Science*, September 1971, pp. 239–264.

———"The Calotype Patent Lawsuit of Talbot v. Laroche 1854." A contribution to the history of photography to welcome the opening of the Talbot Museum at Lacock. Privately printed, 1975.

SELECTED 19th CENTURY JOURNALS, NEWSPAPERS, ETC. WITH ARTICLES BY TALBOT

The Athenaeum, Journal of Literature, Science and the Fine Arts.

Chemical News.

Comptes Rendus Hebdomadaires des Séance de l'Académie des Sciences.

Edinburgh Journal of Science.

Edinburgh Philosophical Journal.

Edinburgh Royal Society Transactions.

Journal of the Royal Asiatic Society.

Journal of the Royal Society of Literature.

Journal of Sacred Literature.

The Literary Gazette and Journal of the Belles Lettres, Arts, Science, etc.

London and Edinburgh Philosophical Magazine and Journal of Science.

Proceedings of the Society of Antiquaries of Scotland.

Royal Society Philosophical Transactions.

Royal Society Proceedings.

The Times (London).

Transactions of the Society of Biblical Archaeology.

[N.B. A complete list of Talbot's published articles is found in Arnold's book on Talbot.]

GENERAL

Beaton, Cecil and Buckland, Gail. *The Magic Image: The Genius of Photography from 1839 to the Present Day.* Boston: Little Brown and Company, 1975.

Buckland, Gail. *Reality Recorded: Early Documentary Photography.* Greenwich, Conn: New York Graphic Society, 1974.

Coe, Brian. *Pioneers of Science and Discovery—George Eastman and the Early Photographers.* London: Priory Press, 1973.

———*The Birth of Photography.* New York: Taplinger Publishing Company, 1977.

Eder, Josef Maria. *History of Photography.* New York: Columbia University Press, 1945.

"From Today Painting is Dead" The Beginnings of Photography. London: Arts Council of Great Britain, 1972.

Gernsheim, Helmut and Alison. *The History of Photography.* New York: McGraw-Hill Book Company, 1969.

——*L. J. M. Daguerre: The History of the Diorama and the Daguerreotype.* New York: Dover Publications, 1969.

Ivins, William M. Jr. *Prints and Visual Communication.* New York: DaCapo Press, 1969.

Johnston, J. Dudley. *The Story of the R.P.S.* London: Privately published, 1946.

Lécuyer, Raymond. *Histoire de la photographie.* Paris: Baschet, 1945.

Masterpieces of Victorian Photography 1840–1900: from the Gernsheim Collection. London: Arts Council of Great Britain, 1951.

Newhall, Beaumont. *On Photography: A Source-Book of Photo-History in Facsimile.* Watkins Glen, N.Y: Century House, 1956.

——*The History of Photography.* New York: Museum of Modern Art, 1964.

——*Latent Image: The Discovery of Photography.* Garden City, N.Y: Anchor Books, 1967.

Pollack, Peter. *The Picture History of Photography.* New York: Harry N. Abrams, Inc., 1969.

Potonniée, Georges. *The History of the Discovery of Photography.* New York: Tennant and Ward, 1936. Reprinted New York: Arno Press, 1973.

Rudisill, Richard. *Mirror Image: The Influence of the Daguerreotype on American Society.* Albuquerque, N.M: University of New Mexico, 1971.

Scharf, Aaron. *Pioneers of Photography: An Album of Pictures and Words.* New York: Harry N. Abrams, Inc., 1976.

Taft, Robert. *Photography and the American Scene.* New York: Dover Books, 1964.

Thomas, D. B. *The Science Museum Photography Collection.* London: HMSO, 1969.

Time-Life Books. *Light and Film.* New York: Time, Inc. 1970.

Tissandier, Gaston. *A History and Handbook of Photography,* edited by J. Thomson. London: Sampson, Low, Marston, Searle and Rivington, 1878. 2nd and revised edition with an Appendix by W. H. F. Talbot (and C. H. Talbot). Reprinted New York: Arno Press, 1973.

Une Invention Du XIXe Siècle, Expression et Technique La Photographie. Paris: Bibliothèque Nationale, 1976.

INDEX

PICTURE CREDITS

All photographs and illustrations are from the Fox Talbot
Collection, Science Museum, London except for the following:

The Fox Talbot Museum, Lacock, Wiltshire: 11, 12, 61
(*bottom*), 63 (*right*), 116 (*bottom*), 124, 135 (*top*),
138 (*bottom*).

The Royal Photographic Society, London: 121 (*right*),
132 (*left*).

The Harold White Collection: 116 (*top*)

The book and its jacket were designed by Philip Grushkin.

The text was set by Precision Typographers Inc., New Hyde Park, New York,

in Trump Mediaeval, a typeface designed by Georg Trump.

The book was printed on Monadnock's Caress by A. Hoen & Co., Lithographers, Baltimore, Maryland,

and was bound by Tapley-Rutter Company, Inc., Moonachie, New Jersey.